ART AND RELIGION IN AFRICA

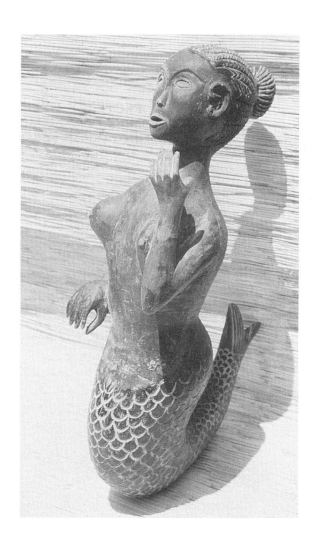

Art and Religion in Africa

Rosalind I.J. Hackett

CASSELL

Cassell
Wellington House, 125 Strand, London WC2R 0BB
127 West 24th Street, New York, NY 10011

First published 1996

British Library Cataloguing-in-Publication Data

A catalogue record for this book is available from the British Library.

ISBN 0-304-33752-8

Library of Congress Cataloging-in-Publication Data

Hackett, Rosalind I. J.
 Art and religion in Africa / Rosalind I.J. Hackett.
 p. cm.—(Religion and the arts)
 Includes bibliographical references and index.
 ISBN 0-304-33752-8 (hardcover)
 1. Art and religion —Africa. 2. Art and society—Africa.
 I. Title. II. Series: Religion and the arts series.
 N72.R4H25 1996
 700'.1'07—dc20 95-48182
 CIP

Designed and typeset by Ben Cracknell Studios
Printed and bound in Great Britain by Martins The Printers

Contents

List of Illustrations

List of Illustrations

■ Foreword

As scholars gradually abandon the old approach of interpreting African art solely on the basis of formal analysis and de-emphasizing considerations of culturally relevant concepts of art and African thought systems, the investigation of the role of religious beliefs which have apparently inspired and supported the creation of many artifacts will no longer be of secondary but rather of *primary* interest to the researcher. Indeed, an interdisciplinary approach is essential as the quest for a culturally relevant definition of African art continues in the era of post-modernist discourse. Most scholars now acknowledge that 'African art' is more than one thing. It is affective—it causes, it transforms. Many things happen, not just what one can see, hear, or think at one time. Ordinary items and objects used in everyday life are transformed into art forms, lending themselves to a virtually unlimited range of interpretations and applications. In pre-colonial times and, to some extent, today, most objects (masks, figures, textiles, pottery, shrine paintings, etc.) which are now classifiable as art, could have been mnemonic devices, transformer-carriers intended to facilitate free communication between the material and spiritual planes of existence, while also providing valuable insights into African metaphysical systems, myths, lore, and complex traditional notions and thought patterns. Not infrequently, these objects would also feature prominently in the settlement of disputes, in the search for solutions to difficult problems, and in the traditional educational systems as important pedagogic tools.

In judging the efficacy and affectiveness of such objects or artifacts, however, considerations of technical skill, design consciousness, and familiarity with culturally relevant aesthetic concerns become paramount. It is at this point that the focus shifts to the artists— their creative genius, their deep esoteric knowledge of things and events around them, as well as their intellectual power of vivid expression—all of which are indispensable in the traditionally non-literate societies of Africa.

That religious beliefs and artistic processes are interdependent, supporting each other through mutual references and allusions in virtually all of Africa, makes it difficult to study one without familiarity with the other. Here, in my opinion, lies the immediate relevance and indisputable importance of this book. Professor Rosalind Hackett examines those issues that many scholars of African art might be reluctant, or perhaps feel insufficiently equipped, to address. This hesitation on the part of Africanist art historians could also be attributed to their inheritance of an art-historical discipline which frowns on or even forbids the mixture of religion and art in its studies. While appreciating the methodologies of a discipline such as art history developed in

the context of Western culture, in this comparative study, Professor Hackett has raised questions regarding the rigid application of a Western art-historical conceptual framework to the study of African art. Thus, *Art and* *Religion in Africa* must be seen as an example of the significant contribution which can be made by a scholar of religion to the study of African art.

Rowland Abiọdun
Department of Fine Art
Amherst College, USA

Preface and Acknowledgements

A friend and colleague once remarked that I possessed an apparent proclivity for gravitating toward the interstices of life. If so, and I tend to share his view, then this work is a manifestation of that tendency. It represents an attempt to bring together data and ideas on the much neglected interconnections of art and religion in Africa. So when approached, some years ago, by John Hinnells (then editor) to produce the volume on Africa for the innovative series on "Religion and the Arts" I agreed for three reasons. First, I knew, somewhat instinctively, from my own fieldwork in Nigeria among the Yoruba and Efik, that this would be an exciting and important area to pursue. Second, I knew academically that such a creative exploration of art and religion in the African context was feasible and desirable. This I attribute to the influence of John Pemberton III who was already forging ahead in this field. As Copeland Fellow at Amherst College in 1984, I had been privileged to co-teach a course with him on "Religion and Art in Africa." It was an inspiration to be privy to his wealth of information and insightful reflections. Third, I was aware of the ever-widening appeal of African art in the international art market, together with a burgeoning scholarly discourse, increasingly enhanced by the voices of African scholars and the artists themselves.

An overview of the study of African art over the last twenty years or so reads like a litany of scholars chiding one another for having forgotten, neglected or over-emphasized one aspect—whether it be form, style, context, iconography, function, meaning, philosophy, psychology, ethnicity, individual artists, gender, ritual, performance, language, oral literature, aesthetics, cosmology, technique, materials, history, etc. Coming as something of an outsider, I therefore saw my task as drawing together and synthesizing disparate, but connected, ideas—arguing a) that the visual and performing arts are indispensable aids to the study of African religions, and b) that a focus on religion provides a fresh perspective on African art—challenging us to reconsider the links between form, meaning, experience, function, and context.

There are any number of ways of coming to an appreciation of African art—whether for its aesthetic, decorative, investment, heritage, spiritual, or scholarly value. It bears underlining that religion is but one, by no means differentiated, part of the mosaic of African material and expressive culture. I have been studying and writing on African religions for the last twenty years or so. This particular study has opened vital doors for me onto the rich and fascinating worlds of African visual representations and conceptualizations. It has brought me to a heightened sense of the multidimensionality and agency of African art. For such a vast and complex topic there are

obviously any number of paths to take toward the clearings, and my efforts cannot in any way be considered definitive or determinative. I hope that I have removed some of the "blind spots" for scholars of art and religion in my excursus, and stirred up the epistemological waters into the bargain. Furthermore, I hope that my comparative synthesis may prove useful for all those engaged in the study of African cultures, and will promote further scholarly inquiry.

To these ends I have chosen and woven together a combination of case studies, together with a variety of examples to support my selected themes. These are in turn illustrated by a range of images—whether field or museum photographs, or line drawings. While interest has been paramount in sub-Saharan Africa as far as artistic production is concerned (in fact mainly in West and Central Africa where sculpting and masking traditions abound), my selections are drawn from the whole of the African continent (except for ancient Egypt which is the subject of a later volume in this series) and from varying historical periods. I am concerned to convey the great artistic diversity of the African continent. With greater space (the chorus of every author), I would have done more justice to Islamic and Christian art, North Africa, the New World, as well as a host of theoretical issues. Another volume calls . . .

Agonies and ecstasies attend any creative effort. The task of academic production is no different. My most arduous task was in accessing and treating the vast array of sources. I was obliged to visit libraries and museums in various parts of North America, Europe, and Africa. But it was also a highly enjoyable task—poring over visually stunning art books, contemplating powerful art works, and conversing with experts in the field. I came to appreciate the primacy of process over product—to the point of not even wanting to see closure for my project! But close it had to, even though so much more could have been said or seen.

One only has to look at my bibliography to appreciate how much I have drawn on the fruits of others' labors. Naturally, I have been selective, utilizing the work of those who have shown some sensitivity to and interest in questions of cosmology, meaning, ritual significance, etc. In the early stages, when I was looking through a glass darkly, a number of colleagues provided much-needed encouragement and direction—Monni Adams, Sidney Kasfir, and Paula Girshick Ben-Amos. Both Sidney and Paula have offered incisive and helpful critiques of chapters. My original proposal was subjected to the inimitable and critical gaze of Rowland Abiọdun. It was he who set me on a more productive and well-charted course, and he has continued to provide wisdom and encouragement all along the way. It is therefore fitting that he kindly agreed to write the foreword to the book in its completed stage.

I have sought wherever possible to use the work of African scholars since they are generally more attuned to the esoteric and spiritual dimensions of art works. I would like to acknowledge the benefits I have derived from dialogue with a selected few over some of the thornier issues raised in this book. In particular I would like to mention Wande Abimbola, Kofi Agovi, Olabiyi Yai, John R. O. Ojo, T. K. Biaya and Babatunde Lawal. All the following people deserve my heartfelt gratitude for their contributions to the project with comments, contributions, illustrations, and/or critical readings: John Picton, John Hinnells, Wyatt MacGaffey, Raymond Silverman, Robert Soppelsa, Marilyn Heldman, John Hunwick, Robin Poynor and his Master's students at the University of Florida, Tom McCaskie, Rosalind

Shaw, Terry Childs, Phillip Lucas, Simon P. X. Battestini, Roy Sieber, Allen Roberts, John Pemberton III, Roslyn Walker, Eli Bentor, Henry Drewal, Philip Ravenhill, Joseph Murphy, Herbert M. Cole, Johanna Agthe, Lisa Aronson, Matthews Ojo, James Fitzgerald, Gary van Wyk, Laura Birch de Aguilar, Till Förster, Zoe Strother, Bogumil Jewsiewicki, Judy Sterner, Mei Mei Sanford, Peter Mark, Mark Hulsether, and Rosalind Gwynne. Simon Ottenberg was as ever generous with both illustrations and written materials. I am also grateful to students in the classes that I taught on African Art at Georgetown University and the University of Tennessee, for entertaining my need for a "dry run" on particular topics.

A paradigm shift occurred in this project when I was fortunate enough to be awarded a PASALA (Project for the Advanced Study of Art and Life in Africa) grant at the University of Iowa in April 1994. My work benefitted from being able to consult the fine Stanley Collection of African Art and from the type of brainstorming that only the Iowa triumvirate— Christopher Roy, Allen Roberts, and William Dewey—could offer. Museum staff there helped make my short visit a profitable one.

As well, my colleagues in Religious Studies at the University of Tennessee kept up our tradition of rigorous, yet productive, substantive sessions by putting my second chapter through their critical mill. Joan Riedl and Debbie Myers have always provided the sort of logistical support that any faculty member in the throes of book-birthing requires. Beyond the call of duty, Joan also worked at eliminating the gremlins of style and error from several chapters. Russell McCutcheon, Bryan Lusby and Lindsey King devoted generous amounts of time and critical reading skills to my project. My thanks also go to those students in my African Religions class, past and present, who read selected chapters of the manuscript to ascertain its reader-friendliness. Predrag Klasnja read portions of the text and helped with its final collation.

As libraries and librarians go, I cannot imagine a greater lifeline than Janet Stanley and her library at the Museum of African Art at the Smithsonian Institution in Washington, D.C.. The Stanley shrine is appropriately a meeting-point of people, resources, images, and ideas, and I am deeply indebted to her (and her staff) for help, inspiration, and moral support over the years. I also spent many a productive hour in the University of Florida library during my annual visit to Gainesville, and was helped considerably by Africana staff there. The Yai family provided a most stimulating home environment on numerous occasions. Northwestern University African Studies collection is a haven for any Africanist and I augmented my sources considerably on visits there, notably during my Zora Neale Hurston Fellowship in April 1993. My thanks also go to the Centre of West African Studies and its library facilities at the University of Birmingham, whose fine resources I availed myself of when visiting my family at vacation time. My other "family," Carol Lancaster, Douglas and Curtis Farrar, and not forgetting Mary Clark, provided a home for me whenever I visited Washington, D.C., to use the library. Their hospitality and friendship have been a source of joy and strength to me over the years.

With regard to the taxing business of illustrations, I owe a debt of gratitude to Vera Viditz-Ward for her technical advice at critical stages, and to Chris Roy, Chris Geary, and Doran Ross for sharing their expertise in visual matters. Manuel Jordán kindly allowed me to select a handful of slides from his magnificent field collection. The Fund for Exhibit, Performance and Publication Expense of the University of Tennessee supplied a welcome grant to allow for the addition of the color plate

section. My thanks go to Sandra Walker, Visual Resource Specialist in Art History and Mac MacDougald of Photographic Services at the University of Tennessee for their advice over choice of illustrations. In Amy Campbell I discovered a talented illustrator and delightful collaborator. In addition to the beautiful line drawings that she produced independently, she also drew on several sketches done by Keith Westbrook, a graduate student at the University of Iowa (kindly supplied by Chris Roy). Figure 8.3 illustrates drawings based on photographs by Jean Morris from *Speaking with Beads* by Eleanor Preston-Whyte, published by Thames and Hudson, London, 1994. Jonathan Reynolds applied his skills as Africanist historian to the business of ethnic group lists and mapping—the final one being professionally drawn up by Jo Moore. Although Janet Joyce came on board as Director of Cassell's Academic division at a relatively late stage of my work, she provided much-needed impetus, enthusiasm, and guidance to help draw everything to a satisfactory conclusion.

Portions of the introduction appeared in my introductory piece to the special issue on "Art" of the *Journal of Religion in Africa* that I guest edited (Hackett 1994). Despite the magnificent help I have had from all quarters to make this book a reality, I alone must bear the responsibility for any inaccuracies contained therein.

This work is dedicated to my mother, Isabel Beatrice Hackett, for she embodies all the good reasons that people think the world of their mothers, and to the "chief" or "Oga" (as the Yoruba call Big Men) of my department, Professor Charles H. Reynolds, whose wonderful support, encouragement, and friendship have over the years proved invaluable to my scholarship and well-being.

Rosalind I. J. Hackett
Knoxville, Tennessee

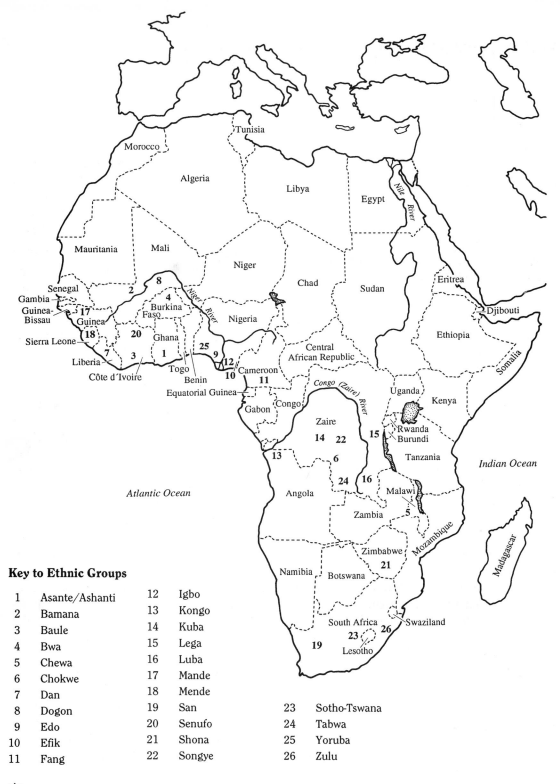

Morocco

Tunisia

Algeria

Libya

Egypt

Nile River

Mauritania

Mali

Niger

Chad

Sudan

Eritrea

Djibouti

Ethiopia

Somalia

8

2

Senegal

Gambia

Guinea-Bissau

17

Guinea

18

Sierra Leone

7

Liberia

3

Côte d'Ivoire

4

Burkina Faso

20

Ghana

1

Togo

Benin

Niger River

Nigeria

25

9

12

10

Cameroon

11

Equatorial Guinea

Gabon

Congo

Congo (Zaire) River

Central African Republic

Uganda

Kenya

Zaire

14

22

15

Rwanda

Burundi

Tanzania

Indian Ocean

13

6

24

16

Malawi

5

Angola

Zambia

Madagascar

Mozambique

Atlantic Ocean

Zimbabwe

21

Namibia

Botswana

South Africa

23

Lesotho

26

Swaziland

19

Key to Ethnic Groups

1	Asante/Ashanti	12	Igbo
2	Bamana	13	Kongo
3	Baule	14	Kuba
4	Bwa	15	Lega
5	Chewa	16	Luba
6	Chokwe	17	Mande
7	Dan	18	Mende
8	Dogon	19	San
9	Edo	20	Senufo
10	Efik	21	Shona
11	Fang	22	Songye

23	Sotho-Tswana
24	Tabwa
25	Yoruba
26	Zulu

Introduction

Preamble

Religion: the neglected and misunderstood dimension of African art

Africa's artistic and religious traditions offer primary evidence of the expressive and intellectual vitality of a vast and fascinating continent (cf. McNaughton 1988:50). Art works,[1] whether sculpted figures, textiles, paintings or pots, are generally enjoyed, critiqued and used by communities or groups, rather than being the prerogative of individuals alone. Hence they provide important points of entry into people's conceptual worlds. Despite the obvious ritual significance of many artistic objects, in their capacity, for example, to embody ancestral power or dispel evil forces, the interactive relationship between art and religion in the African context remains remarkably understudied and misunderstood. Few monographic studies exist which explore this relationship in any systematic or meaningful way.[2] Promising titles of museum exhibitions and catalogues (e.g. "Art Magique" and "Spirits Without Boundaries"[3]), can prove disappointing as they seem more concerned to promote the "exoticism" and "otherness" of African art by highlighting its "supernatural" aspects, or they seem satisfied with undeveloped observations regarding its "symbolic," "ancestral" and/or "ritual" function, than to explore the fascinating conceptual field(s) of art and religion in the African context.[4]

How has such a situation of neglect and misunderstanding come about? This chapter looks critically at the dominant discourses which have shaped the study of religion and art, more especially its interrelationships, in Africa today. Both art history and religious studies are relatively young fields of study, but the roots of contemporary scholarship reach back into the colonial past. In the early seventies (and even before) William Fagg, one of the earliest British scholars of African art, called for British social anthropologists to loosen their pragmatist grip on the study of the African visual arts and material culture to allow questions of meaning and the "philosophical 'nerve ends'" to receive their analytical due (Fagg 1973:161). He was equally critical of scholars of African philosophy (having been overly influenced by Western rational thought) for failing to include in their ambit the visual arts. Fifteen years later another indictment was served by the art historian, Suzanne Preston Blier, in her review of Sieber's and Walker's *African Art in the Cycle of Life* (1987). She notes that the section on religion relies on scholars of religion (such as Mbiti) rather than African-art scholars "probably because this is an issue few, other than Leon Siroto (1976), have really dealt with critically, **even though religion is an important secondary topic of nearly all African-art scholarship**" (my emphasis) (Blier 1988a:23). The present work

1

will go even further in demonstrating its primary importance, and in examining the converse problem—why scholars of African religions have by and large ignored the significance of the visual arts in their studies. But first, it is imperative to consider the methodological issues and problems attendant on a work of this breadth.

Aims and structure of this book

It is hoped that this book on African art, with its new grouping of data and ideas focused on the theme of religion, rather than being centered on ethnicity, stylistic region, corpus, genre, collector, or museum collection, will generate fresh thinking regarding the interdependency and interplay of art and religion in the African context.[5] There are arguably times when a work of a more general, synthetic and comparative nature, supported by well researched examples, may play a cathartic role in stimulating thinking and research in a new or neglected field.[6] Indeed such eclecticism may be more conducive to the type of interdisciplinarity, experimentation, dialogue, debate and processual approaches, which characterize contemporary scholarship (Drewal 1990:49). As examples throughout the book will show, a greater understanding of the philosophical and religious aspects of an art work serves to challenge Western perceptions of what is "important" in terms of artistic representation. In other words, this type of approach reveals that what is small, hidden, unelaborate or even unattractive may be the most spiritually empowering (cf. Nooter 1993, Blier 1995:28). Ceremonial art—generally favored by Western museum curators and collectors—is not the only, nor by any means the primary, artistic expression of religious beliefs and values. Everyday objects and more personal items may be laden with mythological

and symbolic significance. In his book, *L'Art sacré sénoufo: ses différentes expressions dans la vie sociale* (1978), Holas provides several examples of domestic objects among the Senufo people of Cote d'Ivoire, such as doors, musical instruments, cloth, weapons, containers, etc. which draw upon ancestral symbols and traditional mythology. Casting the net more widely in terms of artistic form and media, as this study seeks to do, helps lessen the tendency of generalized works to draw on the more researched groups at the expense of lesser known peoples and their traditions. It also ensures that women's artistic production and expression receive proper consideration.

There exist a number of localized case studies which explore the range of ritual art forms in a particular culture. They are undeniably useful in that they permit the reader to compare the range of artistic techniques and forms employed by a particular people to express, manifest, and control the spiritual forces believed to be active in their environment.[7] However, the present work is, for the reasons suggested above, more broad-based. Its thematic structure is perhaps more familiar to historians and phenomenologists of religion, although the works by Sieber and Walker, *African Art in the Cycle of Life* (1987) and by Robert Brain, *Art and Society in Africa* (1980) have adopted similar approaches.[8] A work of this nature which attempts to offer a general perspective on the relationship between art and religion in Africa requires judicious selections of the work of others, as well as attention to geographical and media diversity. There are obvious shortcomings in that, for example, the multi-functionality of particular objects may be lost in the way the data have been thematically organized. A case in point would be the Akan *kuduo*, brass bowls still kept in Akan stool rooms and shrines—imported Arabic-inscribed basins which served as models for later local

production for which a number of uses have been reported, such as being placed on the graves of those recently deceased, a container for the deity or *abosom*, a receptacle for charms to drive away disembodied evil spirits, a vessel to house goldweights and gold dust, being used in girls' puberty ceremonies, the focus and container for ritual sacrifices made to the spirits of the ancestors, used in rituals commemorating deceased Asante kings, and as treasure caskets being buried with the deceased (Silverman 1983). However, a number of examples will quite naturally recur throughout the text, such as certain masquerades which will be discussed in terms of their spirit-embodying function, as well as for their apotropaic or politically legitimating value, and their frequent associations with funerary and initiation rituals.

Above all, this text adopts the lens of the scholar of religion, draws on the methodologies of several other disciplines, and focuses on the ways in which African art works are believed to represent, channel or transform spiritual energies or beings. But such an approach is not just intended to reveal the hidden meanings (certainly not one Meaning[9]) or ritual functions of such objects. It may also provide a map of seemingly unconnected pathways, processes and participants, whether in terms of commissioning, production, materials, design, color, use, activation, and experience.[10] It may go some of the way to providing what Blier calls an "epistemology of representation," or the "understandability" and multifacetedness of African artworks.

The problems of dichotomies and generalizations

The construction of categories and generalizations has been a marked tendency of Western scholarship, not least the study of art and religion in Africa. While not always being able to avoid them in the present work, one can at least be sensitive to their shortcomings. The anthropologist, James Clifford, contends that the expansion of Western art and culture categories to include "a plethora of non-Western artifacts and customs" must be situated in the socio-historical context of the nineteenth and early twentieth centuries and their evolutionist and humanistic concerns. The current instability of these classifications and appropriations "appears to be linked to the growing interconnections of the world's populations and to the contestation since the 1950s of colonialism and Eurocentrism" (Clifford 1988:235). The term "fetish" is a good example of one of these stereotypes, as it was applied by Westerners to African objects (notably anti-witchcraft objects) whose sanctioning power, in their opinion, was based on deluded, magical belief (see below chapter five). Studies which are attentive to the discrepancy between general terms and ideas and those used by African peoples offset the risks, and ensure a continual process of reinterpretation. Allen Roberts' conceptualization of the "spiral" in Tabwa thought and art is a good example of a careful, localized category/concept, grounded in and emerging from the linguistic terms, philosophical and cosmological ideas, artistic forms, and ritual practices of a particular people (Roberts 1990b; cf. also Brett-Smith 1983, 1982). A non-African perspective may distort our understanding in other ways. In northeastern Zaire, for example, Schildkrout and Keim have demonstrated how Eurocentric comparisons privileged Mangbetu and Zande forms of art over those of neighboring peoples in central and eastern Africa because they were considered to be more naturalistic and employed complex design and symmetry, appealing to European tastes (1990). Furthermore, "[t]heir dress exemplified the European vision of the exotic with its use of

animal skins, feathers and decoration applied to the body itself." They had also developed a more centralized political organization and military strength (ibid.:17).

African art scholarship has also suffered from the imposition of Western dichotomous classifications which has consequences for understanding the religious dimension. One of the most pervasive dichotomies has been the polarizing of African cosmologies in terms of the village and the wilderness, for example, and by association and analogy, the tame and the wild, the social and the solitary, the civilized and uncivilized, and order and chaos. Beidelman has questioned this dichotomy (1990).[11] Dichotomization, he states, may "underplay the deeply positive, integrative forces that are repeatedly drawn from the bush." It may also detract from the complementarity between the two spheres, and their mutually shared powers and knowledge. It may also downplay the conflict and disintegration inherent in village life. Beidelman also points out that the distinction between village and wilderness is less valid for herding, hunting and gathering societies than it is for the more widely studied agricultural societies. In their way of thinking about or addressing the figures or sticks which are believed to embody their ancestral spirits, the Giriama of Kenya normally mix body and spirit and only differentiate them in matter-of-fact situations and conversations (such as over negotiations as to the figure's appropriateness or cost, or when anthropologists ask leading questions about death and spirits). Parkin views this as far more creative and open-ended than the "inflexible duality" and concern with precise categories at the heart of Western thought (1981). This is not to deny that binary contrasts inform certain cultures (e.g. Picton 1989), but it behoves us to examine such distinctions carefully, notably in determining whether a particular art work

actually "embodies" or merely "represents" a spirit or divinity. There is a whole continuum of possibilities, influenced by factors such as historical events, time, location, age of object, ritual performance, attitude/knowledge/experience/gender of wearer/user/ participant, etc. But first, the concepts of art and religion in the African context require careful discussion to establish the concerns and parameters of the present text.

Art as category and lived experience

Western ideas of African art

What passes as African art and the terms employed to describe it whether by museums, scholars, collectors, etc., are as revealing about the latter as they are about the art itself.[12] In the words of Valentin Mudimbe, "what is called African art covers a wide range of objects introduced into a historicizing perspective of European values since the eighteenth century" (1986:3). "Primitive" and "primitivism" continue to persist in art circles as descriptors of African art even when they have been virtually expunged from anthropology (Blier 1990a:95f.). Suzanne Blier points to some notable art history texts that continue to perpetuate the myth of primitivism by portraying African art as primary or primeval, and static. She argues that the perjorative and deviant notions of the term have persisted in the context of art, strengthened by the more recent inclusion of the arts of children and the insane in the category of Primitive art (1988–9:11). Tracing the history of the term, she notes that in the nineteenth century it referred to a host of European and non-European traditions which did not meet the yardstick of the dominant Classical line of European artistic expression. By the early part of the twentieth century it had become reserved almost exclusively for the arts of

Africa, Oceania, and Native America (whose affinities are very debatable). One of the consequences of this has been for African art historically to be housed in natural history museums before it found its way into fine arts museums. Indeed, many of the best collections of African art are still to be found in natural and cultural history museums (such as the National Museum of African Art, part of the Smithsonian Institution in Washington, D.C., and the Museum of Mankind in London). Blier asserts that this reinforces the idea that African arts are more materially oriented than European arts which are perceived as more manifestations of the mind (ibid.:12).[13] So, it is by addressing the question of what African art is *not* in Western eyes that the "underlying rationales" of their classification, valuation, and exposition be discerned (ibid.:15;cf. also Price 1989).

The persistence of ideas in Western culture concerning "primitivism," whether in anthropology, psychology, literature, art, or popular culture, is the subject of a challenging book by Marianna Torgovnick, *Gone Primitive* (1990).[14] Her powerful deconstruction of images of the "primitive" reveals a host of Western obsessions, fears, and longings. She singles out the controversial 1984 exhibition at the Museum of Modern Art in New York entitled "'Primitivism' in 20th Century Art: Affinities of the Tribal and the Modern." The exhibition's concern was to show how early twentieth-century artists such as Picasso, Giacometti, Brancusi and others "discovered" and appropriated tribal objects, celebrating "resemblances" and causing them to be revalued as tribal "art." The omission of political and ethnographic concerns in the way the art works are presented and juxtaposed is particularly criticized by Torgovnik. James Clifford also devotes a chapter to the exhibition in his book, *The Predicament of Culture*, delivering a strong indictment of the modernist

principles of the term "tribal," arguing that it is a hegemonic Western construction rooted in the colonial and neocolonial epoch (1988:ch.9). Ekpo Eyo advocates dropping both terms— "primitive" and "tribal"—since style and form are subject to many more factors than material culture or ethnicity (1988:115;1982). Robert Farris Thompson's pioneering work on indigenous artistic criticism among the Yoruba demonstrates the inapplicability of generally understood criteria of primitivism (1973). His work has been taken up by such Yoruba scholars as Rowland Abiọdun and Babatunde Lawal, whose work is discussed below.

The much acclaimed exhibition, *ART/artifact*, develops these same important ideas on Western perception, classification, and representation of African art. In the words of Susan Vogel, the exhibition is centrally concerned with "our classification of certain objects of African material culture as art and others as artifacts" (1988:11). She goes on to underscore the fact that this common distinction is culturally conditioned. Most works of art were viewed very differently in their original context from the way they were or are seen in Western museums. In Africa some figures were kept in dark shrines, only visible to a few persons, while others were covered with cloth, accoutrements, offerings, and surrounded by music and dancing. Such objects were made to belong to "a broader realm of experience" and so lose meaning by being made accessible to the visual culture of the West. The (re)contextualization of African art is a central concern of the present work. The focus on religion is salutary in that it avoids, or even undermines, many of the canonical distinctions of art in the Western world.

African art as "traditional" art

With the critique of "primitive" and "tribal," "traditional" has become the more acceptable

term to describe that art which is seen as characteristically African. Ironically, it is some Western scholars who have levelled criticism at the term,[15] sparking a defence from African scholars. The debate over the appropriateness of "traditional" is the subject of a recent collection of essays edited by Mọyọ Okediji (1992a). In his contribution, John Picton contends that "traditional" is a fictional and ahistorical category which belies the pre-colonial, colonial, and post-colonial components of a complex phenomenon (Picton 1992a). It represents an attempt by Europeans and Americans to "freeze-dry" all that they consider to be "authentic" and "ideal" in African culture. By and large this constitutes a denial of the temporality of African art and the ability of Africans to respond practically and aesthetically to change. Yet, at least two of the authors in the book (Chima Anyadike and Bolaji Campbell) prefer to retain usage of "traditional" since even contemporary visual and literary works draw on indigenous legacies.

Okediji understandably rejects Picton's suggestion that "traditional" art corresponds to the "pre-colonial" period, for the very reason that "progressive Africans are no longer willing to define their identity in terms of the colonial misadventure, a short, gruesome, and unforgettable trial" (Okediji 1992b:112). As for the terms "primitive" and "tribal" he does understand these as contributing to the exploitation of African art, in that they have encouraged Africans to reject their art as "retrogressive" and "undesirable" allowing it to be collected in foreign museums and galleries. Cast in exotic terms, African art works allow Westerners to be "reassured of their own civilisation and sophistication" (ibid.:117). Because of this, these same museums and galleries, according to Okediji, prefer anonymous, so-called "traditional" art works, while generally rejecting the work of contemporary African

artists. In sum, Okediji persuasively counters the possibility of finding substitute terms, such as "indigenous," to describe African art. He would rather deconstruct the notion of "traditional" culture, in order to reconstruct a "more fitting meta-aesthetic."

So if "traditional" is not taken to mean static, but as drawing on inherited cultural patterns and responding gradually to change, then it is acceptable to many scholars (Vogel 1991:32f.). In this respect, there is no moment when "traditional" art ends and "neo-" or "post-traditional" begins (hence such terms, although not the historical dimension, will be avoided wherever possible in the present work). The problem in Yoruba thought and language is obviated by the fact that innovation is implied in the Yoruba notion of tradition (aṣa) (Yai 1994:113). So artistry for the Yoruba is the "exploration and imaginative recreation of received ideas and forms" (Pemberton 1994:135), as Okediji argues above.

Mudimbe addresses this same issue with his use of the French term of *reprendre*, arguing that, despite the continuities, new "artistic thresholds" have emerged as contemporary African artists have responded to the rupture of the colonial and post-colonial world (1991: 276f.). In this vein, Mudimbe distinguishes between three trends in current African art: tradition-inspired, modernist, and popular (ibid.:287). Although the first two are concerned with the creation of beauty and generally involve trained artists, the second is more actively involved in the search for a new, modern aesthetic.[16] The third trend, popular art, is more locally oriented, often constituting an important historical and political narrative (cf. Barber 1987). The artists are more self-trained and less motivated by the international market. Mudimbe situates Christian religious art and tourist art as between the first and second trends (ibid.:280: cf. Jules-Rosette

1984). Picton advocates a more radical, and potentially more creative, approach to the problems of categorization (1993). He would prefer to drop the various labels since they inevitably reflect (Western) "curatorial authority" (and its privileging of self-trained, "authentic" artists as in the exhibition, *Africa Explores*), and rather focus on the themes and processes addressed by the artists themselves.

It should be remembered that African artists have had contacts with the Mediterranean, Europe, and the Islamic world for centuries, as well as with other African societies, and that they have demonstrated a readiness to appropriate and critique these sources (Vogel 1991:36; Mudimbe 1991:287). While the spread of Christianity and Islam have taken their toll on traditional cults, those art forms associated with entertainment have survived more successfully. So too have those which have incorporated new Western ideas, such as the Yoruba god of iron, Ogun, whose constituency has extended to transport and industrial production, and whose ideology that humans create the means to destroy themselves has travelled to Latin America, the Caribbean and North America (Barnes 1989). In Benin during the oil boom of the 1970s, the worship of Olokun, god of the waters, and especially the construction of mud shrines, flourished, for he was seen as the fount of the new wealth.[17] Unfortunately, "traditional" is associated in many Westerners' minds with notions of authenticity and purity, implying that it could only include art forms produced and used by African villagers around the end of the nineteenth century (ibid.:52).[18] Van Beek's work on the Dogon of Mali illustrates well how they have continually introduced changes (new masks, myths, divination techniques, as well as innovations in performance) into their mask festivals, which are quickly absorbed and soon regarded as "traditional" (1991a:73). Of

interest is that the newer masks tend to have less of a religious function than the older ones. Spiritual themes have not disappeared, however, from Zairean urban painting (Jewsiewicki 1991). Contemporary paintings manifest Christian themes, such as the struggle against "pagan evil" (sometimes in the form of the seductive water spirit, Mami Wata). These paintings are more than signs, they are believed by those who purchase them to have magical potency and apotropaic or protective qualities (ibid.:130; Jules-Rosette 1984:223).

The concept of "art"

Leaving aside the question of the changing nature of African art, and its characterization, we need to examine the concept of "art" itself. Although the absence of a word for "art" in many African languages has been commonly noted, scholars have generally not questioned the existence of art in African societies. For example: "African cultures do not isolate the category of objects we call art, but they do associate an aesthetic experience with objects having certain qualities;" and African languages "have many words that indicate artistry; words for embellished, decorated, beautified, out of the ordinary" (Vogel 1988:17; Danto 1988:26). Blier rather argues that a number of words for art do exist in Africa but that these terms are less concerned with quality than with "the question of skill, know-how, and inherent characteristics" (1988–9:9). For example, the word used by the Fon of the Benin Republic to designate art, *alonuzo*, literally means "something made by hand." For the Ewe of Togo, their term, *adanu*, bears several meanings, viz. art, technique, ornamentation, and suggestion. For some peoples, the emphasis is more on processes of construction, as in the case of the Akan and Edo, while for others, such as the Bamana of

Mali, art is something that attracts your attention, focuses your eye, and directs your thoughts. It also makes the ritual and the performance more interesting. This is further endorsed by the way the Bamana lavishly decorate their sculptures when in use, with oil, coloured cloth, and beads (Ezra 1986:10). The Mande people of Mali give a name to every kind of sculpture that they produce, and also to categories of objects such as wooden twin figures and dolls and animal masks and headdresses (McNaughton 1988:110f.). Some types of objects might not be considered as art by Westerners, as in the case of spear blades and oil-burning lamps. Yet the Mande consider their beauty, symbolism, and place in society to take them beyond simple utility.

Furthermore, the distinction between art and artifact (or crafts), referred to earlier, is not generally marked in the vocabularies of African languages (see Ikenga Metuh 1985:3). For example, Adepegba discusses the various meanings of the Yoruba word for "art," ọna— namely, designs made on objects, the art works themselves, and the profession of the creators of such patterns and art works (1991). The word is also compounded into various Yoruba professional or trade names, such as of the two lineages of leather workers, Otunisona and Osiisona, in Oyo town, who handle important bead embroidery work, such as for the king's crown and the bags and bracelets of Ifa priests. Some scholars argue that the taxonomic distinction between art and craft is relatively recent anyway and an invention of Western origin (Blier 1988–9). Many non-Western cultures value the "soft arts" (often done by women), such as textiles and pottery, as highly or more than the "hard arts." Up until the Renaissance in Europe, art and crafts, were, according to Blier, virtually synonymous. By way of comparison, Arthur Danto points out that the ordinary Greek did not distinguish the terms linguistically, while emphasizing that they (notably Socrates and Plato) made the distinction both conceptually and in practice (1988:27). According to Danto, art works convey meaning, power and higher realities, while artifacts are shaped by their function (ibid.:31). Art works, then, could enjoy a double identity as both objects of use and praxis and vessels of spirit and meaning. The problem of distinguishing art from artifact could be avoided, as Picton rightly argues, by realizing that they both have a similar etymological derivation (Latin, *ars, artis*, skill, plus *facere, factum*, to make, create or do) and that the question of whether something is a work of art or not is irrelevant (1992a:10).

Another important consideration in determining the field of our enquiry is the host of other (non-aesthetic) objects in African cultures, such as shells, animals, metals, certain leaves, bones, etc. which may embody complex meanings. These objects may have more power and significance than the sculpted figures they accompany at an altar, for example. But they do not involve artistry to make them out of the ordinary. So Vogel rightly wishes to add as a distinguishing feature the aesthetic dimension to the capacity of art works to convey meaning (1988:17). Jacques Macquet has analyzed at length the aesthetic experience (1986). He identifies the ability of art works to stimulate and sustain "visual contemplation," and their presence which compels attention and sets them apart (ibid.:119f.) This, in his opinion, derives primarily from the form and not the materials or the meaning. Yet as Danto argues, and this is important for the focus of this book, our aesthetic appreciation of art works cannot be limited to an optical perspective but must include the philosophical, or we will fail to apprehend the power and meaning of the artistic creations from non-Western cultures (1988:32). In Danto's opinion, the sculptures of

Africa are more successful than the idealized statues of the Greek gods in conveying the powers central to human life because they are not bound by resemblance and may find the form to make visible the force or meaning (cf. Macquet 1986:74). In the same vein, Ikenga Metuh asserts that the "expressionism" of African art, so appreciated by Western artists, can only be understood by reference to underlying religious beliefs (1985:2).

These scholarly debates about what is art have had repercussions in terms of who studies African art and how. As discussed earlier, African art was seen as primarily the domain of anthropologists, before art historians began to stake their claim. The latter have criticized the ahistorical and functionalist tendencies of (earlier) anthropology, and preoccupation with context to the detriment of style, form, meaning, performance, and aesthetics (Blier 1990a:100f.). Clifford has argued that the controversial 1984 Primitivism exhibition, discussed briefly above, at the Museum of Modern Art reinforced the division between aesthetic and anthropological discourses by suggesting that cultural background and context are not essential to correct aesthetic appreciation and analysis (1988:200). Henry Drewal argues that art history cannot ignore socio-cultural factors and anthropologists cannot continue to underestimate the role of individuals in the process of cultural creation (1988b:72). Simon Ottenberg believes that African art studies today should take advantage of being "betwixt and between" and combine the best of both worlds (1990:132f.). He highlights in particular the holistic and comparative, as well as self-critical, aspects of anthropology which are commendable.[19] As will be seen below, these shortcomings and assets of the anthropological tradition have similarly shaped, and been contested by, religious studies discourse.

Religion: finite expressions of the infinite

The study of African religions

The study of African religions is no less controversial than the study of African art. Many of the key concepts and theories of the history of religions have been shaped on the anvil of non-Western societies. Yet most of the work on African religions has been done by anthropologists. African scholars of religion have been more influenced by Western scholars with historical or theological training (such as Geoffrey Parrinder), in part because of the colonialist stigma of anthropology and its earlier reductionist tendencies. In return, anthropologists view the descriptive phenomenological approach of religious studies scholars and its treatment of religion as a *sui generis* phenomenon as prone to unhealthy decontextualization and generalization.

African scholars such as Bọlaji Idowu (1963, 1973), John Mbiti (1969, 1970), and J. O. Awolalu (1979) played an undeniably important role in shaping and encouraging scholarship on African religions, at a time of growing cultural nationalism in the post-colonial period. David Westerlund, in his excellent survey and critique of "African Religion in African Scholarship," characterizes the work of the founding African scholars as representing different shades of what may be called a "theology of continuity" with its advocacy of the respectability of African religions (1985:45). Their studies have served as models for the field both in schools, universities and seminaries. But they have also been criticized for being "idealist" and ahistorical (ibid.:26),[20] for using "Judaeo-Christian spectacles" to view African religions (Horton 1986) and for constructing homologies between Western Christian and African religious ideas (such problems beset any exercise of cultural translation). These

homologies have promoted the homogeneity of African religions—notably in the form of the category "African Traditional Religion" (Shaw 1990). This is very much in line with the broader arguments set out in *The Invention of Africa* (1988), by the Zairean philosopher, Valentin Mudimbe, regarding the cultural constructions of Africa in academic discourse, notably African philosophy, theology, and anthropology. Mudimbe, then, demonstrates how these various scholarly discourses that exist concerning the meaning of Africa and being African establish the worlds of thought in which people conceive their identity. Rosalind Shaw has ably illustrated the significance of this process with regard to Igbo religion—in that notions of "sameness" are perpetrated through "authorized" versions of pantheons (where all lesser deities are seen as represent-atives of the supreme being according to Idowu) that feed back into the lives of non-Christian Igbo villagers (1990:347f.).

African scholars have been rightly critical of the terms used by missionaries and scholars to describe African religions, e.g. primitive, savage, native, pagan, heathen, tribal, juju, ancestor worship, animist, fetishist, etc. In response to this, a number of scholars have devoted a great deal of energy to exploring African concepts of God (e.g. Mbiti 1970; Ikenga Metuh 1973) or spiritual hierarchies (Mulago 1980). For example, Idowu rejects the notion of polytheism, arguing instead for the primacy of God in African thought in the form of a "diffused" or "implicit" monotheism (1973:135f.). Several writers have also criti-cized the European deistic notions which have led to the positing of the African supreme being as "*deus otiosus*," and the over-emphasis of Western scholars on ancestors, magic, and witchcraft (Westerlund 1985). Okot p'Bitek, the Ugandan anthropologist, in his well-known book *African Religions in Western*

Scholarship (1971), dismissed theocentric, primitivist and "hellenistic" interpretations of African religions (Westerlund 1985:60f.). Louis Brenner (1989) sees the frequent correlation between "religion" and "belief" as stemming from Western conceptual frameworks and as privileging "religious knowledge" over "religious participation" (when the reverse is usually the case).[21] The problem, he argues, "arises in distinguishing which concepts properly belong to the analysis itself and which to the object of analysis" (ibid.:87).

Anthropologists' interest in the "religious" aspects of the societies they study could best be described as ambivalent (cf. Morris 1987). But a current renewal of interest in religion, ritual, sacrifice, prayer, ideas of the sacred, etc. is evident (Parkin 1991a:1).[22] The focus of these works represents, according to Parkin, "a curious amalgam of contestable and essentialist assumptions" (ibid.:2). In other words, there is a concern to view ritual and religion as "isolable, self-determining phenomena" rather than as epiphenomena of myth or symbol systems. Yet this is accompanied by a drive to unpack such terms and show how people act upon spaces, institutions, landscapes they view as sacred. Among scholars of religion, there has been a trend to embrace more social and cultural approaches which take better account of the context of religious phenomena. The scholarship of Jacob Olupọna (1991), Tunde Lawuyi (1988 with Olupọna), Donatus Nwoga (1984b) and Ifi Amadiume (1987) represents what Shaw calls "a new wave" with its concern for historical change and multiple, contested perspectives (Shaw 1990:346).

Notions of the "sacred"

These developments have resulted, thankfully, in a more nuanced understanding of the notion of the "sacred," and of the dangers of

presupposing a rigid Western-style dichotomy or separation, in the context of a more unitary worldview (cf. Parkin 1991a:7).[23] In other words, the "sacred" does not have fixed boundaries. For example, Brett-Smith (1982: 29, n.42) points out that the Bamana use the same word (with difference in tones), *nyama*, to refer to an unseen but potent (usually dangerous) spiritual power and the harmful power inherent in every person, thing, and animal, as well as in a more banal sense, to refer to the garbage taken out to decompose at the edge of town. She points out that the two meanings are interrelated in that those who deal with filthy substances (such as leather workers) are believed to possess an extremely high degree of mystical *nyama*. She notes that, in conversation, the Bamana play off the mundane and mystic meanings of the word against one another and use mundane occurrences of *nyama* to explain its spiritual power.

For the Giriama of Kenya, the notion of sacred is linked to cleansing and expulsion rather than that of awe which is Rudolf Otto's view of the sacred or holy (1959:19–55, cited in Parkin 1991a:222). In fact, Parkin argues that heightened, numinous experiences are not characteristic of African societies generally, but more of religious hierarchies in Europe and the Middle East. In the world of the Giriama, the act of "repairing or sustaining sacredness" is closely connected with place. That place or Kaya is simultaneously central yet marginal, remote yet immediate. It is a constantly reworked idea subject to socio-cultural, political and economic circumstances. People apply their imaginations multidimensionally or polythetically. For Parkin it is this possibility of imagining and reimagining that liberates us from Durkheim's rigid differentiation between the sacred and profane, and allows us to understand the process whereby people link parts to alleged wholes, themselves linked to other parts and wholes across time and space. This absence of fixed boundaries of the sacred does not deny the existence of a "web of meaning" reflecting the "overlapping, contestable and partially shared views" of a group of people about the sacred, which are then imputed to the diverse qualities of an object (Parkin 1991a:219).

Descriptive labels

The choice of appropriate terms to describe the power(s) of an object, person, or place which distinguish(es) them from the ordinary or the natural, and which implies that they command respect and may be transformative in some way, is hampered by the problems of translation from African languages. It is further complicated by the need for a meta-language in academic discourse. Such terms suggest something inherent, a given, when in reality, a particular object such as a crown, or a staff, or a garment, may acquire sacred power by association or through frequent use. Of the terms available in English, "sacred" and "supernatural" connote the "otherness" and distinctiveness in a relatively general and neutral way, without, as it were, privileging beliefs ("metaphysical"), experience ("mystical") or secrecy ("occult"), for instance. In some cases, the sacred is posited in terms of location (for the Yoruba *ọrun* is the otherworld populated by countless spiritual forces and *aye* the world of the living [Drewal *et al.* 1989:14-15][24]) or the "unseen-ness" of forces (for example, the Edo divide the world into *agbon* "the actual visible world in which men live" and *erinmwin* "the invisible abode of numerous deities" and other spirits and powers [W. and B. Forman and Dark 1960:14]).

Its preternatural and popular uses aside, "supernatural" is a preferred term for a number of scholars, both African and Western,

although it may detract from the immanence of power in the natural world—an important feature of African worldviews (Arens and Karp 1989). Abimbola is prepared to use the term in the same way as the Neoplatonic philosophers as meaning "superior" and involving mysterious forces greater than those of the human and natural worlds.[25] In an article on "Supernatural as a Western Category," Benson Saler maintains that the natural/supernatural distinction has its roots in the Christian tradition. This contrasts with Durkheim's dismissal of the term's salience, with its connotations of "unknowable," "impossible," and "mysterious," because of its recent origins and dependence on scientific constructions of the "nature of things" (Saler 1977). Sullivan circumvents the pitfalls of dichotomous classifications by viewing the human imagination as inherently mythical and symbolic (1989:20f.).

The approximating nature of the descriptive labels in either English or any African language must always be borne in mind since the phenomenon of religion is held by participants to be infinite, indefinable and ineffable, yet only describable in finite terms. Ultimately, discourse about the sacred is about power—not necessarily in conventional terms of domination, but how particular objects of ritual and aesthetic importance may generate an experience of the other-worldly realm or a type of spiritual transformation, such as possession or superhuman power.[26] The focus on art is salutary in that it provides insights into the complex processes and strategies whereby the sacred is (re)presented, contained, generated, constructed and (re)distributed in particular circumstances and localities. In view of the contingencies outlined above, the terms employed will reflect the contexts under discussion, without abandoning the overlapping consensus of ideas about the sacred.

The "connectedness of things and thoughts"

Problems of interpretation of art and religion

Up until now the concepts of art and religion have been considered on a separate basis, but they must now be explored in conjunction with one another in order to understand more fully the shared problems of representation and interpretation. Particular methodological challenges attend the study of art works considered to be charged with spiritual or supernatural power(s). Knowledge of the composition or method of construction of a particular object may subvert or expose its power (cf. Blier 1995:20f.). Such empowered objects are frequently more subject to secrecy and concealment, and have to be studied more "obliquely," as Blier has shown for her work on Vodun arts. With this in mind, some fruitful and meaningful ways of approaching and understanding the interconnections of art and religion in Africa are highlighted in this introductory chapter.

Positing African societies as "small in scale, highly integrated, and slow to change" (Ben-Amos 1989:3) has created problems for the study of both art and religion in Africa—chiefly attracting static, timeless, and functionalist interpretations which fail to treat the distinctiveness of art and religion as systems of communication.[27] Both art and religion, as pointed to already, have been all too frequently studied out of context and in terms of Western-derived categories of analysis rather than "local exegesis."[28] They must rather be defined and redefined in specific historical contexts and relations of power (cf. Clifford 1988:198; Blier 1995). They have each had to suffer the imposition of misleading linear models of modernization whereby the "traditional" is displaced by the "modern." However, some scholars of religion, compared

to many art historians, have not displayed the same nostalgia for the "authentic" past, because of their Christian sympathies. Art and religion in Africa have also been subjected to the distortions of Western criteria—whether in the inflation of sculpture or supreme beings as evidence of great civilization.

There is much to be said about the perceived drawbacks of their mutual association. As stated above, for some Western art historians the association of art with religion nullifies its status as art. But such a narrow definition of art, as destined solely for contemplation in museums and galleries, and which denies its meaning, and social and religious power, must be jettisoned in favor of a more holistic, multi-dimensional perspective, which takes account of indigenous terms and concepts. For others, the close association between the realms of art and religion is methodologically problematic for the Western researcher. For example, Dark (1978:28), speaking of Edo reactions to the Benin plaques:

> Some of these personages and objects he will, quite positively, identify or name; about others he is vague. Even when positive, the associations he will make are often in the realm of myth, or the real and supernatural are bound firmly together so that the problem of establishing facts is always difficult.

Schaedler points to the virtual impossibility of attaining an "overall view" which incorporates the emotional experience of the work of art with the cult framework in which it is embedded, "since it requires too much abstraction on the part of the believers and too much devoutness from the art experts" (1992:28). For the Zairean theologian, Malama Mudiji, art and religion are intimately and uniquely related in the African context in that they evoke and manifest the depths of existence that cannot be expressed, through a synthesis of the imaginary and the real (1988:256).

African art as "religious" art

Earlier studies portrayed art from a functionalist perspective as being in the service of religion, namely harnessing, and communicating with, divine forces (Ben-Amos 1989:3f.; cf. also Bascom 1973:6).[29] This over-interpretation of the religious aspects of African art led earlier writers to claim that African art was predominantly religious or "ritual"—there was no art for art's sake.[30] Other writers readily ascribed symbolic and ritual value to aspects or features of African art they did not understand or that appeared "mysterious." Leon Siroto criticizes the dominance of "ancestral" and "magical" paradigms in Western readings of African religious thought and iconography (1976). Similarly, Schildkrout and Keim observe that: "Non-Western art is almost invariably presumed to be associated with ritual, and often Westerners have difficulty accepting the idea that Africans traditionally produced art just for its esthetic value" (1990:15). Because of this assumption, and the fact that the art was removed from its context without knowledge of its history, Westerners have attributed to art works meaning that they never had. They cite, as an example, the famous Mangbetu carved human figures from northeastern Zaire which have been described as ancestral effigies and memorial figures for deceased rulers when there is virtually no documentary evidence for such interpretations "but they fit the stereotypes that legitimate non-Western art." Likewise Nettleton claims that Zulu sculpture has often been called "ancestor-figures" in spite of the fact that there is no evidence whatsoever that the Zulu ever used these objects in any such context at all (Nettleton 1988:49). This type of reductionism to the religiously symbolic demotes the "artness" of the objects, and fails to address why they take the forms they do and

how they convey meaning (cf. Coote and Shelton 1992:3). In this regard we shall pay particular attention in chapter two to the ways in which art works, through form, materials, performance, aesthetics, etc., represent or make present the spiritual forces that are believed to inhabit people's universes.

The materialist backlash

Several African scholars have strongly reacted to the characterization of their art as essentially religious. For example, Isidore Okpewho, an oral literature specialist, criticizes those scholars who look for religion behind all traditional African art, ignoring both the basic "play" interest of the artist as well as his/her creative role (1977). In other words the artist is not acting "in the service of ritual" alone. Phallic sculptures may be created without their having to be connected to rites of initiation or fertility. Okpewho also shows how, in the oral arts, it is delivery and performance which validate the artists, not the fact that they are believed to be mouthpieces of particular gods. Adbou Sylla avers that the dismissal of aesthetic and social considerations by early commentators on African art in favor of a simplified, magico-religious explanation was a hegemonic act, deriving from primitivist notions of irrationality and dependency (1988). Horton, writing about the Kalabari *Ekine* Men's Society in the Delta region of Nigeria, stresses the need to go beyond the initial interpretation of the society "as a religious institution, designed to solicit the help of the water spirits through invocations and dramatic representations of them by masquerades" (1963:94). Rather he suggests that the masquerades are recreational in their intent, as well as being organs of government. In other words, given the relative unimportance of the gods addressed in the performance and that the

latter seems to be the end to which most *Ekine* rituals are directed, in his opinion the artistic aspect predominates.

Robin Horton is not alone among anthropologists and art historians wanting to downplay, or even ignore, the religious element in favor of the sociological, aesthetic or stylistic for example (cf. Ottenberg 1975:10). This in part results from the fact that metaphysical and esoteric meanings have been lost in the secularized and politicized ceremonies which have developed in some contexts (cf. Harley 1950; Kofoworola 1987; Picton 1990:196f.). It also stems from a tendency to want to demystify the religions of indigenous peoples, viewing them as epiphenomenal, as needing to be explained in terms of something else (by an outsider) rather than acknowledging the intrinsic, spiritual value that people may attribute to them. In our discussions in chapter two on spirit embodiment, we shall examine more creative ways of viewing the balance of religious and artistic elements in African art.

Scholars of religion and the visual arts

The problem is compounded by the very limited interest of religious studies scholars in the visual or performing arts. For example, in an otherwise valuable study of Ondo kingship rituals in Nigeria, Olupona makes virtually no reference to aesthetic techniques in generating or sustaining the king's powers (1991).[31] In francophone Africa, the picture is considerably brighter with Zairean scholars, for example, writing on their artistic traditions, particularly the resurgence of Christian forms in recent times.[32] One could argue that they have been influenced by the work of French anthropologists who have always shown a greater predilection for things metaphysical and cosmological, and the way that such beliefs and powers may be channelled through

material objects. The work of Marc Augé on the "god-object" is salient in this regard (1988). It was Marcel Griaule's own interest in religion that led him to focus on Dogon masks (1938) which he saw as central to their religious world (Ben-Amos 1989:10). After his encounter in 1947 with the Dogon elder, Ogotemmêli, Marcel Griaule changed his approach, focusing rather on the mythical and cosmogonic system which underlay all aspects of the social and cultural order, and insisting that their religious system merited the same type of attention normally paid to other religious cultures. Artistic symbols were viewed as the key to the whole metaphysical code. This initiated a host of studies which utilized ·mythology and cosmology to analyze art. As Paula Ben-Amos rightly points out, however, this approach led to a tendency to disregard the context and meanings of the objects (ibid.:11).

But, despite the fact that Western scholarly traditions, with their quest for "rationality" and "objectivity" and privileging of written texts, have not favored the investigation of the visual arts, it seems more plausible to attribute the reluctance to focus on visual symbols as stemming from the Protestant backgrounds of many scholars of African religions.[33] For many there is a fine line between visual imagery for religious purposes, and paganism or idolatry (cf. Goody 1993).[34] Religious images are generally only permitted for educational purposes.

The importance of experience

Yet it has been scholars of religion who have devoted more attention to the nature of religious experience[35] which has been somewhat neglected in art historical studies (Ben-Amos 1989:32; Adams 1989:73). According to Blier "[t]he experiential is thus in many respects a work's most profound and deeply felt dimension of meaning" (Blier

1988b:81). As she richly demonstrates in her analysis of the powerful and empowering Vodun arts, this emotional dimension cannot be understood by outsiders to a culture nor by scholars who give primary emphasis to the formal and aesthetic features of a work (1995). Malamba Mudiji, the Zairean scholar, has devoted a whole essay to the ways in which aesthetic devices, such as Pende initiation masks, may elevate human spiritual experience (1990). The question of interpretations of meaning (iconology or iconography) in African art is the subject of a special issue edited by Henry Drewal in the *Art Journal* of the College Art Association (1988b). The authors all share the position that meaning is continually emergent, elusive, and constructed from available evidence, namely oral and written literature, the discourse of local specialists, the close examination of the historical and cultural milieu of the work, its morphology, imagery, uses, and its relationship to other arts in performance contexts (ibid.:73; cf. Blier 1988b:83–4).

It is for this reason that the present text draws more on the work of those who have some sensitivity to the "connectedness of things and thoughts" (Drewal 1988b:71) and who are convinced of the importance of interdisciplinary and contextual studies rooted in holistic, localized and historical studies (Pemberton 1990:140). Drewal is keen to stress the merits of the iconological approach, which unites the intellectual and expressive aspects of an art work, in the same way as viewers "use both affective and cognitive capacities of their minds in experiencing art" (Drewal 1988b:73). Appropriately, he turns to a statement by Victor Turner about religion to emphasize that art is not a cognitive system alone, but rather "it is meaningful experience and experienced meaning" (1986:48). In his study of Vigango memorial sculpture—carved, anthropomorphic

posts—among the Mijikenda of Kenya (notably the Giriama, the largest sub-group), Parkin suggests that it is more helpful to regard the aesthetic and sacred as aspects of a single Giriama conceptual field (1986:19). Then the various objects may be seen as more within one domain than another.

A question of balance: holistic and integrated studies

Studies of Yoruba art provide evidence of this more holistic approach (see also Picton on the Ebira 1988, 1989, 1990). For example, in their masterly survey of Yoruba art, Drewal, Pemberton, and Abiọdun, demonstrate the value of identifying the philosophical themes at the heart of Yoruba artistic expression. This comes out particularly well in their first chapter, "The Yoruba World," where they argue that the concept of aṣẹ or life force is central to an understanding of ritual action, social relationships and artistic expression. The Yoruba world is one of "constant flux, creation, re-creation, renewal, and action in a cosmos of aṣẹ" (1989:26; Abiọdun 1994a).[36]

Abiọdun, in particular, has underscored the importance of complementing art historical and anthropological approaches to African art with the philosophies of African peoples or what he calls the element of "soul" (1990). His own work on Yoruba aesthetics has revealed how the values and concepts at the heart of artistic creation and criticism are closely tied to (if not indistinguishable from) religious ideas. He discovered, for example, that experience and expertise to become an art critic or amẹwa (expert on beauty) derive primarily from "walking with the elders." Many of these elder-critics are priests of Ifa, the Yoruba divination system.[37] These priests, because of their participation in traditional community rituals and festivals possess a profound knowledge of the complete cultural background (ibid.:65). Incidentally, discussions of an artist's work or performance are never heard in public. Abiọdun argues, as have others, that the concept of iwa is central to the definition of beauty in Yoruba thought. He is concerned to examine the dynamic relationship that exists between iwa (character) and ẹwa (beauty), as illustrated in the Yoruba saying, iwa l'ẹwa or "character is beauty."[38]

Lawal, in his own study of Yoruba aesthetics (1974), points to both the outer and inner aspects of beauty or ẹwa. But it is the inner beauty, ẹwa inu, or character, iwa, which makes life a joy, endearing a person to others and pleasing Ọlọrun or God. In fact, Ọlọrun is believed to be Beauty par excellence, because as the Creator or Ẹlẹda, He is the source of all that is beautiful. He is known as Ọga Ogo or "The Master in Resplendence" and the Lord of character or Olu Iwa. Because of his omnipresent nature, Ọlọrun is not represented or symbolized in sculpture. Iwa is represented in Ifa divination literature as a divinity or orisa, as a beautiful woman but with bad behavior and dirty habits (Abiọdun 1990:68f.). Yet she is presented as indispensable to her husband, Ọrunmila (god of divination) because she is true to her character and he is portrayed as lacking patience by having driven her out. This is further represented in the way that the Yoruba respect divinities whose behavior may be seen as immoral in human terms, for all creations, whether gods, persons, or things, possess their own inner beauty as a necessary consequence of being and character (iwa).

The artist is considered to possess the kind of aesthetic consciousness, namely patience and gentle character (iwapele), to produce works worthy of praise (in the same way as chiefs, diviners, kings, and family heads). It is Orisanla in the Yoruba pantheon whose

character comes closest to these aesthetic considerations which may account for the identification of this deity with creativity (ibid.:83). Orişanla was commissioned by Olodumare (the supreme being) to create the physical part of human beings (whether they are physically attractive or not), as well as the earth and its arrangement. With this freedom to create, Abiọdun notes that Orişanla or Ọbatala (as he is also known) became the first creative artist in Yoruba culture. The artist, whether as *onişẹ-ọna* (worker of designs), *agbẹgilere* (sculptor/wood carver), *gbẹnagbẹna* (designer in wood) or *alaro* (dyer/colorist), is a devotee of Ọbatala, the first artist, designer, and sculptor. He seeks to transform his raw material in order to realize the identity and character of his subject.

Several contributions to the recent volume on *The Yoruba Artist* (edited by Abiọdun, Drewal and Pemberton, 1994) demonstrate the importance of recognizing the overlap between the Yoruba verbal and visual arts, and the value of indigenous discourses on art and art history. For instance, in his brilliant analysis of the language and metalanguage of Yoruba art history, Ọlabiyi Yai advocates the need to see the visual arts as "modalities of *oriki*"—the verbal arts of praise poetry (1994). In that way, we may begin to understand the dialogue and bifurcation at the heart of Yoruba aesthetics, the invitation to constant departure and difference, rather than imitation and sameness. Yai attributes this privileged idiom to the fact that in Yoruba culture, "*ori*, the principle of individuality, is perceived as a deity which shapes the world view and behavior of persons" (ibid.:113).

This brief summary of Yoruba aesthetic notions nonetheless highlights the value of recognizing the unity of verbal, visual, and philosophical elements in Yoruba art.

(For further discussion see Abiọdun 1994). Furthermore, Yoruba cosmology and mythology form the backdrop for these beliefs. This integratedness of art in the overall cultural matrix is well illustrated in other cases. Baule language, according to Vogel's studies, does not distinguish between works of art and their functions, such as between the mask and the whole dance performance with its costumes, music, and gestures, the persona represented and the spirit served by the event (1987:147). This same integration of art and life is brought out in the case of the Lobi of Burkina Faso and Piet Meyer's short, but rich, account of their art and religion (1981). Meyer's important analysis of the mediatory role of the *thila* or protective spiritual beings, and their manifestation in sculpted figures known as *bateba*, will receive more detailed discussion in chapter two.

Kofi Antubam's examination of Ghana's cultural heritage highlights a number of areas, such as color, where certain aesthetic notions can only be understood in terms of "a philosophical symbolism founded on deep, abstract and spiritual values" (1963:75). Mveng, in a number of publications dating back to the 1960s, explores the role of African art as language, like prayer, expressing the world, humans and God in a quest for failed unification (1963, 1964). His work seeks to decipher the signs, signification, and structures of this language, identifying symbolism and rhythm as basic to African art. By this process, he was concerned not just to promote African art and its expression of African thought and identity, but also to see how African theology and symbolism might become a basis for the liturgy of the (Roman Catholic) church. In this regard he was instrumental in creating the workshop of liturgical art in Yaoundé, Cameroon, in 1966 (1967).

Merits and Challenges

Concluding remarks

This text makes no claims to offer a definitive or universal statement on the interrelationship between art and religion in Africa. Perhaps more than anything it is a "pastiche or montage, a material production built on other texts" (Tilley 1989:193). Thinking along the lines of Stephen Tyler's vision of post-modern ethnography, it is a text which has evolved from conversations and reflexive encounters with people, situations, and more texts (Tyler 1986:125). It is fragmentary because it cannot be otherwise, in that life in the field is not organized around categories, or integrated wholes, nor objects waiting to be represented (ibid.:130–1). It is intended to evoke a meditative integration, thus provoking a less alienating and more synthetic approach to religious and aesthetic issues in African cultures, and especially their interconnections. This seems inevitably to lead to a richer understanding of the multidimensionality of artistic and religious expression, as well as their different levels of meaning (cf. Blier's notion of "multiplexity," 1987:218f.; also Ben-Amos 1989:20f.) and power, for, as the Igbo say, "You do not stand in one place to watch a masquerade." Above all, an appreciation of the agency of art in people's lives is brought to the fore by focusing on religion, and vice versa.

The themes which constitute the structure of this book are necessarily abstracted. They are nonetheless chosen to reflect common domains of experience and expression seen from both an artistic and religious perspective. For obvious reasons, questions of creation, creativity, and agency are addressed in the first chapter. The second chapter engages the popular, yet challenging, question of embodiment—in what way art works may present or represent the various gods and spirits. The area of leadership and authority, treated in chapter three, is replete with legitimating images and instruments of sacred power. It cannot be assumed that ceremonial sculpture or dress carries more spritual weight than simple stone altars or concealed objects, for example. Secret societies in Africa have long been renowned for their patronage of masquerades, notably in the context of initiation rituals. These form the focus of chapter four. On these occasions, often with the aid of fearful masks, young men and women are inducted into life's mysteries and instructed on their social roles. In keeping with the notion that art works have the capacity to transform, chapter five addresses the fascinating area of divination and protection. The apotropaic qualities of African art works have long fascinated Westerners, and there is an interesting association between a diviner's powers and the aesthetic appeal of his or her accoutrements. While the question of religious architecture merits a separate study, chapter six is devoted to the decoration of shrines, altars, and other locations deemed to be or constituted as sacred. Symbolic associations abound at the meeting points of humans and divine beings. Last in some ways, but not least in others, death forms the subject of chapter seven. A great deal of artistic production is centered on funerary rituals, to the point that ancestral representations came to be considered, somewhat falsely, as a dominant trait of African art. Undeniably, the potential of artistic forms and performance to establish lines of communication between the living and the dead, and to express human fears and aspirations concerning the ambiguities and continuities of this life and the next is well illustrated in this chapter. In all instances, art and religion will be seen to be not just expressions of past and present, but as integral and formative elements of culture (Ben-Amos 1989:38).

Beyond the windows that are opened onto people's conceptual worlds by considering their artistic creations and religious beliefs and practices, there is the challenge that such a study presents to the academic discourses of the study of art and religion in Africa. John Picton speaks of exorcizing the "conceptual ghosts" which prevent the visual arts (and the same applies to religion) from being viewed dynamically and comprehensively, and not as mere socio-cultural epiphenomena (Picton 1992:44). With enough critical and imaginative wherewithal, as Blier so ably demonstrates (1993), one can turn the focii of traditional scholarship ("fetish," "custom" and "magic") to a better—more embedded, more multivocal, less universalistic—appreciation of its ideological assumptions and theoretical shortcomings. It is not an easy task to avoid conjecture and disjuncture, but, together with the phenomenological roots of religious studies, this present enterprise should be more in line with the type of emic, integrative and comparative studies that have been called for (Ben-Amos 1989:39). In a less intentional way, some of the ideas discussed in this book may foster that sense of much-needed "common creativity," given that our vision of the world is linked to the ideas (often illusions) we have about others (e.g. Sullivan 1988).[39]

Notes

1 This term is preferred over "art object," for as John Pemberton argues in the case of the Yoruba (1994:133) it conveys the praxis and creative artistry behind the object as well as the interplay of art in its visual, verbal or kinetic modes.

2 See, for example Piet Meyer, *Kunst und Religion der Lobi* (1981) and R.S. Rattray, *Religion and Art in Ashanti* (1969). The latter treats art and religion as virtually separate components of Ashanti culture. The same approach characterizes the short text accompanying an exhibition on the art and religion of the Gbato-Senufo of Côte d'Ivoire (Krieg and Lohse 1981). Swiderski's volume on Bwiti art in the context

of his wider study of Bwiti religion (1989) is excellent. In an essay which accompanied the exhibition on "African Spirit Images and Identities," Siroto explores helpfully the links between religion and art in Africa, and the misconceptions that have abounded (1976). Roy Sieber made an early pitch for a better understanding of the complex religious thought underlying many African artworks and of the importance of artistic forms in expressing inexpressible religious ideas (1977). Arthur P. Bourgeois produced a short descriptive inventory and accompanying illustrations on *The Yaka and the Suku* (1985) in an "Iconography of Religions" series. Clémentine M. Faik-Nzuji's *La Puissance du sacré: L'homme, la nature et l'art en Afrique noire* (1993) is a general text, with many Zairean examples, with a particular emphasis on the symbolic aspects of African visual and performing arts, and the communication and communion these provide with human and spirit beings, as well as natural forces. Other texts such as Glaze's *Art and Death in a Senufo Village* (1981) and Cole's *Mbari* (1982) treat religion as fulfilling a particular function, viz the continuing connections of the human community with the spirit world, in the first case, and in the latter, the human need for renewal and fertility (see Adams 1989). While not billed explicitly as dealing with religion, Suzanne Preston Blier's magnificent work on Vodun art, psychology and power (1995) contains much relevant material and analysis.

It is encouraging that the *Encyclopedia of Religion*, ed. Mircea Eliade New York: Macmillan (1987) chose to include an entry on "Traditional African Iconography" written by John Pemberton III. *Nigeria Magazine* has regularly published articles on festivals and art forms with a strong religious component. The Museum for African Art in New York stages a number of exhibitions and publishes excellent catalogues which address substantive issues and ideas often of a religious nature (such as *Secrecy*, see Nooter 1993), rather than form or style alone. By way of comparison, in Aboriginal Australia, the relationship between art and religion is the focus of an excellent recent study by Howard Morphy, *Ancestral Connections: Art and an Aboriginal System of Knowledge* (1991).

3 New York: Henry Kramer Gallery, 1971 and Montreal: Galerie Amrad African Arts, 1989, catalogue by Esther Dagan. In the introduction to the exhibition catalogue, Esther Dagan reports a conversation with Pablo Picasso in 1959 where he described one of the African masks in his atelier thus: "This is an African work. I think it is from the Congo. Look at it. It has a spirit, a spirit with magic power. This magic power does not exist in our art. We have lost it a long time ago."

4 A recent exhibition and catalogue by Robin Poynor,

African Art at the Harn Museum: Spirit Eyes and Human Hands (1994), explores more sensitively the ways in which art in Africa can serve as a means of communication and transaction between the human and spiritual realms.

5 This type of approach is praised by T.O. Beidelman in his review of the "Wild Spirits, Strong Medicine" exhibition at the Centre for African Art in New York City in 1989 (see *African Arts* 23,2 [1990]:81–2).

6 Cf. the edited work by Coote and Shelton, *Anthropology, Art and Aesthetics* (1992) which seeks to counteract the marginalization of art within anthropology. Eugenia Herbert's recent work, *Iron, Gender and Power* (1993) is another fine example of this type of approach. It demonstrates the value of a comparative and thematic perspective in seeking to discern the cosmologies underlying the working of iron in sub-Saharan Africa, particularly with regard to gender and age.

7 See, for example, the works by Holas on Senufo art (1978) and Kono masks (1952), Drewal, Pemberton and Abiọdun (1989) on the Yoruba, and DeMott (1982) on Dogon masks, and Le Moal (1980) on Bobo masks.

8 Cf. also Sullivan, *Icanchu's Drum: An Orientation to Meaning in South American Religions*, a masterly, comparative survey of South American religions which is structured in order to elicit a "morphology of the sacred," and the "cornerstones of religious life,"—e.g. cosmogony, human growth and creativity, time, death, specialists, etc. (1988:20,22).

9 John Picton was at pains to emphasize this in his keynote address, "Is Your Theory Really Necessary?" at the Tenth Triennial Symposium on African Art in New York City, 19–23 April 1995.

10 I am influenced, in this regard, by the way Suzanne Preston Blier makes a similar case for choosing a psychological thread in her work on Vodun arts (1995).

11 Herbert (1993:95f.), in her study of taboos pertaining to iron smelting, points out the inappropriateness of terms such as "pollution," "uncleanness," or "purity" in connection with sexual activity, menstruation or abstinence. Menstrual blood, for example, is viewed ambivalently as it partakes of both sterility and fertility.

12 There are three important and useful analytical overviews of scholarship in African art, namely Ben-Amos (1989), Adams (1989) and Ojo (1988).

13 It is for this reason that I have chosen not to be too dependent on the term "material culture."

14 Sally Price, in her book, *Primitive Art in Civilized Places* (1989), also challenges the interpretations of Western "civilized" art connoisseurs of "primitive" art objects, their predilection for universal aesthetic canons, their privileging of literate culture, and their failure to recognize the identity of non-Western artists.

15 Terence Ranger, in his chapter on Africa in *The Invention of Tradition* (eds Hobsbawm and Ranger, 1983), is particularly critical of the ways in which colonialism served to codify false models of African "tradition."

16 Ọlabiyi Yai prefers that the terms "modern" or "modernist" be avoided since they retain connotations of Western cultural superiority. Personal communication, 2 June 1993.

17 Paula Girshick, personal communication, August 1994.

18 Sydney Kasfir's call for a rethinking of questions about authenticity (*African Arts*, April 1992), notably a greater recognition of the artistic merits of so-called "tourist art," sparked a lively debate among readers of *African Arts* magazine (25,4: October 1992).

19 I. M. Lewis characterizes anthropology as "a comparative approach that constantly seeks to force anthropological 'theory' into a dialogue with ethnographic particulars..." (1986).

20 Ranger, in his article on "The Invention of Tradition in Colonial Africa" (1983), shows how "adaptation" missionary theory, with its predilection for rites of continuity and stability, fostered the concept of an immemorial and codified "African Traditional Religion" (252f.).

21 This is endorsed by Picton (1989:75, n.4) who calls for an approach to thinking about religion—informed by the African experience—as a "matter of doing" rather than a "matter of thinking about thinking."

22 Parkin cites Morris' introductory text on the anthropology of religion which lists over 100 monographs published on religion since 1980 (Morris 1987).

23 In his very helpful essay, William Paden argues that it is possible to use the term, "the sacred," in a Durkeimian and non-theological and metaphysically neutral sense. He reminds us that Durkheim primarily used the term as an adjective, as in "sacred things." He did not employ it to refer to as a priori religious reality. Nor did Durkheim intend his sacred-profane opposition to suggest that the sacralization of the profane was not possible. So it is with these considerations in mind that the term may be used in the present work because it offers descriptive potential for a range of practices and subject-object relationships.

24 The Yoruba express the importance and omnipresence of the otherworld in the form of a saying: "The world is a marketplace [we visit], the otherworld is home" (*Aye l'ọja, ọrun n'ile*), (Drewal

et al. 1990:15).

25 Personal communication, 15 April 1992.

26 Herbert, following Arens and Karp (1989), argues that a definition of power must emphasize "the *means* by which selected individuals are thought to gain access to and control over people and resources through their mastery over transformative processes" (1993:1f.). She also stresses that power cannot be understood without reference to cosmology, nor to such key constituent elements as gender and age, as they reflect culturally accepted notions about who may mobilize unseen power and how.

27 The communicative aspects of African symbols, notably in the area of body decoration and scarification, body gestures and movement, and the art of oral expression, and hence their capacity to address and transform the spiritual forces which imbue and shape human existence, are well treated by the Zairean scholar, Clémentine M. Faik-Nzuji (1993).

28 Picton, personal communication, 15 August 1992. See also Picton 1989.

29 Herskovits was one of the first scholars in the 1950s to argue that members of other cultures were no more mystical or irrational than we were. See "Art and Value" in Robert Redfield, Melville J. Herskovits, and Gordon F. Elkholm, eds, *Aspects of Primitive Art* (New York: the Museum of Primitive Art, 1959), 41–68, cited in Ben-Amos 1989:24.

30 Cf. Elsy Leusinger, *The Art of the Negro Peoples* (New York, 1967) 47, cited in Okpewho 1977:303. Cf. the title of a recent catalogue and exhibit at Munich's Villa Stuck, *Gods, Spirits, Ancestors: African Sculpture from Private German Collections* (K.-F. Schaedler J.-A. B. Danzker, intro. Munich 1992).

31 Many other examples could be cited, e.g. Udobata Onunwa, *Studies in Igbo Traditional Religion* (Uruowulu-Obosi, Anambra State, Nigeria: Pacific Publishers, 1986). Professor of religion, John Pemberton III, is a notable exception, having achieved wide recognition for his work on the Yoruba. See also Ikenga Metuh's opening chapter, "Religion and Art in Igbo Culture", to his 1985 work. To his credit, Olupọna, in a recent piece on "The Study of Yoruba Religious Tradition in Historical Perspective," *Numen* 40 (1993):240–73, includes a section on "Art History and Yoruba Religion." Ben Ray, in a paper entitled "African Religions: Representations in the Classroom," presented at the American Academy of Religion annual meeting, Washington, D.C. 19–23 November 1993, talked about the quite significant place art now

occupies in his African Religions course.

32 See, for example, the special issue of *Cahiers des religions africaines* on "Art," 16,31–2 (1982) and Kabemba Mafuta, "L'Art dans la célébration cosmique." *Cahiers des religions africaines* 20–1, 39–44 (1986–7). They have established a "Musée d'Art Religieux" at the Centre d'Etudes des Religions Africaines. T. K. Biaya points to the generally prominent place of art in Zairean society and its role as a vehicle for cultural and political expression. Personal communication, 25 June 1993.

33 Although the influence of the Evangelical Lutheran Art and Craft Centre at Rorke's Drift, South Africa (where John Muafangejo was a teacher) and Canon Edward Patterson, who taught wood sculpture in mission schools in Zimbabwe, should be noted.

34 Mark Hulsether suggests that the notion of triviality more aptly describes current (Western) Protestant attitudes to the visual arts, rather than fear of idolatry. Personal communication, 21 January 1994.

35 See, for example, William James, *Varieties of Religious Experience* (London: Collier-Macmillan, 1902), Joachim Wach, *Types of Religious Experience: Christian and Non-Christian* (Chicago: University of Chicago Press, 1951), and Frank Burch Brown, *Religious Aesthetics: A Theological Study of Making and Meaning* (Princeton: Princeton University Press, 1989), especially his chapter on "Varieties of Religious Aesthetic Experience." It should be noted, however, that the category of "experience" remains very problematic from a heuristic point of view for many scholars of religion.

36 The book as a whole is not organized along these lines but rather by the principal regions of Yorubaland, but the conceptual underpinnings of the artistic forms are integral to their discussion.

37 Cf. Blier's observation that the most influential group of people in Africa in terms of shaping and explicating art are geomancers, who serve as intermediaries between the sacred and social realms, as seers and as interpreters of divine wishes (1988:80).

38 For a critique of this argument, see Ọlatunde Bayọ Lawuyi, "Yoruba Aesthetics: Material Representation and Criticism." *The Literary Griot* 4,1/2 (spring/fall 1992):43–53.

39 The import of this with regard to Native American art and the problem of the Other is treated in a special issue of *European Review of Native American Studies*, 5, 1991, guest edited by Armin Geertz.

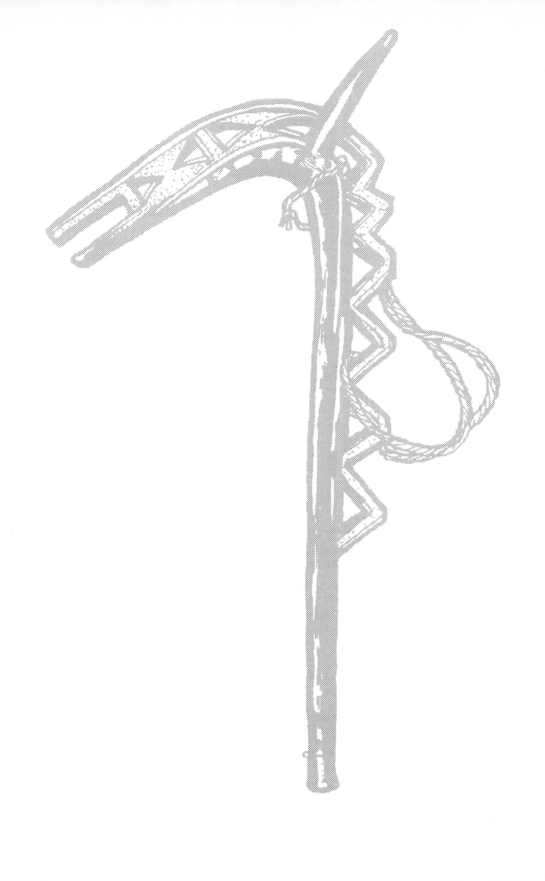

CHAPTER 1 Creation, Creativity and Agency

In his book on *Art History in Africa*, Jan Vansina provides a succinct statement of the concerns of this chapter:

> Creativity was attributed in most cultures south of the Sahara to supernatural forces which made visible out of invisible matter. Prayer or sacrifice to media, such as metal, wood or stone, to the artist's tools, to the processes, have been reported. Ritual conditions to be observed by the artist, especially when making objects which were to hold an invisible life of their own as support or even images of spirits, were fairly common (Vansina 1984:136–8).

Vansina argues that while creativity is not the exclusive domain of religion it needs to be understood in the framework of the dominant cosmology which includes an appreciation of individual input of the artists. He rightly calls attention not just to cultural variations but also to the complexity of the creative process which involves the artist and his/her skills, vision/perception and inspiration, the influences of patrons and public, and the nature of the products themselves.

This commonly articulated association between divine/cosmic and artistic creativity may be expressed in a number of ways whether mythically, ritually, linguistically, experientially or aesthetically. In many African myths, God is portrayed as Creator, Moulder, Carver and Potter (Mbiti 1970:45–8). The Akan of Ghana refer to God as "Excavator, Hewer, Carver,

Creator, Originator, Inventor, Architect" and the Tiv of Nigeria consider God as "the Carpenter" because they believe he "carves" the world, producing the different forms of creation. Tiv woodworking skills are symbolized in the scarification women wear around and above their navel, and the world too is believed to reflect the "beauty scarification" of God.

Paula Ben-Amos has shown how in the Edo kingdom of Benin the analogy is further developed in the Edo language. The verb *yi,* "to create," is combined with the object, *agbon,* "world," to express cosmological creation and with the object, *ama,* meaning "mark" or "design" for artistic creation (Ben-Amos 1986:60–3). In Benin mythology it is held that Osanobua, the Supreme Deity, formed the human body from clay, the same material that artists use to create their pots and shrine tableaux. A member of the carver's guild in Benin told Ben-Amos that:

> The members of Igbesanmwan were formerly in the spirit world and were considered very intelligent. They were the only people working with Osanobua, the Creator God. As soon as they carved a figure it was so beautiful that Osanobua would give it life and send it to earth.

In some cases, the skills and artistry of a particular artist may link him or her in the minds of his/her peers with the gods. Lamidi

Fakẹyẹ, the Yoruba carver of renown, who comes from a lineage of carvers, is referred to in his *oriki*, or praise poem, as "the first born of Ogun"—the god of iron, war and all metal implements, machines and vehicles (Pemberton 1994:130).

Dreams and Divine Commissions

This important association between spiritual beings and artists is further expressed in the inspirational dreams and divine commissions of which many artists speak. In fact, a growing body of ethnographic evidence shows how dreams constitute an important form of mediation between the spirit world and practising artists. Among the Anang of southeastern Nigeria, a diviner may decide that dreams, unusual experiences or sickness are signs that the deity (*abassi*) has designated a particular individual to become a carver (Messenger 1973: 104). It is believed that *abassi* instructed the fate spirit, *emana nnem*, not to assign the craft to a woman. A carver's success is measured by the amount of (spiritual) power or *odudu* that he is able to command through his guiding and protective spirit or *nnem*. There are also intervening factors such as his fate, moral behavior, ritual expertise and outside evil forces. In his work on sources of Gola artistry, Warren d'Azevedo describes the archetypical Gola artist as one who "dreams" and whose creative inspiration is supported by a relationship with a tutelary deity (d'Azevedo 1973a:335). The projection by the artist—into created external forms—of the "ideas" given to him by his spiritual companion or benefactor (*jina* [*neme*]) and the devotional character of the relationship he maintains with the latter distinguish the artist from sorcerers, diviners, warriors, etc. The product of the artist is seen by the public as miraculous and heroic.

The Lagoon peoples of Côte d'Ivoire are considered to be divinely inspired individuals with special powers, bestowed on them by ancestors, spirits or God (Visona 1987:67–75). These "men of talent" (they can be women) are believed to have no need of instruction or imitation. The status of diviners and artists is similar in that they both mysteriously acquire their skills from the spirit world, but artists do not feel forced to begin carving figures in the way that diviners feel compelled to begin their profession as a result of spirit intervention. Artists may have setbacks which lead them to become sculptors but these are not generally interpreted as divinely caused.

The type of spiritual determinism described above is well expressed in the words of a Baulé artist and diviner, Lela Kouakou, from the Yamoussoukro area of Côte d'Ivoire. He comes from a family of sculptors and taught himself, receiving inspiration from his dreams. Here he is commenting on a sculpture of a man and a woman:

> This is for an *asie usu* [nature spirit, cf. figure 2.6]; they ask for many different things. I never saw a man and a woman carved out of one piece of wood before. Probably the spirit asked for it to be made that way. The spirit who follows you tells you how it wants to be carved. In a dream he will say: I want to be sculpted in this manner. It is he himself who determines his form before being sculpted by the carver. This would be a nature spirit and his wife—or maybe it is a female spirit and her husband. They are very dangerous. You must do exactly what they ask. If they ask for a statue in one piece like this, then you must do it exactly. Otherwise you might fall sick or some other misfortune occur. (Baldwin *et al.* 1987:148)

David Omoregie of the carvers' guild in Benin told Paula Ben-Amos: "The spirit of the ancestors works in me, directing me. When I sleep I see things I have never carved before. If I have a big order I will do it step by step. I have

faith in the ancestors because I have learned more from dreams than from actual studying." (Ben-Amos 1986:62). This rather points to the way dreams may be a source of innovation for the artist.

In his work on Tukolor weavers in Senegal, Dilley describes how *mabube* weaving myths portray the weavers' conception of the origin of their craft as deriving from the spirit world (Dilley 1992:71–85). These and other such myths will be considered below, but suffice it to say that the Tukolor conceive of the weavers as pursuing an occupation which brings them into a relationship with the jinn and often refer to them as being "close to the jinn." The weavers see themselves as re-enacting the deeds of the mythical ancestors whose experiences and explanations serve as a model for Tukolor practice. Just as the ancestors had recourse to the jinn through dreams, the weavers derive many of their new cloth designs from spirit visitations during the night. Dilley argues that there are two aspects of the weaver's craft that can be inspired through dreams, namely the practical/technical side and the mystical. The latter concerns the magical formulae, verses and incantations (*cefi*) that are used mystically to improve a weaver's ability to weave well or to affect the fortunes of others. An old man shared one of these incantations with Dilley:

> There are many things in this world
> There is man, there is woman.
> Young and old.
> Woman gave birth to both man and woman
> As this is true.
> Threads come!

It is believed that both weaving expertise and mystical abilities increase with old age. Dilley notes the significance of the externalization of their source of inspiration, metaphorically expressed in the opposition of village and bush,

humans and spirits. He also highlights the problems of considering the veracity of claims about dreams as primary or secondary sources and the consequences for artistic production. In other words, it is through the discourse of spiritual agency that individual differences and abilities are accounted for, as well as deviations from the usual, especially in the face of their ideal conception of their identity and equality. D'Azevedo argues that the passive view of the Gola artist protects him from public scrutiny and control; he indeed "encourages the illusion of spontaneous creation and presents his results as a gift of the spirit" (1973:337). Lagoon artists of Côte d'Ivoire share similar stylistic conventions (explained in terms of the inspiration by "very conservative spiritual beings"), as well as some unusual and distinctive features (attributed to divine agency).

An interesting consequence of the Lagoon peoples' cultural conceptions about artistic creativity is the absence of workshops in the area. This contrasts with the situation in Benin, where the carvers' guild, under the guidance of the patron deity, Ugbe n'Owewe, serves to hand down and replicate a body of forms and patterns (Ben-Amos 1986:60). While Lagoon diviners allow for the range of quality that the absence of instruction may foster, they "prefer to patronize reliable artists whose work has favorably impressed them, for they wish to please both clients and spirits with a commanding image" (ibid.:72). For the Shona of Zimbabwe, creativity does not necessarily mean originality of expression as is often the case in the West (Dewey 1986:64–7, 84). Shona artists respect traditionally accepted formats, viewing creativity rather in terms of the impetus and power to create.

In contemporary African art, it is significant to note that a number of the artists continue to attribute their inspiration to spiritual sources. Agbagil Kossi, a Togolese sculptor, gives a long

25

account of his relationship with his *vodoun* or tutelary spirit by the name of SOSSIVI who guides and protects him in all respects (*Magiciens de la Terre* 1989:173). Dreams, often of mythological themes, form the basis of the work of John Fundi, a Makonde artist from Mozambique (ibid.:137). Mike Chukwukelu, a creator of the monumental Igbo *ijele* masks from southeastern Nigeria, speaks of art as being innate and spiritual and which needs to be expressed concretely (ibid.:115). Seni Camara is well known to many because of her fantastic, grotesque figures that she models in clay in her courtyard in Bignona in Senegal. The subject of a film entitled "Seni's Children", she attributes her creativity and originality to a "gift of God." The villagers look askance at her work which lies outside the local tradition of making clay pots and other functional objects (ibid.:113). Contemporary stone sculpture in Zimbabwe is characterized not by common forms but common claims of inspiration from God or the ancestors, or, in the words of a recent work on the subject: "[i]ts aesthetic origins largely lie in the artists' realisations of the spiritual dimensions of their traditional cultures" (Winter-Irving 1991:1; see also Ponter 1992). The contemporary Nigerian artist from the Niger Delta region, Sokari Douglas Camp, has delighted audiences in Britain and the US with her sculptures made of interwoven strips of metal and interlacings of wire (her exhibition *Alali — Festival Time* 1987). They are inspired by the vivid ceremony, ritual and spiritual significance of her Kalabari heritage.

In some cases a particular deity may be associated with artistic creativity. This is the case of Olokun, the Benin god of the waters, who demands beauty and decoration of his shrines (Ben-Amos 1986:60,62). Many of his devotees are channeled into artistic activities such as the *owurhue* ("chalk markers") who

decorate shrines to Olokun with elaborate abstract designs representing his undersea kingdom (see figures 6.1, 6.2). The choice of the patterns is believed to be divinely directed and the creation of these kaolin markings constitutes a crucial daily ritual said to "open the day for Olokun in the water" (cf. Rosen 1989). Together with the creators of decorative pots (the *omakhe*) and the moulders of life-sized mud figures (the *omebo*), these artists, while operating beyond the bounds of a guild, share the same belief that they are divinely selected, inspired and instructed through dreams.

In Shona cosmology, artists frequently attribute their skills to two types of spirits: the *shave* (alien or wandering spirits) and the *vadzimu* (spirits of the ancestors) (Dewey 1986:64–7). The former are perceived as outside forces (neighbouring groups, intruders, animals) and generally amoral, even malevolent. More benevolent versions of these spirits are said to be responsible for individual artistic and healing talents. In contrast the *vadzimu* are the collective representation of Shona ideals and morality, exerting a protective influence. The wishes of the spirits are interpreted by spirit mediums or diviner-healers, who commission many of the ritual objects made by (male) artists. Dewey cites one spirit medium who claims that his headrest was made and used by the ancestral spirit that possesses him. Few artists report being possessed by spirits; they more commonly claim artistic knowledge communicated in dreams. Some artists do not attribute their skills to the ancestors only their commissions. Dewey tells of a Shona blacksmith who made several ritual axes for a spirit medium. The spirit medium was apparently so pleased with his work that he became possessed on the spot and instructed his companions to give the blacksmith more money (ibid.:66). Dewey argues that it is more frequently men who claim

spiritual callings to be artists and blacksmiths since it is they who produce the ritual art, whereas, more generally, women may become prominent spirit mediums.

Sylla issues a cautionary note regarding the over-mystification of the creative process in Africa (Sylla 1988:227f.). He maintains it is wrong to imply that the artist is at the mercy of divine forces or ancestral powers and works in some trance-like state. Such divine determinism is compounded by social forces, whether caste systems, commissioning groups, stylistic conventions, etc. So the image of the African artist as imitator rather than creator reduces him/her to the status of artisan. Sylla attributes the generation of this image in the various works on African art as well as in African literature (such as Camara Laye's *L'Enfant Noir*) to the basic perception of the African as essentially religious, discussed earlier in the introduction.

It is perhaps appropriate here to allude to the discussion surrounding the "anonymity" of traditional artists. As stated earlier, this was in part due to Western inattention to individual non-Western artists, and (neo)colonial collecting practices. Several art historians have made a concerted attempt to identify individual artists. That notwithstanding, Abiọdun notes that, among the Yoruba, the lack of association between specific art forms and their authors/creators is not due to lack of interest (1994a: 42-3). Rather it is because people rarely gave out their full names.

The Yoruba believe that calling out a person's name can summon her/ his spiritual essence and cause her/him to act according to the meaning of the name (given at birth) or the desire of the caller. Artists are considered to be especially vulnerable to malevolent forces, hence the practice of using nicknames, such as Olowe Iṣẹ (meaning Olowe from the town of Iṣẹ) (see Walker 1994).

The Occult and Artistic Powers of Blacksmiths

In many parts of Africa the ability of blacksmiths to work creatively with iron is understood in mystical and occult (i.e. non-ordinary and hidden) terms. Their ability to transform ore into metal and unrefined metal into an object through the control of fire is widely viewed as a precarious act of creation and subject to interference by ancestral spirits and sorcery (Childs and Killick 1993:325; Herbert 1993). For this reason, they are both feared and revered, and are versatile in the number of roles they perform. The materials that they work with and the objects of power and prestige that they produce all enhance their status, both socially and politically.

Mande blacksmiths from Mali belong to a special professional clan which is believed to possess special occult powers. They themselves claim to have been born with the powers (McNaughton 1988). McNaughton argues that in spite of their separate status, blacksmiths (and other special clans) produce much of the art and "literally infuse the culture with much of its character" (ibid.:5). They are also trained to be sculptors, diviners, amulet-makers, doctors, priests and social intermediaries. Blacksmiths are believed to possess and work with great reservoirs of *nyama* (special energy or occult power which the Mande see as both natural and mystical) (ibid.:15–16). Iron working and the forging of useful implements and art release large amounts of the energy. Leather workers and bards work with *nyama*-laden devices and must possess enough of the energy to defend themselves against its "awesome effects." The Mande view *nyama* as a morally linked force which is a "rationale for their most fundamental behavior patterns and as an explanation for the organization of their world" (ibid.:16).

It is the association of blacksmiths with

spirits of the bush which also heightens their power, as well as generating feelings of ambivalence and ambiguity, in the eyes of other Mande. Smiths are believed to be able to negotiate treaties with the fearful spirits through ritual, allowing them to go into the wild space and collect wood and other organic materials (and in the past ore). Hostility towards blacksmiths is further reinforced by the mythical belief that a legendary smith created the boys' *ntomo* association, whose monstrous mask and rites of circumcision are a source of fear to the boys (ibid.:19).

Some may question why blacksmiths should be sculptors, but McNaughton argues that not only are they experts in the shaping of wood and iron, but their very heritage, multifunctionality and powers predispose them to this role if one considers that art is more than form. In his words: "It is a part of the force of religion, ideology, psychology, and organized society. It is both abstract and instrumental; it gives pause and it allows implementation. It is a functional cornerstone of civilization." (ibid.: 72). Since sculpting is more difficult than producing tools and utensils, it is likened to sorcery in that there are few practitioners. McNaughton highlights the important link between knowledge and power in production of sculpted objects, whether they be door locks, amulets or the carved wooden heads for bird masquerades. The blacksmith must reduce the object to a collection of highly abstract raw elements which are then linked in "dramatic, but carefully controlled configurations through the acumen of the smiths, so that a vigorous new entity is created" (ibid.:103). It is the knowledge and synthesis of the elements which is important, as they generate power that can be controlled and put to work for people. The Mande smiths are "points of access to terrific powers and rearrange and transmit these powers in all that they do." In effect, therefore,

they are harnessing the unrefined world, translating it into a Mande frame and civilizing it—a highly creative act of taking the world apart, and reassembling and remaking it.

These ideas are well illustrated in the sculptures themselves which exhibit high levels of visual energy, "often created through geometric exaggeration and generally controlled through compositional subtleties that systematically reintegrate the energy back into the art" (ibid.: 105). The Mande favor formal clarity and real meaning. McNaughton demonstrates this lucidly by drawing on Mande philosophy and aesthetics. The term *wòròn* means "to husk" or "shuck," more generally to get to the core and master something, whether music, song, speech or any artistic enterprise. So "true speech," purity and simplicity of form, and focused, controlled activity is culturally valued. This extends to the area of divination—the various techniques being intended to help humans "strip away the superfluous features of a situation, so that its basic structures may be understood and acted upon" (ibid.:110). So we may see how the smith is revered because of his reputation for precision and clarity, and ability to harness and redistribute occult energy.

The figural iron staffs demonstrate the smith's use of imagery to connote power (figure 1.1). Equestrian figures are an obvious power image (ibid.:125), together with hats, which are also worn by hunters, bards and sorcerers. These are a sign of personal power, since they are worn laden with amulets to fend off the dangers associated with wilderness and sorcery. Response to the potency of the hats is further understood if we take into account Imperato's observation that they are known as "crocodile mouth" (*bamada*), being worn in former times by Bamana elders and symbolizing the power of the crocodile's mouth to neutralize (metaphorically) types of sorcery (Imperato 1983:45 in McNaughton 1988:126). Features of the hat

resemble crocodile tails and feet. Crocodiles are perceived as intermediaries between the divine and human worlds—they may serve as oracles for soothsayers, for example.

The material of the staffs themselves must be seen as part of the power imagery. As McNaughton argues, the choice of iron over wood symbolically expresses their aggression and power. The essential occult power of the

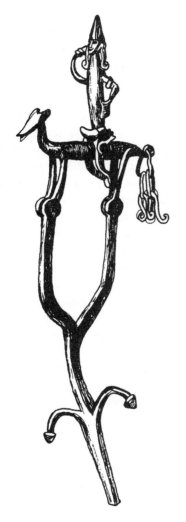

Figure 1.1 Bamana forged iron equestrian figure and staff, Mali. 1979.206.153, Metropolitan Museum of Art, New York. After McNaughton 1988:pl.66.

staffs is further conveyed by the difficulty of the workmanship, inducing and releasing additional energy or *nyama*. The object is further charged with power by the ongoing sacrifices of millet, water and beer performed by the owners (McNaughton 1988:125-6). In addition, the staffs are placed around altars to empower and honour them. They frequently received sacrificial offerings during festival time, being paraded during dances and admired as the "supreme test" of a blacksmith's forging skill.

Sylla again seeks to tone down exaggerated claims, this time regarding the status and multiple functions of the blacksmith (Sylla 1988:190-4). While acknowledging the central importance of the blacksmith in Mande societies, he feels this should not exclude the social, ritual and professional responsibilities of other individuals or groups, nor the fact that in many other societies, due to the caste systems, the role of the blacksmith is less important and polyvalent. He does not accept the portrayal of the forge as a sacred place; its isolation is more explicable in practical terms. Eugenia Herbert claims that more generally, because of the emphasis on the smith as culture hero, the distinction between smith and smelter is often lost (1993:13). Yet more "magico-religious practices" are associated with those cultures that smelt iron (because of the notions of transformation) than those that simply forge. In practice, however, it is difficult to adhere to the distinction because of changes and ambiguities in the sources.

Divinely Created and Humanly Discovered Masks and Objects

McNaughton's study (1988) has provided a fine opportunity to appreciate the complex interdependency, almost indistinguishability, of artistic form, sources of power, aesthetic appreciation, mythology, ritual, social status

and political influence. Returning to ideas about artistic creation, there are many cases where this is attributed to a pre-existent (preternatural, divinely known) form—mask, textile, statuary, etc.—usually discovered by a community's ancestors. For example, Bobo farmers from Burkina Faso consider their masks of leaves to be the most ancient and important of all their masks (le Moal 1980:170, 267ff.). A number of cosmogonic myths establish this primacy, as well as the divine character and archetypal role of the leaf masquerades. In one of the variations of the myth, it is noteworthy that the Creator God (Wuro) does not "invent" the mask, but initially reveals it in a complete state, only later (the next year) does he provide the necessary materials for humans to construct it themselves based on the prototype. Le Moal informs us that numerous Bobo myths affirm the belief that the mask has a life of its own, that it has pre-existed and that masks can be seen emerging from the ground or out of the water. In several of the myths, Wuro reveals the mask of leaves to two hero-figures, a blacksmith and a cat (highly re-spected as an emissary or witness for God), or to a dog (commonly an incarnation of the black-smith) and a cat in the forest. It is the cat who bears the mask back to the village. In alternative versions of the cosmogonic myth, Wuro does not dispense his creative gifts until after he has distanced himself from earth. In these circum-stances he operates through an intermediary—usually an heroic figure or child prodigy. Furthermore, these masks constructed of freshly cut leaves (and therefore of ephemeral quality) are believed to make present Dwo, one of the hypostases ("sons") of Wuro. These cultic manifestations of Dwo also take on regional and gender distinctions, and are richly and meticu-lously described by le Moal in his study of Bobo masks.

The Kuba (Bushoong clan) people recount how a spirit or *ngesh*, known as Moshambwooy,

used to haunt their waters and torment the inhabitants, inflicting them with illness and death (Cornet 1982:256). In the time of the king Bo Kyeen, a man named Bokomboke went into the forest and encountered the spirit. He was unable to describe the spirit, but claimed he could attempt to recreate its appearance. So following the king's instructions to build a hut far from town, he set about dressing himself in barkcloth, feathers, a bat's skin, which he painted yellow, black and white. Upon seeing this strange costume, the king had an idea and disappeared from the town. That night a strange being appeared in the capital, terrifying the people. It was the king imitating the spirit Moshambwooy. He later hid the costume in the bush. The next day the king returned to Nshyeeng, feigning surprise at accounts of the mysterious personage. But he claimed to know its origins: it was the spirit Moshambwooy who had come to see if there were quarrelsome women and disobedient children. Thus was born the royal mask (see figure 1.2). Even today, the king is supposed to be away travel-ling when the mask comes out. Many chiefs wear the Moshambwooy mask on solemn occasions and may even be buried in or with it.

The belief in the divinely created origin of a ritual object may elicit heightened emotional responses. For example, Griaule attributes the emotional, aesthetic response to the red skirts of the Awa dance society not only to their association with blood, the vehicle of the sacred force, *nyama*, but also to the fact that they are not held to be human creations. They are believed to have been given directly by the god, Amma (1938:791).

The Tukolor weaving origin myths outlined by Dilley (1987:70–9), which are expressed in myth and oral literature, not only point to different social identities but, more importantly to varying religious interpretations. In Tukolor thought it is the Senegal river which is seen as

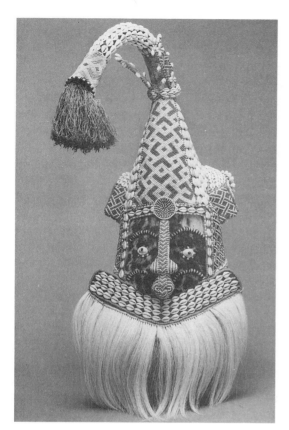

Figure 1.2 Kuba *Mwash a Mbooy* mask, Kasai province, Zaire, *c*.1948–60. McClung Museum, University of Tennessee, Knoxville. Photo: W. Miles Wright, 1992.

the source of much knowledge and inspiration since it is the dwelling place of influential spirits. The weavers themselves, experts in both weaving and magic, believe that the jinn play a central role in their craft, together with a semi-divine ancestor named Juntel Jabali. Common to all the variations of their origin myth is the centrality of Juntel Jabali. In one account, for example, Juntel leaves the man he is fishing with and encounters a jinn in the forest, weaving, and Juntel returns daily to study his techniques before eventually making off with the loom. His insufficient technical knowledge causes him to turn to his mother (a "jinni") for

the necessary skills. The Islamic clerics claim in contrast that weaving is derived from the spider, ridiculing the ancestral pretensions of the weavers. As Dilley indicates, the spider is said to have brought weaving to humans in other parts of West Africa, such as to the Asante (a major Akan-speaking group in central Ghana). The spider symbolism is an appropriate perception of the weavers since the latter employs verses and incantations to ward off the harmful effects of the jinn and malevolent weavers and to entrap (like the spider) or threaten those around him. A more radical Muslim myth of origin tells of Adam being the first weaver and the Prophet blessing the craft. Juntel's role becomes that of an exceptional person with magical power, one in a long line of weavers, deriving his saintly or mysterious powers from Allah's gift of grace and not to his origins among the jinn. As Dilley cogently suggests:

> the narrator of this reinterpreted version of weaving origins is trying to resolve a sense of ambiguity and ambivalence deriving from his status as a Muslim and from his position as a weaver who is identified and brought into contact with spirits devalued by his religion. (ibid.:77)

Such a reinterpretation undermines the very self-perception and conception of the weavers and explains their strong resistance to such Islamic versions of the origins of weaving.

The discovery of masks made by women is common to many traditions (on the Kono of Sierra Leone see Holas 1952:143ff. and on the Lunda of Angola see de Heusch 1988:22). Common to most of the accounts is the fact that the material mask, including its spiritual substance, appears as a pre-existent phenomenon which is usually found in the ground or fished out of the waters. Women are also considered the first owners of a number of important sacred and ritual objects, such as

bull-roarers, ceremonial songs and dances, totemic emblems, etc. and as the source of many cultural institutions and even natural phenomena (Pernet 1992:140). Pernet argues that these transfer myths serve to demarcate boundaries and hierarchies between male and female in many societies, allowing male identity and independence to be established in separation from female powers of reproduction. When examining the relationship between gender and creativity in many parts of Africa, complementarity is emphasized (often idealized rather than realized) in terms of production and reproduction, as well as in the ritual sphere (Hackett 1993b). The associations of women and creativity in myths of origin is noteworthy. For example, the origins of Akwete cloth (southeastern Nigeria) are attributed to a woman known as Dada Nwakwata. One legend recounts how she wove cotton cloth (later using silk and imported yarns), the techniques and designs having been given to her by the ancestors through dreams. She worked secretly for ten years in the confines of her own backyard, not allowing anyone to see her loom, and even, according to one version, keeping spirit-related sculpture to ward off unwelcome onlookers. Another version of the myth recounts how a deaf-mute woman slave, Ngbokwo, secretly passed on the knowledge of weaving after the death of Dada Nwakwata (Aronson 1989:154). Dada Nwakwata is important as a role model and heroic figure for Akwete women, as she introduced change in weaving styles and she served to legitimize the secretive and exclusionary behavior that has given Akwete women economic and geographical control over their craft.

In a short, but insightful piece, Monni Adams argues that there is one notable area which lies outside this complementarity and that is childbirth for women and the carving of wooden images for men (Adams 1980:163–7). She sees a parallel between the production by men of human imagery in wood and women's giving birth to small human creatures. This is well illustrated in the conditions of creativity for the carver which resemble those of the pregnant woman: isolation of the carver, subjection to food and sexual taboos, and performance of sacrifices. Furthermore, among the Gola of Liberia, d'Azevedo states that carvers dream of a spirit mate (*neme*) and consider the completed carving as a child of their union (d'Azevedo 1973b). This is well illustrated by a carver's own reflections on a recently completed Sande mask (ibid.:148, cited in Adams 1980):

> How can a man make such a thing? It is a fearful thing to do. No other man can do it unless he has the right knowledge. No woman can do it. I feel that I have borne children.

Adams also notes the parallel between the feeding of children by women and the feeding, cajoling and entertaining of small human figures in ritual. Adams rightly notes the asymmetrical power relations occasioned by men having the exclusive right to create figures with the powers of mediation and fertility, and to control the cults. It is only women's images that predominate in the ritual context, for it is the kneeling submission and devotion of the woman to her child and her deity that serve as the model and metaphor of divine/human relations. That does not detract from this being also a statement about women's inherent powers.

Among the Igbo of southeastern Nigeria, Ala the earth goddess is considered to be the source of all beauty in nature, and by extension, morality and beauty more generally (Willis 1989:62–7). The word *nma* means both "good" and "beautiful." Just as Ala is believed to sanction what is natural, normal and life-

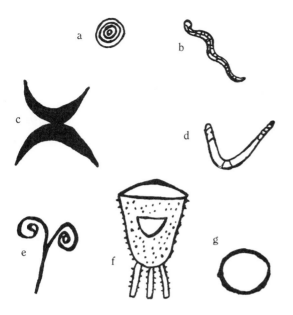

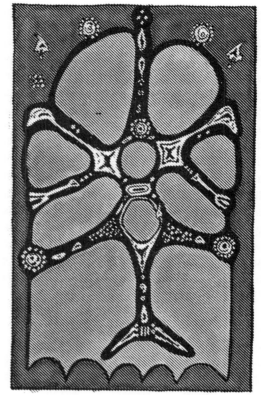

Figure 1.3 *Uli* designs, Igbo, Nigeria. After Willis 1967. 1.3a *Agwolagwo*, spiral. 1.3b *Agwo*, snake. 1.3c *Ìbe onwa*, segment of the new moon. 1.3d *Okwa nzu*, wooden chalk bowl (chalk is a symbol of purity and peace, used in ritual, and when welcoming guests). 1.3e *Mkpisi igwe*, iron pin, spoke, skewer to take yam from the pot. 1.3f *Ite ọna*, metal pot for cooking yam, etc. 1.3g *Onwa*, moon.

Some of these designs, notably the spiral, snake, moon, and chalk bowl are still employed by contemporary (male) artists in eastern Nigeria.

Figure 1.4 *Uli* mural design from Nnobi representing the wooden ritual platter, *ufo*, a symbol of good luck. After Willis 1989:fig.3.

sustaining, she is also believed to punish offences against the land (*nso ala*), such as murder, yam stealing and adultery. The consequences may be failed harvests, natural disasters, and untimely death.

Women have a special relationship with the goddess on account of their procreative and nurturing roles, and have an important part to play as upholders of Ala's customary law. It is the mythical belief that women were endowed by Ala with gifts of artistry, notably in the art of body painting and wall decoration known as *uli* which is significant. Initial inspiration for *uli* designs is believed to have

come from patterns that Chineke or God created for animals. These eye-catching and beautiful designs were then interpreted by female artists and translated into the *uli* idiom, beginning with the first *uli* artist, Asele (figures 1.3a–g). They are used to adorn the bodies of young women making the transition from girlhood to womanhood, emphasizing their sexual attractiveness and beauty, and to decorate shrine and house walls (figure 1.4). Willis' interviews with an elderly *uli* painter reveal a concern to convey the three states of reality—physical, spiritual and abstract—in her work (cf. Nwoga 1984a).

Creation Symbolized and Ritualized

In this section we examine how ideas about the events of creation may be relived ritually and symbolically in a community. The Dogon people, who inhabit the spectacular Bandiagara cliffs of Mali, provide a striking example of how a sculptural tradition can portray creation myths and ancestral figures. The French anthropologist, Marcel Griaule, who worked among the Dogon from 1931 to 1956, held that Dogon images represent complex statements of cosmology and mythology that can only be understood by the most learned members of society (DeMott 1982:28). While his approach and ideas have been continued in the work of his colleagues and successors such as Griaule

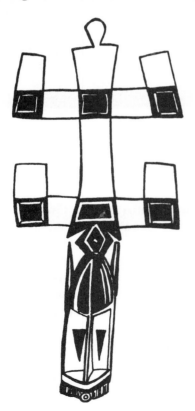

Figure 1.5 *Kanaga* mask, Dogon, Mali. After Griaule 1938:471.

and Dieterlen (e.g. 1965, 1989), Laude (1974) and Imperato (1978), they have been questioned by some scholars for over-emphasizing the importance of mythic explanations of art (DeMott 1982:28), or for insufficient attention to the contexts in which the objects were used (Ezra 1988b; Roy 1983; van Beek 1988).[1] Clifford (1988:55–91) raises the problem of the "totalizing claims" and essentialized traditional cultural patterns posited by Griaule and his associates with regard to Dogon culture and thought. Given the sheer complexity of the latter, the absence of female informants and the (undue) emphasis upon "secret," initiatory nature of revealed knowledge, Clifford prefers to see the Griaule tradition as expressing a Dogon truth which is "a complex, negotiated, historically contingent truth specific to certain relations of textual production" (ibid.:60).

Griaule's landmark study of Dogon masks nonetheless provides a detailed account of their forms, as well as the accompanying myths, songs, costumes and dances (Griaule 1938). Through his well-known conversations with Ogotemmêli, the old hunter chosen by the council of elders in Sanga to introduce Griaule to higher levels of the cosmological and mythological system (Griaule 1965), Griaule and his colleagues began to see all aspects of Dogon life as connected by the mythic structure (Ezra 1988b:32). An example of Ogotemmêli's teachings is cited by Dieterlen: "The society of masks is the entire world. And when it moves onto the public square it dances the step of the world. Because all men, all occupations, all foreigners, all animals are carved into masks or woven into hoods." (Griaule 1948:179 cited in Dieterlen 1989:34)

Griaule's study of the masks revealed those that were permanent, that took part in each *dama* or "end of mourning" ceremonies (Dieterlen 1989:34–5). They are related to

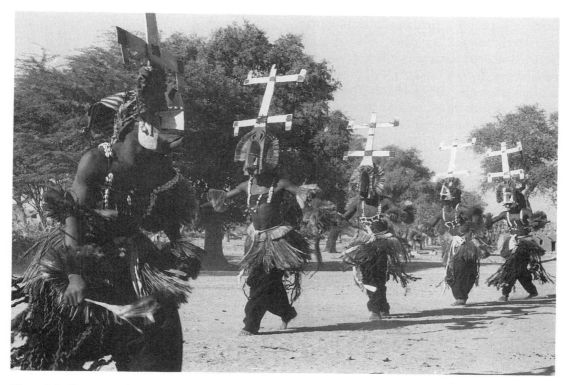

Figure 1.6 *Kanaga* masked dancers, Dogon, Sanga, Mali. Photo: Maya Bracher, 1971. Eliot Elisofon Photographic Archives, National Museum of African Art, Smithsonian Institution, Washington, D.C.

mythical events and personalities; their symbolism, according to Griaule, is only understood by those who have reached the uppermost level of Dogon knowledge. The three main types of masks are the *kanaga, amma tā* and *sirige*, all depicting different stages of the cosmogony either through their form, the steps of their accompanying dances, and/or associated rhythm changes (Dieterlen 1989:35). All three masks represent events that took place at the beginning of the creation of the universe by the single omnipotent, omniscient and omnipresent God, Amma. The colors of the masks, ornaments, and costumes also make present the four basic elements (black refers to "water," red to "fire," white to "air" and yellow or ochre to "earth"). These are the matrices with which the Creator Amma brought the universe

into existence (ibid.:34; Griaule and Dieterlen 1965:61).

The *kanaga* mask is described by Dieterlen as representing the movement imposed upon the universe by Amma (figure 1.5). *Kanaga* can be translated as "God's hand" and the dancers repeat, using circular movements of their heads and shoulders, the gestures made by God when he founded space and created the earth (Brain 1980:188) (figure 1.6). The cross or geometrically decorated pole which tops the mask is interpreted by Griaule as symbolizing the equilibrium between heaven and earth, and divine order in the cosmos (figure 1.7). Alternative interpretations posit the *kanaga* as the crocodiles of Dogon mythology on whose backs the first Dogon rode through the rivers (Brain 1980:188) or as "a water insect that, in

order to benefit the Fox [an important mythic character], wanted to moor Nommo's ark [which contained items of human culture] after its descent. In the end the Fox died, after causing grave disorders on Earth. The *kanaga* mask represents the insect on its back, four legs in the air, imploring his creator in vain." (Dieterlen 1989:n.6, 87). Figure 1.8 shows the depiction of *kanaga* on the walls of Dogon caves. Even though they have been simply executed (sometimes just using a finger), Griaule maintains that they have great religious significance as they are intended to retain the *nyama* or power of the dead. That is why they

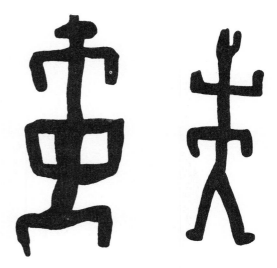

Figure 1.8 *Kanaga* cave paintings, Dogon, Mali. After Griaule 1938:627, fig.172.

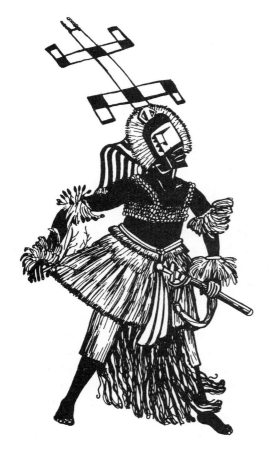

Figure 1.7 *Kanaga* mask, Dogon, Mali. After Griaule 1938:476, fig. 112.

are most frequently found in places consecrated to mask activities or initiation ceremonies (Griaule and Dieterlen 1965:605). The *kanaga* image seems to be associated with female qualities, in contrast to the *sirige* mask, a huge vertical superstructure described below (DeMott 1982:116).

The second type of mask, *Amma tā* or "Amma's door," according to Dieterlen, "represents Amma 'open' so that the totality of creation may emerge from his breast, or 'closed' after he has finished his work" (1989:35). She describes the third main type of mask or *sirige* as representing the stars in great number, "implying infinite multiplication and suggesting a series of galaxies and their movements in space" (figure 1.9). It has a large vertical superstructure. The mask is also symbolically referring to Ogo's journey between Heaven and Earth, when he was trying to find a cure for his incompleteness (absence of his female twin), to the descent of the ark, and to the family house with many stories, which shelters the ancestral altars and whose

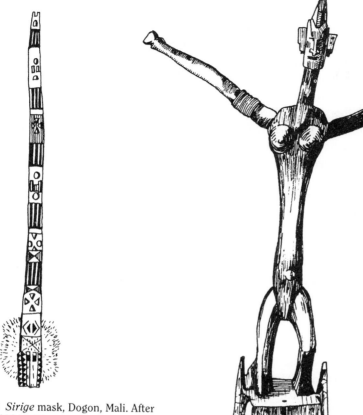

Figure 1.9 *Sirige* mask, Dogon, Mali. After Beaudoin 1984:113.

Figure 1.10 *Satimbe* mask, Dogon, Mali. Stanley Collection of African Art, University of Iowa. The mask represents the *Yasigine*, the only woman in the village who is allowed to participate in the ceremonies to honor deceased elders.

architecture ostensibly recalls the preceding events. On the basis of her own research, Dieterlen shows how other masks serve to reveal the nature and function of various humans, animals, and plants which play a role in the succeeding events of creation or in the history of the Dogon themselves (ibid.:36–43). It is possible to make only brief reference to some of these figures: the ambling, direction-less *dyobi* mask which represents Ogo before his transformation into the Fox; *walu*, the Antelope, who was born at the time of the sacrifice of Nommo, the mythic genitor of humanity, was gravely wounded by the scheming Fox—his dance steps and mimes as well as cave paintings symbolize the path that he took before he finally died of his wounds.

The *satimbe* or "superimposed sister" mask (figure 1.10) represents an Andoumboulou woman (descendants of Ogo prior to his

transformation into the Fox) who discovered the red fibers and used them to mask herself in order to frighten away men. The men removed the fibers from her, affirming their authority, but naming her "sister" of the masks to commemorate her discovery (Griaule 1938:52ff.). Significantly, this is the only mask representing female characters which is made of wood not fibers. A female figure sits atop the mask, dressed in a skirt and ornaments made of red fiber as well as a hood of braided black fibers. At the higher level of interpretation, that of the "speech of the world" or "clear speech," the female figure on the mask is Yasigi, the female twin of Ogo before he became the Fox. The fundamental, ancestral role of the woman is signified by the calabash in her hand which recalls how she distributed beer made by the women at the celebration of the first *sigi*. The drink was consumed by all participants, thereby celebrating the revelation of "speech" transmitted by Nommo to the ancestors of humankind. Yasigi as the first dignitary of the ceremony became known as *yasigine* or "woman of *sigi*." The dances and rhythms accompanying the *satimbe* mask at the *dama* ceremony (for the recent dead) are related to the seeds sown by the Fox and Yasigi's cultivating and impregnating the earth and the plants with her own blood. Today when a *yasigine* dies her body is displayed dressed in skirts and adornments made of red fibers and it is greeted by all masqueraders before being transported to the cemetery.

Finally, the mask called *dyōnune* represents a "healer" or problem-solving specialist. The masked figure carries in one hand a carved wooden cup, an imitation of the pottery vessel in which healers macerate plants and useful ingredients. He also carries a flywhisk and walks alongside the masks during processions, plunging his flywhisk into the bowl and sprinkling the dancers and audience as soon as any disorder occurs. In addition he purifies the ground should any fibers fall or mask break. According to Dieterlen, the mask refers to Dyongou Sérou, one of the primordial ancestors who came down on Nommo's ark. Dyongou Sérou was the first healing expert. He tried to heal the antelope, *walu*, and as a result invented medicine. The wooden mask serves to express this accomplishment, and that he was the first human to die (Dieterlen 1989:39; Griaule 1938:552ff.).

Continuing with the theme of creation myths expressed through artistic means, Dominique Zahan (who worked later in the field with Griaule and Dieterlen) provides a fascinating account of a Dogon pendant, which he calls the "boat of the world" (1988:56–7) (figure 1.11). A perfectly round, free-moving piece of firestone (flint) sits in an ovoid space created by the opening up of a rod of iron. The stone, the "yolk" of Amma the Creator's egg, represents a summary of *yala* (images) of things and beings created by God. The ends of the original rod continue in an upward curve, ending in hooks curled toward the centre. This object, of high religious value, is suspended around the wearer's neck by a plaited leather cord. The iron "boat" with its four sections represents the four primordial ancestors of the Dogon who are the living equivalents of the four elements of water, fire, earth and water. As Zahan points out, there are many representations of the boat of the world, some far more ephemeral—traced or painted on the walls of rocks, sanctuaries or cult houses.

Dogon shoulder crooks (figure 1.12) also have cosmogonic significance. These intricately carved wooden objects are worn over the shoulder or carried by ritual thieves known as Yona (Roberts 1988:70–5). Roberts argues that they represent a critical moment in Dogon cosmogonic thought—"the 'original sin' of defiance of God (Amma) in the theft of a piece

of sun to bring fire to earth, an act of disjunction and transformation that would bring about the creation of human culture. Yona reenact this event in their ritualized theft of property at the death of one of their number." Roberts notes that the zigzag motif is frequently used in rock paintings and other forms of Dogon artistic expression to represent the descent of the ark and the transmission of knowledge and power from the elemental act of theft of a piece of the sun. The superimposed wooden figures with upraised arms (a common feature of many Dogon wooden figures) may suggest the transfer of knowledge from ancestral figures to priests. The unusual funeral practice for deceased Yona consists of blood from a sacrifice on the house roof of the deceased being conducted down a millet stalk to the corpse's chest. Similarly, in Roberts' opinion, the flow of blood may represent the zigzag descent of the ark and the imparting of vitality that this implies. He goes on to argue that the ritual thieves and emblematic crooks are an expression of the disjunction at the heart of Dogon philosophy. These tensions and contradictions are dramatized and negotiated both through the art and the storytelling.

DeMott is also interested in the significance of the patterns on Dogon masks (1982). She shows how the checkerboard arrangement (see figure 1.13) which is characteristic of many activities and aspects of Dogon culture, such as the layout of their fields or facades of their village structures, serves in myth as an image of the cosmic completion and the balanced order of human culture. The creative forces of Dogon deities are transformed into checkerboard patterns. She gives the example of the Nommo imparting the supernatural Word in the form of weaving to the human world. The spiralling threads that emerge from the Nommo's mouth are transformed into vertical warps and the horizontal wefts of his woven fabric which

Figure 1.11 Dogon pendant, Mali. After Zahan 1988:56. The pendant represents the creator Amma's egg and the boat of the world.

Figure 1.12 Dogon crook, Mali. After Roberts 1988:70, fig.1.

39

is revealed to humankind. The ordering of supernatural force in the human world is distinguished by its structure of interlocked horizontals and verticals (DeMott 1982:17–19).

The Creative Process

Turning now to the actual creative process, its vagaries and demands are believed to require special ritual and moral prescriptions on the part of the artist. For example, since artists in Benin are believed to work closely with their divinities or ancestors in creating, they must be in a state of ritual purity. This may involve sexual abstinence, bathing, or changing clothes after sexual contact (Ben-Amos 1986:61). Periods of incubation and quietude alternate with intense activity. Ben-Amos notes that among Benin artists this may occur in dreams. Yoruba artists list certain mental abilities as being essential to the creative process, viz. visualization, concentration, patience, as well as moral rectitude and cool-headedness (Drewal 1980:10f.; see also Drewal and Pemberton 1989:42). In Yoruba thought it is believed that Yoruba artists must possess the attributes of good character in order to create beautiful forms and to capture their essence, hence the importance of the well-known saying *iwa l'ewa,* or "essential nature is beauty" or "character is beauty" (see Abiọdun 1983). The special status of artists in many societies and their "strangeness" or "otherness" are attributed to their close relationship with the spirit world and with religious specialists. The Gola link a certain psychological type ("a person of special mind" or a "dreamer") through small signs of deviance: early talents, particular food preferences, and early spiritual leanings (d'Azevedo 1973a:323 cited in Kasfir 1987). After attempts to dissuade the child from an artistic career, the parents may then send him/her to be apprenticed.

In addition to moral and ritual prescriptions, knowledge of appropriate materials is essential. For example, the choice of wood requires knowledge of its physical properties as well as its ritual appropriateness. In the Ẹfẹ/Gẹlẹdẹ festival among the Yoruba, the image of the Great Mother Goddess, Iyanla, has to be from the *iroko* tree, for this tree is believed to be the abode of supernatural forces allied with the Great Mother and serves as their nocturnal gathering place. Before cutting the tree, the carver invokes the spiritual beings believed to inhabit the tree. He then performs an abbreviated divination ritual with kolanuts to determine the positive or negative response from the spirits. A sacrifice, such as of liquor or palm oil, may be offered to further assuage the spirit beings and gain permission to fell the tree. Fresh wood may be preferred over dried wood or other materials for spiritual reasons, since trees are living, growing entities. For instance, the Yoruba say that trees possess vital force or *aṣẹ* of their own. The trees used for the carving of Gẹlẹdẹ masks have a red sap, like blood, which runs just underneath the bark. So the act of cutting into the wood and metaphorically shedding its blood may be regarded as a sacrificial action toward the patron deity of carvers, Ogun (Drewal and Drewal 1983:262).

Asante craftsmen also propitiate tree spirits, believing that the three trees upon whose wood the carver chiefly depends, namely to make talking drums, stools and other objects, are all trees possessed by potentially vindictive spirits (Rattray 1969:5). The rites of propitiation further continue when the talking drum is completed, for the wandering spirit is invited to re-enter the material substance it once inhabited. The rites of consecration for the talking drum or stool thus transform these artistic creations into shrines for the dis-embodied spirits of the trees, as well as of the

elephant, whose ears form the tense membrane of the drum. The Anang carver rubs a sacrificed animal across the face of the completed mask (*mbop*) of the *ekpo* society. He prays that the wearer will have good luck and return for future masks and that his own future offspring will not have the ugly features that he has given the *mbop*[!] (Messenger 1973: 112–13).

The dangers involved in the creative process may extend to the whole community, as in the case of the Dogon, who believe that the dyeing of the fibers and carving of the wood for their Grand Mask is particularly hazardous (Griaule 1938:405). Every tree that is cut down to make a mask has to be propitiated. To this end a cowrie shell is buried with a prayer at the foot of the tree. Then a propitiatory sacrifice is made on an altar to masks; water from a family altar is poured on the trunk of the tree after a hen has been sacrificed there; the man who fells the tree dons a leather arm bracelet which has apotropaic qualities; he touches the trunk with it before cutting; a necklace (used by healers and believed to be a replica of that worn by the spirits) is employed in the same way.

Yoruba carvers, as well as other artists who make use of iron implements, make invocations and sacrifices to Ogun, the god of iron, before commencing their work (cf. Barnes 1989: 52,251–2). In fact, all carvers have personal or lineage shrines for Ogun, often close to their work area (Drewal 1980:11). The shrine is known as the site or "face" of worship (*ojubọ*) and iron implements, palmfronds, a cotton-wood tree and a white silk cotton tree are generally found there. The carver offers prayers and sacrifices to Ogun to ensure appeasement, safety and completion. He pours the blood of a cock as well as liquor and palm oil onto the shrine and on his carving tools. Anang carvers have a guardian spirit known as *obot uso*, a male spirit who inhabits a shrine placed in the corner of the house in which a carver works

(Messenger 1973:106–9). When travelling to another compound or village to work, he takes the shrine along with him in a special bag so that he may perform his daily worship. A common prayer before the shrine is: "*abassi, obot uso*, let whatever I touch prosper. Let me have many wives and children. Let my life be long. Let people come to me often for carvings." Certain food items will then be sacrificed. On special occasions, an animal may be slaughtered. The carver is careful to use his right hand, just as he does when he carves, in order to honor the deity. One only uses the left hand to outwit ghosts and witches, otherwise it is a gross social insult. The carver has to remember also to respect sexual taboos and to avoid carving on the day of the week that he was born, out of respect for *abassi*, but also out of fear of being wounded by his tools (as instigated by his guardian deity). It is for this reason that when a youth's apprenticeship ends with the construction of his carver's shrine, he is also given lengthy instruction on how the deity is to be worshipped. The apprentice in turn must offer expensive gifts to his instructor.

For the Yoruba as for others—and this is vital to emphasize—the process of creation does not cease after the carving and painting of an object. It is not uncommon for owners or caretakers to make aesthetic alterations over time, such as innovative designs, pigmentation or addition of decorative items. Twin memorial figures (*ibeji*) (see figures 7.9, 7.10) are one of the best examples in this regard, since there are ritual obligations to nurture them just as the departed children they represent. They may be washed, oiled, rubbed with various substances, such as camwood and indigo and adorned with jewelry, clothes (such as a cowrie jacket) and amulets. Many of these figures develop a fine patina with constant use.

It is in the arts of masquerading that the ongoing creative process is most evident.

A sculpted headdress is but one element in a complex ensemble of creative input from carvers, painters, weavers, embroiderers, tailors, dancers, musicians, and singers. In some cases the headdresses may not be seen apart from the costume, as in the case of the Egungun masqueraders who are believed to be "beings from beyond" (*ara ọrun*) (see figure 7.11). Another interesting example from the Yoruba is that of the Gẹlẹdẹ festival and masquerade tradition, where emphasis is placed upon borrowing cloth (see figure 5.10). Women express their moral support for the masquerader by loaning headties and wrappers. It is not their visual qualities that are primary but that "when they are combined with other cloths they form a variegated and voluminous costume of multiple layers and are thus testaments of female patronage" (Messenger 1973:18). It is not uncommon either for Gẹlẹdẹ masks to be changed by the application of new layers of pigments or the addition or alteration of attachments on the superstructures. These modifications are more often done by society officials or the families of dancers (Drewal and Drewal 1983:269).

The *bobongo* dance in Zaire provides an interesting case of ritual and mythical renewal (Mudaba 1982:282–5). Founded by an Ekonda man, known as Itetele, in the latter part of the nineteenth century, the unifying *bobongo* dance and cultural movement was viewed by the missionaries as subversive and dangerous on account of the association of dancers with Bontala, a deity associated with artistic inspiration. In other words, it was believed that through physical and oral performance, each dancer could recreate the original creative model, even mystically nurture, his own divinity. A 1950s ballet troupe (Ballet Congolais d'Alexis Tshibangu) drew on several of the initiatory elements of the *bobongo*

institution (ibid.:291).

The creation of the Dogon Grand Mask, mentioned above, which is performed every sixty years for the death of elders and the Sigi festival (a celebration of renewal), offers another good example of ritual and artistic regeneration. The mask is carved a few months before the ceremonies take place in each village (Brain 1980:192–3) (figure 1.13). After the ritual felling of the tree, the carving is supervised by men who attended the previous ceremony, sixty years ago. As the "snake" or long post is carved out of the length of the tree, an elder recites part of the myth referring to the discovery of the fibers by the First Men and the death of the ancestor in snake form. Black and red triangles are painted on the finished snake-pole and a grass bracelet is attached to its end.[2] The new and old posts are then taken to the cave where the old mask has been preserved for the past sixty years and placed next to it on the shrine. It is believed that there is a transfer of power to the new Sigi pole at the moment of sacrifice. When the initiates enter the cave for the period of retreat they are only permitted to wear a skin and leather sandals to recall the time before the invention of cloth when they wore skins and lived in caves. The initiates learn the Sigi secret language and the taboos of the mask. They watch the elders paint the mask with rice and red earth. The mask is made to touch their shaven heads, and then the painted wall of the cave. The red earth signs are removed from the mask, in conjunction with a sacrifice, and the same signs are reproduced in millet porridge. These signs are believed to become red magically, sixty years later at the next Sigi, empowered because the painting reproduces what the ancestors painted at the original shelter, and because it recreates a mythical action.

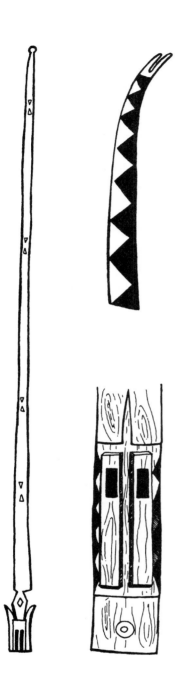

Figure 1.13 Dogon Grand Mask, Mali. After Griaule 1938: figs. 29,35,41. The overall shape of a Grand Mask is shown here. This particular one is nearly 7 metres tall. The details of another type of Grand Mask's extremities are also shown.

Patronage

The relationship of artists to their patrons is a complex one, but one which merits a brief mention here. While individuality or innovation may not have received the public recognition as did patrons or owners in many societies (such as on Muslim monuments [Vansina 1984:138]) and individual artists were and are glossed over (cf. Drewal 1981:36), it was still appreciated. In the introduction to a series of papers on patron-artist interactions in Africa, Paula Ben-Amos highlights the effects of the forces of supply and demand on the artist (1980). She also asks to what extent the patron is dependent on what the artist supplies. For example, in the Niger Delta area, Akwete cloth is used in nearly every Rivers ritual and so the relationship between artist and patron is an economic one which sustains the social and religious structures.

Sidney Kasfir provides a useful overview of the relationship between patronage, training and innovation (1987). She shows how a greater demand for art by patrons leads to the growth of specialist occupations, such as wood carving, as well as the development of apprenticeship systems. Where there are a variety of patrons who may compete with one another, artists may become itinerant or they may branch into other part-time specialist occupations such as divining, drumming and dancing. While patrons do exert an influence on an artist's style, artists have to deal with a variety of commissions. For example, in Idoma, Nigeria, where Kasfir conducted fieldwork, the ancestral mask cult was very conservative, secret and controlled by senior men, and did not encourage innovation, whereas the regulatory masking society was led by younger men's age sets who were more in favor of "modern" things.

In some cases, regulatory societies and mask associations (to be discussed in chapter four)

may be stronger patrons than royal courts (see chapter three). They may impose restrictions on artistic production. For example, the carvers of western Liberia who produce masks for the Poro (male) and Sande (female) associations are supposed to keep the commissioning and production of such sacred objects secret and are subject to punishment for producing any articles for the open market (d'Azevedo 1973b: 135). A carver may be supported by a wealthy patron, but is rarely full-time. Renowned independent specialists, whether carvers, dancers, story-tellers, singers or other artists, are popularly held to be conceited, arrogant and irresponsible. This is heightened in the case of those artists who claim spiritual sponsorship, who have a tutelary spirit. Such spirits may request food, entertainment and female companionship while at work on the mask in a secluded forest place.

This relationship of negotiation and accommodation, as well as secrecy and intimacy, continues until long after the production of the mask—whether in the naming of the mask or its proper treatment or payment. There are many tales of *zogbe* masks cracking or mysteriously bursting into pieces in front of horrified spectators. Such an occurrence will entail recriminations and propitiations (ibid.:147). Apart from local Poro elders, no other man such as the carver can move so freely in Sande circles. Blier maintains that it is geomancers in Africa, in their multiple roles as seers, consultants, therapists, medical practitioners, religious interpreters, and philosophers, and as intermediaries between the divine and human realms, who can exert such influence on the commissioning, formal features, symbolism, and placement of many forms of art (1988b:80f.). Ben-Amos argues that it is the gods and ancestors who are the ultimate patrons as far as many Africans are concerned,

commissioning, as we have seen earlier, their works through dreams and divination. Sometimes they are exacting with regard to the form of the work and punish those who do not comply. Yet, as both Ben-Amos and Aronson (1986) emphasize, dreams are an important source of creativity and allow for the introduction of new designs and negotiations with human patrons.

Concluding Remarks

As this chapter has sought to show, the whole question of artistic creativity is bound up with religious beliefs, individuality, patronage, community, as well as social change and economic factors. Divine inspiration is commonly invoked as the motivation for artistic expression and techniques, and patrons are often remembered or recorded rather than the artists. But we should not downplay the agency of individual artists or guilds. Some artists, notably blacksmiths, enjoy considerable status by virtue of the mystical forces they are believed to manipulate and the materials they work with. The next chapter focuses on the relationship between artists and the spiritual world by looking at the multiple representations and manifestations of the spirit forces and beings who are believed to influence the affairs of this world.

Notes

1 In his 1991b "restudy" of the Dogon, van Beek claims that much of Griaule's work was constructed and his picture of Dogon religion is unrecognizable by the Dogon today. His essay in *Current Anthropology* was critiqued by a number of commentators.

2 The *sirige* mask and the Great Mask share a similar form, the elongated vertical superstructure, and similar functions as *axis mundi* and an association with ancestral veneration. However, the Great Mask remains horizontal during the rainy and thus female-associated season (DeMott 1982:117).

CHAPTER 2 Envisioning and (Re)presenting the Spirit World

As argued in the introduction, the study of African art and religion is relatively young and still in need of continued reflection and debate. The area that we are about to discuss in this chapter—the relationship between art works and spirit forces—is one of the most challenging to take on, but it is central to any consideration of the interrelationship of art and religion in Africa. For these reasons, this chapter, more than any other, tries to sort out some of the scholarly debate on this subject, in conjunction, of course, with a range of examples and perspectives from the people who use and make the art. We shall be looking in particular at masks and masquerading traditions since these are commonly believed to embody supernatural powers. Carved figures, pots, altars, crowns, and stools, also feature in this chapter.

African art has long fascinated its observers —whether scholars, missionaries, artists or members of the general viewing public—over its purported capacity to embody spirit forces and empower its users and beholders. Such reactions derive, in part, from popular Western thinking which has generally over-emphasized animist and polytheistic notions within African thought. But it also stems from the commonly held belief in many parts of Africa that some, if not many, artistic forms derive from, depend on, and bring forth, spiritual forces. Western academics have often failed to do justice to this aspect of African art. Leon Siroto wrote an important essay in 1976 entitled "African Spirit Images and Identities," which unmasked the ways in which Western academic interpretation had downplayed the "very significant area of traditional concern with spirits" in favor of identifying figures as ancestors.[1]

Therefore, this chapter, to some extent, carries on Siroto's earlier work of reclaiming the "animistic" perspective in scholarship by seeking to understand the many ways in which art objects may be considered to make present, construct, or manifest aspects of the spirit world for humans, or simply remind them of it—or in Blier's terms, the difference between "actual" rather than "representational" power.[2] It also raises the intriguing questions of knowledge and imagination: in other words, how people choose to make visible that which is predominantly conceived as invisible.[3] Against the background of the contributions of literary and critical theory since the 1970s, the whole issue of presentation and representation defies simple, dichotomous interpretations, especially when local knowledge and socio-cultural context are taken into account.[4] It is a challenging area for both scholars of religion and art to understand, as evidenced by their avoidance of it or uncritical use of terms.[5] So the chapter begins by examining some of the important debates in this area before proceeding to examples which illustrate the

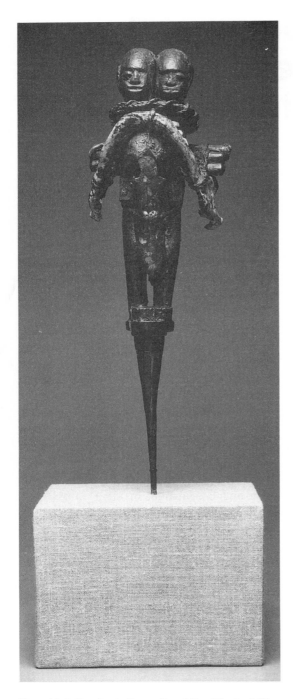

Figure 2.1 Fon *bocio* figure, Republic of Benin, 19th century. 49.45, Brooklyn Museum, New York, by exchange.

range of both iconic and aniconic forms which mediate between the human and spirit worlds. Attention will also be paid to the processes and media involved in (re)presenting powers held to be sacred, as well as the "periodicity of power," i.e. whether an object temporarily, gradually or permanently embodies supernatural power(s)— the contingencies of its ongoing career, as Mary Nooter Roberts aptly frames it (1994:40).

African art works are rarely believed to embody spiritual power in their own right; rather they must be activated in some way. It is frequently the act of sacrifice which turns a simple piece of wood into a powerful mask or statue, but it may also be activated or animated by an event or performance, the addition of medicines, herbal preparations, or accessories, or its (frequent) association with a person of ritual authority. This may be a one-time consecration or repeated ritual act. Many communities would say that the power of ritual objects increases with use over time. Suzanne Blier underlines the variety of interactive properties and means which are employed to activate or energize Vodun *bocio*, or empowering figural sculptures (1995:74) (figure 2.1). They are: assemblage; speech (and associated saliva); heat (in the form of pepper and alcohol); knotting (attaching or twisting); and offering (to a higher power or deity). Even the base form of the figure can be correlated with the source of the sculpture's underlying power and determine how often it is to be used. Works with pointed bases, driven into the earth, from which the trickster deity, Legba, derives his power, can only be activated once, in contrast to those with plinth bases. Blier is correct in reminding us that the activation of such works of art may involve multiple artists, agents, and audiences. This is evident in the various cases described throughout this chapter. However, Blier's and MacGaffey's work is particularly attentive to the artistic and

ritual processes, as well as attendant beliefs, involved in activating such objects.[6]

Before moving on, we should mention briefly two concepts related to our discussion of the embodiment of spiritual forces. The first is that of containment. Several works in the "Secrecy" exhibition staged by the Museum for African Art in New York are containers for hidden things (Nooter 1993:52). Some secrets, such as relics or powerful medicines, may be made known by a swelling or protrusion (usually in the stomach area), or by a mirror over a cavity in a figural sculpture. This is well illustrated in the 1993 exhibition, "Astonishment and Power" at the National Museum of African Art in Washington, D.C., on Kongo *minkisi* or "power figures" (MacGaffey and Harris 1993). Pots, too, as we shall see below, may serve as containers of spirits. Other secret forces or powers may be concealed as in the case of the protective and empowering breath of an ancestor which is held to be hidden in a Bemba figure (Nooter 1993:cat. 27). Accumulation, through the collage or assemblage of various materials, whether nails, cloth, animal skins, shells or bones (see figure 5.1), or in the form of chalk drawings (Rosen 1989), is also linked to containment, and the generation or presence of spiritual power. This is well illustrated in the case of the Kongo nail figures which are covered with metal blades or nails, intended to activate forces within (figure 2.2), and the ambiguous *boli* figures or altars of the Bamana, discussed in chapter five, with their accretions of initiatory materials (see figure 2.15).

The question of the links between aesthetic experience and the experience (awe, fear, veneration, mystification) of an object's credited "supernatural" powers is also relevant to our concerns in this chapter. Do they mutually enhance one another? This is well illustrated below in the discussion of Baule spirit-figures (see also Blier 1995). Rowland Abiọdun argues

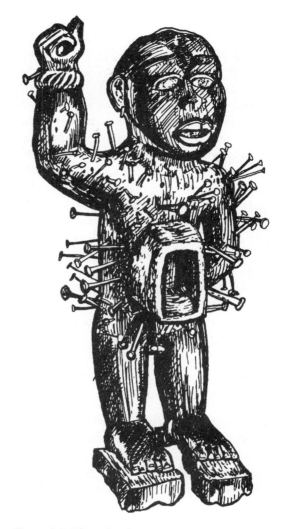

Figure 2.2 *Nkisi nkonde*, Kongo, Zaire. Stanley Collection of African Art, University of Iowa.

that *aṣẹ* or power is an integral part of the Yoruba aesthetic which triggers an affective response in the audience. Expressed either separately or jointly through the visual, verbal, and performing arts, *aṣẹ* imbues sound, space and matter with energy to restructure existence, transform the physical world and also to control it" (1994a). In the same vein, Robert Plant Armstrong preferred to coin his own term

"works of affecting presence" rather than "art," just as he believes that the nature of the aesthetic is better approached in terms relating to *power* than to *beauty* (1981:5f.). He distinguishes between works of "invocation," which are dependent on external power and are concerned with "managing the energies of this world," and works of "virtuosity," which are dedicated to the "management of the energies of their own internal systems." The latter require no special treatment, while the powers which infuse the first type are variable and subject to particular conditions. While the concern here is not to establish overarching theories or frameworks with regard to the artistic (re)presentation of the spirit world,[7] there is little doubt that the concept of power—its source, its significance, its control—is central to any understanding of the embodying, symbolizing, or transformational capacities of art in Africa.

Notions of Embodiment

An important corrective regarding prevailing uses of the notion of (re)presentation is issued by the French scholar, Lucien Stéphan (in Kerchache *et al.*:1993). He argues that the "naturalist primacy given to representation" orients any enquiry away from "granting use the importance it deserves" (ibid.:237). In other words, there is a tendency by some scholars to proffer "short-circuited" interpretations by moving from an object's association with power, to presupposing that it is an image or representation of that power, or even further to the power of the image itself. Stéphan prefers to substitute the question, *what does it do*, for the iconographic question, *what does it represent*, for an object is more commonly produced to act or cause action than to show in the sense of to represent (cf. van Beek 1988). He expresses this through the notion of "presentification" (first conceived by Jean-Pierre Vernant)—"the action or operation through which an entity that belongs to the invisible world becomes present in the world of humans" (ibid.:238). He further notes that this change in state in the entity may be due to its own initiative, to that of humans, or to a collaboration of the two. Hence, presentification is distinguished from representation because what is presentified and what presentifies it constitute one and the same being. Representation assumes the anterior presence of an object which does not belong to the category of invisible entities. The distinction may not always be clear but it is implicit in the expressions people use such as to animate (the object), to capture, incarnate, materialize, lodge, enshrine or contain (the spirit), vessel, receptacle, for the spirit to reside, etc. Even the term, symbol, if understood more in local terms, may include the notion of making visible and activating powers, as shown by Victor Turner for the Ndembu in central Africa (cited in Kerchache *et al.* 1993:241).

Centered as they are on usage, these notions of presentification and representation offer a distinction, but do not need to engender a dichotomy or alternative. For the same object may in one circumstance "symbolically" represent an invisible something, and, in another, presentify it. For example, an ancestral figure may represent a deceased person, but with the addition of magical substances, it is believed to become the true substance of that person and is accordingly given its own name. Another important consideration raised by Stéphan is that the transformation between worlds that occurs with presentification may be executed in both directions—from the invisible to the visible and from the visible to the invisible, as with a human being going to reside in the spiritual world at death. This two-way operation is very much the domain of ritual specialists.

Stéphan lists a number of examples where representation would be an inappropriate description, such as in the case of the Dan of Liberia and Côte d'Ivoire, who would not even say that the spirit resides in the mask because the spirit, with the help of a human, created the mask as its material manifestation (Fischer and Himmelheber 1984:8 cited in Kerchache *et al.* 1993:239). Often the names given to the masks convey their embodied status. The whole question of the mask being better suited to presentification than the statue will receive further discussion below. It also raises the issue of whether statuary and masquerades will necessarily predominate over painting in societies that give primacy to presentification, as Stéphan suggests (1993:248).

The attribution of personhood to ritual objects is addressed insightfully and critically by Wyatt MacGaffey in one of his many publications on Kongo *minkisi*, which are usually referred to in English somewhat problematically as "fetishes" (1990). These objects (discussed in more detail in chapter five) are particularly relevant to the concerns of this chapter, as they appear to the European mind to confound the distinction between persons and objects. They are fabricated and yet may be invoked to produce desired effects, have a will of their own, and may influence human behavior. MacGaffey perceptively suggests that instead of asking why Africans fail to distinguish adequately between people and objects, we might reverse the question and ask why we make such a dubious distinction. The answer lies partly in the realization that thingness and personhood are culturally constructed. Western tendencies toward commodification in the modern world obscure the memory of the divine power medieval Christians attributed to relics of saints. In the case of the *minkisi*, their personhood derives from their internal composition (medicines)

Figure 2.3 *Bateba* figure, Lobi, Burkina Faso. Stanley Collection of African Art, University of Iowa. These figures serve as intermediaries between the human and spirit worlds.

Figure 2.4 Mossi mask, Burkina Faso. Stanley Collection of African Art, University of Iowa. The wooden mask is worn with a fiber costume to represent spirits that appeared in the form of wild or domestic animals.

the *nkisi does*, i.e. punishing and inflicting misfortune, than to the appearance of the empowering spirit. In other words, it represents the relationship between the spirit and victim. In any case, the Kongo would say that spirits and souls have no appearance until they are put into or adopt some outward semblance (see figure 2.2).

Along similar lines, Piet Meyer's study of art and religion among the Lobi of Burkina Faso (1981) emphasizes the importance of situating our understanding of particular figures within the overall Lobi cosmology. The supreme being is invisible and unreachable, but the *thila* or spiritual beings, who are also invisible, may manifest themselves temporarily in animals, objects, and shrines. Some of these beings are responsible for the moral well-being of particular human groups. They communicate through soothsayers and may request people to complete shrines, install objects, or make sacrifices for them. The Lobi carve figures or *bateba* (figure 2.3) which serve as inter-mediaries between the *thila* and humans. In some areas, the *bateba* have ancestral status. But Meyer argues that it is more helpful to keep the Lobi term, *bateba*, since translations ("statue") tend to detract from the belief that these are living beings—from the moment they are placed on a shrine or surrendered to a *thil*—who combine human appearance with superhuman qualities. They are made to look human, often through hairstyles and tattoos, so that they can be active in the world of humans and save them from misfortune and witchcraft. The *bateba* who fight witches generally have grim and aggressive faces. In fact the Lobi refer to the *bateba* as persons or children of the *thila* for they belong to and work for these spiritual beings in the same way as humans do for their parents. Unlike the *thila*, the *bateba* have limited functions and can die if their bodies deteriorate or they are neglected.

which, in turn, lays obligations on those who come in contact with them to treat them as though they were persons. It also derives from the KiKongo world "in which material things were not set apart in an objectivity alien to human subjectivity" (ibid.:58). Echoing the arguments adumbrated in the preceding paragraphs, MacGaffey emphasizes that the physical appearance of a *nkisi*—raised threatening spear-arm and perhaps a pro-truding tongue—corresponds rather to what

Many of the confusions expressed by observers of African art over the relationships of art objects to the spiritual or supernatural powers they are believed to (re)present derive from the influence of Near Eastern religions with their preference of the word over the image and the abstract over the representational (Goody 1993). But Goody wants to suggest that the iconoclasm and aniconic ideology of Islam and Christianity, as they affected African art, raise the wider philosophical problem of making material images of the immaterial divine. First, the creation of images may appear to duplicate the act of creation itself; second, it raises the specific issue of how to put the immaterial, the spiritual, into "human" form and the need to establish a point of contact with the divine which may be of an anthropomorphic kind; third, there is the special situation of representing not just the creation but the creator. The virtual absence of representations of the Supreme Being is to be noted across most of Africa (see Mudiji 1990:259f.). Goody is concerned to show, however, that the reluctance to create representations of divinities, as well as the uneven distribution of cultures that produce any form of three-dimensional images points to the presence of aniconic, even iconoclastic, attitudes in Africa. So Western societies are not unique in this regard even if they are more explicit.

Masks and Metaphysics

It is the area of masking that has generated the most discussion regarding the question of spirit representation and embodiment. The idea of the "mask" is infused with European assumptions of disguise and pretence (Napier 1988; Jedrej 1980; Pernet 1992). Masks are complex symbolic objects, reversing what is normal, i.e. people are normally visible and spirits are not

(hence their common use in rites of transition, such as initiation and death) (Jedrej 1980:225f.; Bentor 1994). The stylistic reversals in masks (such as slit or projecting eyes and mouths) and accompanying super- or non-human costumes (figures 2.4, 2.5) make them believable as spirits (Ottenberg 1988a: 78). Masks are also ideally suited to condensing and redistributing power (Tonkin 1979, 1988), and for treating

Figure 2.5 Kuba/Bushoong mask, *nyata a masheke*, Zaire. Stanley Collection of African Art, University of Iowa. This mask was used at funerals of the ruling elite. The hybrid nature of the mask, with its part human and animal and natural attributes, conveys the supernatural power of the character impersonated.

51

fundamental oppositions, such as the differences between men and women. Their association with ambiguity, paradox and irony enables them to serve as "agents of ideology" and provide symbolic stategies for dealing with social change (Jordán 1993). Masks are widely used in Africa and, because of the element of disguise, some form of transformation of the identity of the wearer is assumed by outside observers (Cole 1985). David Napier, writing as philosopher and anthropologist, argues that as outside (Western) observers, we are intellectually limited in trying to understand or express the ontological or metaphysical transformations that may be said to occur when people don masks in other cultures (1986, 1988). We are prone, he argues, because of our Cartesian heritage, to resort to the fundamental distinction between body and soul or inner states and outward manifestations. The word "mask" conjures up ideas of falsehood and imitation, rather than the development of an incarnated figure or *persona*, as it is in many other cultural contexts. Part of the problem, he continues, also lies in the reluctance of anthropologists to tackle psychological issues (cf. Ottenberg 1988a). Yet the very ambiguity of the masking process lends itself well to shifts away from empirical judgement about what constitutes personhood.

Masks, because of the reasons outlined above, play an important role in many parts of Africa in mediating between the human and spirit worlds. But this role can only be understood if the masks are situated as part of a larger, dramatic event where particular kinds of experience are created, and boundaries between audience and performer may, through mutual interaction, be dissolved or reinforced (Tonkin 1988). This is well demonstrated by the Igbo scholar, Onuora Ossie Enekwe (1987: 76f.). He dismisses the idea that beliefs in the supernatural powers of masking have to be subordinated for a performance to be enjoyed as theatre. Rather, he highlights the interplay of the supernatural, mimetic, and display elements as crucial to a successful masked performance. The powers of the masks are activated as much by the human skills of the performers, and by contextual factors such as music and dance, as by the various sacrifices and rituals. Dramatic feats are linked to concealed charms and medicines, and the dramatization of the invocation and emergence of masks from anthills or underground holes makes it all believable for the spectators. Even if aesthetic appreciation appears to predominate at the conclusion of a successful performance, failure would be treated as a matter of communal concern because of the possible calamitous repercussions from the spirits or ancestors.

This concurs with Ottenberg's observation about the ambivalent attitudes among Afikpo masked dancers and audience in eastern Nigeria (1975:11f.). Although women are quite aware who the players are, they do not reveal this to the men. They may make gifts to their men in recognition of a fine performance. This is not addressed directly but the men know what is meant. Women do, however, fear the dancers because of their association with the powerful secret society spirit. Any contact with the latter is believed to cause infertility. Men know who the *mma* or spirit manifestations are, but they also fear the spirit of the local secret society, and so adhere to the various ritual prescriptions and sexual taboos, and will not remove a mask during the performance no matter how hot or uncomfortable they become. Sieber (1977) argues strongly against any use of the term "idolatry" in the African context. There is no confusion as such between the object and what it (re)presents, which is what idolatry connotes. Ambivalences may occur as

evidenced by some of the examples in this chapter, but there is an awareness, notably at the level of the elders, of the mechanics of its production and its anterior status as a piece of wood, for example.

We should now try to examine more closely the notions of mystical transformation associated with masking, and the capacity of masks both to reveal and conceal spirit forces. The moral and metaphysical question of what happens when someone puts a mask on is lucidly explored by John Picton in his study (1990) of masquerading traditions of the Ebira people who inhabit the area immediately southwest of the confluence of the Niger and Benue rivers in Nigeria. He is careful to point out that the redefinition of a performer's identity may even occur prior to, and is therefore not always dependent on, the wearing of a mask. Picton describes how, even when a masked performer (*eku*) removed his mask when visiting houses, he was still addressed by the name of the mask and consulted for its oracular and healing powers. In that respect he was no longer himself, but still himself— occupying space that belongs to that other realm of existence, that of the dead. By virtue of this liminal status, not because of the mask or some inherent force, the performer is empowered. He also notes more generally that Ebira masks varied in whether they seemed to derive "meaning" from iconographical matter and accoutrements or the context of the performance.

Drawing on Jedrej's (1980) enumerations of the differing relationships between performer, mask, and identity in performance, Picton constructs a helpful four-part typology which is "concerned with questions of identity that may or may not be created when someone puts on a mask within one of the essentially pre-colonial traditions of sub-Saharan Africa" (ibid.:191). The first type is when the mask effects a

difference between performer and audience, but not necessarily a metaphysical transformation. The second type covers masks that both effect dramatic distance and deny human agency. In Picton's words: "[t]he mask, with its costume and accoutrements, is the acceptable face, so to speak, of something, a power, an energy, a metaphysical presence, otherwise too dangerous to see" (ibid.:192). Not only does this re-identification involve secrecy (not necessarily about knowledge but more about time and place of discourse, in other words more for dramatic than ritual purposes), but also danger and rites or sacrifices may precede or succeed the performance. In some cases, possession is involved as for the Yoruba *egungun* (see figure 7.11) masqueraders whose swirling, multi-layered costumes are believed to embody the ancestors. In contrast to the two previous types of mask, there are masks which are held to be "the literal embodiments of metaphysical energy, or presence, or 'spirit'" (ibid.:193). Secrecy is less of an issue here since the mask reveals rather than conceals. The embodiment can be either permanent (as in the case of the masks of Dan forest spirits in Liberia) or temporary (such as the *ekine* water spirit masks of the Kalabari).

Picton suggests, with some caution, that when the concern for secrecy is minimal then the iconography of the masks will be more elaborate. The fourth type of mask is very different from the others in that it looks like a mask but is used differently as regalia of kingship or initiation, for example, and may be worn on different parts of the body or not at all. Picton emphasizes that these mask-types are not "self-contained categories, but . . . functional polarities distributed along a four-part continuum" (ibid.:195). He also introduces a historical dimension to his model deriving from his analysis of Ebira masks, by showing how there is a movement from masks which

deny human agency and stress ancestral presence to ones which emphasize display and entertainment. This "secularizing" trend is observable elsewhere. However, it is less uni-linear than might be assumed, for as Picton demonstrates, there is also a movement from the second to the third type of mask in that masks which have their own inherent healing potential embodied and developed through medicine and sacrifice tend to survive as independent metaphysical entities despite the declining abilities of performers.[8]

The historian of religion, Henry Pernet, has been particularly critical of the prevailing tendency in the West to assert that masks represent spirits. In his book *Ritual Masks* (1992), he takes the example of the Dogon, maintaining that "to explain Dogon masks by merely affirming that they represent spirits would amount to biasing the facts from several points of view, most seriously by overlooking that the masks represent the cosmos and the events that made it what it is" (Pernet 1992:62). He describes how neighbors of the Dogon, such as the Bamana, also employ a series of masks to relate and dramatize the history of the universe. Bobo leaf masks follow the movements imprinted in creation as a whole and serve to maintain its rhythm. The massive *ijele* mask of the Igbo of Nigeria (up to six meters tall and three meters wide) with its layers of figures and animals is a tableau of the mythic, historic, and daily life of the community. For Pernet, therefore, "the equation masks = spirits does not do justice to this complexity" (ibid.:66). Furthermore, he argues that the majority of figures depicted in masks are primordial beings, culture heroes, mythical ancestors, and gods (Pernet 1987). These figures are contextualized as well as represented. The labelling of them as spirits or spirits of the dead results in part from a lack of precision over the definition of "spirit."

In his chapter on "The Ritual Mask and its Wearer," Pernet examines more closely the ethnographic literature on the theory of "actual transformation" in masking. He argues that this theory results from persistent Lévy-Bruhlian notions of the "primitive mentality" which characterized "primitive man" as unable to distinguish between the thing and its image, the signifier and the signified. Pernet dismisses the metamorphosis theory—that putting on a mask entails a real transformation—by high-lighting terms, such as those used by the Dogon, that express the idea of reproduction or image. He further argues that it is generally only noninitiates that believe masks to be spirits or gods, and that the elements of trickery and deceit involved are eventually revealed to initiates. Even the noninitiates are often not "deceived" by masks and masquer-ades which underscores the ambiguity of Lévy-Bruhl's position. Pernet points out that even Mircea Eliade, who subscribed to the "primitive mentality" thesis, introduced a note of doubt in the introduction to his *Myth of the Eternal Return (Cosmos and History)* (1958) by suggesting that the wearer of a mask became another, *only in appearance* (Pernet 1993: 119). Some authors have tried to overcome the contradiction between illusion and transforma-tion by claiming that possession occurs with the wearing of the mask. Pernet points out, however, that possession is not a logical consequence, and is not always present in masking traditions.

Pernet's concern to correct the notion that all masks involve some mystical transformation is both understandable and helpful. He is not denying that masks may be held to be charged with forces or powers that may come from the materials used, sacrifices performed, events or figures represented, or from spiritual beings or powers. He lists several examples, in this regard, of how the mask may be treated as an

altar, and receive offerings and special treatment.[9] Pernet ends up in the same place as Picton by proposing a continuum for understanding the relationship between the wearer, his mask, and the power, event or spirit represented. This ranges from "the simple dramatization or a character or a mythic narrative to a possible 'actual transformation' of the wearer, including a number of cases where the 'supernatural' power or element is present, completely or in part, in the mask, its accessories or the costume" (Pernet 1993:134). Both Picton's and Pernet's work highlights the problem of trying to find a general theory of masks. Such generalizations can give vent to persistent Western ideas of and nostalgia for difference and primitivism.

Sidney Kasfir charts a course through this debate by demonstrating that masks can mediate between *both* ritual and play, rightly insisting that it is more illuminating to view masks as "vehicles of transformation" than as unique, three-dimensional artifacts (1988:5).[10] African societies possess many mechanisms and processes through which transformation is effected, whether spirit possession or reincarnation. It has been noted that there are similarities between the faces of the possessed and some masks—the former being the domain of women and the latter of men (Kramer 1993:162f.). Body painting, for example, also serves to transform the body image and replace it with something more liminal but less secret. It is often used as part of female initiation ceremonies, providing an aesthetic and ritual separator but without "usurping the usually-male privilege of transformation from visible person to visible spirit/invisible person" (Kasfir 1988:5). To endorse further this important idea that embodiment must be seen more holistically, we could turn to the Mende. They do not have a separate word for "mask" itself as for them the distinction of mask, costume,

human being and headpiece would contradict the notion that the masked figure is an *ngafa* or spirit (Phillips 1995:51). Ruth Phillips illustrates this from her early fieldwork when she tried to see just carved headpieces of the Sande Society, but was told in no uncertain terms that only the complete and correctly garbed maskers could appear—for who would appear without their head?

Furthermore, over-emphasizing the role of masks may obscure the fact that sound rather than appearance may be the most important element of some masquerades. Described as "acoustic masquerades," they use instruments made of animal bones and membranes to create "mask voices" and disguise the human voice (Lifschitz 1988; cf. also Poppi 1993, Enekwe 1987:81). These "other-worldly" sounds are considered to be associated with, if not manifestations of, spirit beings. The sound which emanates from behind the *ukara* or patterned indigo cloth (see figure 3.9) of the temple of the Ekpe or Ngbe secret society among the Cross River peoples of Nigeria and Cameroon is more feared as the site of the leopard spirit than the various elaborate and more public masquerades which represent the different grades of the association. Acoustic masquerades generally appear at night, as in the case of the Sapo people of Liberia. (Indeed, the timing of many West African masquerades at night points to the masking qualities of darkness [Tonkin 1988:243].) The masker does not cover his face, nor dress in any elaborate or concealing fashion. He may wear a white cotton wig, signifying judicial authority. Among the Sapo and other peoples of the region, the visual maskers are referred to as "dressed" and the acoustic masks as "naked." Regarding the nature of the sounds, it is interesting to note that secondary sounds may be added to the primary sounds to create a reverberating or buzzing effect, connoting spirit or ancestral

presence. Having established the range of possible interpretations of the relationship between masks and spirits, we can now move on to the intriguing question of why people give the visible forms they do to the invisible forces they experience.

Visualizing the Spirits

Many African cultures have developed a rich and imaginative array of visual forms—statues, carved posts, altars, stools, pots, textiles, as well as masks—to give substance and life to the spiritual world (this is not to deny that artistic forms may serve other purposes also), in ways that allow humans some measure of conceptual access, communication, and control. In this regard, Isidore Okpewho (1977:306) is critical of the tendency to label some forms of African art "abstract" as this tends to detract from the fact such figures are "the artist's vivid portrait of an ancestral or genial presence" or "vivid elements of a people's living myth." They constitute the artist's endeavors to strike a "just balance" between his/her limitations and his/ her knowledge of the real, or how the spirits are or how they look. As will be seen in the cases chosen for discussion below, namely Baule nature spirits and spirit mates, and the Yoruba thunder divinity, Ṣango, the images vary a great deal in whether they are considered to portray, idealize, or allude to the gods and spirits. In contrast to many European artists, African sculptors generally do not seek verisimilitude in their figures, mainly due to the common fear that likenesses may have magical power (Kramer 1993:194). Some sculptors may even seek solitude to avoid unintentionally incorporating the face of a living person. The reason given by the Bobo as to why they do not use anthropomorphous masks is because human survival depends on receiving the gifts of Dwo, the intermediary

Figure 2.6 Baule nature spirits or *asie usu*, Côte d'Ivoire. Stanley Collection of African Art, University of Iowa. It is quite common for the female figure to be larger than the male in this type of sculpture.

between Wuro, the creator, and human beings. The latter must renounce arrogance—the arrogance of duplicating the divine creative act—in order to receive this beneficence (Le Moal 1980). But it is important to note that there are some societies which never developed

"any tradition of elaborated images that were vested with inherent powers" such as the Asante of Ghana. Tom McCaskie attributes this in part to the conceptualization of the *abosom* or gods/spirits as being evanescent like the wind and difficult to "capture" because of their capricious wills (1995:108f.).

Wande Abimbọla, a major exponent of Yoruba thought, reminds us that each *orisa* or divinity in the Yoruba pantheon is believed to have its own separate identity and existence independent of any images through which it is represented.[11] By turning to the ancient texts of the Ifa divination corpus, he argues, this is made more clear. There we learn that the divinities originally came to earth in human form, but then departed. People looked for objects closely associated with them (e.g. medicine may be made from garments and footprints), and these developed into artistic representations. These forms derived their power from frequent use and contact, and by association with a particular individual (nearly half the Yoruba gods are held to be apotheosized humans) or office. This also illustrates well the "slippage" between notions of presentation and representation. The image of the deity or *ere orisa*, once ritually consecrated can no longer be criticized. It is held to be (increasingly, with use) the locus of the deity's power, but is not the deity itself. The Yoruba know that images are not unique and can be replaced. There are many other forms of invoking the deities, such as through divination, sound, dance and drumming.

Nature spirits and spirit mates

The Baule peoples of central Côte d'Ivoire carve human figures to represent two types of familiar spirits that may be diagnosed by a diviner as causing problems for an individual. These figures illustrate well the links between aesthetics and beliefs about the spirit world (Ravenhill 1994). The first kind is the nature spirit or *asie usu* (figure 2.6) (Vogel 1980). These spirits are believed to inhabit untamed nature and natural phenomena. They are either male or female, with personal names, life histories, and spouses. Those who have reportedly seen them in the forest describe them as "immoderate in appearance," as either hideous or beautiful, and often with feet turned backwards.

Dramatic possession by these spirits is an indication that an individual should become a spirit medium. Not all clairvoyants are requested by their spirits to carve figures, but those that do will "feed" them, so that many exhibit sacrificial encrustations of blood believed to make them more powerful. Figures which are put on public view to enhance the medium's sessions are more likely to be clean and painted than those that are kept in private rooms. The attractiveness of the carved figures is believed both to tame the nature spirits' harmful impulses and provide a locus where they can be contacted and appeased. The extravagant features of the spirits are not deliberately reproduced, rather they are made to look beautiful in order to lure and civilize the spirits. In return, the spirits dictate through dreams to the diviner, carver, or client, their preferences for choice of wood, form, posture, and decoration, such as wearing a beard or carrying a baby.

The second type of Baule figure is carved to represent the "mate" a man or woman had in the other world before coming to this one. These spirits are called *blolo bian* ("man from the Other World") and *blolo bla* ("woman from the Other World"). Women have male spirits and men have female ones (figure 2.7). Everyone is believed to possess such a spirit, but only those who have troubles caused by them must create a shrine to their spirit mates.

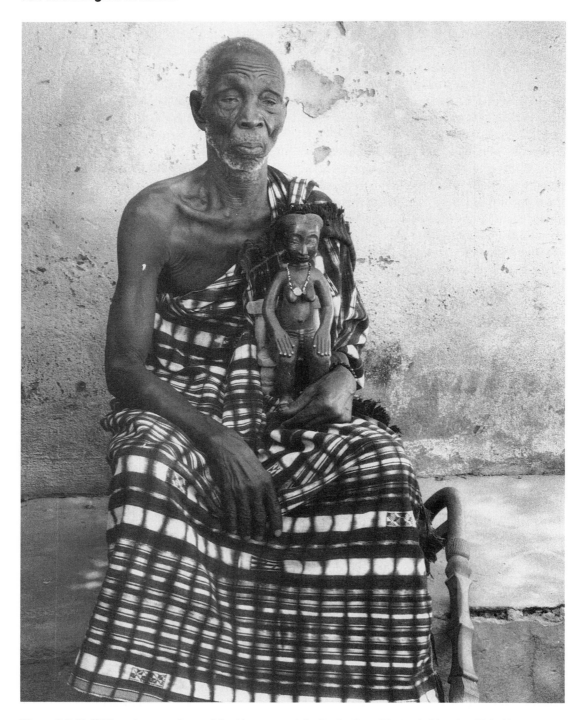

Figure 2.7 Koffi Nianmien, a sculptor of the Aitu group of the Baule, Côte d'Ivoire, holding his *blolo bla* or "other-world woman" of forty years' standing. Photo: Philip Ravenhill, 1981.

Problems are often, but not exclusively, sexual—infertility for a woman (women are predominantly blamed for this), or failure to retain women for a man. One night a week is reserved during which one "sleeps" with the spirit and has intercourse in dreams. It is through dreams also that the spirit mate dictates how it would like to be portrayed. In the course of the relationship, the surface of the figure may be modified through ritual cleaning, applications of oil, kaolin or paint (Ravenhill 1980:7). The spirit partner may even ask for a new figure to replace one it is dissatisfied with.

There is a general sense that the figure has to be beautiful (elongated neck, downcast eyes, clearly delineated facial features, composure, dignity, strong calf muscles—for both men and women—and ample pelvic circle and breasts in the case of women alone) in order to be efficacious in "presentifying" and placating a spirit. The miniature idealized figure is said to "bring down" or "create" the invisible mate in tangible form—rendering it present both "here" and "there" (Ravenhill 1994:27). Baule critics speak favorably of figures resembling a "village human being," connoting the physical and moral qualities of a social, orderly, and productive life in the village, as opposed to the disorder and extremes of the forest. As Susan Vogel (1980) emphasizes, some knowledge of Baule concepts of good and evil, which are more situational and not as absolute as in Christianity or Judaism, for example, is crucial to understanding Baule aesthetic choices and judgements, which are predicated on ethical values as much as they are on more formal, visual qualities.

Philip Ravenhill's study of these other-world lover figures addresses some of the gender differences, as well as developments in this type of sculpture (1980, 1993, 1994). He discovered, after four years' observation of the art market in the town of Bouaké, that male statues outnumbered female statues by a ratio of at least five to one. He attributes this to the fact that other-world lovers are more problematic for women than for men, which is linked to the fact that women cannot escape the problem of sterility. The relation which exists between an other-world person and the spouse to whom she/he is linked may be adversarial, or at least contrastive. Male figures tend more often to be clothed, and, more recently, in modern dress, suggesting that women employ more social criteria in their selection of spouses in the contemporary situation. Such fashion statements also point to the responsiveness of the Other World! Ravenhill is interested in the fact that of all the divinities and spiritual agencies, it is only the Other World mates and nature spirits that are seen and represented in such personal, human terms, and treated with such respect. He considers this to derive from the active, volitional aspect of their nature (1994:35). The creation of the form serves as a material recognition of the existential personhood of these spirits who choose to impinge on human existence (ibid.:45).

A more extensive study of nature spirits has been conducted by Martha Anderson and Christine Kreamer in their book *Wild Spirits, Strong Medicine* (1989:46f.). Their study provides an idea of the range of possible forms of embodiment and representation of one type of spirit. They list the various ways in which, and reasons people give for which, nature spirits are believed to materialize. It is not all spirits that request physical embodiment, but those that do may even specify the forms they prefer. According to some peoples, spirits can be more easily influenced when given visible form. Among the Baule, Senufo (also Côte d'Ivoire), and Ijo (of the Delta region of Nigeria), for example, it is held that more idealized representations placate and tame the spirits. Deformities and abnormalities, while

Figure 2.8 Dan *tankagle* mask, Liberia. Stanley Collection of African Art, University of Iowa. This type of mask is used in entertainment masquerades. Its slit eyes are considered feminine, and it was worn with a cape, cap, and enormous fiber skirt. The mask in general is believed to be the medium through which spirits communicate with humans.

spoken of verbally, are not depicted. If they are, as in the case of the Lobi, it is to connote their exceptional or dangerous status. Other spirits are represented by non-figurative objects—receptacles or medicines, for example. These are more closely examined below. It is important to note that neither form nor aesthetic appeal reflect the power associated with the spirit. Anderson and Kreamer note that elaborate cults have developed for spirits embodied by ordinary pots, sticks, or imported dolls. The most important spirits of the Poro Society generally manifest themselves only by sound. The masquerade representations of nature spirits tend to be more unflattering and realistic, as compared to those depicted in figures.

Given the "other worldly," i.e. beyond the world of humans, provenance of many of these spirits, the channels of communication merit examination. Dreams are one means whereby spirits are believed to determine the manner in which they should be manifested and sustained (Fischer 1978). The Dan people who inhabit the hinterland of Liberia and the Côte d'Ivoire believe a type of bodiless spirit inhabits the forest and difficult, mountainous terrain. Dan spirits have names, personalities, and definite characteristics, and generally prefer to be part of the human world. For this reason, the spirit will appear in a dream to a sympathetic individual, requesting her or him to be responsible for its manifestation. In return, the spirit may furnish its human friend with divinatory powers, animal strength or political influence. The spirit dictates how it should be manifested and sustained—whether as a bundle of fur, horns or shells or as a "mobile, living manifestation," namely a mask. It is the wooden face masks that are held to really embody the spirits, even if they are not actually worn (figure 2.8). The masks are believed to be alive and people say that they can be heard gnashing their teeth. They receive sacrificial offerings even when the spirit has not revealed itself to a masker, and it is kept on a mat within a family home. In times gone by when warriors sacked a village, they always sought out the masks before burning the houses as they wanted to capture the helpful spirits embodied in the carvings.

The Dan use words to describe their masks—*ga* in the north and *glo* or *gle* in the south—which roughly translate as "awesome being." Because the masks are considered to be forest creatures their clothes are made from forest materials, such as raffia and cords, feathers, furs, and animal fangs. They also have animal names, and in songs the masker may be compared to wild animals or birds. But, as Fischer emphasizes, it is the combined effect of the colors, the movements, the type of equipment, the size of the orchestra, the songs and music styles, which informs the spectators at festivals of the nature and status of the spirit-

incarnate. As a mask becomes older, and hence more powerful and respected, it can be promoted to be the spirit-mask of a village section, where it then acts as judge and peacemaker. To reflect this change, a mustache may be added and the costume and headpiece of a more senior mask may be adopted. In the past, the large and powerful masks possessed great reputations and only emerged for important ceremonial occasions. In the 1970s, Fischer states that these masks continued to be used to judge cases that could not be handled by modern laws, such as at initiation ceremonies. The whole range of mask types and the spirits they embody address virtually all human concerns, whether education or entertainment, war or peacemaking. They also symbolize the interactions between male and female, and between the worlds of the village and the forest.

These issues are further explicated by Charles Jedrej in his comparison of Dan and Mende masks (1986:74f.). Dan masks provide examples of ritual reversal in that they permit normally invisible forest-dwelling spirits from the forest to appear in the village, the world of humans, while people disappear into the forest to undergo changes in their being. Mende spirits, on the other hand, do not become visible through being provided with embodiment by someone, but are described as being pulled out of concealment into view in their pristine state. Yet having left their underwater, forest abode for the village, they perform among humans only with reluctance and impotence. The Mende masks and masked figures, which are viewed as mere copies of the originals, the spirits, possess none of the life-promoting powers which the Dan attribute to their masks. The Mende masks appear generally in town at the mortuary rites, when the spirit of the deceased is said to be going "beyond the water" to the land of the dead.

Most of the Mende masks lack anthropomorphic and zoomorphic qualities, in contrast to the Dan masks. The latter are more human in appearance as they are supposed to operate effectively between humans and their affairs. Both Dan and Mende masks are intended to conceal the wearer of the mask and the costume, but Jedrej argues that the:

> Dan masks develop ontologically and typologically in a direction that makes them less mask-like and more magically potent, so that the most powerful masks are seldom worn, seldom used as masks at all, but, as taboo objects and therefore highly ambivalent, have themselves to be concealed (ibid.:77).

The Dan masks are less associated, therefore, with events, than with legitimating the social and judicial authority of the chiefs who possess them. They begin as simple masks formed in the liminal zone of the initiation camp, but become highly potent objects after being inhabited by otherwise impotent spirits. It is thus that they become incorporated into the daily life of the Dan, in contrast to the Mende masks, which come from outside society, either as the result of a "legendary extraction from the forest" or as the historical result of a commercial transaction with some distant community. Figure 2.9 shows a Poro *goboi* masked spirit, which is believed to be an embodiment of the medicinal substances or *hale* found in the bush (Phillips 1995:53). Jedrej surmises that Mende masks have evolved toward representing rather than embodying the spirits, and that this could be linked to the history and migrations of Mende society over the last 450 years.

Aquatic spirits are generally held to be more attractive and benevolent than their dry land counterparts in many parts of Africa. As in the case of Niger Delta masquerades, they may combine the features of animals, fishes and

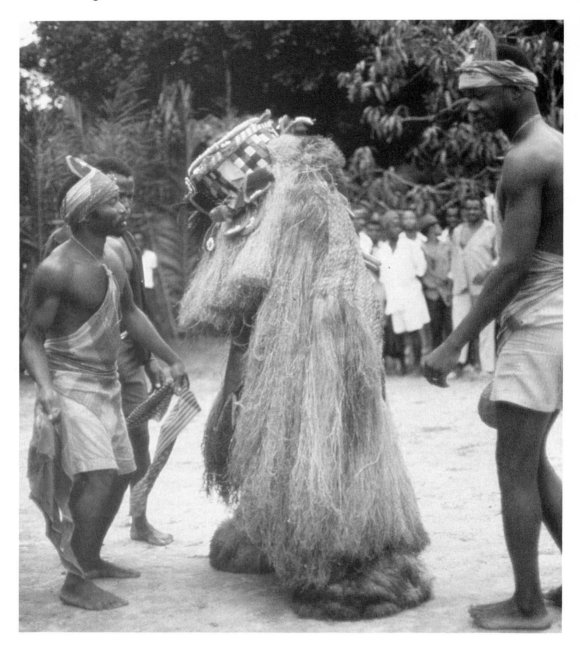

Figure 2.9 *Goboi* masquerade and attendants, Ibangema village, Jaiama-Bongoi chiefdom, Mende, Sierra Leone. Photo: Ruth B. Phillips, 1972.

humans, and, as part of the performance, emerge from and return to the waters from whence they are believed to originate. Olokun is god of the waters for the Edo of Nigeria and his primary symbols—mudfish, pythons, and chalk—come from the riverbank, that liminal

zone where earth and waters meet (see figure 6.1). Often water spirits are believed to accumulate great wealth in their underwater kingdoms, and their masquerade costumes reflect their riches and predilection for fine things. The costumes are often white, denoting their aquatic origins. Imported goods and novelty items adorn the shrines of many water spirit cults, such as the widespread Mamy Wata cult. In addition to the history of foreign contact in the coastal areas this seems to underscore the perceived relationship between Europeans and these spirits. Mamy Wata shrines receive more discussion in chapter six, but it could be added that the more recent artistic representations have been influenced by a German chromolithograph of a female Indian snake charmer which circulated in West and Central Africa at the turn of this century (Drewal 1988a). This image proved popular in Africa, as it bore the features of local water spirits—beauty, snake-handling powers, seductive and fashionable clothes and adornments, and a lighter skin complexion denoting watery and/or foreign origins. Margaret Thompson Drewal suggests that this image, which has served as a model for the work of many contemporary artists (see Salmons 1977), be considered a portrait since it is seen by many artists as a "photograph" of Mamy Wata under the water. It constitutes a visual construction of Mamy Wata's reality, thereby serving as a focal point in shrines or festivals (M.T. Drewal 1990:42f.) (plate 1).

For the Chamba who inhabit the border of Nigeria and Cameroon, masks constitute important representations of the wild (Fardon 1990:151f.). They are composite creations in which the wild predominates. The distinctive, bulky form is created by a huge wooden head and layered fiber costume, which conceal the human wearer. The mouth and horns appear as projections in a single plane added to a cranial dome. So the mask head looks like a human skull with added animal characteristics, in other words an aggregation of the dead and the wild. This is further reflected in the names that some of the Chamba groups give to the mask. The masks most readily resemble bushcows, because of the horns; although the mouth is like that of a crocodile. Informants also say that the masks represent founding ancestresses of the owning clan. Women and bushcows are both "animal donors of substance" (ibid.:156). The masks are stored outside the village and enter to dance, particularly for rites of passage such as chiefmaking, circumcision or festivals for mourning and remembering the dead. The relationship between the mask and its custodian suggests a delicate balance between human authority and the forces of the wild. Richard Fardon argues that it is both the anomalous and exemplary nature of the image which lends it its power. As a human-made anomaly that enters the village from the bush, combining the features of the dead and the wild, it exhibits an ability to cross boundaries. Yet it is also exemplary in that it visibly demonstrates, in its composite form, the disparate qualities that coexist in all areas of Chamba life—the living, the dead, and the wild.

The case of Ṣango

Deities in sculptural form are another of the most obvious illustrations in many people's minds of the relationship between art and religion. Statues representing deities who protect those who work in the field of art or crafts, such as the Igbo deity, Ifẹ Nwe Nka (Ikenga Metuh 1985:5), perhaps epitomize this relationship. Ṣango, the deified fourth king of Ọyọ, in western Nigeria, offers a fine example of the range of imagery that may be associated with a particular divinity. As John Pemberton rightly states: "For the art historian, the variety

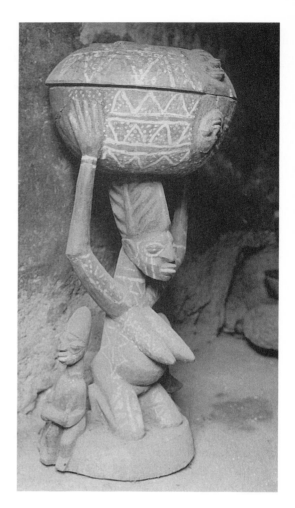

Figure 2.10 Ṣango staff, ọṣẹ Ṣango, Yoruba, Nigeria. Stanley Collection of African Art, University of Iowa. This is a dance wand carried by a devotee of the thunder deity, Ṣango.

Figure 2.11 *Arugba Ṣango* on Ṣango shrine in Odoode's compound, Ila-Ọrangun, Nigeria, 1977. Carved by the elder Fakẹyẹ, *c.* 1930. Photo John Pemberton III.

of sculptural forms and the richness of iconography as well as the oral poetry associated with the worship of Ṣango may be Ọyọ-Ile's greatest legacy to the history of Yoruba art" (Pemberton in Drewal *et al.* 1989:156). The following discussion draws on Pemberton's excellent account of the verbal and visual imagery of the Ṣango cult within the context of the Ọyọ empire. This lasted from about 1680 to 1830 during which time the

myths, rituals and iconography surrounding Ṣango played an important role in legitimating the king's (or Alafin) political power and authority. There are many myths surrounding Ṣango's reign and death. Some accounts portray him as a tyrannical leader, who was dethroned by his people and then went and hanged himself. His supporters learned the art of causing violent thunderstorms, and claimed it was his vengeance. He was declared to be a

deity who required sacrifices and an appropriate priesthood. Another version recounts how, in playing with magical powers, he inadvertently caused a great storm to occur, killing all his wives and children except his wife, Oya. In disgrace he left the capital and hanged himself. These and other myths convey the sense of ambiguity about the power of Yoruba kings, and the dangers of an excessive desire for power in human beings more generally.

A Ṣango festival offers a "conflict of imagery." The praise singer recites poems (*oriki*) that convey the god's fiery temper, capricious behavior, and destructive power, while the carver's *oṣe* or dance wand portrays a woman kneeling in "quiet supplication before her lord, effortlessly balancing upon her head the twin thunderbolts of Ṣango" (ibid.:162). The Ṣango worshipper must suffer the unpredictable behavior of their deity, who hurls down his ancient celts with fearful lightning in the midst of thunderstorms:

> The dog stays in the house of its master
> But does not know his intentions
> The sheep does not know the intentions
> Of the man who feeds it.
> We ourselves follow Ṣango,
> Although we do not know his intentions.
> It is not easy to live in Ṣango's company
> Rain beat the Egungun mask, because he
> cannot find shelter.
> He cries: "Help me, dead people in heaven!
> Help me!"
> But the rain cannot beat Ṣango.
> They say that fire kills water.
> He rides fire like a horse.
> Lightning—with what kind of cloth do you
> cover your body?
> With the cloth of death.
> Ṣango is the death that drips to, to, to,
> Like indigo dye dripping from a cloth.[12]

Ṣango, too, is believed to descend to the world of humankind and possess his worshippers. He is the giver of children and protector of twins or *ibeji*. The *oṣe* Ṣango or shaft with double axehead (figure 2.10), already signifies the deity's vital force, although the dance must activate the possession trance and actualize the deity (M.T. Drewal 1986). However, it is the priest as mediator who is represented in the dance wand, not the deity. The twinned celts represent the priest's inner spiritual reality with Ṣango's power imbedded in the head and emanating from the top. The head of the Ṣango priest has been prepared with power substances to stimulate possession. Distinctive female hairdos (shaved to the crown and braided down the back) worn by Ṣango priests convey the idea of swelling which is a way of describing possession trance. The fact that it is mostly women who are depicted in the *oṣe* further signifies the special role women play as nurturers of the gods. The sculpture symbiotically relates the deity and priest in the same way as the trance performance. There is a wonderful case of ambiguity and transference here—as the deity is represented/presented by the object/priest. Margaret Thompson Drewal further points to the fact that the priest carries the dance wand in her left hand since this indicates a visitation from the spiritual realm. In fact, lefthandedness in ritual both establishes and suggests spiritual communication more generally among the Yoruba.

Another sculptural form associated with Ṣango is a bowl carrier or *arugba* Ṣango. It depicts a seated or kneeling female figure, holding a large bowl above her head (figure 2.11). The bowl contains Ṣango's thunder celts and portions of kola nuts and other offerings which form part of the weekly sacrifice to the deity. She may carry in one or both hands a cock for sacrifice to her deity (*not* in this figure). Pemberton describes the iconographic

interest of a particular *arugba* figure (not the one depicted here), carved by Areogun (Drewal *et al.*, 1989: fig. 169). The embossed faces on the front of the bowl and its lid are touched by the devotee, when making sacrifices to Ṣango, with her or his forehead, as well as by a kola nut or sacrificial offering. The figures are painted with dark indigo coloring for in an Ifa verse the suppliant is instructed to desire to be colored "black," which connotes the possession of the deep and hidden knowledge of Ifa. It is like looking into an indigo dye pot whose depths cannot be seen. Other carved figures represent persons offering rams to the deity. A series of triangular shapes along the edge of the bowl recall the tassels of the large leather bag or *laba* carried by Ṣango priests to transport the celts or thunderbolts.

Being a Ṣango devotee is both burdensome and empowering—just as Ṣango's power may destroy as well as give life. Evidence of the deity's power, *aṣẹ*, is found in the bowl on the woman's head, a metaphor for her womb. Her graceful power and composure reflect the attributes of the Ṣango worshipper. Pemberton emphasizes that just as the visual imagery of the bowl carrier draws on the verbal imagery of Ṣango songs, so in the ritual context, there is an important interplay of verbal and visual imagery. He sums this up as follows: "Art and ritual coalesce, creating a universe of experience and a distinctive sensibility" (ibid.: 163). In essence, the Ṣango worshipper is acknowledging the creative and destructive aspects of human action. Margaret Thompson Drewal notes that in western Yorubaland during Ṣango festivals large sculptures are placed in basins containing the vital force of particular deities (1986:61). They are then placed on the heads of priestesses who will transport them to a nearby stream to collect water and herbs. As the bowls are placed on their heads, the priestesses fall into trance, reinforcing their mediumistic role.

Contemporary Nigerian sculptors continue to carve figures which represent traditional deities. Some renowned examples include the massive thirteen-feet high Oduduwa statue, by Lamidi Fakẹyẹ, which was commissioned by the University of Ifẹ (now Ọbafẹmi Awolọwọ University) (cf. Okediji 1988b). Also, figures of the thunder deity, Ṣango, have been carved by Ben Enwonwu, as well as Fakẹyẹ. Enwonwu's Ṣango, bursting with raw energy, is prominently displayed in front of the Nigerian Electrical Power Authority's (NEPA) building in Lagos. Traditional attributes and symbols of power are evident, expressing mythical and cultural identity. As Fakẹyẹ himself remarked, the religious aspects have been lost because of the nature of the context and the commission.[13]

Susanne Wenger, the Austrian artist who has lived and worked in Oṣogbo, Nigeria for many years, is concerned to convey that the "Yoruba Heaven, metaphorically and unsurpassably alive, represents just this ever-fluid, ferociously vital rhythm of a material world that is spiritual essence" (Wenger and Chesi 1983:226). Her shrine sculptures, discussed in chapter six below, are intended to create a "home for the gods." Her batiks are a major aspect of her creative work and deal predominantly with Yoruba mythology. She provides a vivid description of one particular batik representing Ọbatala, the god of creativity and molder of all human bodies. The evocative nature of her narrative and the fascinating and vibrant complexity of the batik representing her own patron deity seem to result in a blurring of the boundaries between presentation and representation. Several of the artists who work with Susanne Wenger in Oṣogbo, such as Adebisi Akanji, famous for his large openwork screens of cement, Asiru Ọlatunde, who does aluminium and copper repoussé panels, and Buraimoh Gbadamọsi, who has created many

shrine figures, depict the history, religion, and daily life of the people of Oṣogbo, as well as the Yoruba myths more generally (Kennedy 1992:62f.). Akanji and Gbadamọsi are both Muslims, but also belong to the Egungun cult or cult of the ancestors.

Ancestral Figures and Symbols

As stated at the outset of this chapter, the earlier tendency by Western scholars to view African sculpted images as predominantly ancestral (cf. Vogel 1988:2) has been criticized by Siroto (1976).[14] He does suggest, however, that such an interpretation may derive in part from a desire to redeem African iconography from the stigma of animism to the more ennobling (and less threatening?) belief in deceased family members (ibid.:8f.).[15] But images which are considered by Western observers to depict particular dead persons may in fact be images of tutelary deities. This is the case, for example, of the Dogon, for whom ancestors play a minor role (cf. van Beek 1988:91, n.6). An alternative explanation may lie in an actual overlap in practice between ancestors and minor deities. In her study of Akan terracotta heads, for instance, Michelle Gilbert argues that confusion has occurred as to whether they are representations of gods or ancestors precisely because "there is a built-in ambiguity in the context of use that is not apparent from the lexically discrete terms" (1989:41).

While there will be further discussion of ancestral art in chapter seven on death, there are some examples which are highly pertinent to notions of embodiment and representation. The Igbo carve Nkwu Mmo or statues of ancestors, generally for lineage groups (figure 2.12) (Ikenga Metuh 1985:15f.). The Igbo say that a particular ancestor (usually someone who had achieved high status and recognition) makes known through divination his desire to

Figure 2.12 Ancestral figure, northern Igbo, Nigeria. After Aniakor 1979.

be "born again" into the family, i.e. through a carved image which will be placed in the lineage house. This belief means that the carver is seen as a "midwife" who makes it possible for ancestors to be reborn (Aniakor 1979:18). An Nkwu carver must have been called by the *agwu isi* or deity of divination and initiated into the cult of the deity in the same way that diviners and medicine-men are. Chike Aniakor describes the art objects produced by these

special carvers as bearing the hallmark of "ancestral legitimation" in that they have a collective and unchanging image—a static and impersonal aloofness—reflecting their "generative force" over time, in contrast to other more aesthetically pleasing Igbo art forms. The carver, rather than carving, searches through the wood for the forces within or in the "depths" (ibid.:22). Furthermore, these "expressive icons," as Aniakor terms them, are not subject to the same aesthetic evaluation as other art objects such as masks or *ikenga* figures. In fact, Aniakor maintains that these ancestral figures may only be understood in terms of Igbo thought:

> Their incarnation in wood fulfils that aspect of Igbo notion of reincarnation shown in a cyclic view of life. Just as men take titles, become the authority symbols of the living, and die to reunite with the ancestral dead, so also do the ancestors return to the living as art objects whose external symbols lend an authoritative voice to the affairs of the living (ibid.:24-5).

For the Asante it is not figural representations but blackened stools which are the most powerful symbol of the ancestors (figure 2.13) (Sarpong 1971). But perhaps more than representing the ancestors, they provide an earthly home for departed rulers and receive regular offerings. They are like shrines in that they are supposed to have powers of their own, but unlike the shrines of various deities they cannot reveal things or communicate messages. They do not have a priesthood as such. Sarpong poses the important question: why is a seat chosen to be a shrine of the ancestor? One reason concerns the taboo on a ruling chief—who is not allowed to come into contact with death in any form. So the stool-house becomes the substitute for the mausoleum, the stools taking the place of the corpses. But why not choose the chief's

Figure 2.13 Asante stools, *Mmarimadwa* and *Osramdwa*, Ghana. After Sarpong 1971.

sandals, rings, crowns, palanquin, swords, cups, etc.? The answer lies in the material from which the stool is made. The wood comes from a tree believed to be the abode of a powerful spirit who may still come and inhabit the carved stool. So in that regard the stool constitutes the ideal object to prepare for the spirit of the deceased chief to come into. Furthermore, a stool is the only object that may provide rest to the spirit of a dead person. The living chief derives his authority from the blackened stools—from the moment of his accession up to the time he dies or is destooled. As to why they are blackened, there are various explanations which range from preservation and durability, to black being a suitable color for the ancestors, and creating awe in the beholder. The stools are blackened ceremonially with a mixture of kitchen soot, spiders' webs, and eggs. The web signifies the wisdom of the ancestors and the chief's potential to subjugate troublemakers just as spiders may ensnare their prey. The egg portrays the peaceful nature of the stools.

Beyond Masks and Figures

It would be wrong to assume that masks and figures are pre-eminent in terms of embodying spirit forces. In the case of the Omabe masking tradition within one northern Igbo community near Nsukka in Nigeria, a being (or group of beings) known as Omabe and associated with the justice, peace and welfare of the community is believed to be present not just in the masquerades but also in objects of a non-material nature (Ray and Shaw 1987).[16] The shrine complex located in each village is also considered to be the "mouth" of Omabe. Offerings take place on the earthen mound there and music, another form of embodiment, is performed there. But it is the ritual objects and sacrificial materials, first buried and then distributed among the Omabe priests, that signal the arrival of Omabe in the community from the underworld via the sacred forest, and not the emergence of the masquerades. Localized deities are also believed to be manifest in figures known as Onumonu. They appear with ritual objects—a bundle of ritual materials consisting of wads and long strips of cloth, congealed sacrificial matter, feathers and loops of copper—on their backs which are clearly distinguished from the masked figure. In fact the medicine is also known as Onumonu and embodies the deity, transforming the bearer, who carries it, from human being to spirit. He falls down mute, his movements controlled by the deity and his perceptions extended beyond the normal. Yet because he is "conceptually separable" from the Onumonu which turns him into a spirit, he is able to discuss his experiences unlike the bearer of a masked spirit.

Keith Ray's and Rosalind Shaw's study is important for the way it highlights the links between masquerades and medicine, and suggests that "medicine is both a primary and

Figure 2.14 Yoruba crown, Ila-Ọrangun, Nigeria. After Drewal *et al.* 1989:pl.37.

69

Figure 2.15 *Boli* image of cow form, Bamana (probably San region), Mali. 1979.206.175, Metropolitan Museum of Art, New York. After Brett-Smith 1983:48.

premier source of spiritual power" (ibid.:659). It is not just an impersonal force, outside the category of "religion," as some anthropologists have argued, but rather a means of producing new forms of religious expression. Picton has also demonstrated the importance of medicines in enhancing and developing the power of masked performers (1989:91). Indeed, he argues, the medicines can take over the mask such that the mask becomes a power-object. What characterizes the medicines is the metaphorical relevance of the ingredients, which is "actualized by appropriate ritual." After they have been roasted and ground down, they may be applied to the headpieces of certain masquerades. An accumulation of substances is an indication that a particular mask is efficacious in healing. The medicines also serve to protect the wearer and fend off trouble for "[e]ntering a costume is entering a space proper to the dead themselves" (ibid.:92). Yoruba crowns may also possess a medicinal package. It is attached or sewn to the top of the crown and may be concealed under heavily beaded decorations, or disguised as a bird motif (Abiọdun 1989a:2) (figure 2.14). The king's authority and vitality are closely linked to this tuft or package, and the wearer must never see

its contents. In some cases, mask and medicine are coaxial and codependent forms of power. The female masked figure, which is believed to be an embodiment of the Sande women's society's particular spirit in Mendeland, is also viewed as a personification of the society's medicine or *hale*—which empowers and legitimizes it. The medicine is also collected in the rivers where the society's spirit is found (Phillips 1993:234).

The significance of substances is strikingly illustrated in the case of the large Bamana sculptures or *boliw*, whose most important magical ingredients are hidden in the center of a thick black coating (Brett-Smith 1983). These imposing sculptures depict cows, human beings, or round solid balls (figure 2.15). They are unappealing to Western collectors because of their unpleasing appearance, but they are the most sacred objects for the Bamana. These "metaphorical stomachs," as Brett-Smith describes them, derive their terrifying power to judge and execute from the fact that "they assemble in one dense, compact object the poisons the Bamana most fear, namely the human and animal excrement used to create their exterior shell" (ibid.:50). Their mysterious and secretive power is further enhanced by the fact that they are sequestered in the sacred grove and only seen by high-ranking elders of the secret society. As spirits, they transcend and control the uncontrollable desires of men. But the extraordinary power of the *boliw* lies in the way in which they reverse normal processes by putting the poisonous feces on the outside and their "skin" in the form of a wrapped cloth on the inside. Since such cloths are linked to childbirth, the sorcerers who construct such objects are thereby appropriating the most fundamental characteristic of women—the right to produce and control life. Such sexual transgressions are both empowering and threatening and so must be kept from public view.

We turn now to pots as containers of spiritual forces. Despite the fact that making pottery is as significant a medium of art as the metalwork or woodcarving which are the province of the smith, and is just as central to African ritual and religious observance, the potter does not enjoy equal status (Herbert 1993:ch.8). In fact, potting, which is frequently dominated by women, is an even more ancient art. In many parts of Africa, pots accompany people from the cradle to the grave—serving as the vessels in which to bury the placenta or to contain the spirit of the ancestral dead. But they do more than just symbolize life cycle changes: they are in many cases equated with people—in the widest sense, to include ancestors, nature spirits, and divinities. The pots may actually contain spirits, whether permanently or temporarily in certain ritual contexts. This complex and fluid interaction between the spirit and human worlds may be indicated by anatomical decoration, such as breasts, or through socially and culturally constructed markers. As Eugenia Herbert observes, "if pots have the potential for becoming people, it seems hardly surprising that women should produce them" (ibid.:213). However, she cautions against assuming a "natural" relationship between women's procreativity, potting, and the deified Earth. In some cultural contexts, the perceived danger of like to like, i.e. human reproductivity may imperil potting, and vice versa, results in ambivalent attitudes and negotiated terms of participation.

The Mafa and Bulahay of northern Cameroon provide an example of how a special relationship is conceived between pots and persons, with analogous decorations (David *et al.* 1988). For these peoples of the Mandara Highlands, millet is a staple food. Understandably, several of their pots are decorated with representations of millet. In fact, millet is considered to be a powerful spirit, capable of hiding grain from sorcerers, or even killing the latter. Millet bands, or appliqué pellets, as motifs on sacrificial pots have a definite apotropaic function, to protect the stored grain. But both the Mafa and Bulahay believe that pots can be used to trap spirits, or when ritually closed, to hold them. Some pots are made with bars across the mouths for this purpose, whereas others are kept sealed. David *et al.* surmise that the decoration of the pots does not merely protect the pot and its contents from external powers, but it serves to set up a "ritual boundary to protect the weaker from the stronger—whether the dangers emanate from the inside out or the outside in" (ibid.:374). Interestingly, the authors go on to consider why certain motifs are absent on certain pots. For instance, pots that represent male ancestors or portray aspects of the supreme being, Zhikile, are not held to need protection. Zhikile pots (figure 2.16) may be placed strategically around the compound to fend off harmful natural and supernatural forces. But as the authors suggest, "Power. . .must be able to flow through them; insulating decoration would be counterproductive, if not futile"

Figure 2.16 God pot or *Zhikile*, Mafa/Bulahay, northern Cameroon. After David *et al.* 1988:369, fig.3.4.

Figure 2.17 Dangme stone altars, southern Ghana. After Quarcoopome 1994.

(ibid.:375).[17] What is interesting about these various pots which are believed to contain spirits is that they are generally the most elaborately decorated ones and are more likely to be hidden from view (Sterner 1989). But even the less decorated domestic pots may be put to "sacred" use after being discarded.

The Yungur of northeastern Nigeria, like other peoples in the area, also make anthropomorphic ceramic vessels to contain ancestral spirits (Berns 1990). These pots or *wiiso* are more than depictions of their subjects—the meanings they carry are linked to their "active role in constructing and maintaining the world in which the Yungur live." They contain the spirits from which the creator god, Leura, is said to create new life. Women play a key role here in that they are the primary producers of the pots which facilitate the transformation of the dead into spirits and as mothers they perpetuate the lineages. Yet, in her study of these pots, Marla Berns notes that female ancestors are generally absent in the *wiiso* shrines (as they are in the public domain). She further indicates that the pot-person linkage also derives from the manner in which people,

particularly chiefs, are buried—in ceramic tombs before their spirit becomes embodied in another. It is also linked to the way in which Yungur chiefs manipulate and control the pots, affirming their social power and dominance, before they too undergo the transition to ancestral status. An interesting point to note is that even when people move away from a particular area, the precincts of pots which remain behind are considered to be a source of power and a suitable location for making oaths.

Turning to aniconic forms believed to contain sacred power, stools, thrones, and shrines offer some salient examples. Nii Quarcoopome has shown how, for the Dangme of southern Ghana, an important emblem of power, such as a throne or altar, does not have to have an elaborate form, precisely because it conceals communal and ancestral secrets (figure 2.17) (1993). In fact it can take any form, such as a carved wooden object, a rock, or a human skull. The stool's physical form serves only as a focus of ritual. In Quarcoopome's words: "it provides visual metaphors for the stool's nonvisible qualities" (ibid.:116). These innate powers are known as *hewam*, and combine with taboos, ancestral oaths, and the more tangible, physical components such as herbs, animal or human relics, and other natural substances, to effect the stool's consecration. The stool is always concealed in darkness, adding to its efficacy, and is ritually bathed once a year. Quarcoopome is careful to point out that the stool is not believed by the Dangme to contain the soul of any ancestor, but rather to embody ancestral secrets and values, which have been verbalized upon it in the form of spells, curses, blessings and aspirations by generations of rulers. The ruler is able to appropriate for himself part of the object's essence by coming into contact with the relic. Similarly, the rectangular or cylindrical stone throne, a distinctive attribute

of the Dangme priest-kings, kept in a shrine near the entrance to the sacred room of a Dangme deity, is viewed as a shrine structure which is a repository of a secret. This secret is a combination of herbs, which, when combined with other herbs, can serve to focus or channel a spiritual force on the shrine. As Quarcoopome emphasizes, "[t]he shrine is therefore only an occasional point of contact with a spirit or deity, not its abode" (ibid.:117). We should note that stone thrones have been associated with theocratic styles of government in Ifẹ and other parts of Africa.

Some further examples drawn from the realm of kingship illustrate well how regalia may convey the sacredness of the king's person. The crowns worn by Yoruba kings, discussed in chapter one, would be relevant here. Andrew Apter, in his rich analysis of ritual power among the Yoruba (1992:101ff.), describes the importance of a calabash, borne by the high priestess of Yemọja during the latter's festival to the king's palace in the Yoruba town of Ayede. The calabash is held to contain the concentrated powers of kingship and symbolize the welfare of the community in the form of water drawn from the grove where the deity dwells. Its decorative symbols—a beaded fan (connoting kingship and the identification of the Yemọja priestess as a female ritual king), red parrot feathers (signs of witchcraft power and public disaffection) and royal velvet cloth—are charged with subversive, antithetical power whose meaning is hidden from public interpretation. The king's revitalization involves both death and rebirth, at the hands of the priestesses of Yemọja, goddess of fertility. The calabash is wrapped in a white cloth of ritual composure because its contents are so "hot." It has to remain intact, and its water, like the cult secrets, never spilt or leaked, thereby representing a whole, healthy town, whose fragility and power are regulated by the cult. Apter reminds us that Yoruba sculpture often depicts women presenting calabashes as an extension of their healthy, pregnant wombs.

Akuapem kings of southern Ghana are believed to straddle the worlds of both the living and the dead (Gilbert 1993). Their regalia, whether stools, staffs, or ornaments, must both display and conceal the king's ambiguous powers. They are a metaphor for kingship itself, as in the case of the umbrella, which always covers the king, promoting spiritual peace and "coolness." It is likened to trees which give shade to his people and hence to the protective function of kingship itself (ibid.:139, n.7). His costume and regalia symbolically remove him from ordinary space and conceal his ordinary mortality. They also reveal the greatness and sacredness of his power which is linked to the mysteries of the royal ancestors. Stools—which we already looked at above in reference to the embodying of ancestors—are commonly used as artifacts among Akan peoples in Ghana to express the powers and mysteries of leadership. Some are never sat upon and some may be turned on their sides at night to prevent wandering spirits and ancestors from using them (ibid.:132; cf. also Sarpong 1971). Particular stools may be held to contain the king's soul or *kra*. Gilbert makes the important point, however, that to understand the sacred powers of the king, one must also focus on his functionaries who attend him at important ceremonies, and who are seen as extensions of his person. They may be spokesmen who carry staffs, drummers, executioners, or soul people (*akrafo*) who share the king's destiny—symbolized by the large repoussé or cast-gold disks around their necks.

Abiọdun notes the Yoruba preference for an abstract form such as a cone to symbolize the important philosophical concepts and ideas (ọrọ) which make up *Ori-Inu* (literally "inner

spiritual head") and to distinguish it from its physical counterpart (1987). It is believed that *Ori* provides the *aṣẹ* or authority to make all accomplishments possible and that the tip of the cone symbolizes the location of *Ori-inu*'s *aṣẹ*. The *Ori*-symbol, or *ibori*, made of hide, cloth, and cowrie shells, is kept in a conical container, or *ile-ori*, except during consultation or propitiation. In addition to echoing the beaded crown or visual symbol and vestment of an *ọba*'s *aṣẹ*, verbal images convey the similarity and importance of the physical and spiritual heads. In Yoruba figural art more generally the head is rendered unusually large in size and is often elaborately decorated. Abiọdun argues elsewhere (1989b) that this attention to hairdressing and hairplaiting among the Yoruba, and the need to honor and beautify the *Ori-inu*, point to the respected status of women. For it is the river goddess, Oṣun, who is in charge of the profession of hairplaiting/dressing. Hence she is believed to have the power to influence the destinies of humans and gods. Most of the deities depend on Oṣun for their power, thereby enhancing the status of women more generally.

To conclude on the rich theme of kingship, Sidney Kasfir (1991) creatively juxtaposes Idoma kingship and masking, revealing their parallels—both "wear" symbolic power, employ many of the same colors, symbolic designs and materials, and share the same metaphors, metonyms, and analogies to describe them. For example, both kings and ancestral masks use red and yellow cloth with triangular or concentric lozenge patterns. The triangular pattern in particular is understood by the Idoma to represent leopard spots, and in fact is a major metaphor, both visual and verbal, of royal authority and ancestorhood, across the Niger and Benue valleys, as well as the Cross River region and the Cameroon Grassfields. There is another interesting parallel in that the

Idoma say the "king is like a woman" because both are believed to be imbued with secret knowledge and supernatural powers which may be both dangerous and beneficial. Kings and women are subject to taboos because of their life-giving forces—associated with rain and crops, and menstrual blood and procreativity, respectively. The king even dresses as a woman on important ceremonial occasions—in a manner analogous to certain transvestite masquerades—to reinforce the belief that he is no longer like other men, and is not human but supernatural. The king is also considered to be ritually "dead," like the ancestors—his funeral is celebrated as part of the installation rituals. So, like the masks, his status is marked, separated, but still liminal. Only when he is physically dead does he become, according to Kasfir "the precise equivalent of a masquerade."

Concluding Remarks

This chapter has attempted to present a more nuanced, yet far from exhaustive, overview of questions and manifestations of spirit embodiment and representation in African art. We have seen how complex the subject becomes when one necessarily takes into account the range of beliefs, ritual practices, experiences, forms, symbols, aesthetic devices, accoutrements, mediators, as well as historical and socio-cultural factors.

In conclusion, we may briefly note how the influence of Western buyers and museum curators may be revealing in terms of these issues. For example, it was reported at the beginning of this century that the Fang of Gabon readily sold their reliquary guardian figures but steadfastly retained their (irreplaceable) family skulls as relics (Siroto 1976:16). So the figures served more as "points of contact" or as means of dispelling threat-

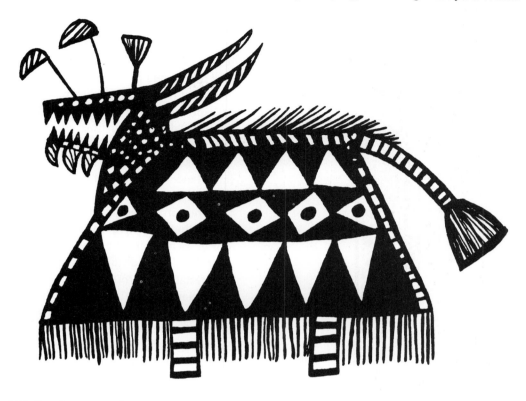

Figure 2.18 Senufo masquerade, *nassolo*, depicted on cloth sold to foreigners, Côte d'Ivoire. After Laget 1984.

ening forces. If the village were attacked, it was the relics that were sought rather than the guardian figures. Masks associated with secret societies and initiation rites are normally excluded from public viewing, yet representations of some Senufo masquerades, such as the Nassolo—a buffalo-like mythical animal— appear on cloth which is sold to foreigners (Laget 1984) (figure 2.18). But the Senufo designers say that the buyers are only interested in the aesthetic aspect of the cloth, and that a graphic representation of a symbol is not sacrilegious since the power of the mask resides in its actual presence. The decontextualizing of objects in the museum context has naturally raised questions about loss of authenticity and disempowerment (see Nooter Roberts 1994). Yet the staging of the Museum

of African Art's "Face of the Gods: Art and Altars of Africa and the African Americas," curated by Robert Farris Thompson, demonstrated how objects could (re)discover "life" in a museum setting because of the responses of both visitors and artist-practitioners.[18]

Once one begins to probe the depths of the question of presentation and representation of the spirit world in African art, one is also struck by the shortcomings of Western perspectives on the subject, notably the inflexible duality of much Western thought. Its over-discriminated and undefined categories of body and soul, and mind and soul prove logically inconsistent and are not borne out in practice. So, in this vein, David Parkin (1981:22) believes that it simply makes more sense for the Giriama to address

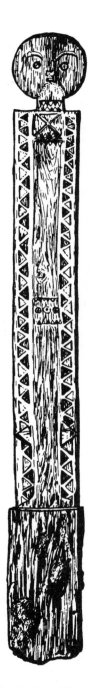

Figure 2.19 Memorial effigy, Ghonyi, Kenya. 84.1857, Hampton University Museum, Hampton, Virginia. After Zeidler and Hultgren 1988:146.

and think of the wooden memorial as the ancestral spirit rather than as a representative of it (figure 2.19). More attention needs to be paid by scholars to the less obvious, but no less important (Freedburg 1989:60), aniconic forms of expression and embodiment. The various examples discussed in this chapter challenge any assumptions regarding a correlative relationship between the apparent visual importance of an art work and its perceived spiritual potency. The visual and performing arts remain a powerful medium for communicating and negotiating with the spirit world. Whatever the beliefs of particular societies or individuals concerning spirit manifestation through art works and/or performance, one thing seems clear: art, with its capacity to express ambiguity and secrecy, serves to reveal the limitations of human knowledge and the finitude of the human condition. It bears remembering that despite the Western ethnographer's quest for explanation and coherence, many Africans are content to live with the mysteries and ambiguities of life.[19]

Notes

1 Freedburg (1989:32) is also interested in the way Westerners refuse to acknowledge the traces of animism in their own perception of and response to images, notably "in the sense of the degree of life or liveliness believed to inhere in an image." Siroto (1976:21) even suggests that there may be links between iconographic elaboration and innovation, and the "animist" perspective on the dependency of power relations on control of supernatural forces, through objects of prestige, figural representations, cult paraphernalia, or ritual techniques.

2 Paden reminds us that the "classical religionist model was interested in *kinds* of objects that mediate the sacred by virtue of their inherent form or the inherentness of the supernatural in that form" (1991:16). More constructivist approaches would emphasize the ways in which particular forms generate ideas about the sacred, and under what conditions.

3 Blier's detailed analysis of the variety of genres of Vodun *bocio*, and the spiritual energies or forces which empower them, is especially illuminating in this regard (1995).

4 In this connection, the Nigerian anthropologist/art historian, John R. O. Ojo, reminds us of the need to understand religious images in context, notably the influence of such elements as dance, songs, gestures, and verbal utterances (1979). For, even in the case of Yoruba iconic images, such as the equestrian and mother-with-child figures, where there is some feature of likeness between form and content, the name attributed to the image may provide the necessary clue to its significance, which, depending on the spiritual entity each figure is supposed to represent, can vary from one ceremony to another. He argues that not all anthropomorphic images used in ritual contexts represent deities or their attributes. They may represent priests or worshippers, or just be shrine furniture. Similarly, Roy (1987:328) points out that sacred Bobo masks which take animal form may not represent an animal but rather recall the spirit of an animal which saved the founding ancestor of the clan. He therefore terms them "allegorical" and "non-representational."

5 Siroto (1976:16) is particularly critical of the "facile notion of collective symbolism of general and collective symbols." He discusses a range of ethnographic evidence to question the "integrity of the relationship between ancestor spirit and supposed ancestor image." What he terms as "ancestor-fixation" on the part of Western observers leads to tutelary, protective or divinatory spirits, for example, often being characterized as depicting deceased persons.

6 See, for example, MacGaffey's translation of Kavuna Simon's (a Kongo evangelist at the turn of the century) important account of the empowerment of northern Kongo ancestor figures (*muzidi* or *kimbi*) (Simon 1995).

7 By the use of the term, "(re)presentation," I wish to connote the range of meaning which is possible between an object representing or providing an image of some perceived force or spirit, to actually making it present, by providing a suitable host, for example.

8 A similar observation is made by Jedrej (1986:77) with regard to Dan masks.

9 Wande Abimbọla informed me of a case in Lagos in the 1950s which involved an assault and murder where the defending lawyer attributed the blame to the mask his accused client was wearing. Personal communication, 25 April 1992.

10 We may recall Robin Horton's earlier perspective on the question of spirit embodiment in masquerades (1963). Even though he stresses that the sculpted masks of the Ekine society of the Kalabari of southeastern Nigeria are first and foremost instruments "for securing the presence of a spirit, and not something produced as a work of art," they are nonetheless of secondary importance compared to the dance performance and its recreational value. Furthermore, he notes that the gods (re)presented are minor ones anyway. Horton attributes this misplaced understanding as stemming from the privileging of sculpture over performance, notably dance, by Western observers. It also stems from drawing distinctions which may not be present in practice.

11 Wande Abimbọla, personal communication, 25 April, 1992.

12 H. U. Beier and B. Gbadamọsi, *Yoruba Poetry.* Special edition of "Black Orpheus." Ibadan: Ministry of Education, 1959, p. 16, cited in Pemberton in Drewal *et al.*, 1989:162.

13 Personal communication, Ifẹ, 3 June 1991.

14 David Zeitlyn (1994:40) notes that the claims of earlier scholars concerning the protective figurines stored inside or outside Mambila granaries in Cameroon were predominantly ancestral are not sustained by the relatively rapid disappearance of the cult of which they formed part. It is more likely to have been a healing cult.

15 Sidney Kasfir remarks that it is really a question of perspective and that one could rather argue that there is a predominance of interpretations of African figural sculpture as "fertility figures." Personal communication, 27 January 1995. Perhaps the difference lies in whether they are male or female figures.

16 Zeitlyn (1994:n.20) endorses Ray's and Shaw's interpretation from his own work on the *sùàgà* masquerades among the Mambila of Cameroon.

17 A number of interesting commentaries were published (in the same and succeeding issue) in response to the David *et al.* article, expressing varying degrees of support for their cultural, symbolic and social interpretations of pots. Some commentators endorsed the interpretation of certain decorations in religious terms, while others considered this to be an over-reading of the data.

18 This is further discussed in chapter six on shrines.

19 This point is well brought out by Fardon (1990:224) in the last part of his book, entitled "Beyond Closure."

CHAPTER 3 Ethos, Cosmos and Hierarchy

Many African societies view their earthly hierarchies as a reflection or extension of the divine order.[1] This chapter is concerned with how political authority may be interpreted in religious terms, and expressed, manipulated, and negotiated in ritual and aesthetic terms. At one level, these distinctions are philosophically fused in the symbols of authority, whether crowns, masks, staffs, statuary or cloth, although the various ritual contexts may designate different types of power and responsibilities. The discussion will inevitably be centred on the concept of power, but it is the powers of governance which command our attention here, for they have traditionally been associated with artistic patronage and ritual displays which convey the solemn importance and complexity of leadership. That does not mean that there is a direct correlation between art forms and social prestige; in other words, leaders and rulers do not have to express their authority through a hierarchy of art objects (Brain 1980:117; Fraser and Cole 1972:299[2]). Similarly, acephalous and non-hierarchical peoples, such as the Lega, where spiritual, political, economic and social powers are dispersed throughout the *bwami* society, may still employ art objects (ibid.:296). Nor should we assume that there is a relationship between visibility and importance; the most important pieces may be concealed or appear briefly at the end of the proceedings (Preston 1985:18).

So, as stated above, whether as heads or rulers of lineages, villages, kingdoms or empires, or trustees of community groups, African leaders are often viewed as having a spiritual relationship with the land and their people. Ritual symbols and regalia serve to align, regulate and commemorate this relationship for rulers and subjects alike. The artistic traditions of the Cameroon Grassfields, Kuba, Asante, Yoruba and Benin kingdoms have been well documented and will constitute the substantive part of this chapter. After considering some art associated with chieftaincy and ancestorhood, the chapter concludes by examining the ways in which the perceived secret powers of masks may play an important regulatory role in many African societies.

Kingship

It is not uncommon for kings to be viewed as sacred figures and hence to exercise a priestly as well as political role.[3] In fact, Evans-Pritchard in his 1948 Frazer lecture concluded that "kingship everywhere and at all times has been in some degree a sacred office" (cited by Feeley-Harnik 1985:276).[4] In her important overview and analysis of the literature on divine kingship, Feeley-Harnik highlights those approaches to kingship which address the culturally and historically specific ways in which power and leadership are socially

constructed, and how "'impersonal' (divine, transcendent, bureaucratic) creatures are created out of intensely human beings" (ibid.:281). This leads naturally to a consideration of the ritual and artistic components of this process of differentiation. In their book, *Creativity of Power*, Arens and Karp make a similar plea for a more subtle and meaningful understanding of power by recognizing the creative and cultural basis of agency, and its interactive components of semantics, cosmology and action (1989:xx–xi). Likewise, Gilbert argues that to understand Akan kingship one must take into account "the indigenous concept of power in its relation to cosmology, not that of power in its form of legitimated and responsible authority" (1987:299).

The ruler, or Fon, of the various Grassfields kingdoms in northwestern Cameroon provides a case in point. He must be approached and addressed indirectly—commoners must cover their mouths to speak and avert their gaze so as to recognize and not pollute his sacred presence (Northern 1984:29). The center of the kingdom's art is the palace, and a panoply of insignia invest the Fon with privilege and royal prestige: architectural sculpture, ancestral figures, stools, caps, masks, drinking horns, pipes, loincloths, gowns, necklaces, armlets, anklets, whisks, staffs, standards, swords, ivory tusks, calabashes, ceremonial and food vessels, display cloths, drums, beds and bags (ibid.:31). The stool or throne is the primary symbol of office. It is often draped with a leopard skin or supported by carved human and/or animal caryatids. These express the belief that the king possesses the ability to transform himself into a leopard (the leopard is also believed to be able to assume human form). The king is addressed as "leopard" and all dead leopards are delivered to him with due ritual precaution and purification (ibid.:44). Another animal

frequently represented in prestige art is the spider. The earth spider serves as the divination animal in the Grassfields region; it is interpreted as an animal of wisdom and as associated with the earth into which the dead are committed and emerge as ancestors. So, since the spider shares the ancestors' world and humans depend on the latter for continuity, the spider icon appears frequently on the prestige art (masks, stools, pipes, ceremonial vessels, bracelets and sheathed swords) customarily granted to title-holders by the Fon (ibid.:49–50).

For the Asante, the largest and best known of the Akan kingdoms in Ghana, the well-being of the state is reflected in the well-being of the ruler, or the Asantehene. Much of the art reflects this interdependency, whether in the form of staffs, brass bowls or especially stools. It is customary for any Asante lineage of consequence to have a stool, which serves as the symbol of authority of the chosen lineage head. In the words of the Ghanaian scholar, Kyerematen, who has conducted detailed research on the royal stools, they serve "as a bond between the living, the dead, and those yet to be born. This bond is the very essence of Akan culture" (1969:1).

The personal stools of heads who are chiefs or elders to chiefs are preserved in their memory after their death (see figure 2.13). They look like ordinary wooden stools but are never used for seating. The stools are varnished with a mixture of soot and egg yolk and kept in a special room. They derive their name as blackened stools from the resulting shiny black surface. Gilbert notes that the Black Stools of Akuropon, a small Akan kingdom, are anointed with blood, spider's web, eggs and other matter (1987:306). The delicacy and bonelessness of the eggs connote care and peace, and the spider's web may refer to the wisdom of Ananse, the trickster spider. Alternatively, it

may be a reference to the wisdom of the old women of the lineage in genealogical matters, since the spider's web is generally found in the kitchen, blackened by smoke from the fire (ibid.:n.11).

The location and treatment of the Black Stools convey the power they both symbolize and contain. The stool room, symbolically located in the center of the palace, is out of bounds to ordinary people and extraordinary things are believed to happen to those who enter the room without ritual preparation and authority, such as being dazzled or blinded by the sight (ibid.:305). Offerings and libations are made to the stools in the hope that they will offer protection, prosperity, health and long life. Their power derives from the belief that they are inhabited by the spirit or *sunsum* of the head of the lineage for whom it was consecrated. Kyerematen notes that when sacrifices are made on behalf of the matrilineage, it is the spirit of the patrician of the deceased stool-occupant which is addressed. He explains that the Black Stool symbolizes the two necessary components—physical body and spirit, inherited from the mother and father respectively—of a person and a king. The body and stool, however, both belong to the matrilineage (1969:2).

In contrast to the Black Stools, the Golden Stool enshrines the soul of the whole Asante nation. It was believed to have been brought down from the sky by the priestly counsellor, Komfo Anokye, of the Asante leader, Osei Tutu, as a validation of the new order after 1701 (ibid.:2; McCaskie 1995:127). As the story goes, all previous regalia had to be destroyed and buried, except for the stool of a royal ancestress, to mark the beginning of the new kingdom. After incantations by Anokye, the Golden Stool is said to have dropped from heaven into the lap of the king, who was seated outside the palace in assembly, to the accompaniment of thunder and lightning. Subsequent ritual activities involved the vanishing of a human being and seven pythons into the stool, and the rubbing of the stool with nail parings and hair clippings from the various Asante chiefs. This symbolically confirmed that the stool was owned not by the king himself but by the Asante nation as a whole.

Because of its sacredness, it was decreed that the Golden Stool should never be allowed to rest on the bare ground, but rather on a camel hair blanket or a piece of elephant skin. Several bells are attached to the Golden Stool, one of which is regarded as having been attached to the stool when it came down from the sky. It is believed to have the power to summon all people when rung. Every Black Stool possesses two bells which are rung when it is carried in procession to announce its arrival. Additional gold bells have been attached by subsequent rulers to the Golden Stool, some in the form of effigies of defeated warriors. Charms or *suman* have been added by each king to recall historical events. The stool itself is a mass of solid gold, standing about a foot and a half high, with the seat itself being two feet long and one foot wide. Not only is the stool named according to the day of the week on which it was "born" (Sika Dwa Kofi—"The Golden Stool born on Friday"), but it is also fed regularly according to the Akan calendar, with brown sheep, yam and liquor.

But it is not just the mythical origins and ritual surrounding the Golden Stool which account for its significance. Its historical and political importance have already been emphasized. Indeed, important laws are linked to the occasion of the descent of the stool, and custody of the stool was a prerequisite for office. McCaskie emphasizes the instrumental role of the nascent Asante state in using this historical artifact and conceptualizing its appearance or revelation in terms similar to the

manifestation of the gods or *abosom* in order to validate the new historical order (1995). He goes on to argue that the category of "divine kingship" fails to capture both complexity and process. It is also interesting to note that the stool, along with other regalia, has also served to reflect and incorporate new religious influences, such as Islam. Islamic talismans, believed to offer protection and potency, decorate many items of royal regalia (Kyerematen 1969:5).

The multivalency and sacredness of the stool are also attested to by a Ghanaian churchman, Alfred K. Quarcoo. He writes of the challenge of the traditional Akan stool or *asesedwa* to Christian missionaries (1990). By this he means that such a powerful symbol of political unity and ancestral significance runs the risk of being misinterpreted as a symbol of idolatry and preoccupation with the dead. He argues that the ceremonies surrounding the stools rather point to the quest for community and continuity, and the need for periodic renewal of identity. He believes that evangelism would ignore such a powerful and central cultural symbol at its peril.

In addition to the stools, *kuduo* or brass bowls served as objects of status and prestige for the Akan (figure 3.1). The earliest forms were imported Arabic-inscribed basins which arrived among the Akan as a result of trans-Saharan and trans-Sudanic commerce in the second half of the fourteenth century (Silverman 1983). They served as models for later local production and are still kept in Akan stool rooms and shrines. The six earliest Egyptian basins, currently located in Nsoko, are perceived as having supernatural powers. They are not viewed as gods (*abosom*) but rather communicate their messages through intermediaries. Each vessel is served by a ritual attendant and is believed to be able to ensure the protection and prosperity of the

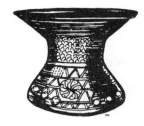

Figure 3.1 *Kuduo* brass containers, Akan, Ghana. After Silverman 1983:22.

community. In all but one case, these basins are held to have descended from the sky at some time in the distant past. The fact that these Muslim vessels were incorporated into Akan culture as sacred objects suggests, according to Silverman, that the new owners were aware of their special status and ritual use.

Most of the *kuduo* still functioning in traditional contexts are possessed by chiefs or associated with the shrines of powerful state gods (ibid.:20). There are accounts of important men, such as paramount chiefs, being buried with their *kuduo* (which might contain gold dust and aggrey beads). The *kuduo* would later be dug up and placed in the royal stool room next to the blackened (ancestral) stool. They might also be used in rituals commemorating deceased Asante kings. Personal stools of reigning Akan chiefs often have *kuduo* set in front of them. For certain festivals, the *kuduo* may serve as receptacle for the sacred water used to purify the soul of the chief (ibid.:23).

The focal point of the highly centralized political organization of the Edo people of Edo State, Nigeria is the king or *Ọba*. He is thought of as the reincarnation of a past king. His powers have to be sustained through the appropriate rituals for the good of the nation (Forman and Dark 1960:13). The most important of these rituals were the sacrifices to his ancestors and his own head. In pre-colonial

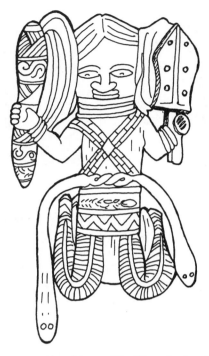

Figure 3.2 Ọba of Benin (Ọba Ekwuakpe) as fish-legged figure. Igbesanmwan motif from an ancestral altar tusk in the Museum für Völkerkunde, Berlin (No. IIIC 7761). After Blackmun 1990:69, fig.17., adapted from Von Luschan 1919 Pl.H, fig.740.

times, the rule of the Ọba embraced a much wider area than that of the territory occupied by the Edo-speaking peoples today. When the British ransacked and captured the capital, Benin City (known as the British Punitive Expedition), in 1897, they were amazed to find enormous quantities of bronze castings, ivory carvings and other art objects. Many of these ceremonial pieces were taken back to Britain and sold by the Foreign Office. Benin sparked sensational interest among the British public, becoming known as the "City of Blood," because the expedition had intervened when the king was making his annual sacrifices to his ancestors (Dark 1962:9). Initially it was supposed that the art had originated from Benin's early contact with the Portuguese in

the fifteenth century. But local tradition disproved this as well as the established ward-guilds which were responsible for most of the important Edo crafts commissioned by or for the king.

Today, despite the precarious nature of any traditional kingship institution in the face of pressures for economic and cultural change, and wavering support from civilian and military governments, kingship in Benin continues to provide a cultural bedrock and framework for Edo socio-political organization (Nevadomsky 1984b). With its origins dating back nearly one thousand years, the monarchy ritually and symbolically re-enacts the history of the Edo people through elaborate annual festivals and succession rituals. Detailed descriptions of these festivals of the 1978–9 installation of the thirty-eighth Ọba of Benin, Omo N'Ọba N'Edo, Uku Akpolokpolo, Erediauwa, were made by Joseph Nevadomsky in a series of articles in *African Arts* (1983, 1984a, 1984b). He stresses the efforts of the Ọba to preserve the rituals. Both Nevadomsky and Paula Ben-Amos, along with others who have studied Benin art and kingship rituals, stress the importance attached to the mystical powers of the king, in addition to his political authority, and the way in which these powers are expressed and sustained through myth, symbol and ritual. This section will focus, therefore, on the king's persona and the art objects which are the primary vehicles of cosmological and political meaning.

The authority of the king derives historically in part from his descent from the Yoruba king, Oranmiyan, and from his ethnic identity as Edo, ruling with permission of a council of "kingmaker" chiefs (Gallagher 1983a: 21). In fact, artistic, ritual and political developments in the kingdom may be interpreted as efforts by the various Ọbas to reinforce their power, particularly their spiritual power, vis-à-vis the chiefs—what Gallagher terms "a continued

campaign of aesthetic propaganda." The Ọba is also believed to be the king of the dry land and as such is the counterpart of Olokun, king of the great waters (Ben-Amos 1980:68). Olokun is the most popular and widely worshipped of the Benin deities. His role is greater than that of his father, the supreme deity, Osanobua. He is associated with health, wealth, and children, and is held to demand beauty in all its forms, whether dance, songs, shrine decoration, rich fabrics or beautiful women (Ben-Amos 1980: 46). Olokun's palace under the sea is believed to be the storehouse for all the riches in the world, including the coral beads which are the prime feature of the Ọba's costume and authority. In fact, in shrines to Olokun, the deity is frequently represented in the form of a Benin king in full ceremonial regalia (Ben-Amos 1980:48f.).

An actual description of the Ọba runs as follows:

> The costume of the Ọba on certain ceremonial occasions was extremely elaborate and weighed heavily on him; the coral crown with its wings, the coral choker, the coral shirt, the coral pendants from the crown, the large number of necklaces, the medicines and coral ornaments on his chest, the cloths tied around his waist with tassels, the ivory pendants suspended round his waist, the ivory armlets, all these make him a strikingly regal figure, sedate, aloof, and divine, but a divinity among men (Dark 1973:69).

This is well illustrated in plate 1. The coral beads are more than decorative; they determine royal authority and are believed to have the power of *aṣẹ*, in other words, whatever is said with them will come to pass (Ben-Amos 1980:68). They constitute a source of the Ọba's fearful power to curse. As king, he alone had the right to take human life and offer human sacrifices. Ben-Amos comments that although the Ọba's proclamation staff gives him the

powers to curse and issue proclamations, it is the beads which really define the monarchy and provide its mystical sanction. Chief Ihaza informed Ben-Amos that: "When the king is wearing this heavy beaded costume, he does not shake or blink but stays still and unmoving. As soon as he sits down on the throne he is not a human being but a god." So not only did his costume and powers generate awe and fear, but depictions of his origins in the waters communicate his liminal status and inter-mediary role between his subjects and inhabitants of the spirit realm (Gallagher 1983a:21). Pythons and crocodiles, potentially dangerous animals which operate in the two realms of land and water, are associated with Olokun and are therefore an appropriate symbol for the king. So too are the mudfish, fish which are able to spend long periods out of water. Blackmun claims that the fish-legged ọba (figure 3.2), a common iconographic motif, "reinforces the ancient belief that the Ọba's feet are so highly charged that they must never touch the wet ground for fear of damaging the land" (1983:64). While some mudfish evoke succulence and benevolence, in this motif it is a different variety of fish, which possesses an electric charge capable of inflicting a shock, which forms the legs of this legendary figure. Some fish have poisonous spines and may cause painful wounds, perhaps alluding to the Ọba's strengths as a warrior and military commander (Gallagher 1983:93). Coiled fish, grasped in the hand of the Ọba, may also symbolize the ability of those with magical power to control and direct it against their enemies.

Within the confines of the palace, which is believed to reflect Olokun's kingdom as a source of beauty, wealth and fecundity, important rituals are conducted to ensure the well-being of the Benin nation and its leader (Ben-Amos 1980:70f.). The art is intended to

reflect the importance of the monarchy. At the royal ancestral altar commemorative heads refer to the powers of the Head to direct life successfully (Ben-Amos 1980:63). They are made of brass, a material used only for royalty since it never corrodes or rusts, has a beautiful sheen when polished, and, because of its red color, is held by the Edo to be threatening and drive away evil forces. A carved ivory tusk rests on the top of each head. Barbara Blackmun has undertaken an extensive analysis of these tusks (e.g. 1983). She demonstrates their role as historical documents, as well as their spiritual force. This is evident in the belief that only male officials are able to touch them without harm. Likewise, the interpretation of the various motifs, which point to the spiritual and physical resources which have traditionally sustained the Benin kingdom, is limited to those who have the required ritual knowledge. The permanence of ivory is also valued, as well as its association with the elephant, connoting strength and longevity. The color of ivory is also significant, since it resembles a kaolin substance known as *orhue* (chalk), which symbolizes purity, prosperity and peace. According to Blackmun, this chalk is rubbed on the face and body during ceremonies, mixed into ritual food, and constitutes a regular offering to Olokun. The tusks themselves are cleaned before major annual ceremonies to restore their whiteness, and they may be rubbed with the chalk itself. There are also shrines to the Queen Mother, where brass commemorative heads, staffs, and bells reflect the special powers of the woman who bore the future king. Her son later draws on these powers in his claim to the throne and for his reign (Ben-Amos 1983:82).

For all neighboring Yoruba peoples, the *Oba* (or king of the various sub-groups) shares in the divine attributes of the *orisa* or divinities (Olupona 1991:58f.). He is believed to descend from Oduduwa, the founding divinity of the Yoruba, and is considered to be his representative on earth. The Ondo people, as well as other Yoruba peoples, hail their king as *ekeji Orisa* ("the one whose power is like that of the *orisa* or gods") and also as coequal with death, *Uku*. In his detailed study of Ondo Yoruba religion, Olupona claims that all aspects of cultural life are subsumed under the system of royal rituals and ideology, which is expressed in various forms: oral traditions, rituals, and the performing and visual arts.

The beaded crown or *ade* is the main symbol of a king's authority (see plate 2). Its most common shape is that of a cone, with a fringe of beads hanging down to cover the face of the wearer (Beier 1982). An image of a bird or *okin* sits atop the crown and a frontal face or multiple faces are featured at the front or the back of the crown. The crowns are generally decorated with an interlace and zig-zag or check patterns. The symbolism will be discussed in more detail below. According to one ruler (the Orangun-Ila), the *ade* is an *orisa* (Pemberton 1989:125). When the crown is placed upon his head, "his *ori inu* becomes one with all those who have reigned before him, who are now *orisa*" (Drewal *et al.* 1989:33).

Tradition states that Oduduwa, the founder and first king of the Yoruba people, gave a beaded crown to each of his sixteen sons, commissioning them to go off and establish their own kingdoms. Thus, the primacy of Ile-Ife was established and all Yoruba kings must trace their descent to Oduduwa. This reflects a need among the Yoruba since the civil wars of the nineteenth century to affirm a cultural center, and a sense of unity and common identity, while not denying regional diversities (Drewal *et al.* 1989:38).

Ancient crowns, worn from the sixteenth to eighteenth centuries, appear to have been decorated with red stone and coral beads and

cowrie shells (ibid.). When European "seed beads" arrived in West Africa during the nineteenth century, they were artistically incorporated by Yoruba crown makers, such as the Adesina family in Efon Alaye. The beaded fringe seems to mark a transformation of the concept of royalty, in that the individuality of the oba is increasingly disguised (Beier 1982:33). Beaded objects are the prerogative of those who represent the gods and with whom the gods communicate (Thompson 1972:228). Thompson argues that the fringed crown or *adenla* implies a sanction which distinguishes it from lesser forms of head covering. The king must not look upon the inside of his crown, where spiritual forces might blind a careless wearer (in the past it was a form of impeaching despotic kings).

As stated above, the traditional structure of the crown is cone-shaped. This contrast with the naturalistic head symbolizes the divine aspect of leadership. In fact, the cone is a primal image for *aṣe* or power in the world and is a symbol of the *ori inu* or inner head (Drewal *et al.* 1989:26f.). This abstract conical form is reproduced throughout Yoruba culture, such as in the cloth cone of umbrellas, and the pointed spires of roofs, both of which protect the king's sacred head. In the Yoruba creation myth a cone of land is created by a creature who descends to spread earth on the surface of the water. This is the origin of the name Ile-Ifẹ (Home-Spread), the city at the center of the Yoruba universe (Drewal *et al.* 1989:32). Two-dimensionally the cone is rendered in the triangles of cowries and leather panels on *ibori* (the container for the inner head), in amulets containing power substances, and in the red, serrated borders enclosing the ancestral spirit in *egungun* masqueraders. It may also represent generative power and, when pointing downwards, symbolizes the heart, which is an organ central to royal enthronement rites, for example.

Figure 3.3 Iron staff, Yoruba, Nigeria. Stanley Collection of African Art, University of Iowa. This staff was used by diviners who were followers of Osanyin, the deity of herbal medicines. Birds represent the voice of Osanyin. The 16 birds depicted here stand for the 16 original kingdoms of the Yoruba.

The face (or faces) on the crown have elicited a variety of interpretations. Some say that it is the face of Oduduwa, while others say it is the face of the *ori inu* or inner head of the wearer of the crown. Beadworkers in Efon Alaye have claimed that it is the face of Olokun, god of the

sea and "the owner of the beads" (ibid.:38). The very first crown is said to have been brought from Olokun and the oldest crown of the Ooni of Ife is known as "Olokun" (Beier 1982:25). For some the faces on the crown represent ancestral forces or decapitated enemies or felons. Generally the Janus qualities allude to the earthly and spiritual aspects of Oduduwa, and, by extension, the king. Another ruler interpreted the multiple faces as signifying the all-seeing power of the king in his domain.

Images of birds surmount the crown. They are also found on staffs for Osanyin, the god of herbal medicines, as well as on those for Ifa divination priests (figure 3.3). This points to the links between kingship, healing and divination and alludes to the power of the ancestors to protect the community from witchcraft (Thompson 1972:248, 255). The gathering and hieratic ordering of birds reflects the distribution of power in Yoruba society (ibid. 1972:247). But the predominant interpretation is that the birds refer to the mystical powers of women (Abiodun 1989b; Campbell in Okediji 1992a). In respect of the ambiguity of women's powers, women are called affectionately *awon iya wa* ("our mothers"), or abusively *aje* ("witches") (Drewal *et al.* 1989:38; Abiodun 1989b). The implication is that the bird-mothers, who play a central role in rituals surrounding the crown, can either protect and destroy the wearer of the crown; hence, the king himself rules only with the support and cooperation of *awon iya wa*.

Sacrifices and ritual precautions surround the making and consecration of the crown. Crown makers work in the palace of the *oba* who commissions them. Sacrifices must be performed to Ogun, god of iron, by the crown makers who will be using a needle. The sacrifice usually consists of a snail to ensure peace and composure for carrying out the work and a tortoise for wisdom and shrewdness to

complete the work successfully (Beier 1982:34). Then the beadworker begins to sew beads to the surface of the crown, which has been constructed out of a cone of palm ribs and built up with four layers of white cloth, attached to the framework by an application of damp corn starch (Drewal *et al.* 1989:38). The white cloth may signify birth. The multi-coloured beads symbolize the worshippers of the different *orisa* or gods, and the king's ability to unite all the different cult groups in the town (Beier 1982:31).

Herbal preparations are required before the crown may be worn. A packet of herbal medicines will be secretly inserted in the top of the crown. It is believed that when the *oba* puts on the crown for the first time, "he is transformed into one whose head is em-powered by an *orisa*" (Drewal *et al.* 1989:38). Thus the crown, through a variety of iconographic and ritual means, reveals the power (*ase*) and identity of the king, and his relationship with the people and the gods. This is well summarized as follows:

> Concealment constitutes heightened spirituality. It is a way of conveying the ineffable qualities and boundless powers of the divine person of the *oba*. The veil, therefore, is a mask, hiding the face of the *oba* so that the power of the crown may be seen. It also moderates the penetrating, piercing gaze of one whose power is like that of a god. More importantly, as a person's *ibori* is guarded within its cloth, cowrie, and leather house, so too the king's inner spiritual person is protected, enclosed within the enveloping form of the cone and beaded fringe of the crown (Drewal *et al.* 1989:39).

Other forms of material culture may express the king's vital power. For example, Pemberton shows how the panels at the rear of the palace veranda in Ila-Orangun depict the *oba* as central to the socio-political structure in that he is surrounded by chiefs and figures from all

areas of society (Pemberton 1989:125-9).

The Kuba of Zaire commemorate particular rulers through their well-known king figures or *ndop* (figure 3.4). These figures are believed to be "spirit doubles" and embody the principles of kingship (Mack 1990:71-2). In the king's physical absence from the capital they were rubbed with oil to preserve the spirit of royalty. New rulers slept with them to imbibe the spiritual aspects of the new role, yet they were only seen as an adjunct to kingly power and not as a direct source of it. The Hungarian ethnographer, Emil Torday, found it easier to acquire the king figures than the royal charms. The latter were considered to be powerful objects in themselves and their removal might have constituted a possible diminution of royal power.

Vansina states that these statues, which originated in the eighteenth century, were displayed for commemorative purposes in the palace and were also possibly used as a charm to facilitate childbirth and as a receptacle for the breath of the dying king (1984:pl.8.4). During his lifetime, the statue was supposed to house the king's double. Informants reported to Vansina that when King Mboong aLeeng was mortally wounded by a sword stroke, a similar cut appeared on his statue and is still there (1972:44). There was also an important association between royal power and sorcery which had probably existed since the eighteenth century (ibid. 1978: 208f.). He also links the emergence of these royal statues to the decline of regional cults and the rise of a cult for the king as nature spirit (*ngesh*) (1984:154). In trying to retrace the religious history of the Kuba and the kingship rituals, Vansina describes how the king was credited with "extranatural powers" either because of his charms or because of his being a spirit. He was believed to be able to "send storms or tornadoes and could ward off attacks by witches

Figure 3.4 Portrait of a king, *ndop*, Kuba, Zaire. Stanley Collection of African Art, University of Iowa. The king was Shyaam aMbul a Ngwoong whose reign from 1600 onwards marked the golden age of the Kuba. He may have been the ruler responsible for introducing the practice of carving portraits. The figure was carved between 1916-18 to replace the original (see Roy 1992:226-7).

against his capital, as is shown by his mastery over lightning, thought to be an animal. He protected the fertility of villages by throwing white porcelain clay in the air and reciting a formula, but he could also withdraw his protection" (ibid.). The Kuba kingdom, a federation centered around the Bushoong clan, is

renowned for its elaborate court art. Vansina maintains that the statues (*ndop*) were commissioned by kings during their lifetime. The naturalistic figures depict the ruler as a symbolic, idealized leader rather than portraying individual kings. The calm, composed figure is motionless in a cross-legged position (unusual in African art). The same restrained authority is present in the slow and quiet elegance of Kuba rituals.

In addition to the *ndop* statues, Kuba masking traditions reflect royal power. The central character of a triad of masks, known as Mwash a Mbooy, is a spectacular beaded mask which represents both the founder of the Kuba kingdom (Woot) and the creator of humankind (Mwash a Mbooy) (see figure 1.2). The latter was the king who introduced royalty and the arts of civilization, namely agriculture, weaving and iron working, to the Kuba (Nooter in Preston 1985:65, pl.63). The elephant symbolism of the mask conveys the strength and authority of the king. His successor wears the mask at the funeral ceremony to receive the power of Woot and symbolize the continuity of the royal line.

Insignia of Ancestral Status

An examination of the artistic creations associated with royal or ancestral authority sheds light on how that authority is constituted and sustained. Cloth is central to the creation of ancestors in many parts of the world and Gillian Feeley-Harnik shows how indigenous silk textiles, handwoven by Merina and Betsileo women, constitute the focal point of reburial ceremonies in the Malagasy highlands (Feeley-Harnik 1989). At these ceremonies, kin gather every few years to honor important ancestors by exhuming them, rewrapping them in new shrouds, and reburying them. The Sakalava of western Madagascar do not practice reburial

but they use imported silk textiles in spirit possession. They wrap their own relatives and friends in shrouds as they are possessed by the spirits of former kings and queens.

This ambiguous process of clothing the spirit to enable it to speak and then to silence it is similar to the other forms of exchange with the Sakalava royal ancestors, such as annual purification services and generational reconstructions of the royal tomb. Ancestors are considered to have more power than living people and hence a greater voice in domestic and political affairs. During services for the royal ancestors, all forms of European clothing are prohibited, including anything sewn rather than wrapped. In fact any clothing that is knotted or tied shut is not worn in the royal centers, as the Sakalava are required to be open to involvement with royalty and not suggest concealment of evil thoughts. The inherent ambiguity in the socio-political processes and relationships which are part of the reburial is well expressed in the materials with which spirits are wrapped: combinations of soft and hard materials such as cloth and sticks, trees and stones, tombs and bodies, bones and flesh of human beings, both female and male. People are faced with the decision of whether to use more durable materials and hence eliminate the reburial process, but royal spirits speaking through the mediums have consistently rejected the use of these new materials.

Venda chiefs of the Northern Transvaal were held to have semi-divine status which they passed on to their successors through the installation ceremony of a new chief (Nettleton 1989). In some cases the deceased ruler was enclosed in a burial chamber which was sealed with carved wooden doors. It was believed that admission was only granted to the selected heir; the ancestors would recognize him and cause the door to open. Only chiefs were allowed to have carved doors (figure 3.5). Just

as the door was known in court speech as *ngwena*, meaning "crocodile," so too was the chief referred to as the "great crocodile" or "crocodile of the pools." This connoted both strength and longevity as well as fear—potential eater of humans and possible witch familiar. The pool is a metaphor for the court of the chief; it was accompanied by the python, viewed as marginal, mediatory and associated with the diviner-healer without whom the chief was believed to be unable to rule. The relief carvings of these royal doors represent a crocodile only through designs—compositions of opposed and interlaced chevrons which create diamond shapes into which concentric circle motifs are placed. The doors are no longer used, only the drums. Before the tympanum is stretched across, one or more pebbles from the stomach of a crocodile are placed inside, ritually identifying the drum with the chief, the pool and the crocodile. Legendary drums of the past were reputed to be able to cause rain, mist, fogs and plagues. The iconography of Venda court arts can only be understood within the perspective of myth and history, and concepts of spiritual and political power.

Figural staffs are common symbols of chiefly authority among the peoples of West and Central Africa. For example, the Dogon depict their mythical ancestors, the *nommo*, in the form of spear heads atop iron staffs. Sometimes the original Dogon smith himself is represented at the top of a wavy iron shaft, possibly signifying his descent from the heavens (Griaule in McNaughton 1988:122). These iron staffs seem to have been principally used by diviners, healers and chief priests in the Dogon communities. McNaughton also notes that in Zaire and Angola, the figural staffs used by the Kongo, Yaka, Pende, Luba, and Chokwe are surmounted by a female ancestor, who represents the source of chiefly authority

Figure 3.5 Carved door, Venda, Northern Transvaal. After Nettleton 1989:74, fig.6 (taken from H. Stayt, *The Bavenda* [1931], pl. XVI).

(McNaughton 1988:121). The iron staffs used throughout the Mande diaspora (see figure 1.1) are almost always figural and McNaughton suspects that "in private they possess sacred names that reflect their power and their use in

secret situations" (ibid.). Like most Mande sculpture they are minimal in form and their smaller surfaces and details require the blacksmiths' ultimate skills. Their varied use suggests that they were viewed as more than symbols of authority and rather as "supernaturally powerful devices" (ibid.:124). For instance, they were placed in the tops of trees around ceremonial groves or buried underground. The imagery of these staffs is one of power and "ability beyond the ordinary": horses, spears and weapons, and hats. The latter resemble the hats worn by hunters, hunters' bards, and sorcerers, which are laden with protective amulets. Sometimes these hats appear on female figures, denoting those women who have acquired personal power and prowess through sorcery or force of character and who are affiliated with one of the hunters' association branches. The occult power of these staffs is also inherent in the material used. The mere act of smelting and forging by the blacksmith releases great levels of *nyama* and the working of the difficult metal forms adds to the energy (ibid.:126).

While it is difficult to generalize about Igbo art forms, in part because of their non-centralized social structure, the title associations and secret societies do provide some interesting examples of the relationship between art, leadership and religion. Title-taking in the Ozo society in northern Igboland requires the candidate to undergo a ritual death and rebirth and a period of seclusion, as well as to participate in blood sacrifices, ceremonial washing, the taking of new names, and the establishment of a new personal god (*chi*) (Cole 1972:81). It is also believed that with each successive stage of initiation, a man not only becomes closer to the concerns of his community but also to the gods and ancestors. The higher status of the initiates is reflected in their more elaborate burials. Sometimes the

carved openwork double panels in the larger *obi* (meeting-house of an Ozo man) form the backs of the "altars" where the other paraphernalia of status are displayed, namely the *ofo* (staff), *ikenga* (personal shrine), and *okpensi* (ancestral symbols), together with the staffs and spears collected by the owner and his titled predecessors (ibid.:86).

The insignia may be ranked in importance according to the primary motivation of each title-holder (Melii and Wass 1983:67). For instance, someone who takes the title to become more eligible to serve as the spiritual head of his lineage rates most highly those items with spiritual association, such as the *okwa-chi*, or vessel of god, and *okpulukpu*, another sacred vessel. In some cases, Christian members of the society dissociate themselves from the insignia. The sculptures known as *ikenga* are used in male cults (very occasionally by women) and "address the powers, successes and failures of an individual" (Cole and Aniakor 1984:24). The basic image is a human being with horns, rendered in either an abstract or naturalistic form. The right arm or hand, which does virtually all important things, often wields a hoe or weapon (figure 3.6). Cole and Aniakor point to the direct correlation between the wealth and status of a man and the size, artistic quality and complexity of his *ikenga* (ibid.:28). A newly titled man in the Ozo society might commission a new *ikenga* to reflect his heightened status. *Ikenga* is viewed as shrine, symbol and idea, and as embodying a person's *chi*, his ancestors and his power. It is "an active spiritual principle which mediates in the vicissitudes of human existence" (ibid.:26). Nwoga also underlines the agency and power of the *ikenga* in an individual's life endeavors (1984a:48).

The Luba of southeastern Zaire employ a number of objects which not only convey prestige but also recreate the first mythical

enthronement as told in the Luba genesis myth (Nooter 1990). For the ruling class know that the political authority of the chief is dependent upon the *budye*, a powerful secret association. In this connection, Nooter points to the similarities between the scarification patterns on the female figure's stomach atop a chief's staff of authority, which were described to her, and the patterned rim of pots, the headdresses worn by *budye* diviners and members, and the decorations on the diviner's instruments (rattle, drums and receptacle). This scarification pattern, known as *nkaka*, is also found on most of the royal emblems, such as the rims of stools and headrests, and axe handles. The term refers to the scales of crocodiles, snakes, fish and the pangolin. The latter are used by diviners and healers in their medicinal compositions, as "the firm, textured surface is identified with the containment of spiritual energy" (ibid.:44). She also notes the similarity between the signs on the mnemonic device (*lukasa*, a rectangular wooden board covered with clusters of beads and shells and/or figures carved in relief) used to convey initiatory teachings and the scarifications on a woman's body. Nooter links this and the use of the female form on the staffs (as well in bowl-bearing figures and stools) to women's prominent political and religious roles. Illustrated here is a Luba power or guardian figure (figure 3.7). This prominence stems from the belief that women are believed to embody the secrets of rulership even though they are not the visible leaders (1993:100). Women perpetuate the royal line and the chief's mother and his first wife are important counsellors to the ruler. Almost all spirit mediums are women, for, according to the Luba, "only a woman's body is strong enough to hold such a powerful spirit" (1990:45). While these various levels of meaning are not disclosed to all members of the society, Luba art, such as the chief's staff, reflects Luba power.

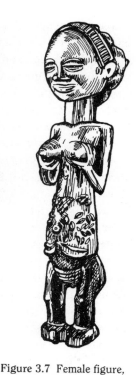

Figure 3.7 Female figure, *mikisi mihake*, Luba, Zaire. Stanley Collection of African Art, University of Iowa. This finely carved figure must have belonged to a person of high social standing (Roy 1992:168). The prominence of women in Luba art is a reflection of their important political status.

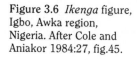

Figure 3.6 *Ikenga* figure, Igbo, Awka region, Nigeria. After Cole and Aniakor 1984:27, fig.45.

Secret Societies

In the next chapter we shall look more closely at secret societies in the context of initiation. These societies, such as the Ekpe or Ngbe society of the Efik and Ejagham peoples of southeastern Nigeria and western Cameroon, may provide important illustrations of the relationship between artistic expression and religious beliefs in establishing and sustaining authority during the eighteenth century (Jones 1984:63f.). Believed to have originated among

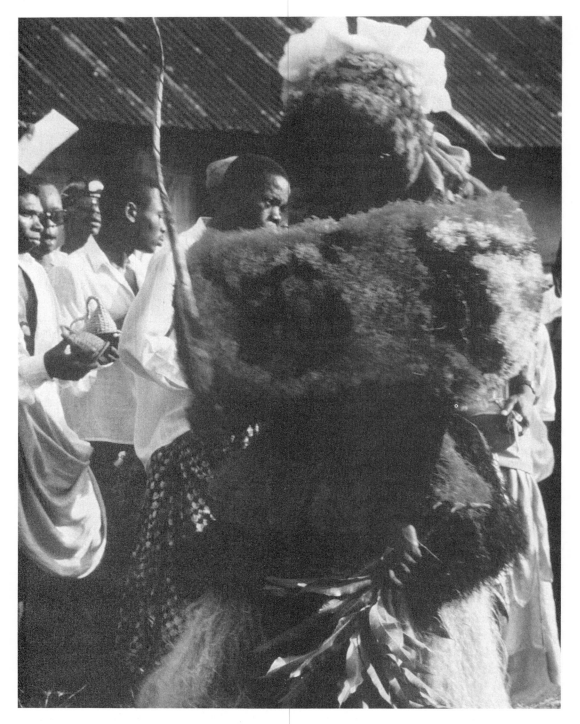

Figure 3.8 *Ekpe* masquerader at chieftaincy installation, Calabar, Nigeria. Photo: Rosalind I.J. Hackett, July 1991.

the Ejagham, this secret association spread to the important trading area around Old Calabar, where its common ritual practices and secret language and script, *nsibidi*, served to unify diverse peoples (see Battestini 1991). Initiation into the various grades was open to all who could afford the fees, although women, slaves and foreigners were restricted to the lower grades. "Ekpe" in Efik means "leopard" and was said to have been a mysterious and invisible being inhabiting the forest. Occasionally the *ekpe* was captured by the initiates and brought to the town or village for ceremonies. Its fearful roar was then heard by all, yet its source was known only to the initiated. In the pre-colonial context, the Ekpe society (known as Egbo in pidgin English) functioned as the government of the day, using the fearful aspect of the cult to enforce law and order, and protect the rights and property of its members. Today the society has little authority, although status is still attached by many people to membership, and important cultural traditions are perpetuated through its ceremonies.

Masqueraders in multi-colored costumes with raffia manes around the chest, as well as at the ankles and wrists, run and dance (never walking) like the leopard (figure 3.8). These masked figures represent the different grades. Except for special occasions, such as a coronation, the various costumes are not seen by non-initiates. Only two types are generally seen in public as they clear the way for the *ekpe* and deal with miscreants. Their characteristic body costumes of knitted fiber or rope are either dyed black or have stripes of black, red and yellow, recalling the ferocity of forest animals (Ekpo 1978). The one masquerader serves as messenger, *idem ekpe* or "body of Ekpe," but is believed to represent a forest spirit. Some of the leopard figures wear a hat or cloth-covered disk which hangs from the neck. Robert Farris Thompson interprets this disk as

a Janus form, granting the spirit-dancer extra eyes and special vision which are often represented as appliquéd mirrors (1974:182). The bell worn at the waist is attached by two sashes, red and white. The associations of the spirit with the dead are alluded to by the sashes which refer to mourning bands. In his hands, he carries and shakes leaves which denote his forest origin. Sacrifices may be performed before certain costumes are donned. It is also claimed that possession occurs when particular costumes are worn.

The performance or "play" of the leopard-spirit maskers is a complex and impressive display of mime, esoteric knowledge, rhythmic movement, drumming, and singing (ibid.:184; Leib and Romano 1984). Powers are challenged, harnessed and transformed—whether it is the wild power of the leopard, the authority of the elders and the ancestors, the nascent powers of initiands, the misused powers of criminals, or the well-being of the community. The myth of the origin of Ekpe, as reported to Talbot (1912:46–8), tells of the interactions between human and spirit beings from ghost town and how Ngbe ("Leopard") stole the magic drum given to Nki. Ngbe beat the drum so hard that seven "images," as they are called, sprang out, each armed with a whip and began to flog him. Ngbe then proceeded to break the drum in fear and anger, and threw the pieces into the forest. The "images" could no longer return to their home in the long drum so they ran into town, beating all who came in their way. This is the reason given for the erratic and excited behavior of leopard masqueraders today (Ottenberg and Knudsen 1985).

The secrecy and divinely sanctioned activities of associations like Ekpe or Ngbe are further expressed in the *ukara* cloth, an indigo stitched-and-dyed cloth imported from Igboland (where, interestingly, Ekpe activities have less

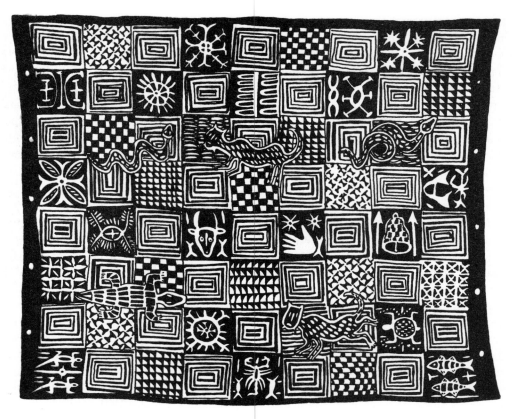

Figure 3.9 *Ukara* cloth, Igbo (Aba), Nigeria. X84–24, Museum of Cultural History, University of California at Los Angeles. After Cole and Aniakor 1984:60, fig.97.

secrecy attached to them). The cloth is traditionally used as either a wrapper, worn by high-ranking members of Ekpe who often custom-design it, or as a backdrop in the throne-rooms of chiefs or kings. It also features in some masquerade costumes, such as Nkanda. For the burial of its members the society would erect a tent-like structure, the walls made of *ukara* cloth, in the deceased member's house (Bassey n.d.). The secrets of the society are believed to be brought to the temporary cabin. Hung in Ekpe lodges, it served to demarcate the boundaries between initiated and uninitiated, hiding the source of the "leopard voice." This large rectangular cloth (smaller and banner versions do exist) is

divided into seventy-two or eighty squares, superimposed by three to five large stylized animals (Cole and Aniakor 1984:59) (figure 3.9). The squares (or rectangles) are composed of four design-types: a) concentric rectangular boxes; b) various checkered patterns; c) representational motifs, such as fish, scorpions, crocodiles, hands, moons, stars, etc.; d) abstract or geometric signs from the secret, ideographic writing system known as *nsibidi* (Battestini 1991). There are both naturalistic and abstract references to the leopard (*ekpe*), such as in the bold, checkered patterns, symbolizing the leopard's multiple spots (figure 3.10). The pythons and crocodiles also refer to the fearful and mystical power of the Ekpe society. The

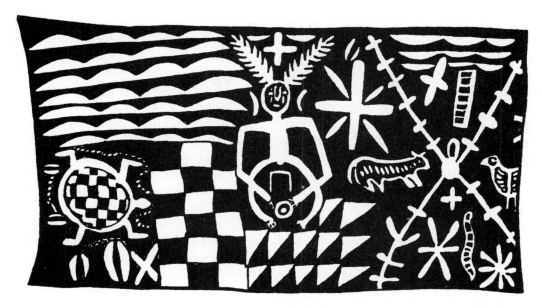

Figure 3.10 *Ukara* cloth, detail, Igbo (Abriba), Nigeria. X84–27, Museum of Cultural History, University of California at Los Angeles. After Cole and Aniakor 1984:60, fig.99. This section shows clearly the abstract references to the leopard whose spirit empowers the Ekpe secret society. The peacock feathers attached to the head of the masquerader figure denote membership of the secret society.

various *nsibidi* signs, which refer to the ideas and values which bind people together, as well as the mystery and prowess of the society, also find parallel expression in the mimes performed in public by members of the society (Thompson 1974:180f.). Just as some oral traditions speak of women founding Ngbe/Ekpe and men later wresting its secrets from them (Hackett 1989:35), early accounts of the making of cloth suggest it was a dangerous activity, done secretly by post-menopausal women (rather than openly by young males as seems to be the case today) (Cole and Aniakor 1984:59).

Ekpe symbols and titles have persisted as expressions of authority, even with the advent of missionaries and colonizers in the nineteenth century. Up until today, the Efik king, or *obong*, must hold the Eyamba title—the highest rank in the Ekpe society. Yet archival photographs of Calabar kings depict them displaying the regalia of Western European royalty. Nicklin's analysis of the photographic portrait of a Calabar chief (identified by him as Prince Archibong II) points to the intermediary and puppet-like role of such a chief with regard to the colonial administration (1989). His symbols of indigenous office and Ekpe status, such as woven string cap, staff and stool, took second place to brass objects, scepters, crowns, thrones, and imported hats and costumes. This combination of roles and regalia is clearly seen still today at such important events as the coronation of the Obong of Calabar. At the public ceremony which takes place at Duke Town Presbyterian Church, just across the street from the main Ekpe lodge, a veritable array of imported and indigenous forms of dress are visible, together with the masked leopard figures who greet and challenge the new ruler as he enters the church grounds.

95

Concluding Remarks

Any consideration of the relationship between art, leadership and religion reveals a great diversity of materials and forms employed artistically to express ideal qualities, dramatize rank, and generate power and status for leaders and institutions. Yet it would be a mistake to assume that all African rulers derive their powers from ritual objects or from spiritual sources, and that this relationship does not change over time. The Azande, for example, see the basis of Zande power as the person of the king himself, and view their arts in a predominantly functional light (Schildkrout and Keim 1990:221). It would also be a mistake to view particular objects in isolation from performance, ensembles, cosmologies, etc. It is within the ritual context that a complex negotiation of forces and symbols occurs, recalling mythical and historical events, and evoking divine powers and experiences instrumental to the construction and maintenance of authority.

The multivalency of the materials used in the creation of art works of status is worth recalling. For example, raffia is used in the leopard society masquerades of the Ekpe or Ngbe society in southeastern Nigeria and southwestern Cameroon, pointing to the forest origins of the leopard spirit, but also the apotropaic and mysterious powers of raffia. Materials such as brass and copper may not only signify political authority but also protective and divinatory qualities (Herbert 1984:254f.). While materials such as ivory and metal were used by the Mangbetu to symbolize status, unworked and natural materials were thought to endow more or at least equal power,

because of their medicinal and generative properties (Schildkrout and Keim 1990:235).

In the variety of artistic forms employed to express the power of the leader or ritual specialist, the less obvious ones should not be overlooked—whether musical instruments (e.g. Schildkrout and Keim 1990:202f.) or entrance posts (Roy 1987:170-2). We have also seen how leadership regalia often incorporate "the ambivalent and dangerous qualities of the wilderness into symbols of power" notably through the use of animal skins and body parts (Anderson and Kreamer 1989:77). The chapters on magic and divination, and death and the ancestors, will also treat the delicate balance between human and cosmic order that people of status in Africa are expected to preserve.

Notes

1 See Preston, 1985:17f. My title for this chapter is derived from Preston's discussion of how ensembles express the basic themes of African art.

2 The problem with the comparative approach as adopted by Fraser and Cole is that it glosses over differences in order to discern similarities in terms of form and function. Furthermore the emphasis in the book on the visual arts of centralized societies leads to generalizations about the leadership arts.

3 W. Arens cautions against "overly simplistic dichotomies" of sacred and political authority, "The Divine Kingship of the Shilluk: a Contemporary Reevaluation," *Ethnos* (Stockholm) 44, 3/4 (1979):175. In the case of the Shilluk he argues that "the truth might well lie somewhere between the two extremes" given the historical and cultural complexities of the institution.

4 Schildkrout and Keim argue that royal shrines and regalia are not a feature of Zande kingship (1990:221). Almost all their arts are functional and the "basis of Zande power was the person of the ruler himself, not sacred and magical qualities seen as inherent either in his person or the office he occupied."

CHAPTER 4 Revealing and Concealing:

The Art of Initiation and Secret Societies

Life is full of transitions from one status or condition to another. Africans frequently mark these transitions with collective rituals. Daniel Biebuyck here addresses the varying scope and character of the widespread initiation systems:

> They are concerned with the solution of various crises in the life cycle of individuals and occur at such critical stages as social puberty, nubility, investiture and enthronement, adoption into age- or cult-grouping, accession to or promotion in associations, acquisition of specialized skills. Various functions are performed by the groups of individuals constituted through these initiations, which regardless of other characteristics, involve a process of systematic teaching and learning (duties, skills, moral code of behavior, rights and obligations, supporting texts, objects, rhythms) (1968:36).

While variations occur in terms of formality, ceremony, participation, periodicity and secrecy, these rites of passage dramatize the change in status both for the individual and the wider society. In many parts of Africa it is the male and female secret societies which are responsible for these rituals. Western observers have long been intrigued by the perceived "mysteriousness" and "secrecy" of the ceremonies (see, for example, Butt-Thompson 1969). The significance of the secret societies in commissioning art objects and transmitting artistic styles across cultural, linguistic and political boundaries has long been recognized

and is a major focus of this chapter (Schildkrout and Keim 1990:239).

The visible, social aspects of initiation have been more readily described by anthropologists, but Dominique Zahan argues that these are not its essential features: "[I]nitiation in Africa must rather be viewed as a slow transformation of the individual, as a progressive passage from exteriority to interiority. It allows the human being to gain consciousness

Figure 4.1 Mask, *lukwakongo*, Lega, Zaire. Stanley Collection of African Art, University of Iowa.

of his humanity" (1979:54). He adds that the absence of initiatory practices should not imply the absence of spiritual life since the latter is more commonly "developed, perfected, and completed by constant meditation." Just as Zahan is keen to research the deeper significance of initiation, Donatus Nwoga stresses the ontological implications of the initiation process. He singles out identity as the essential human component and primary statement of reality for the Igbo people. While identity is made manifest in biological, social and religious activities, the latter do not define the person. He goes on:

> Initiatory rites act on that identity to release it for heightened performance of the person. *Ima ogwu* refers to the strengthening of this personal identity and is quite a different thing from religion. Religion involves interaction with deities. *Ima ogwu* is more internal to the person, invigorating the inner forces of the person in his interaction with both men and spirits and deities. In masquerade performance, it is this identity that is transformed (Nwoga 1984a:46).

Through adult initiatory rites the community equips the Igbo person, therefore, for the fullest realization of human potential. Nwoga adds that spirituality may become a handicap to a person's status (ibid.:55). Biebuyck expresses reservations about over-emphasizing the religious component of initiation systems at the expense of their didactic content or socio-political context (1968:36). This chapter will seek to balance the internal and external aspects of initiatory rites and associations, and to respect the multi-dimensionality and multivalency of their complex, varied and changing forms of artistic expression. Questions of perception and representation are paramount in the control and distribution of power and knowledge, both of which are central to initiation rituals and secret societies. The 1993 exhibition and accompanying catalogue on "Secrecy: African Art that Conceals and Reveals" curated by Polly Nooter at the Museum of African Art in New York examines how art uses specific aesthetic devices, such as ambiguity, concealment and aniconic symbols, to embody secret knowledge and how this is transmitted through initiation and kingship rituals (Nooter 1993).

Initiation ceremonies have been reported from the various parts of Africa since the nineteenth century (Sieber and Walker 1987:46). The fortunes of the male and female secret associations which are responsible for the inductions and training have wavered in the post-colonial period, with the challenges of different governments, and Christianity and Islam. The male Poro and female Sande associations still remain a strong presence in many parts of Liberia, Sierra Leone, and Côte d'Ivoire. Yet Harley, a medical missionary, reported during the 1940s being given masks by his informants (some of which dated back to their grandparents' generation in the 1850s) for safe keeping, given fears of neglect or repression (1950). *Mukanda* circumcision rites were of major importance as a rite of passage for young Pende men (in present-day Zaire) until about 1930 (Biebuyck 1986, Vol. I:223). While some associations have declined, others continue to persist after having adjusted to modern times, by shortening the period of confinement, for example, or situating it during the summer vacation. Roberts reports the development in more recent times of a spirit possession cult among the Tabwa of Zaire, which is a form of initiation using beaded masks (see plate 3), providing an important sense of spiritual and personal transformation in the difficult colonial and post-colonial periods (Roberts 1990b).

The transition from childhood to adulthood is perhaps the most frequently celebrated with artworks (Sieber and Walker 1987:46) and

therefore merits the most discussion in this chapter. The initiation procedure, which may be very lengthy, involves not just the display and manipulation of a great variety of objects, both manufactured and natural, but also oral and dramatic performance, and music and dance (Biebuyck 1968:37). Yet Biebuyck cautions us not to judge the importance of an object by its aesthetic complexity or manifest usage. Sometimes the simplest figurines may be the most profound and secret iconic devices to the people themselves. This is well illustrated by the art of the Bwami society, an age-grade hierarchical association among the Lega of Zaire. Masks such as the one shown here are owned primarily by members of the second highest grade (which only very few men attain) (figure 4.1). They may be fastened to the face, other parts of the body, carried around or attached to a fence or the central pole of the initiation hut (Biebuyck 1973: pl. 62; Roy 1992: notes to fig.77). Masks are linked to the dead, and therefore symbolize the continuity of *bwami*. The anthropomorphic, ivory figurine, known as *iginga*, which is illustrated here (figure 4.2), is owned by members of the highest grade of *bwami*. It is used in different phases of the initiation process, either as part of a configuration or danced with by its owner.

Indications of the significance of an object may come from the way in which it is made, protected, avoided, handled and/or stored. For example, Ottenberg describes how sacrifices must be made to the spirit of the secret society (*egbele*) of the Afikpo Igbo if an uninitiated person sees any aspect of the carving process of the masks (1975:74). This is done to prevent illness, death, barrenness or any other misfortune from occurring. Women of childbearing age among the southern Kuba avoid the masks ("masks have a power, the power of nature spirits" stated one woman) and even the smallest piece of raffia which might have

Figure 4.2 *Bwami* ivory figure, *iginga*, Lega, Zaire. Stanley Collection of African Art, University of Iowa.

fallen from a male novice's costume (Binkley 1990:161).

The symbolic and physical transformations and marking of the body which occur as part of these rites of passage are important signifiers of changes in social status, as well as more hidden, spiritual meanings. The esoteric aspects, although variable, of these ceremonies and associations, allow us to examine more general issues of secrecy, knowledge, power and gender. The generation, representation and interpretation of secrecy within these organizations has interested a number of scholars. Earlier studies (Zahan 1960; Turner 1967) worked on the notion that the meaning

Figure 4.3 Mother and child figure, Senufo, Côte d'Ivoire and Burkina Faso. Stanley Collection of African Art, University of Iowa. The figure represents the old mother of the village, the central divinity of the initiation cycle, who nurses adolescents with the milk of knowledge before redelivering them as initiates. It also reminds people that the first *poro* society belonged to women before it was seized by the creator god who gave it to men to punish women for their wickedness (Roy 1992:25).

of a particular cult, etc. was only known to neophytes and anthropologists once the whole range of symbolic associations was known (Poppi 1992). More recently a number of writers have rather focused on the *pragmatics* of secrecy—the way in which the polysemic nature of symbols is manipulated in different

contexts. Poppi, for instance, in his study of the Sigma initiation society in northwestern Ghana, explores the paradoxes of secrecy. He argues that there is an inverted, proportional relationship between the power of an object and its "iconic and semantic opacity." Cult objects (epitomized by the bullroarers) lend themselves to this disjunction of form and content—non-initiates "see" an object but do not "understand" its meaning. The notion of secrecy may be expressed not only through the manipulation of symbols or by location (forest, bush) but also by time. The Beti of Cameroon consider the night, or *alu*, to be the time for secret activities, as well as for the mysteries of procreation. The critical moment of the boys' initiation rites takes place in full daylight but is referred to as the "Night" (Laburthe-Tolra 1985:7; cf. also the Bangwa Night Society masks, Brain 1980:149–51).

In terms of gender, initiation rites for girls may not be as common or as elaborate. They may also involve the use of different materials, such as pottery images as in the case of the Chisungu, or nubility rite, among the Bemba of Zambia (Richards 1956), and the girls' initiation ceremony or *cinamwali* among the Chewa discussed below (Yoshida 1991). Zahan attributes this in part to the belief in some societies, such as the Bamana, that women are considered as naturally carrying knowledge within them (1979). Alternatively, as among the Chamba, it may be held that girls achieve adulthood through the development of their bodies and through marriage, whereas adult males must be made through circumcision (Fardon 1990:95). Women's exclusion from the secret societies and their attendant rites of initiation is explained by some scholars in terms of a theory of matriarchy (Pernet 1992:136ff.). In other words, men created secret societies to resist and reduce women's former religious, economic and political

supremacy. (This is the case of the Poro, a secret society for Senufo men, discussed below, yet women's original power is still recognized and respected—see figure 4.3). Masks were the symbolic means whereby power was wrested from women and male domination was established. Pernet demonstrates the untenability of this theory, given that masks can exist without secret societies and vice versa. At very least one must say that the relationship between women and masks is complex, nuanced and differentiated. The dangers of generalizing are also reflected in the varying levels of participation in both the secret societies and rituals of puberty and death. Some societies admit all males without restriction whereas others are more selective. Women may play crucial roles behind the scenes in certain rites.

Initiation Masks

In a number of cases, masks play an explicit and central role in the process of initiation. This is especially true for the male Poro and female Sande secret societies of West Africa which are important local-level associations, found among the Mande-speaking peoples of

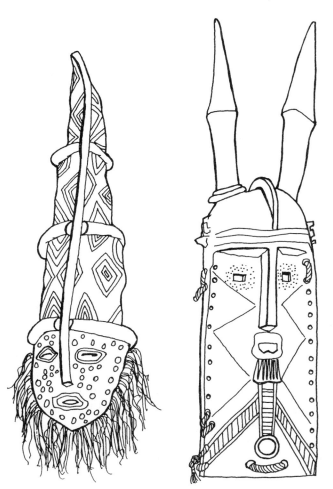

Figure 4.4 Mask *cikunza*, Chokwe, Angola, Zaire, Zambia. Private collection.

Figure 4.5 Mask, *polo*, Bobo, Burkina Faso. Stanley Collection of African Art, University of Iowa. The masker either wears a costume of leaves or dances nude to emphasize the opposition between village and wilderness. These masks meet the initiates coming from the forest at the entrance to the village and beat them to remove traces of the wilderness.

Figure 4.6 *Ejumba* mask, Diola, Senegal. Acquired in 1927 by the Museum für Völkerkunde, Frankfurt, a.M.

its ancestors. They are discussed in more detail in chapter seven in connection with funerary rites. The Chokwe mask illustrated here (figure 4.4) is the most important circumcision mask employed in the *mukanda* initiation camp. The boys are taught that this mask, the *cikunza,* embodies the spirit of fertility and good hunting. It appears as a type of hybrid nature spirit, with symbolism relating to the grasshopper. The conical top of the mask is imitative of an antelope horn, which can be charged with powerful substances in ritual contexts. The mask leads the initiates through the transitional period of the *mukanda.* Some masks, such as the Bobo blacksmiths' mask in figure 4.5, serve to reintegrate the initiates into society by removing the wilderness from them as they return to the village.

The Diola of the Lower Casamance region of Senegal are predominantly wet-rice farmers with many of their northern people having converted to Islam (Mark 1988:139–46). Even so, the *bukut* initiation, with its cattle-horned headdresses, survives. There are in fact two types—the horned mask (*ejumba*) and the horned cap (*usikoi*). They are an integral part of the initiation ceremony, with the dancing and drumming providing the necessary energy to bring the headdresses to life. The men's initiation ceremony is the most important ritual occasion in Diola society, being celebrated only every twenty years. Sacrifices and feasting precede the circumcision and initiation retreat in the sacred forest. On the day of the exit from the forest, some of the initiates wear the full-faced *ejumba* mask.

Bovine imagery is central to the symbolic meaning of the *ejumba* mask (ibid.:141). To the Diola, the ownership of cattle is an important form of wealth. Cattle are sacrificed only at men's initiation and funerals. Horns signify the wealth of the deceased as decoration on his house, but they were also associated with

Liberia, Sierra Leone, Côte d'Ivoire and, to some extent, Guinea (where Poro was outlawed). There are regional variations and sub-groups. All men and women are expected to join the societies and a Kpelle proverb states, "[t]he Poro man is in the stomach," indicating the expectation that the new initiate already knows how to keep a secret. The societies train them about secrecy, about the consequences of inappropriate disclosures and about assuming their respective gender roles. Poro and Sande are also concerned with local governance, adjudication of disputes, and imparting of social knowledge and protective techniques. Initiation involves a period of seclusion followed by a year-long period of initiation. The animal-like Poro masks in particular play an important role in invoking the spirit world and reinforcing the authority of the association and

witch-finding. The horns on the funeral bier were believed to lead the corpse to suspected witches as it was borne around the village. Mark notes also the aggressive and sexual power symbolized by the horns. The *ejumba* are "an abstract amalgam of bovine and human elements" (ibid.:142) (figure 4.6). Tubular eyes protrude from the ambiguous bovine/anthropomorphic form, which is covered by a tightly woven palm fiber. This ambiguity is appropriate given the liminal stage of the initiates between childhood and adulthood. Among the items used to decorate the masks are red seeds, shells and small mirror shards—all believed to protect the owner from witches. This explains Mark's difficulty in seeing an *ejumba* mask while conducting his fieldwork and the fact that only those born with "clairvoyance" may make and wear the mask. The spread of Islam in the northern areas is contributing to the decline of the use of the mask and to a simplification of initiation rituals.

Bamana Initiation Societies

The various initiation societies of the Bamana peoples provide us with rich data on the relationship between art and initiatory practices. The rites in the various initiatory grades—the *N'domo, Komo, Tyi Wara, Nama* and *Kore*—are all centered upon agriculture (Brain 1980:72f.). The masks appear in the dry season to celebrate the onset of the new farming season. In the wet season, they come to "help" with the weeding and harvesting, and appear during initiation ceremonies and the funerals of great initiates. Zahan attributes more importance to the mystical aspects of the masks and rites than the mere parallelism between human and crop fertility (1960).

The *N'domo* is the first of the cult associations that a young boy must go through before joining the other societies. Following

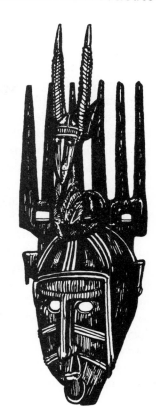

Figure 4.7 *N'domo* mask, Bamana, Mali. After Brain 1980:76, fig.4.2. Carved in the Segu substyle, the mask shows an antelope mounted on the forehead.

circumcision at the age of seven or eight, the young boys go through the various stages of *N'domo* over the next five years. In this association they begin to learn the farming duties and corporate discipline, as well as the rituals and masking, that they will practice all their lives in one or another of the initiatory associations. In fact, Zahan goes as far to say that the boys are the instruments of the rites, as yet unaware of their deeper meanings (1960: 43). The boys farm a ritual field, re-enacting the creation myth when the Bamana abandoned their nomadic life of hunting. Not only is the harvesting and feasting symbolic, but the preparation of the masks also prepares the future farmers. The cult objects are taken to the *N'domo* fields to reactivate the forces of germination. Other cult activities involve exuberant dances and collecting food for their

feasting. They eat beneath the sacred tree of their society and its protective spirit, offering sacrifices, dancing and recalling the myth of creation. The dances link their precious staple crop, millet, with the sky, the sun and the forces of the cosmos. The life and death of humans is paralleled with that of the growth of the millet through the energetic dancing of the *N'domo* masker. There is a message of rebirth and reciprocity.

The most important and striking feature of the *N'domo* mask is the horns, carved from the same piece of wood and rising upwards in one row, like stretched fingers, above the top of the head and on the same plane as the ears (ibid.:76) (figure 4.7). They are usually eight in number (but may be less) and are usually of the same length (10–15cm). The mask is said to symbolize the millet and next season's fertile harvest of corn. It usually has an anthropomorphic face, oval in shape, with an exaggerated nose (the latter signifying the social character of human beings [Zahan 1960: 79–80]); the forehead is sometimes surmounted by an animal or mythical human figure. There are varying interpretations of the symbolism—Dieterlen sees the horns as schematically recalling the various episodes of the creation myth (1951). The horns represent eight primordial seeds created by God for the building of the universe and the masker is the sower of discord, the first child of God who stole the seeds from the sky in an attempt to appropriate the universe (Brain 1980:77; Zahan 1960:75).

For Zahan, the horns are associated with the growth of grain and an analogical extension of the human liver; in human beings the liver is viewed by the Bamana as a connecting point between the human soul and body, and between the spiritual and physical principles represented in blood. These forces are released during the blood sacrifice of animals, when the liver is carefully removed, shared and eaten by ritual experts. Furthermore, the form of the chief *N'domo* mask, *n'domo ku*, is believed to have emerged from the hands of *N'domadyiri*, or God, and to represent through its silhouette, its decoration, and its horns, the essence of humanity (ibid.:78). Such notions are also tied to the types of wood used to make the mask. Most preferred is *m'peku*, the original wood of the first mask and a symbol of abundance and human multiplicity because of its plentiful fruit production. The costume of the masker— covering the entire body—is also important, according to Zahan, signifying the hidden, interior life of humans (ibid.:pl.1). At the higher levels of initiation into Kore, the mystery of knowledge is conveyed by the teaching that "the light of knowledge is in a bag" and visually reinforced by the sack-like costume of the "lions" or young initiates (ibid.:54–8). The lion is also considered as the symbol of teaching.

In the Komo society, Bamana cosmology is taught via hundreds of signs. Some are drawn into the ground before sowing. The movements of the sun are represented by zig-zag lines and are found in all agrarian and rain-making rites. They are even engraved on tools and traced in millet porridge during certain religious ceremonies. The Bamana associate the snake with the sun's movements and equinoxes. In the ritual field where edible plants are cultivated, a hollow-headed mask may be found, together with simple tools, representing the ancestors who first used the tools, in the midst of a shrine on a stick pole. Sacrifices are poured down into the ground through the hollow stick, establishing contact with the earth, the dead and the living. There are seven cicatrized marks on the forehead of the mask which symbolize the first Bamana word. These lines are also traced on the forehead of a newborn baby. On the Komo head may also be found two incisions under the eyes to give it

double sight—so that it can observe everything going on in the field and at night. Again, interpretations vary. The mask is said to represent the hyena who is the great labourer of the earth and the guardian of life, therefore connoting continuity and tradition, cohesion and order.

The masks are also said to be made out of the elements of the universe—water, earth and sun—linking them to a cult of increase and Faro, the great creator (ibid.:78–9). The hyena appears to children as a stupid animal. In the Komo society, however, they learn that hyenas in fact possess great knowledge and powers to become invisible and devour sorcerers. Blacksmiths are believed to be able to transform themselves into hyenas (McNaughton 1988: 137). Among the Mande the Komo association is owned and led by smiths, yet open to every Mande (the Bamana are a sub-group) male (ibid.:129f.). It is the blacksmiths alone who can make the masks and dance. The masks reflect this air of inaccessibility, through their ambiguity, their fearfulness and various coatings. In McNaughton's words, "[t]hese masks symbolize and assemble power. They portray wisdom while partaking of it. They reach to the very core of what the Mande hold to be the most significant, potent, and sacred aspects of their lives" (ibid.:130). Their names are not pronounced before the uninitiated. They are kept hidden in shrines or the homes of leaders. Komo is expected to protect the community from "acts of natural and supernatural violence"; the Mande feel that the blacksmith-leaders are ably equipped, with their range of *daliluw* ("practical configurations that allow people to accomplish things" [ibid.:42]), to neutralize malevolent and capricious forces and spirits.

What is significant for this discussion is that the most powerful of all the power objects (*siriw*) owned and manipulated by the blacksmiths are the sculptures, whether *boliw* power devices, flutes or masks. Together with the horns articulated in wood and iron known as *komo buruw*, they represent "organized bodies of highly suggestive symbols" (ibid.:131) and which serve to render Komo an exceptionally powerful institution. The masks are the most dramatically powerful of all the sculpture types and this is reflected in the creative process. The blacksmith retreats to the bush, special wood must be chosen and herbal components found. The community believes that *nyama* is unleashed as the mask is made and carefully avoids the spot. Often it is only the mask maker who will be the mask wearer, since only he knows the contents of the work and the *daliluw* present, and so has the strength to wear it.

The mask is also crucial in the transfer of leadership. At the death of a leader his mask is passed to one of his sons. If no one is deemed appropriate to take the mantle then the mask owner will hide the mask, together with his other sculptures and power devices, in a secret place in the bush. The branch of Komo is thereby disbanded and its members join another branch or association. The mask may be rediscovered, sometimes after several generations, when a man receives a sign that he has been chosen to be *komotigi*. He may or may not be related to the former leader; in any event, he is considered to have the personal strength and knowledge to wear the mask. The location of the mask is revealed to him in a dream, through the agency of a spirit or *jine*, associated with the hidden mask. New Komo branches with old Komo masks are considered more powerful, since it is believed that the mask itself sought out the wearer (ibid.:134). So in that respect, McNaughton observes, masks are like people, acquiring power (*nyama*), wisdom and respect over time, and increasing the capacity for success.

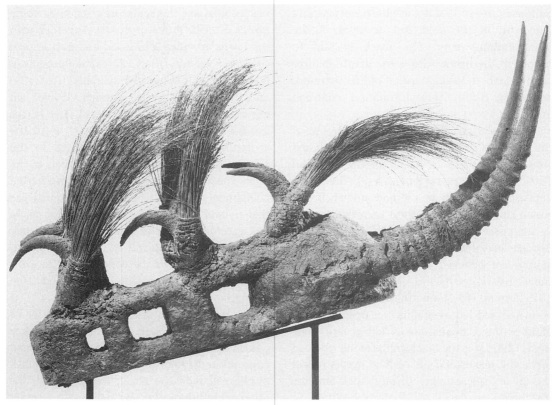

Figure 4.8 *Komo* mask, Bamana, Mali. Late 19th–early 20th century. 69.39.3, Brooklyn Museum, New York, by exchange.

The man who is called to be a Komo leader enters into an intimate relationship with the spirit of the mask; some of these spirits become renowned for their power and effective unions with masks and wearers. The spirit will be present when the man dances in the mask, when he divines and as additional support when he performs demanding tasks such as the destruction of sorcerers. The costume which is worn with the mask may have several feathers and amulets inserted into it, to supplement its power. The mask itself has a central dome-like unit, into which the wearer's head fits (figure 4.8). Large antelope horns curve out from behind the head and sweep along and up connoting "ominous energy" (ibid.:136). The horns also suggest potential aggression and

strength, as well as traditional knowledge, since horns are often used (by many societies in fact) as containers for traditional medicines. Quills may be attached to the top of the mask, alluding to the fact that the smiths can fight sorcerers with the same means as sorcerers use. The enormous size of the mask is significant given that mouths are believed to be sources for *nyama* and that speech is considered to be a potent force. It also depicts the overwhelming power of the association (ibid.:137). The presence of bird feathers (often vultures') connotes knowledge of celestial forces and the power to divine. The surface of the mask is coated with sacrificial materials (as for the *boliw*, discussed in chapter two), producing an uneven, cracked, changing and

Figure 4.9 *Tyi* (or *Chi Wara*) dance crest, a popular design motif.

Figure 4.10 *Tyi* (or *Chi Wara*) dance crest, Bamana, Mali. Stanley Collection of African Art, University of Iowa.

empowering appearance. The masks constitute a visual record of the blacksmith's knowledge and manipulation of *daliluw* ("recipes"), becoming "energy symbolized and energy actualized" (ibid.:138). This together with the "generalized animality" combine to produce an electrifying effect on the viewer.

In addition, the Komo dance performance provides an important dramatic focus for the powers of the mask and wearer. In some cases the dancer may prohibit the wearing of certain colors, red for example, which might threaten or weaken the effect of their own energies. Participants will be asked to interpret a series of signs to prove their Komo membership. After invoking the spirit of the mask and singing

songs which exonerate him from blame, the dancer engages in some rites of detection, then begins to activate energy for the purposes of divination. When he divines while dancing, he becomes an oracle, choosing or composing songs which offer solutions. Since his voice is unclear, the songs are interpreted by a bard to the audience, presenting a fusion of soothsaying, drama and art (ibid.:141). The masker's ability to dance impressively, in spite of the heavy mask and costume, perform acrobatics and purportedly "spit fire" and "spout water" all add to the renown of the leader and their extraordinary capabilities.

The obscurity and ambiguity of the Komo masks are intriguing and can only be

Figure 4.11 *Kore* initiation mask, Bamana, Mali. After McNaughton 1988:pl.43.

understood in the light of the cosmology and conceptions of power. As McNaughton explains, "[t]he goals that define the form of *komo* masks, then produce a kind of sculpture that is antithetical to the general tenets of Bamana aesthetics. To truly judge the quality of a mask, however, the Bamana evaluate more than its form" (ibid.:144). This observation is especially relevant when considering the *boliw* or power objects, discussed below.

The antelope masks of the *Tyi Wara* society are among the most well-known and loved of African masks. The image appears in numerous places in the West—on posters, flyers, book covers, T-shirts—having taken on an almost metonymic quality (figure 4.9). These male and female masks, carved abstractly or semi-naturalistically, represent the sun and the earth using the antelope as an intermediary and instructor on agricultural affairs (Brain 1980: 82–7). The relative homogeneity of form belies

the cosmological complexity of the mask. The antelope on the mask is a supernatural being— half-man and half-animal (figure 4.10). It was believed that imitations of Tyi Wara would give human beings his gift for work so scarifications, designs and images appear on faces, shrines and granaries. Nowadays many of the myths have been forgotten and Tyi Wara is more of a dance association than the secret dance of an initiation society.

While space precludes a discussion of the *Kore* cult association and its monkey and hyena masked dancers and orgiastic ordeals, it further illustrates the multifaceted nature of initiation rituals. In this case, they serve as both fertility, rain and farming rites and rites which demonstrate human perfectability and mystical union with God (Brain 1980:81; Zahan 1960:350, 354). The mask shown here (figure 4.11) is one of several types used by the association in performances to express ideals, often by their opposites, and through the exaggeration and repetition of the relevant behavior of animals (McNaughton 1988:104).

The Nyau Association

The Chewa masked association demonstrates important symbolic and ritual connections between initiation and death. The Chewa people live in the area across the borders of Zambia, Malawi and Mozambique. Almost all boys of between twelve and fifteen years of age are initiated into a masked association known as *nyau* (Yoshida 1991). The major function of the association is to perform masquerades at funerary rituals. In the colonial period in Zambia the association had to operate underground but since independence in 1964 it has been able to perform openly. In Malawi, it has been practiced continually.[1] *Nyau* means sound or the name of an animal, but it also

refers to the society in which humans are in constant communion through dance and performance with spirit forces (Ntonga 1979:113). In Malawi the meaning is interpreted as a "crinkling of the skin, as in fear." There are three types of *nyau* masks. The first type is a feathered net mask which covers the whole head of a masker (Yoshida 1991:215). The second is a wooden face mask, while the third is a large zoomorphic structure which covers the whole body of the dancer. Characteristically these structures dance round and round, and they are known collectively as *nyau yolemba*, "*nyau* which draw circles." The majority of them represent wild animals. Laura Birch de Aguilar reports that in Malawi they do not always twirl in circles. These forms are collectively referred to as wild animals (*chirombo*). The most common form, particularly for funeral and initiation rituals, is the antelope form, *Kasiyamaliro* ("to leave the funeral behind").

In his study of *nyau* as dramatic performance, Ntonga sees the ritual as re-enactment of the Cewa primal myth (Ntonga 1979:115).[2] The dance provides a context for the temporary reconciliation of humans with the animals and ancestral spirits that emerge from the bush. The use of fire, in both the initiation and funerary rituals, to destroy the property of new initiates and the deceased, recalls the role of fire in radically changing the original condition of the cosmos. It also serves to mark the end of the liminal period when individuals pass from one condition to another.

The fact that it is men who disguise themselves as *nyau* is kept secret from women and children. It is taught that *nyau* are dead persons who have been revived and that *nyau yolemba* are real wild animals. This secrecy is maintained in a number of ways, namely through the use of falsettos and nasalized voices; second, the masks are made in the bush

some distance from the village; third, a secret vocabulary is employed to refer to the tools and materials; fourth, riddles and questions are used to determine membership of *nyau*. Also there are sanctions against revealing the secrets of *nyau*—it is believed to entail a curse, whereby the culprit may be struck down by a fatal nose bleed. In reality many women learn from their husbands that *nyau* are men in disguise but they maintain the pretence of not knowing. The men also keep up the pretence that the masked dancers are spirits during the ritual performance. Despite this awareness of the dramatic aspects of *nyau*, Ntonga believes that this does not detract from its similarity with spirit possession cults where animals are believed to inhabit humans (Ntonga 1979:113).

In Zambia, the initiation ceremony for boys wishing to be admitted to *nyau* occurs at the same time as the funerary ceremony. The boys who are to become initiated are known as *namwali*. They are led out of the village at the start of the festivities to the deep bush by an instructor. The latter informs the members of *nyau* that "We are bringing the dead." In response they shout back and set about beating the *namwali* with whips of torn branches. It is at this point that the boys learn that the *nyau* are neither the dead nor animals, but really men of the village in disguise. The repeated whipping is intended to drive away the soul of a child and attract the soul of an adult. They have to bathe frequently in the river and maintain the same posture as that of mourners at a funerary ceremony. They stay with the instructor but during the day they learn riddles and how to make their own mask from the men preparing for the funeral. They are then returned to their parents.

As seen briefly above, the *namwali* were treated like the dead. They are referred to as being "cold." To counteract the ill effects of the encounter of the "cold" and the "hot" spirits of

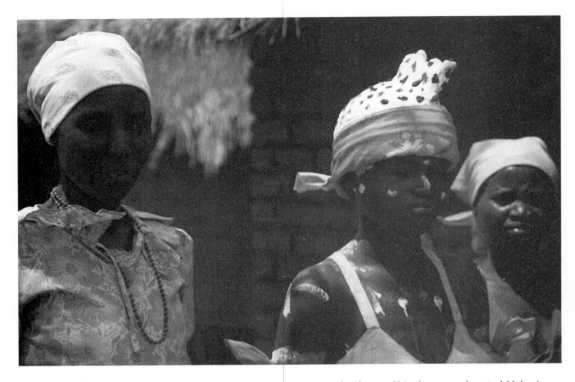

Figure 4.12 Young woman in the girl's initiation dance, wearing a clay figure, Chitedze area of central Malawi. Photo: Laura Birch de Aguilar, 1992.

the deceased, the *namwali* are coated with ashes from the masks to enable them to become as "hot" as the spirit of the deceased. This is why the initiation ceremony is held at the same time as the funeral as it is the only opportunity for the boys to obtain this quality of "hotness."

In the past the girls' initiation ceremony, or *cinamwali*, used to be held at the shrine of a medium of the python spirit called *makewana* (Yoshida 1991:245). Nowadays the links are only suggestive. The ceremony is for girls who have had their first menstruation. The teachings which are transmitted during the *cinamwali* have an air of secrecy about them, in the same way as the knowledge about the *nyau* masks for the boys is protected. In former times the *nyau* always performed in the

ceremony. Following their banning, dramatic elements were borrowed from a neighboring people, the Nsenga. During their seclusion, the girls, or *namwali* as they are also known, are taught through songs and dances the various requirements of a grown-up woman and practical instruction in sex life and child-rearing. The instructor used to take the *namwali* to the bush on the last day of the ceremony to make clay figures or *vilengo*. Yoshida and his wife were able to find two elderly women to reproduce these figures after a hiatus of about forty years. They created a python, a snake, a tortoise, a vessel for drawing water, a hare and a male and a female couple. Nearly all of the figures are associated with water. They are made using the same techniques as for making pottery. Black and

white (sometimes red) dots were used for decorative purposes and to imitate the dotted pattern of the python. Dances and songs were performed to each of the figures by both the instructor and initiate. The latter is also decorated with painted dots, linking her with the power of the python who is believed to be in control of the fertility of the land and human beings (figure 4.12).[3]

Formerly the *nyau* used to take the *namwali* back to her home, or more specifically to her husband's house, for the first intercourse after menstruation. Pregnancy was, and still is, believed to be a process whereby the spirit of a certain ancestor was reincarnated in the embyro. So this was regarded as the first opportunity for the girl to receive the spirit into herself. In fact, the *nyau*, as the spirit of the deceased, would return to the village on that particular night. Yoshida argues, therefore, that .it is possible to attribute the failure of *nyau* to resume its activities at the *cinamwali* after independence to the decline of early marriages due to the influence of Western educational and missionary values (ibid.:251). *Nyau's* religious significance in the Zambian context gave way to a new role in the post-independence period as source of public entertainment and socio-political commentary in public theater. In Malawi, in the villages, *nyau* has not lost its religious meaning, despite the fact that dancers do perform for national events.

Women's Rites

This section highlights further examples of women's initiation ceremonies and the art-works associated with these processes of transformation. In Ghana, the Fante use precious beads or *bodom* as part of their puberty rites (Sackey 1985). These heavy, colorful beads are hung over the breasts and around the waist to transfer their fertility potential. An ancient Asante belief attests even to the reproductive power of beads to give birth to humans. The children of Asante kings were washed in powdered *bodom* beads to increase their growth. There are various accounts as to their mystical origins, their emergence from the ground, particularly in the forest. Sometimes they are supposed to take the form of or sound like a dog ("bodom" is the Fante word for "dog"). It is believed that when buried and subject to seasonal libations, the beads may reproduce.

Bamana mud-cloths, in particular the *Basiae* and *N'Gale* cloths, are worn following excision (the ritual surgery that transforms girls into women) (Brett-Smith 1982). Since they are both believed to possess *nyama* (potent, generally harmful, spiritual force), Sarah Brett-Smith was able to understand the importance of these cloths by studying the *nyama* of children, since this is believed to commence at birth. The Bamana hold that this negative power is contained in any action, thing or human being waiting for a catalyst "to unleash its disastrous effects" (ibid.:16). The *nyama* of children is considered to be strong since they come into the world from the realm of the ancestors and generally display extraordinary powers and fearless behavior. The Bamana believe that excision and circumcision serve to mold and stabilize a child's character, in addition to instruction. As a precaution, immediately following the operation where powerful blood is shed, the new adult is dressed by her sponsor in "red" *Bogolanfini* (mud-cloth) of either the *Basiae* or *N'Gale* design. After four weeks of healing seclusion, there is a coming-out ceremony for the women. The *Basiae* design (although this is also the generic term for the cloth) is a "severe pattern of black and white lines divided at regular intervals by a white zigzag design" (ibid.:26) (figure 4.13).

Figure 4.13 *Basiae* cloth, Bamana, Mali. After Brett-Smith 1982:24.

The second type of cloth is "composed of large and small white circles on a dark ground framed by a rectangular grid."

The production of *Basiae* cloth, in general, is considered to be a more spiritually dangerous operation than that of other types of cloth. This cloth is worn at critical, transitional moments in a woman's life: after childbirth, prior to consummation of the marriage, and at death. The porous *Basiae* cloth is able to absorb the blood from her wounds and the *nyama* released by the excision. As Brett-Smith observes of the reaction of her informants, "[n]o wonder that *nyama*-infected *Basiae* is an object of fear and awe, the complex circular motif seeming to lock this formidable power into the very fabric of the cloth" (ibid.:27). The cloth, with its protective powers, is treated in a distinctive way in the course of the seclusion. The color and pattern of the cloth are designed to scare off people (sorcerers) who might want to interfere with the healing process. The newly excised girls, as they acquire their sexual and reproductive powers, are held to be very vulnerable to the ill intentions of family and especially co-wives. It is the sponsor who takes possession of the *nyama*-impregnated *Basiae*, not just to guard it from misuse and theft by sorcerers, but as a visible sign (for the sponsor wears it daily) of the bonds of trust and affection between young and old women. But it is also a question of power. In Brett-Smith's well chosen words:

> Wearing a *Basiae* cloth impregnated with the *nyama* of childhood, a powerful woman elder moves imperceptibly closer to the shadowy void where generations mix and fuse. Wrapped around an aged body, the mysterious powers of infancy are safe and secure as they slowly disperse into the invisible realm of the dead, leaving their bearer just this side of that final transition (ibid.:29).

Lisa Aronson (1991) points out that in general most female-produced initiation art falls within the category of body arts and coverings. She highlights some of the work

done by scholars on body markings (e.g. Berns 1988), notably in the way some of these body designs are applied to other media such as on the surfaces of architecture, granaries or burial pots. The fact that men use some of these female-associated symbols suggests the perceived potency of such symbols.

Wooden masks are a common feature of men's initiation rituals, but virtually non-existent in women's rituals. Perhaps the most notable exception is the head mask (*Sowei* or *Sowo*) (figure 4.14) which incarnates the spirit of Sande or Bundu or Bondo, the female counterpart of the male Poro society, found throughout Liberia, Sierra Leone and neighboring countries. Gola (male) informants told d'Azevedo that Sande had preceded Poro but proved to be unsuitable for defence purposes, leading to the development of Poro (d'Azevedo 1973b). Today the two associations complement each other in the task of instituting and protecting social roles and values, and both use clay facial coverings and masked performances. Sylvia Boone has focused on the ways in which Sande communicates ideals of womanhood, together with female principles and aesthetics in her book on Mende notions of female beauty in Sierra Leone (1986).

Organizational structure varies in Sande societies, but there are generally lodges, headed by a Sowei from the *sowo* rank, who is viewed as the arbiter, teacher and healer of women. The Sowo mask is the spirit counterpart of the Sowei, and embodies the social ideals of Sande (ibid.:37f.). But the transcendent womanhood of the Sowo mask is counterbalanced by the comical and ridiculous Gonde mask. The sacred initiation grove, where the girls are instructed by their female elders, is both physically and metaphysically a world apart—it is talked of as an underwater paradise of beauty and peace. The more important masks, distinguished by their classical, un-

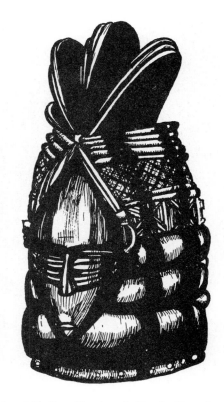

Figure 4.14 *Sowei* head mask, Mende, Sierra Leone. Stanley Collection of African Art, University of Iowa.

adorned form and white headties, and restricted use for the Sowei and in the shrine, are believed to have emerged from the sacred waters. The sculpted helmet mask (*sowo-wui*), made of polished black wood, is combined with a black raffia and cloth costume (ibid.:153) and appears only four or five times a year. Resting on the (female) dancer's neck, the coiffure, fine, compact features and neck rings are clearly visible. According to Boone's informants, these neck coils are said to resemble the ripples created by the spirit emerging from the water (ibid.:170). When the Sowo leaves the camp to dance for the public, it is said to be coming from the water, a re-enactment of its original arrival (figure 4.15). The tightly pursed lips denote self-control and silence—the character-

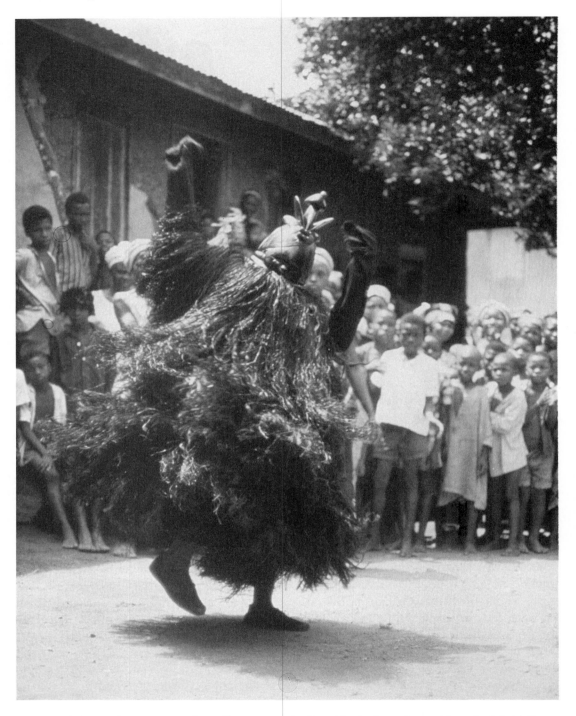

Figure 4.15 *Sowei* dancing in Ngiyehun Village, Luawa chiefdom, Mende, Sierra Leone. Photo: Ruth B. Phillips, 1972.

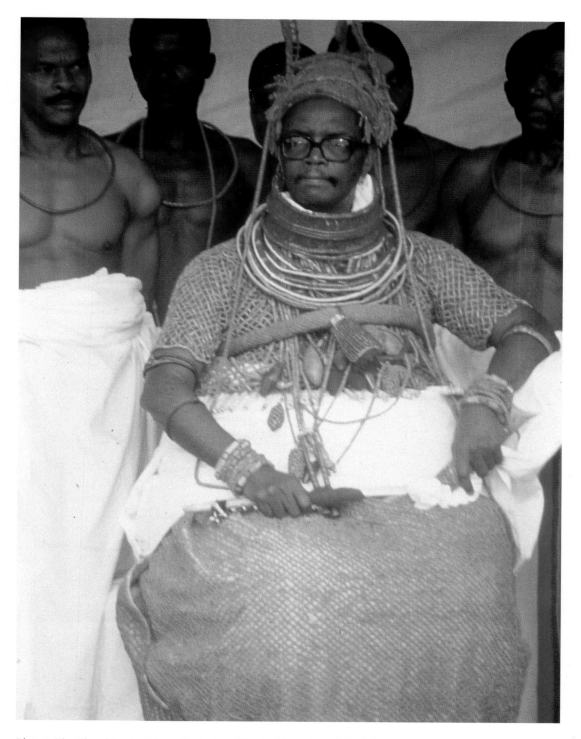

Plate 1 The Ọba of Benin at Igue, Benin City, Nigeria. Photo: Joseph Nevadomsky, 1978.

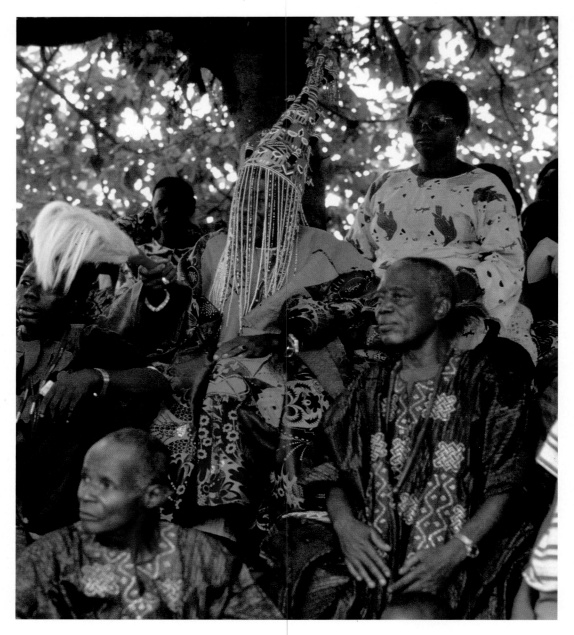

Plate 2 Ọrangun-Ila, William Adetona Ayeni, Ariwajoye I, Ọba of Ila Ọrangun, Nigeria. The photo was taken at the concluding rites, known as Isinro, of the festival for the King's Head, Ebora Ila. Photo: John Pemberton III, September 1984.

Plate 3 Tabwa beaded mask, Zaire. Glass beads, leather, rooster feathers, monkey pelts. Height 87.5 cm. x1990.656, Stanley Collection of African Art, University of Iowa.

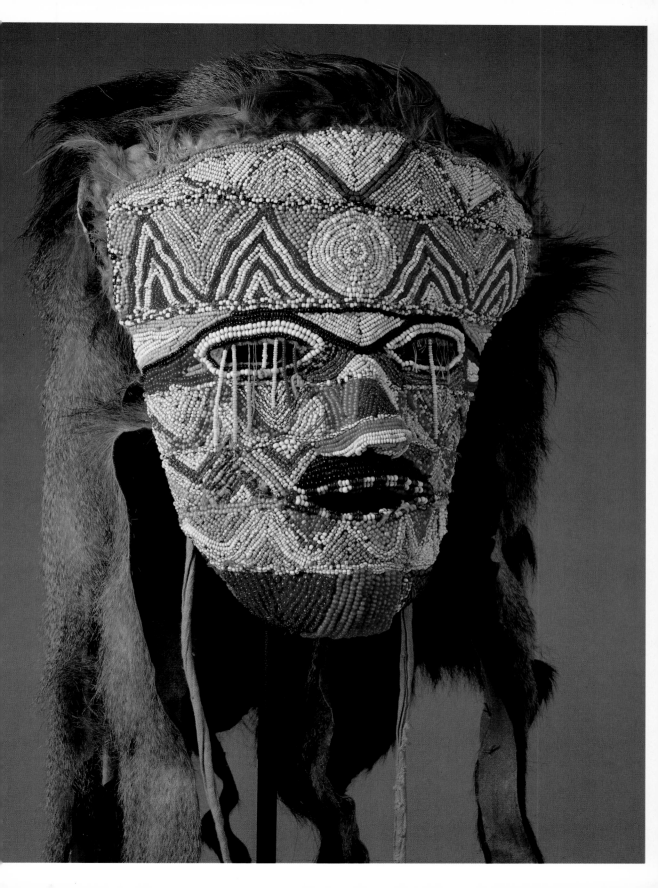

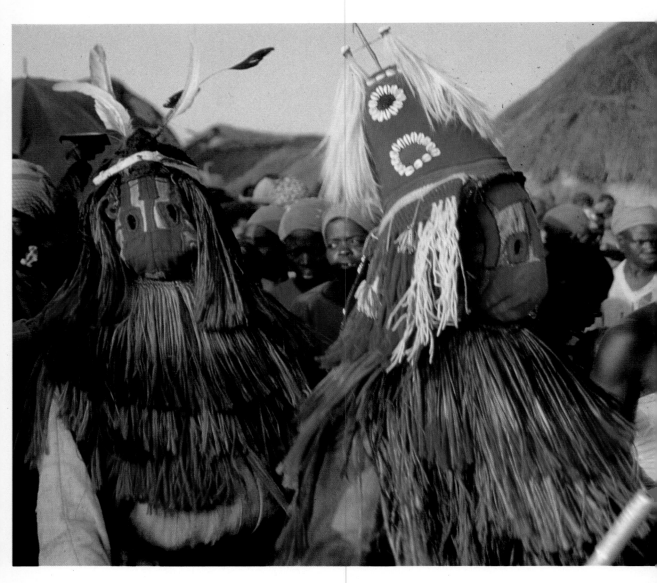

Plate 4 Poro *Yarajo* masks, Senufo, Côte d'Ivoire. Photo: Till Förster, Nafoun, 1987. They are shown dancing during the last day of mourning.

istic of important persons and spiritual beings. The slitted eyes reflect Mende belief in the contrast between clear, human eyes and veiled, supernatural ones, as well as being alluring and chaste for male onlookers and disguising the wearer. The Mende attribute a great deal of "communicative power" to women's hair (ibid.:184f.). Well-groomed, luxuriant hair serves to identify women with the female principle of God, *Maa-Ndoo*, the Great Mother Earth—whose "hair" or verdure suggests life-force, profusion and prosperity. Birds in the coiffure connote clairvoyance and mystery. Boone describes her informants as claiming to be awestruck and overwhelmed at the sight of the masks and their mystical presence (ibid.: 194).

For the Temne of Sierra Leone, the black-ness of the mask, as well as of the gown of black raffia worn by the masker, represent the female and civilizing principles, as opposed to the association between maleness, whiteness and spirit (Lamp 1985). The sexual identity of the Sande or Bundu or Bondo spirit has been reported in contradictory terms, because of ambiguities of dress, language and stylistic expression, particularly among the Vai, Gola (both of neighboring Liberia) and Mende. Lamp argues that for the Temne the Nowo (Sowei) or mask of the Sande society is both guardian and patron of the physical realm (which is introduced through the female principle) and that the spirit itself is characteristically female (ibid.:32). He also points out that in Temne the mask and a moth/butterfly chrysalis bear the same name. They are both considered to be objects of beauty, are similar in color and form, and associated with female sexuality. Just as the mask is believed to be a spirit which emerges from the waters, butterflies are identified with mediumship as they collect around water, the medium between the physical and spiritual worlds. The serpent, like

water, may be represented on Bondo masks by a series of zigzag lines or diamond shapes along the neck rings. Lamp maintains that these mediating points are a common feature of Temne sculpture, serving to distinguish the head and its spiritual associations from the larger body and the things of this world (ibid.:37). In fact, the iconography of the mask is a cosmological map of Temne ideas about new life being germinated from the spirit of the dead "in the cultivating milieu of the village through the mediating force of women" (ibid.:43).

An alternative view of the Sande society is put forth by Bledsoe who argues that rather than reinforcing women's solidarity, Sande elite often side with elite men and exploit subordinate women (1984). Sande ritual and symbolism emphasize male—female sexual mingling and integration as much as sexual segregation. Bledsoe further stresses the need to view this within the wider political economy, since the ability to merge the sexes may yield substantial power (ibid.:465).

Initiation and Experience: San Rock Art

As has been alluded to above, rites of initiation and their accompanying ordeals generate a range of experiences (fear, empowerment, etc.). As a result of their detailed analysis of South-ern Africa's San (formerly referred to as "Bushmen") rock paintings and engravings, Lewis-Williams and Dowson argue that both types of visual art were closely associated with the activities of San shamans or medicine-people (Lewis-Williams and Dowson 1989). Their work has generated much debate and controversy (see, for example, *Current Anthropology* 1988) as they dismiss Western interpretations of the rock paintings as sym-pathetic magic or representations of everyday scenes. This is a very ancient tradition and at

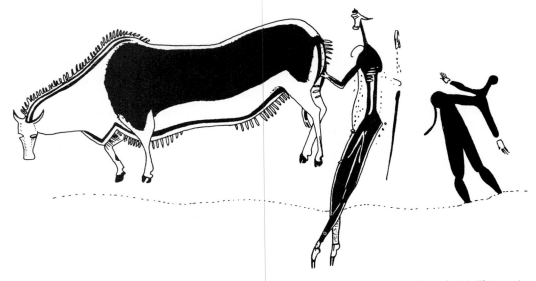

Figure 4.16 Rock painting, San, South Africa. After Lewis-Williams and Dowson 1989:50,51, fig.20. This section of the painting shows a dying eland and two shamans, who have become transformed as they "die" like the eland in the transition into the spirit world.

least some southern African rock art is considered to be contemporaneous with the Upper Palaeolithic Art of Western Europe. More recent paintings have been done in the 1880s and 1890s (ibid.:21). In San society, shamanism is practised mainly at a trance dance. The combination of rhythmic clapping by women and the circular dancing of the men is believed to release the supernatural potency in the songs and the shamans themselves (ibid.:31–2). While in trance the shamans perform a variety of tasks, such as healing, rain-making, visiting distant camps and control of animals.

Most young men desire to become shamans and become apprenticed to an experienced shaman, learning and absorbing his potency. The pain and terrors of the spirit world dissuade many from going on to become effective shamans. It is possible, therefore, that the rock paintings may be the after-images and records of their powerful experiences in all their diversity and idiosyncracies. These paintings of the spiritual realm, while apparently done only by shamans, were nonetheless seen by many people. Many of the symbols in the paintings connote the shaman's privileged and multidimensional view of real and visionary elements. Nasal blood is an indication of trance; so too are animal characteristics metaphorically linking "dying" shamans to potent but dying animals (figure 4.16). Other metaphors are underwater, flight, and fight. These are represented along with the entoptic phenomena "seen" by the shaman in the earlier stages of hallucination (luminous, mobile geometric shapes—zigzags, chevrons, dots, grids, vortexes and nested U-shapes—deriving from the nervous system and involuntarily experienced by all who enter certain states of altered consciousness) (see Dowson 1989). They often combine with the iconic hallucinations of the later stage (frequently depicting animals and people) (ibid.:60f.).

Lewis-Williams and Dowson maintain that

116

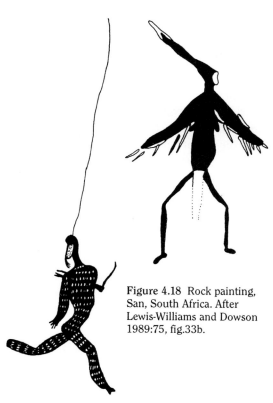

Figure 4.18 Rock painting, San, South Africa. After Lewis-Williams and Dowson 1989:75, fig.33b.

Figure 4.17 Rock painting, San, South Africa. After Lewis-Williams and Dowson 1989:74, fig.33b.

bringing together the results of neuro-physiological research and San interpretations of their hallucinations leads to a better understanding of San shamanism and its related art (1989). Many of the therianthropic representations (humans with animal features) probably reflect potency, and the transform-ations from human to animal identity, with their accompanying physical or somatic sensations, were often represented as small entoptic dots (see Dowson 1989) (figure 4.17). For example, the tingling sensation experi-enced at the top of the head may have been the basis for the San belief that the trancer's spirit leaves his body through a "hole" at the

top of his head. The lines leaving the head and pointed caps in many paintings probably represent therefore the spirit leaving the body (figure 4.18). Whether it be elongated forms, extra digits and limbs, handprints, these hallucinatory representations are all depictions by the shaman-artists of the interaction between this world and the spirit-world (Lewis-Williams and Dowson 1989:75) (figure 4.19). Women feature less frequently than men in the rock art, which is not surprising since there are fewer female shamans.[4] They are usually shown as carrying digging sticks or clapping, and occasionally dancing (ibid.:105). Lewis-Williams notes that the engravings, which are not found in the rock shelters, reflect a greater emphasis on geometric entoptic forms and animal species. He suggests that the engraving sites, therefore,

> may have been principally but not entirely vision quest sites where the shamans' initial acquisition of power was signalled by their experiencing the entoptic phenomena of the first stage of altered consciousness. The engraved entoptics and animals may thus have been symbols or representations of the potency shamans seek. Contemplation of them may have induced visions of that kind, as neurophysiological research suggests, and their depiction and re-depiction may have been demon-strations of successful quests (1989:47).

The paintings are more varied and discursive, perhaps representing the hallucina-tions experienced after the initial acquisition of power. Research continues on the relationship between this unique art form with all its emotional, intellectual, technical and aesthetic impact and complexity and the whole range of San shamanistic experience and belief (see, especially, Dowson and Lewis-Williams 1995).[5]

Figure 4.19 Rock painting in red and white of three hallucinatory shamans, Natal Drakensburg, South Africa. After Lewis-Williams 1989:39, fig.5. These three large figures combine both entoptic and representational elements. Each figure carries a flywhisk which is closely associated with trance dance.

Concluding Remarks

Secret societies and their initiation rites provide an important forum for artistic expression and production. Artistic objects, elaborate masquerades, and dramatic performance help negotiate and define gender and social roles, as well as impart knowledge (cf. Binkley 1987, 1990). It is important to emphasize that initiation rites are frequently more than just education or socialization; religious beliefs play a key legitimating and transformative role. Dance, music, songs, and visual symbols serve to (re)enact experiences of identification with and separation from both the animal and spiritual worlds, as well as the social world of humans. The evolution and transiency of human life are simulated through rituals of death and rebirth. The esoteric and liminal aspects of many of the rituals and art objects have long intrigued Western scholars, not just because of parallel examples in other parts of the world but also the perceived similarity to freemasonry (Harley 1941:5). However, it is important to emphasize that not all mask societies are secret (cf. Roy 1987:48). Some outside observers have played up the "mysterious" aspects of rituals and associations they did not understand or were excluded from, or failed to appreciate the nuances of concealed and revealed knowledge in particular communities. More research is coming to light on the complexities and ambiguities of secrecy, and the role of religious beliefs and symbols in this regard. Many of the examples in this chapter have also highlighted the centrality of ancestral beliefs and metaphors in the context of initiatory and secret societies. These will receive further examination in chapter seven on death.

Notes

1 Laura Birch de Aguilar, personal communication, 14 June 1995. I am indebted to Laura for sharing with me her data on *nyau* in Malawi. See also Laura Birch Faulkner, 1988.

2 I am grateful to Kofi Agovi for making this work by Ntonga available to me.

3 Laura Birch de Aguilar reports that in Malawi these clay figures have been made without interruption and without the specific borrowing described by Yoshida in his research site. She also notes that the Malawian figures are smaller and intended as replicas of the zoomorphic structures made by the men. Personal communication, 14 June 1995.

4 Solomon (1995) suggests that it is also due to the fact that women are more prominent in the oral than the visual arts. Her article is a brilliant analysis of gendered symbolism in San rock art.

5 Peter Garlake, in his recent work on the prehistoric art of Zimbabwe (1995), argues that, unlike South Africa, the paintings of Zimbabwe do not illustrate the supernatural world exclusively, or even to any great extent. The emphasis on potency animates and adds significance to the art, but is not central, in his opinion.

CHAPTER 5 The Aesthetic as Antidote and Transformer

In many parts of Africa there exists a range of objects, masquerades, or other art works that are believed to project or repel mystical forces. These forces may be benevolent and/or malevolent—depending on how or to what ends they are employed. In other words, it may be expedient to invoke dangerous, evil forces to counteract the same and to bring about beneficial ends. The wilderness or "bush" is held by many African peoples to be the predominant source of these fearful powers. This was well illustrated by the exhibition on "Wild Spirits, Strong Medicine: African Art and the Wilderness" held at the Center for African Art in New York City in 1989, which examined the wilderness as "a catalyst for art and symbolic thought" (Anderson and Kraemer 1989:23).[1] Artifacts and costumes may incorporate natural ingredients, and take on animal forms, and important rituals, such as initiation and secret society activities, may be performed away from the village (figure 5.1). A variety of specialists seek to harness and manipulate these powers—diviners, priests, hunters, farmers, performers and artists, often working in conjunction with one another. Some peoples, such as the Senufo of Côte d'Ivoire and the Ijo of Nigeria, believe that the spirits desire beautiful objects and performances, and make aesthetic judgements and demands (ibid.:58). This chapter is concerned with the contiguous areas of divination, protection, healing, witchcraft and sorcery, and

the important role played by artistic expression in mediating and transforming potentially threatening spiritual forces.

Divination

The overlap between divination, sorcery and artistic production is clearly illustrated by the case of Ojiji, an Idoma artist known well to Sidney Kasfir during her field work in central Nigeria in the 1970s. A product of both the Idoma and Akpa cultures, he was a successful woodcarver, diviner, dancer and Anjenu priest. Renowned as an innovative dancer (before arthritis took over his legs) and carver of masks, Ojiji was an important mediator with the spirit world. Divination is an essential component of Idoma thought, linking the unexplained misfortunes of individuals with a pre-existing body of esoteric knowledge and offering solutions and reassurance through a set of rules and rituals.

Ojiji's divining equipment included seed pods connected by snake vertebrae. He treated people who were suffering from misfortune, ill health and suffering believed to have been caused by malevolent spirits. Kasfir witnessed him healing a sick baby, whose problems were linked to an uncompleted cycle of re-incarnation. A sacrifice ensued. She emphasizes that many of the problems he treated as diviner were the same as those he treated as

priest of the Anjenu cult—headaches, bad dreams, infertility. In this regard, it is helpful to see his various mediatory and creative roles as different aspects of the same calling. In Kasfir's words:

> As a carver he concretized the spirit world, making visible what is normally invisible. As a masked dancer he gave the fullness of interpretation to the embodied spirits he and others had carved. As a diviner he performed a parallel feat by explaining through revelation the interventions of spirits in the client's life—again making visible what is hidden from ordinary people. As a man of knowledge he was able to link the destinies of the Idoma as children of Apa with their destinies as children of Aję, Earth. And as an Anjenu priest he could summon the spirits with incantation and song, bringing them into his compound at Oko during a ritual performance (ibid.:51).

Divination systems are central to a people's worldview and the proper ordering of social action, and are not just reflections of other aspects of a culture. In a recent volume on *African Divination Systems*, the editor, Philip Peek, describes divination as "a system of knowledge in action" (1991:2). The introduction to the book provides a useful and revealing background to the study of divination in Africa.[2] Earlier anthropologists (notably the British) were particularly dismissive of the efficacy of divination and the seriousness of diviners. Generally speaking, divination has received far less academic attention than witchcraft. Divination is not exclusively a religious matter (as implied by earlier works), but religious beliefs and practices are integral to this very ambiguous phenomenon. As Peek rightly insists, "[m]any African peoples claim that 'real' knowledge is hidden, secret, available only to certain people capable of using it properly. Frequently that knowledge is only revealed through divination" (ibid.:14).

The trend toward seeing divination as a disparate process and one which involves revelation as much as or in interplay with legalistic analysis is now being emphasized by a number of scholars (see Shaw 1991). This greater openness to the role of symbol and metaphor in the divination process obviously sheds greater light on the various art objects

Figure 5.1 Magical figure, *nzinda*, Pende (eastern or Kasai province), Zaire. Stanley Collection of African Art, University of Iowa. This female figure was empowered with substances from the forest by the *nganga* or diviner/healer. The heavy braids were believed to allow it to deliver oracles. It would tip over and make marks in the sand with the horn attached to the top of its head.

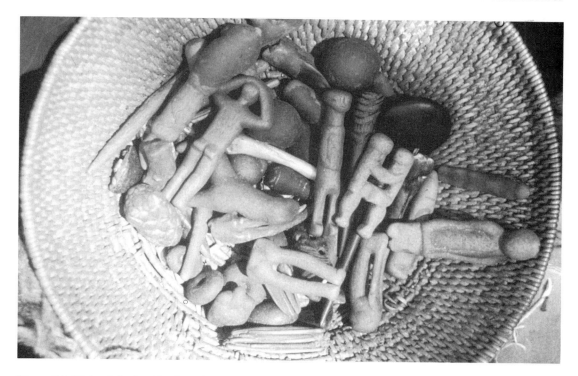

Figure 5.2 Diviner's basket, Zambia. Photo: Manuel Jordán 1993. The Chokwe/Luchazi diviner, by the name of Chipoya, who died in 1993, used small figurines as well as natural objects to determine his clients' problems. He would shake the basket, throwing the contents high into the air, and then see which fell to the front. The joined figures, for example, would signify the quest for fertility. The woman with her arms raised suggests the hypocrisy and suffering that come with accusing others.

which play a vital role in storing, transmitting, concealing and revealing this knowledge. Their place and significance in the overall process is frequently overlooked or marginalized. A brief example can demonstrate the importance of one such piece: a Yaka diviner makes constant use of a wooden slit-gong which has a carved human head on top and a stick inserted into the slit (Devisch 1991). He uses it to tap on while divining, to sit on, and to drink from. It is supposed to be "the very image" (*yidiimbu*) of the diviner. The phallic- and womb-like shape is a metaphorical statement of the diviner's capacity "to self-generate his new condition" as well as to elicit new meaning "in a sub-verbal, bodily, manner." As a miniature and modified form of the larger, message slit-gong drum, it

symbolizes the diviner's role of communicating messages to all people.

Divination involves a variety of techniques and objects of consultation, such as spirit possession, stones, shells, sticks, gourd rattles, pocket watches, money, seeds, chains, words, songs, dance, books, carved figures, poison, animal parts, and water (figure 5.2). David Parkin draws an interesting parallel, based on Lévi-Strauss's distinctions, between the artist and the diviner as *bricoleur* or myth-maker (Parkin 1991b:184–5). The artist creates a model or structure, such as a painting, out of pre-existing images. The work of the diviner also involves both semantic and dramatic creativity, as well as solving practical problems and touching on modern medical science in its

diagnostic parallels with psychotherapy. Diviners are often viewed as special persons either during divination or more permanently. This may be distinguished by their clothing or regalia. Their marginal or liminal status is also conveyed in the way they apparently combine both male and female characteristics in cross-dressing and through spirit possession by opposite-sexed spirits. In some cases, the utilization of the left hand also establishes difference. There may be particular restrictions and requirements regarding the time and location of the divination events and the residence of the diviner. The diviner's association with animals in physical or symbolic form is evident on his/her divination apparatus. These animal agents are selected for their powers of detection (e.g. dogs) and wisdom (e.g. tortoises). Peek (1991) describes the various intensifying activities (sound, dance, smell, drugs) and elaborate ritual and symbolism which combine to produce the "non-normal" state of consciousness of the diviner, enabling him/her to communicate between the human and spirit worlds.

Sandogo: A Women's Divination Society

The Senufo women's divination society, Sandogo, provides fine examples of divination-related art which merit detailed discussion (Glaze 1981:54–81). The Sandogo works in a more closed, inner arena, where the individual struggles with day-to-day personal problems, than the (male) Poro society groups which emphasize prestigious visual displays for large audiences at funeral and initiation rituals. The dazzling and complex visual forms which fill the diviner's room, intending to impress clients of her spiritual powers, are appropriately on a miniature scale—reflecting the intimate and private relationship of diviner and client. Sandogo is a powerful women's organization

with two primary responsibilities: first, to safeguard the purity of the matrilineage and, second, to maintain good relationships, through a particular system of divination (*tyëlë*), with the hierarchy of spiritual beings. In Senufo oral tradition, Sandogo predates the men's Poro society. It comprises members of every matrilineage segment and "house" (extended household unit) in the village. Anita Glaze does point out, however, that in some areas there are as many male practitioners as women, and that not all *Sandobele* are practicing diviners. This is because few women master the difficult system beyond the training given to all novices. A woman may become a *Sando* through kin group succession or through direct intervention of the python-messenger or the "bush" spirits. Ultimately, however, the appointment of a *Sando* reverts to matrilineal succession.

Glaze defines the divination system as a "ritual form of diagnosis," a technique for determining the mystical causes of any misfortune and for actively soliciting the aid of the spiritual beings and the ancestors in matters such as farming, hunting and pregnancy. The same root word, *tyëlë*, refers to both the act of divining and the act of consulting a diviner. The relationship between the diviner and her spirits is sustained by a number of ritual abstinences, prayers and sacrifices. These spirits, or *madebele*, are believed to be ambiguous, animate nature-dwelling spirits who require gifts, worship and commemoration to avoid causing misfortune to humans. The Senufo believe that these spirits have the potential for benevolent action if properly treated and herein lies the importance of analytical divination and the "aesthetic as antidote" (ibid.:62).

Furthermore, it is held that the *madebele* have some humanlike responses and enjoy such aesthetic forms as music, dance,

Figure 5.3 Large, cast-brass bracelet of *Fo* the python, Senufo, Côte d'Ivoire. After Glaze 1981:77, fig.38. This is used rather as a display ornament for diviners' shrines.

sculpture, and ornaments. Hence the steps taken by the *Sando* to make her consulting-chamber pleasing to the spirits, as well as her appearance and her divination equipment. The clients, too, wear cast-brass ornaments, painted textile-clothing and masquerade costumes as appeasement and protection. Glaze rightly maintains that the *Sando* art objects must be seen as part of a conceptual and functional whole, that includes non-art objects such as seeds, horns, buttons, shells and baskets. Essential to the diviner's equipment is the figurative sculpture (also known as *madebele*) displayed in front of the seated diviner and client. The beauty of form and detail of these figures is intended to reflect the diviner's prestige and powers. The diviners say that the carved images also serve as mouthpieces or oracles for the invisible *madebele*. They are said to "speak." Some of the pieces may have been commissioned as the result of a dream or vision. A male and female pair are required figures; there will most likely be the popular equestrian figure who represents for the Senufo power, wealth and status.

The majority of the traditional ornaments worn and displayed by the Senufo are related to divination and chosen for their protective and redemptive qualities (figure 5.3). The iconography is dominated by the python and chameleon, two primordial beings renowned for their powers of transformation, power and primal knowledge. In addition, most diviners include small twinned baskets or cast-brass figures or bracelets to "speak for the twin spirits" to the appropriate clients (ibid.:73). Spirits of twins are very significant for the Senufo. Human twins are viewed ambivalently and are considered to have closer ties with the spirit world than ordinary people. As Glaze points out, the twin tradition "provides yet another example of how Senufo culture brings beauty into difficult circumstances as a positive and ameliorating force" (ibid.). The twin theme is also present in the scarification patterns cut into the abdomen of every young girl by the age of puberty. Not only does it recall the balance of the first man and woman and the promise of the young woman's future procreative role, but the design, emanating from the navel, also reminds women of their ancestral mothers reaching back to the Ancient Mother.

Ifa Divination System Among the Yoruba

No discussion of divination-related art would be complete without including the range of sculpture and apparatus of the Ifa divination system among the Yoruba. They range from natural, unadorned palm kernel nuts (*ikin*) to the highly sophisticated and sculptured *agere ifa*, a wooden container with lid (Abiọdun 1975). The Ifa divinity, also known as Ọrunmila, is the only *orisa* or divinity held by oral tradition to have been present at creation and is therefore second only to Olodumare, God the Creator. Since he knows the secret of creation, he is considered to be the source of

great wisdom and knowledge in heaven and on earth and as possessing the attributes of the other deities. When consulted, Ọrunmila's priests, the *babalawo*, recite the verses indicated by Odu—the relevant set of oracular formulae. Ọrunmila is also closely associated with Ori, the divinity of the Head, embodiment of a person's past, present and future and the

Figure 5.4 Divination tapper or wand, *irọkẹ ifa*, Yoruba, Nigeria. Stanley Collection of African Art, University of Iowa.

essence of his/her personality, and Eṣu, the trickster deity who facilitates or hampers communication (usually sacrifice) with the gods. From what is known of Ọrunmila in oral tradition, he is the most esoteric of all the deities, speaking and acting without physical form. Ifa sculptures and apparatus do not therefore adequately reflect Ifa's greatness; they only complement his ordering principle and esotericism.

The Ifa literature also reveals to us the importance of the *ikin* in providing a link between mortals and Ọrunmila. Sixteen palmnuts were bequeathed to his children after Ọrunmila ascended into heaven. They are believed to provide solutions to all problems on earth when interpreted by the *babalawo*. Their blackness would seem to symbolize the deep and esoteric nature of Ifa. During divination, Ọrunmila is invoked by an important implement known as *irọkẹ Ifa* (Abiọdun 1989a) (figure 5.4). This is a thin, usually ivory, wand, used to tap against the divination tray, *ọpọn*. Up to 30cm in length, it has three parts—the pointed, uncarved end, the middle section which is either a human head or a kneeling nude female figure holding her breasts and the bottom section (*not* depicted here) which often has images of material and worldly success (often an equestrian figure). The divination process begins with the diviner tapping the tray and reciting the *oriki* or praise songs of Ọrunmila. It is also an invocation asking Ọrunmila to reveal the *ori* of the supplicant. In this connection, the iconography becomes significant. The conical superstructure on the top of the head symbolizes the person's *ori inu* or inner head, significantly distinct and unknowable yet attached to the *ori ode* or visible head. It recalls a traditional Yoruba myth concerning the choosing of *ori* from Ajala, the great molder of *ori* in heaven, the most important event in a person's life before

birth. The kneeling female figure in some of the diviners' wands represents humanity; her position is the most appropriate way to salute the oriṣa or divinities, who are known as Akunlebo ("the-ones-who-must-be-worshipped-kneeling-down"). Her nudity is evidence of the solemnity of the moment (Abiọdun 1989a: 111). As Abiọdun rightly observes, it is highly significant that a woman is chosen to handle the most significant stage in the act of creation—choosing one's destiny.

Another divination implement is the *agere ifa*, a carved container with a lid that holds the sixteen palmnuts for divination or *ikin*. It is generally made of wood, and sometimes of ivory. The carved figures that hold up the bowl in a caryatid fashion depict figures celebrating life and a successful divination—dancers, equestrian figures, musicians, kneeling women. The *agere* is like a miniature shrine of Ọrunmila, with the palmnuts elevated and supported by the carved figures. The *agere* are highly valued for their workmanship and creativity; in Ifa literature they were said to cost as much as 3,200 cowries. It is either the priest who may commission the vessel or the clients who may present it as an act of gratitude.

The divination tray or *ọpọn* is a flat wooden board, either circular, semi-circular or rectangular in shape (figure 5.5). There is usually a carved border with a depressed central area which is dusted with powder from the irosun tree so that the diviner may record the relevant *odu* which appears in answer to the question posed. In the past, diviners used the ground. The variety of images which are arranged around the border "articulate a cosmos of competing, autonomous forces" and are meant to "praise the momentous work of diviners as they seek to disclose the forces active in a situation" (Drewal *et al.*:1989:17). The only constant image is the face of Eṣu (or one of the faces if there are several), the divine mediator,

Figure 5.5 Divination tray, *ọpọn ifa*, Yoruba, Nigeria. Stanley Collection of African Art, University of Iowa.

which must face the Ifa priest during the divination process. Eṣu's power and importance is recognized as the *oriṣa* who maintains the precarious balance between the benevolent and malevolent forces of the universe (Abiọdun 1975:437–8). The *babalawo* must face an open door to give free access to the forces invoked. The richness of design on the border of the *ọpọn* depends upon the means of the one commissioning the piece. The diviner praises all sections of the tray, alerting its spiritual powers and readying it for action. People, animals, birds, cultural items, combine to express the themes of leadership, warfare, protection, survival, sacrifice and others (Drewal *et al.* 1989:17; see also Witte 1994 for a detailed description of one particular tray). Drewal draws attention to the sound which accompanies the divination process, and which is also instrumental, in addition to the images, in generating "transcendence" (Drewal 1994: 196). The hollow area carved into the

underside of the tray creates a sound chamber, which resounds when the board is struck with the tapper. As one diviner told Drewal, the sound reverberates in order "to communicate between this world and the next." (figure 5.6).

Abiọdun suggests that there is a link between the introduction of the tray and the increasing prestige and prosperity of the diviners (Abiọdun 1975:436). As a display tray, it is intended to flatter Ifa, as well as invoke otherworldly powers and legendary diviners of the past. Drewal, Pemberton and Abiọdun argue that the divination tray, along with the lidded bowl, veranda posts, carved doors, and ancestral maskers, must be seen as "segmented compositions" which "mirror a world order of structurally equal yet autonomous elements" (Drewal *et al.* 1989:16). The arrangement of motifs in an object (often documented in myth), in conjunction with efficacious invocations and actions performed in its presence, provide "a formal means of organizing these diverse powers, not only to acknowledge their auto-nomy but, more importantly, to evoke, invoke, and activate diverse forces, to marshal and bring them into the phenomenal world." As the authors themselves contend, this aspect of Yoruba art can only be appreciated by seeing art and ritual as integral to each other.

Tabwa Beaded Masks: Motifs and Mediumship

Tabwa beaded masks provide excellent ex-amples of personal and societal transformation (Roberts 1990b) (see plate 3). Insightfully described and analyzed by Allen Roberts, these masks have been found in the area between Zambia and Zaire, where the Tabwa, eastern Luba, Bemba, Shila and other ethnic groups mingle and share language, history, culture and basic metaphors (ibid.: 38–9). The most common representative pattern on these masks, and in fact in all Tabwa art, is the isosceles triangle or *balamwezi* (meaning "the rising of a new moon"). The new moon is an ambiguous metaphor which subsumes both darkness (obscurity, ignorance, danger and destruction) and light (perception, wisdom, safety and hope), enabling people to understand and cope with misfortune and death. Roberts maintains that Tabwa beaded masks serve the same functions as the beaded headdresses (*nkaka*) worn by adepts of the Bulumbu possession cult. The central motif is a spiral which is a pervading concept of Tabwa thought in terms of time, origin myths, kinship. It is often represented in the form of a shell disk worn by chiefs on belts, symbolically recalling the ancestors, spiralling back in time. Roberts links this motif mythically to the earth spirit or *ngulu*, Kibawa, whose oracle and spirit possession cult which emerged in the mid-1890s, provided new, individualistic strategies for coping with problematic social change. Examples of such spirit medium cults abound in several parts of Africa.

During the Bulumbu performances, beaded headdresses are worn. The central beaded spiral is said to be the "eye of Kibawa" and so represents "the entire paradigm of the moon, contact with the ancestors, and fertility" (ibid.:42). Since Tabwa diviners are said to have "eyes," the significance of the placement of the third "eye" over the center of the adept's forehead is understood. In addition, a bundle of "activating agents" is sewn into the headdress behind the spiral. Each one of these elements has a protective and empowering function, particularly that of the pangolin scale. The latter are burned to scare off lions. The word for pangolin (*nkaka*) is the same as for the headdress. There is also a visual analogy between the scales of the pangolin and the triangles of the headdress. As further indication of the importance of the structure and messages of these masks and headdresses,

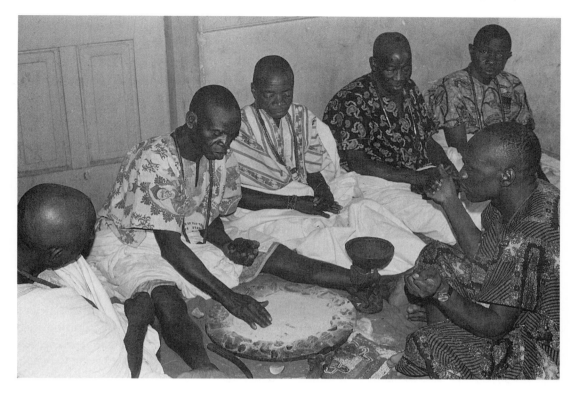

Figure 5.6 Senior priests of Ifa divining for the king at the palace at Ila-Ọrangun, Nigeria. Photo: John Pemberton III, August 1982. The divination was to determine the sacrifices that the king must make in the Festival for the King's Head (personal destiny), Ebora Ila, and to the *orisa* or divinities in the years ahead.

Roberts informs us that the Lumpa Church of the prophetess, Alice Lenshina, which became a focal point of anti-colonial response in Zambia in the 1950s and 1960s, included the use of beaded headbands and *ngulu* spirit-possession. In conclusion, Roberts underlines the ambiguities and paradoxes of masked performance—the entertainment and the dangerous possession, the belief and disbelief.

Witchcraft

In his work on the Azande of the Sudan, Evans-Pritchard (1937) ascertained that witchcraft is a mystical phenomenon that explains unfortunate events and provides a system of values that regulate human conduct. Witch-craft and sorcery are both feared by the Azande, but sorcery is a more conscious act, using magical techniques and medicines, in contrast to witchcraft which uses "hereditary psycho-psychical powers" (ibid.:387). There are many African societies, however, where the language does not reflect this dichotomy (nor the distinction that he made between magic and religion), and where there is far greater conceptual ambiguity and fluidity. It is indeed common to hear people describe witches as anti-social, inverted human beings, whose powers and intentions are solely evil, but we should not overlook the ways in which witchcraft does not meet those criteria.

I. M. Lewis tries to go beyond the particularistic definition of Evans-Pritchard and the

limited functionalist interpretations of many observers by demonstrating the links between witchcraft and spirit possession (1986:51–62). He sees "extravert" witchcraft and sorcery (where the bewitched accuses others) and "introspective" witchcraft or peripheral spirit possession (indirect or self-accusation) as both responses to affliction that at the same time highlight problems in social relationships. He provides evidence of how both may occur in the same context, but argues that possession by capricious or malevolent spirits is more generally limited to domestic contexts (such as between man and wife), whereas witchcraft and sorcery tend to operate in a wider sphere of interaction and in cases of hostility between an inferior and a superior or between equals. Lewis also stresses the importance of viewing concepts of positive and negative power situationally, for they are constantly redefined in function of changing historical and political circumstances. As he so aptly concludes, "[p]ositive charisma, we may say is the acceptable face of witchcraft, and witchcraft the unacceptable face of charisma" (ibid.:62).

In light of the above, a consideration of art works related to witchcraft and sorcery in particular contexts will provide a better understanding and appreciation of the ambiguities and limitations of these concepts. Siroto has argued that Western interpreters of African art have tended to privilege sculpture dealing with "religious" themes (e.g. cosmology, cosmogony and mythology) rather than sculpture associated with more "mundane" aspects, namely witchcraft and sorcery (1979). This is in spite of the fact that witchcraft has been a significant field of anthropological inquiry. Focusing on the Kwele of present-day Gabon, he shows how witchcraft beliefs can be a primary determinant of representational elements and themes. For example, he attributes the white faces or white areas around the

eyes of the masks representing the *ekuk* (forest spirits) to clairvoyance, symbolizing the light and clarity required to expose and repel witchcraft. The prominence of the eyes carved out of the facial plane or as depressions in the plane further express the power of distant, clear sight. Some helmet masks even have two to four faces. He also suggests that the absence of the mouth on several masks may reflect vigilance against the attack of witches. The Kwele believed that the witch was an organism imbued with unseen, superhuman powers, which had to reside in the body of a human host. The relationship between host, indweller and victim was ambiguous, rather determined by the attitude of the host, so that a distinction was made between obstructive and destructive witchcraft. Siroto surmises that this reflected "the societal dilemma of recognizing and resenting success as a result of unjust exercize of supernatural power and yet having to remain under the influence, indeed often protection, of those sinister men who had succeeded" (ibid.:248).

Several of the Kwele masks represented animals and birds. Not all of these can be related to witchcraft. But the combination of animal with human features in some masks points to the Kwele belief in the power of great witches to transform into large animals, giving them the potential to harass their rivals. The absence of certain animals in representational form is also significant. For example, the leopard and the crocodile are both considered too powerful and dangerous to refer to. Apart from the owl, associated with night and the forces of witchcraft, high flying birds, such as the eagle, swallow and stork, may relate more easily to the idea of clairvoyance. One mask represented the butterfly who "gaily dances about at crossroads, despite the common knowledge that these places are among the favourite haunt of witches" (ibid.:257). From an

Figure 5.7 Mask, Kwele, Gabon and Congo. Stanley Collection of African Art, University of Iowa. Such masks were worn at the rites of the cult of *beete*, when a 'magical stew' was prepared for communal consumption to dispel inter-lineage rivalries.

aesthetic point of view, the Kwele prefer the horned mask which represents a forest spirit in the form of a ram (figure 5.7). According to Siroto, the most important of the Kwele masks was "a large, fringed carapace made of coiled young leaves of the raffia palm, the leaflets hanging down to conceal the dancer's head, torso and upper legs" (ibid.:259). This mask was viewed as a being in itself, *keez*, as possessing great witch power and as a vital part of the *beete* ritual complex. The dancer had to be a notable witch in his own right and would carry powerful relics under the mask as he danced to validate his role. As in many other African societies, young raffia leaves are held to be deterrents to evil forces. They are often seen tied to vehicles conveying corpses; people tie

Figure 5.8 Reliquary guardian figure, *bwete*, Kota-Mahongwe, northern Gabon. Stanley Collection of African Art, University of Iowa.

them to candles in some churches for prayers of protection.

Carrying further his conviction that witchcraft beliefs have influenced African iconography more than generally recognized in scholarly interpretations, Siroto maintains that Kota reliquary figures—wide, flat, bodiless, wooden images, covered with a metal overlay (figure 5.8)—are not ancestral figures (as they are indeed widely known—see chapter seven), but rather representations of tutelary or familiar spirits whose function is to avert witch power. Both the Kota and Mbete believe in

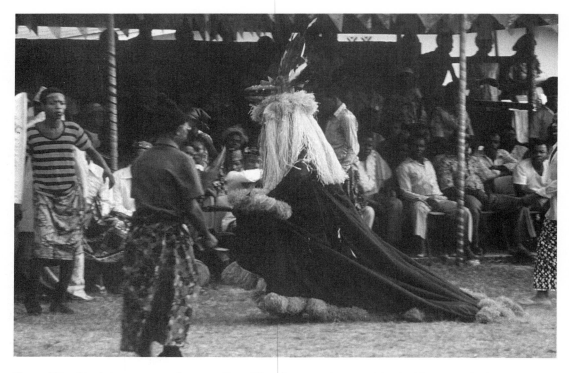

Figure 5.9a *Abasinjom* masquerade, upper Cross River State, southeastern Nigeria. Photo: Rosalind I.J. Hackett, Calabar, 1982. This witch-finding masquerade was here performing at ceremonies marking the installation of the new *obong*, or king, of Calabar in 1982.

witchcraft, in the power of skulls of important people, and in the keeping of these skulls in lineage reliquaries. Earlier images of these guardian spirits were painted in white kaolin, signifying daylight and clairvoyance, conditions that deter witchcraft. This gave way, with the advent of European trade, to a preference for the use of brass, which was not only seen as more prestigious but also more efficacious in that its reflecting surface could destructively reflect the image of the witch back in its face.

Witchcraft for the Banyang, who live in the central area of the Cross River basin in the western part of Cameroon, is a "metaphor for selfish individualism and anti-social irresponsibility" (Thompson 1974:209). As in some other parts of Africa, people believe that witches are able to assume animal forms at will, particularly at night. It is not this power *per se* which is feared but its use for or against the common good. The purification of the negative forces in society is carried out by the Basinjom cult, which seems to have originated in the early 1900s among the neighboring Ejagham in what is now southeastern Nigeria. "Basinjom" means "the future brought by God" in Ejagham, referring to the divinatory, healing and protective powers of God. Thompson describes a Basinjom initiation ritual that he witnessed in 1973, which involved the application of eyedrops to effect "mystic vision" in the initiate. The ritual performance is of more interest here. I witnessed such a performance as part of the festivities surrounding the coronation of the Obong (Paramount Ruler of the Efik) of Calabar in 1982. An Abasinjom group came down from

Figure 5.9b *Abasinjom* masquerade, upper Cross River State, southeastern Nigeria. Photo: Rosalind I. J. Hackett, Calabar, 1982. Detail of head with mirror and feathers.

the northern Cross River region to pay their respects to the new king, along with many other masquerades (figure 5.9a).

The eyes of the Basinjom masquerade are indeed its most striking feature, reflecting its powers of detecting and exposing witchcraft. Thompson offers us a synthesized exegesis of the costume based on his interviews with a number of initiators, who reveal the details of the cult to the four different stages of initiates (ibid.:212). Basinjom is a very composite figure—sweeping black gown, crocodile head, feathers, mirrors, knife, quills, raffia, roots, animal skin, etc. (figure 5.9b). The black gown hides his witch-finding activities at night. His blue feathers are those of the "war bird," the red feathers symbolize hot, dangerous forces. The porcupine quills among the feathers are strong medicine against thunder and lightning, and the roots in the headdress signify the identity of the initiate and serve to activate his possession by Basinjom. His mirrored eyes enable him to see into other worlds, to the place of witchcraft. His striking crocodile snout and shells and bones from inside the crocodile suggest fighting bad things with bad things, as well as the later relationship the initiate will enjoy with the animal. The back of his head has all sorts of medicines applied as well as a small mirror so that Basinjom can see behind. In his mouth he carries a piece of wood from the most powerful wood in the forest and attached to his costume is a skin from the predatory genet cat. The raffia hair and hem denote his forest origins and energy. All initiates must also learn of the importance of the owl whose abstract image is situated in the Basinjom grove in the forest, together with the medicines.

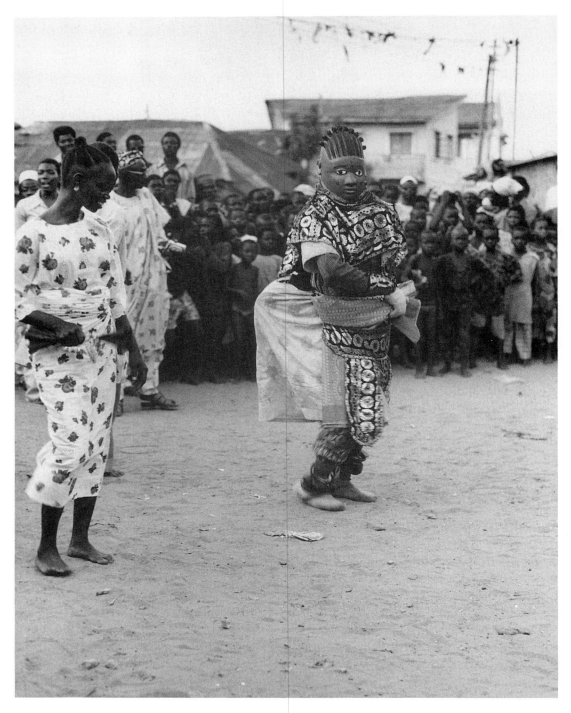

Figure 5.10 Gẹlẹdẹ masker, Isale-Eko, Lagos, Nigeria. Mask carved by Kilani Ọlaniyan of Ota. Photo: Henry John Drewal and Margaret Thompson Drewal, 1982.

The mask-carrier becomes possessed by the spirit of Basinjom after a solution of tulip tree resin is sprayed over his eyes and body. To the accompaniment of musical and percussion instruments, the gown is placed on his body. His army assembles—cutlass-bearer, riflemen, spear-carrier, and blower of the cooling, horn of silence. He lifts and holds his gown in a pre-scribed manner and begins to swoop and glide, the gown hiding his short, rapid steps. Occasionally he stops and listens to unseen disturbances. The men keep their rifles pointed at the sky, where it is believed that witches keep destructive magic in the form of lightning. Basinjom continues to wheel around the town and scrutinize until he detects the culprits. In this case it was two women whom he accused of selfish, uncooperative acts. In the end they beg forgiveness for their unknowingly destructive behavior. The ritual confronting of evil in this public drama, using powerful aesthetic means, assuages and purifies the community. Basinjom leaves, but may return unexpectedly.[3]

Among the Ejagham of western Cameroon the mask is considered to be medicine or *njom* (Koloss 1984). It is held to be the strongest of medicines and for this reason is known as Obasinjom or "God's Medicine." As a speaking mask (one of the few in Africa) with clairvoyant properties, it not only hunts out witches, but also serves as a vehicle for God to inform people about medicine and healing. So while the potency of the mask is ultimately attributed to God and the ancestors, it is still considered to have a life of its own as medicine as witnessed by the prayers and rituals addressed to the mask. The dancers or mantlebearers who perform the masks are "cooked" or prepared with medicine. Not only do the chosen candidates experience trance-like states when wearing the mask, but they also exhibit abilities to perform unusual tasks such as climbing tall trees and buildings. While women are excluded

from membership in the society, Koloss reports that pre-pubescent girls of five to ten years of age are wedded to Obasinjom because of their ability to control and stop the mask should it go wild, and also to reactivate it after periods of inactivity. Known as "Ma Njom", these young girls with their ability to "cool down" Obasinjom also spit a "hot" drug on the mask during performance to ensure that the mask will tell the truth and conceal nothing.

A secure community is one where the powers, human, natural and spiritual, are regulated and fruitfully utilized. The Gẹlẹdẹ masquerades among Western Yoruba peoples in Nigeria and Benin are "lavish spectacles of carved wooden headpieces, cloth costumes, dances, songs, and drumming" whose aim is "to pay homage to women so that the community may partake of their innate power for its benefit" (Drewal and Drewal 1983:xv) (figure 5.10). Both the night-time (*Ẹfẹ*) and daytime (*Gẹlẹdẹ*) performances offer a very visible, artistic expression of an important Yoruba belief: that women, notably elderly women, possess extraordinary power which is equal to or even greater than that of the gods and ancestors. The powers of the women (referred to as "our mothers," "the gods of society" and "the owners of the world") can be either beneficent or destructive, bringing health, wealth and fertility, or sickness, drought, and pestilence to the land and its people.

Margaret Thompson Drewal and Henry Drewal provide a detailed, sophisticated, and captivating study of Gẹlẹdẹ performance. They situate the Yoruba understanding of spectacle in relation to the concepts of *aṣẹ*, or life force, and *ọrun*, or otherworld, and offer a more balanced and integrated view of women's spiritual and social roles, rather than just emphasizing the negative aspects of female power. They give accounts of how the various masks, Ẹfẹ songs and literary allusions celebrate those who

133

Figure 5.11 Mask, *kifwebe*, Songye, Zaire. Stanley Collection of African Art, University of Iowa. A lion's mane would have been attached to the holes on this mask's edge, connoting wisdom and strength. The mask would have been empowered and activated by substances taken from the forest by the *nganga*, or ritual specialist.

contribute to the stability of society and ridicule those who threaten societal harmony. The high point of the festival is the appearance at the marketplace of the most revered of Gẹlẹdẹ and Ẹfẹ forms, the Great Mother (*Iyanla*), depicted as either a bearded woman or as a Spirit Bird (*Eye Ọro*) and trailing a white cloth. A beard normally connotes knowledge and wisdom, but the elongated and exaggerated woman's beard symbolizes extraordinary spiritual power and the capacity for transformation. This may be further endorsed by birds atop the mask which is a common Yoruba symbol of transformative

power and night-time activities (ibid.:71;cf. Campbell 1992). The liminality of the bird mother image is expressed in the synthesis of animal and human features—"the one with two bodies" or "the one with two faces". These praise names reflect the belief that women are more skilled in self-containment and secrecy, and in controlling their *ori inun* or "inner head." The latter is where an individual's character, potential and personality reside and ideally it must not be revealed, only through thoughts and actions. So "[t]he cool female exterior reflects a composed inner self" and the mask expresses these awesome qualities of composure and restraint. Concealment is another important feature of the performance: what is unseen has more impact than what is seen.

While Drewal and Drewal emphasize that the elderly women and priestesses are not considered as inherently anti-social, nor the embodiment of evil, they do describe how the mothers when angered surreptitiously seek out their victims. Their attacks purportedly result in debilitating diseases and pregnancy complications. Adams (1983:95–6) believes that this frightful, unaesthetic side of women's perceived nature and actions needs more emphasis in research. Emmanuel Babatunde, a Yoruba anthropologist who conducted research on Gẹlẹdẹ in Ketu in Western Yorubaland near the border with Benin, is likewise concerned to challenge some of the prevailing scholarship (1988). He argues that women's views have been neglected.

The Gẹlẹdẹ ritual, in his opinion, provides expression and temporary resolution of the muteness and subordination of women. Fear of social extinction and the importance of fertility—broadly conceived in human, natural and divine terms—constitute the central nerve of Ketu society. Even in a patrilineal society, women, as mothers, feel a stronger sense of

social immortality and ownership of the children in a way the men cannot. So it is in this regard that men are at their weakest and most dependent. The ritual context therefore provides an acceptable forum for men to express their indebtedness to women as mothers without compromising their position in a patrilineal society. Women achieve dominance by being symbolically transformed into the "wild" of the male world. They are considered marginal and dangerous—witches or *aje*. By caricaturing women, the men adopt a position of ritual self-defence. An understanding of the Yoruba concept of "witch" is apposite here. In addition to the witch's conventional destructive tendencies and skills, she also possesses some allegedly positive features, namely the power to bestow fertility. This stems from the Yoruba belief that there exist special links between witches and the earth goddess. So petitions for fertility must be done in cooperation with the witches, who are to be appeased and amused in order to direct their powers to the service of humanity. There is further evidence in the figure of the *Iyalaṣe* or "mother of power" whose role is central not only to the Gẹlẹdẹ rituals but also to society at large. As priestess of the earth goddess, she is the personification of female power. Together with her council of women elders she approves the choice of masks and dancers. Significantly, the performances are held in the market-place—an area dominated by women. But her power extends to most religious and state affairs as she plays a key role in the installation of the king. Other cults must seek her permission before holding festivities. She prays annually for the people and during times of famine. In sum, the Gẹlẹdẹ festival illustrates richly how artistic expression can provide effective strategies in balancing the complex and ambiguous worlds of male-female relations.

Evil magic is a subject of much concern and discussion among the Songye people of Zaire. Yet, they pride themselves on the power and repute of their magical experts. The Songye are closely related both linguistically and culturally to the Luba and have been researched by Dunja Hersak (1985). Their *kifwebe* masking tradition again underlines the important links between cosmological beliefs and artistic forms. The face is considered to be the focal point of the mask in terms of its power: it resembles a ferocious animal such as a crocodile, lion or zebra (figure 5.11). The striations of the *kifwebe* evoke the special powers of both the zebra, an animal alien and mysterious to the inhabitants and the striped bushbuck antelope. The temperament of the *kifwebe* masker also matches the aggressiveness of the two animals. The birdlike features of the mask (beak, crest) also recall more generally the intermediary role of birds between humans and the cosmos. Hersak also contrasts the male and female masks. The former is more associated with the malevolent and aggressive action of sorcery, purportedly performing miraculous feats such as breathing fire, cutting themselves in half, and flying like beasts. The female mask rather reflects the ambivalent nature of mystical powers, well symbolized in its more common use and association with the night and the moon, linked with both fertility and witches.

Power Objects

Some healing medicines may be prepared for a particular occasion, while others may be given more permanency and potency in the form of amulets, charms or "power objects" (Anderson and Kreamer 1989:59). The visibility and ubiquitousness of such objects in a number of African societies have misled a number of European observers into characterizing them as being at the heart of a particular belief

system. For example, McCaskie notes that the Asante of Ghana viewed their various charms, amulets and talismans (*nsuma*) as often temporary in nature, highly specific, personalized, and as derived powers, in contrast to the *abosom* or spirit beings who made themselves known voluntarily and could not be manufactured or bought (1995).

Divination and sculpture are jointly used to counteract misfortune among the Bangwa-Bamileke of Cameroon (Brain 1980:216f.). According to Brain, there are essentially two main types of objects which are used by the Bangwa to protect themselves from witchcraft. The most common are the *njoo*, which are usually malformed, anthropomorphic figures. They are most often small in stature and have bent legs, depicting human affliction. Since they may be carved by amateurs in a matter of hours and are generally unadorned, it is their ritual power—deriving from the diviner's applications of medicines—rather than their aesthetic appeal which is valued. The figures associated with the *kungang*, an older anti-witchcraft society, are carved with greater care and play a prime role in the ritual cleansing of the chiefdom (figure 5.12). In some respects they resemble the royal portraits, but instead of depicting authority and fertility, they symbolize lowliness, sickness and rejection. With their stomachs swollen with dropsy, they serve as a visual warning to potential evildoers. A pair of anti-witchcraft figures might feature as part of a Bamileke palace door frame as a symbolic deterrent to anti-social behavior (Northern 1984:88). The *kungang* figures are rarely sold to outside buyers, as they are believed to accumulate potency over the generations. They develop a thick patina through constant sacrifices and often have a small panel in their stomach or back which can be opened for the insertion of medicines.

The Bangwa believe that witches attack close kin, so jealousy and financial problems take on mystical dimensions within a compound or neighborhood. When a statue is employed in divination, it is brought by the diviner out of its hiding place and placed before the group of people accused of witchcraft. Each person, adult or child is given a bean which they must throw at the figure, declaring "If I have harmed this person let this fetish kill me." Since the bean comes from a sensitive plant, it is believed to carry an element of the person to the object, resulting in sickness of the guilty person. Confession and exorcism may then ensue. At one time the whole palace, wives, sons and retainers, were forced to take an oath on the *kungang* figure in the public market place, swearing their innocence in a series of deaths or misfortunes. This was often conducted by one of the many anti-witchcraft societies operating among the Bamileke. Now local chiefs seek to keep their palaces free from witchcraft and death through newer societies which have come up through the forests. Their art forms are very different and resemble the animals of southeastern Nigerian cults (Brain 1980).

Central Africa is an area renowned for its power objects. Among the most well known are *minkisi*—a KiKongo term that has no equivalent in European languages. An inadequate, yet common translation is "fetish"—a term which will be discussed below. *Nkisi* (in the singular) may refer to a spirit, amulet, a medical treatment, a mask and certain specially qualified human beings (MacGaffey 1988:188). While *minkisi* are difficult to study because of the diversity and secrecy, a great deal is known about those of the Bakongo of western Zaire owing to the work of the Swedish missionary, K. E. Laman, who collected a large number of *minkisi* and indigenous texts describing their origins,

composition, uses, and ritual context. These texts were written by his research associates who were evangelists of the Swedish Protestant Mission in Lower Congo. One of them, Kavuna Simon, wrote a description of *minkisi* in 1915:

> In my country there is an *nkisi* called Na Kongo, a water *nkisi* with power to afflict and to heal; other *minkisi* have these powers also. They receive these powers by composition, conjuring, and consecration. They are composed of earthes, ashes, herbs, and leaves, and of relics of the dead. They are composed in order to relieve and benefit people, and to make a profit. They are composed to visit consequences upon thieves, witches, those who steal by sorcery, and those who harbor witchcraft powers. Also to oppress people. These are the properties of *minkisi*, to cause sickness in a man, and also to remove it. To destroy, to kill, to benefit. To impose taboos on things and to remove them. To look after their owners and to visit retribution upon them. The way of every *nkisi* is this: when you have composed it, observe its rules lest it be annoyed and punish you. It knows no mercy (cited in MacGaffey 1993:21).

The *nkisi* that he is describing is a small and crudely carved figurine, with a striking red and white face. It was part of an exhibition on *minkisi* held at the National Museum of African Art, entitled "Astonishment and Power." *Minkisi* were mostly not anthropomorphic (though the preferences of collectors has created that impression [MacGaffey, pers. comm. 1993]). They were never intended for contemplation as art (MacGaffey 1993:89). Each *nkisi* contains an efficacious combination of medicines. The term translated as "medicines," or *bilongo*, is related to the word *nlongo*, "which refers to things set apart, sacred, subject to ritual precautions" (ibid.:62). These medicines are used to treat illnesses, which in the KiKongo world covers misfortune as well as sickness. The ingredients of *minkisi* were selected for linguistic and figurative

Figure 5.12 *Kungang* power figure in a crouching position, Bangwa, Cameroon. After Brain 1980:10,14.

reasons, not pharmacological ones. They were minerals from the land of the dead (since to the BaKongo all exceptional powers stem from some sort of communication with the dead), items chosen for their names, and metaphorical materials. So the "medicines" in an *nkisi* were "a kind of material, nonverbal list of its abstract qualities" (ibid.:63). While these qualities and functions were common to the majority of *minkisi*, there were different types for different diseases. Since the various ingredients were usually reduced to powder or fragments, they had to be contained in something, such as the shells of large snails, antelope horns, cloth

Figure 5.13 Power sculpture, *nkisi*, Kongo, Zaire. Stanley Collection of African Art, University of Iowa. Medicinal ingredients have been inserted into a stomach cavity which has been sealed with a mirror, indicating the ritual expert's mystic vision. Other materials have also been added to the figure such as leopard teeth, shells (signifying long life), a crown of chicken feathers, metal anklets and collars. A medicinal plant is held to the mouth, which the *nganga* chews and spits out as part of the healing ritual.

bags, gourds, and clay pots, as well as wooden figurines. These various packets, tightly wrapped in knots and nets, gave visual expression to the idea of "contained forces," contributing to the idea of *ngitukulu* or "astonishment" in the mind of the beholder suggesting the presence of extraordinary forces. Nowadays, people may use screw-cap

jars as containers, but the addition of a lattice cord further connotes the idea of forces under control.

Wooden figures had their medicines placed in cavities or protuberances on the head, on the belly, or between the legs (figure 5.13). The head was believed to be an important site of communication with the spirits. Sometimes medicines placed in the belly were sealed in with resin and a mirror. The mirror served as a compass to show the diviner in which direction danger lay. It is ironic that the various attributes and accoutrements of the *nkisi*, so crucial to the visual effect and power of the object, were removed by collectors before they placed them in their museums or galleries.

Minkisi were divided into those "of the above" and those "of the below." The male informants accorded more respect to the latter, in particular the *minkondi* or "nail fetishes" as they have been termed by modern art collectors (see figure 2.2). They are esteemed by both the latter as well as the BaKongo themselves, because of their formidable power and ability to act in more than one domain. The word *nkondi* means "hunter"—it was supposed to hunt down "at night," through occult means, witches, thieves and wrongdoers. The double-headed, nailed dog, for example, is not a depiction of a dog as such, but rather a statement about tracking down wrongdoers and movement between the two worlds of the seen and unseen (ibid.:89). The priest, or *nganga*, would drive nails into the figure to arouse *nkondi*. The nails symbolize the intention that the wrongdoer shall suffer terrible pains in the chest. The appearance of the *nganga*, or ritual expert, often resembled that of his *nkisi*. They were both intended to suggest frightening, supernatural powers. His costume frequently included pieces of "power jewelry," such as a knotted necklace, connoting his ability to bar the way to spiritual forces, for good or ill

(ibid.:53). The painted lines around his eyes signify his ability to see the hidden forces or evil (since death and disease for the BaKongo were [and are] never considered to be "accidental").

MacGaffey describes the invocations to *nkondi* as "extraordinary hymns to violence, transferring into the realm of the imagination the real violence of a harsh existence amidst disease, enslavement, tropical storms, and, since the mid-1880s, the overwhelming violence of the European invasion" (ibid.:79). He emphasizes that they are complex objects which are seriously misrepresented by the theory of fetish. Furthermore, their political and religious significance is suggested by the fact that the colonial states (the Portuguese, French, and Belgian) saw them as elements of African resistance and carried many of them off, and the missionaries burned or carried them off as proof of the destruction of paganism (ibid.:33).

The neighboring Songye produce the most numerous and distinctive of these *minkisi*, or figure sculptures (figure 5.14). Their *mankishi* are believed to serve the well-being of either the community or an individual (Hersak 1985). The most well-known figures, unlike their KiKongo counterparts, are most often anthropomorphic, with a large, geometric form. The hands are characteristically held to the belly. The larger figures are usually covered with a variety of animal, plant or mineral substances (the figure here has metal tacks which follow the contours of the face), adding a visual and symbolic impact of strength and power. The protruding abdomen which is a feature of Central African sculpture connotes not just fertility but also continuation of the lineage. The *nkishi* must portray comparable physical strength, social status and mystical power. The latter derives from combinations of material substances which are inserted into the horn or hollow on

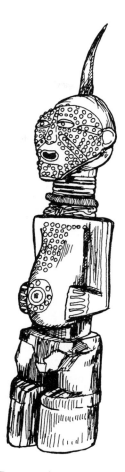

Figure 5.14 Power sculpture, *nkisi*, Songye (Bekalebwe), Zaire. Stanley Collection of African Art, University of Iowa.

the head of the figure or inside the abdominal cavity, all of which signify metaphorically and metonymically the potency of the *nkishi*. The ingredients have been prepared secretly by a particular *nganga*, or sorcerer. Hersak makes the important point that without this the statue has no purpose and is simply regarded as "a piece of wood." It is one of several possible containers along with horns, shells, calabashes, and even old food tins (ibid.:118).

Mankishi are just like other herbal medicines (*bwanga*) in that they are subject to

certain conditions and taboos. Since they involve more specifically spirit appeasement, the figures are fed and anointed, and receive sacrifices. The benign, protective quality of *bwanga* stems from the belief that they were produced by the supreme being, Efile Mukulu, at the dawn of creation. Most of Hersak's informants stressed that the *nkishi* form was a later development, necessitated by a time of vicious sorcery. The largest forms of *mankishi*, some of which may be a meter in height, are the ones which serve and protect the community. Specific *mankishi* are named and remembered by people for their inherent power. These figures are distinguished from other magical objects because of their association with the ancestral spirits. This is seen in generalized traits of chiefs, hunters and warriors portrayed by the figures. The Songye do not say that the spirits inhabit the figure, but rather that they are believed "to communicate and project their power through the medium" (ibid.:121). The life of these magical objects is short-lived, as with human lives, since they fulfill their tasks and are often eclipsed by more esteemed objects and *nganga*. In contrast, the personal *mankishi* which serve the needs of individuals and nuclear families are more anonymous, although they do reflect the ills and tensions of the community (figure 5.15). Many of them are intended to deal with witchcraft and sorcery, and in that respect epitomize the "co-existent duality of this spirit realm," since they invoke malevolent forces to produce benevolent effects. They can be produced by a variety of specialists (even by users themselves), rather than by *nganga* or sorcerers alone. They are also more diverse in form and quality of craftsmanship.

Even for the larger *mankishi* it is interesting to note that, with regard to their creation, the Songye refer primarily to the *nganga* who endowed the particular figure with magical

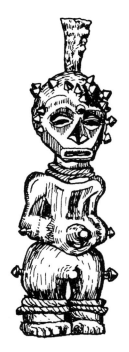

Figure 5.15 Magical figure, *nkisi*, Songye (Batempa), Zaire. Stanley Collection of African Art, University of Iowa. This small figure probably protected an individual or a family against malevolent forces. The tacks driven into the body as well as its suffering face indicate that it protected against witchcraft (Roy 1992:163).

substances. All *mankishi* are assigned a guardian, usually an old man or old woman, who plays a very important role in the ritual life of the statue. He or she will receive messages from the *nkishi* through dreams and gives evidence of the actions of evil spirits through possession. If the guardian dreamed of danger to the community, the *nkishi* would be paraded in public, supported by poles made of wood from a burial ground. The *nkishi* was believed to signal through gestures the way in which certain *bwanga* should be concocted and administered, for example. Communal *mankishi* are also carried from one end of the village to the other at the time of the most

important public ritual, the day of the first quarter of a lunar cycle. They are believed to chase away the malevolent spirits. The personal *mankishi* are often kept in the huts of their owners and may receive small food offerings at mealtimes. Some are small enough to be carried while traveling.[4]

The Concept of "Fetish"

The type of object described above necessitates some discussion of the concept "fetish," even though it has virtually no currency in current anthropological discourse in English. It is viewed as disparaging and misleading, not just for its sexual connotations but also its colonial heritage. As early as 1927, Emil Torday referred to "fetish" as a word "which has been a nuisance to all of us" (cited in Mack 1990:90). He advocated the use of indigenous terms to avoid any prejudicial framework. In a trilogy of essays on "The Problem of the Fetish," William Pietz traces the history of the concept and then analyzes the discourses about fetishes (1985, 1987, 1988). European voyage accounts of the seventeenth century attribute the "primitive's" propensity to personify objects and to account for certain processes in terms of supernatural agency to their lack of scientific knowledge (ibid. 1987:42). Just as Africans appeared to assign religious value to trifling objects, they also overestimated the economic value of trifles. So in other words, it was the "thoroughgoing mercantile ideology" of these writers that associated false economic and religious values. Another theme behind the fetish idea was the view of African societies as devoid of reason, law and religion. The diversity of fetishes was thus a function of a fanciful, irrational human imagination. Used as oaths, fetishes represented, in the eyes of these European merchants, a sanctioning power based on deluded, magical belief and violent emotion, rather than rational institutional sanctions.

Pietz argues that the Fetisso (a pidgin term deriving from the Portuguese word *feitiço*, meaning "an object or practice pertaining to witchcraft" and from the Latin *factitius*, meaning an object made by humans), was a novel idea emerging out of the cross-cultural interaction on the West African coast and should not be confused with the Christian theory of the idol (where verbal pact united human soul and demonic spirit). The fetish idea was the result of a particular historical and social situation (i.e. Christian feudal, African lineage, and merchant capitalist social systems [ibid. 1985:6]) which was then elaborated into a general theory of "fetishism" during the Enlightenment. Fetishes for seventeenth and eighteenth century Europeans constituted a confusion and conflation of six distinct kinds of value-objects, ranging from religious to commodifiable and technological objects (ibid. 1988:109).

The paradigmatic image of Afro-European discourse about fetishes was usually a wooden figure, leather amulet, gold necklace, stone, bone or feather, or potentially any inanimate material object. MacGaffey has described the fetish as always a "composite fabrication" (MacGaffey 1977:172). It enjoys much wider use as a concept among French and Francophone scholars (cf. de Surgy 1985). Gwete argues that it is human agency that defines, creates and activates the "fetish" through the assemblage of powerful medicines; it is not the object itself (despite the appearances given by certain ritual acts) that constitutes the power (1982; cf. Brain 1980:208). MacGaffey's work illuminates the nexus of relationships which underlie the "animistic" or "magical" qualities of certain ritual objects. He demonstrates the relationship between object or container, spirit or soul and

practitioner in the context of the Kongo ritual system, pointing to the strong resemblance between the *nkisi* cult and the cults connected with descent groups (ancestors and chiefs) and those connected with localities. In fact, he argues that (in contrast to Durkheim) Kongo magic and witchcraft are "integral parts of a conceptual set which is central to Kongo religion though not exhaustive of it" (MacGaffey 1977:182). Augé argues that the "god-object" permits humans to reflect upon the relationship between matter, identity and relationships (and the attendant transitions) and must be understood in the context of a belief system that views humans and gods as resembling one another and mutually dependent (1988).

Amulets, Talismans, and Body Adornment

While there may be disagreement over terms, the diversity and complexity of accoutrements which are believed to have apotropaic (capable of averting evil) or empowering qualities is not in doubt. This final section contains some additional examples of interest. Mande amulets or *sebenw* are, in McNaughton's words, "prominent physical manifestations of Mande beliefs about the world's deep structures and the practical access that human beings have to them" (1988:58). The same word also refers to "writing" which not only suggests some of the amulet's contents but also the fact that written scripts are generally secret and destined for spiritual use. A *boli*, such as we saw in chapter two, is a type of amulet or power device. It is a huge sculpture with a thick black coating of earth or mud, with pronounced traces of blood sacrifice and giving the sense of concealing important magical ingredients in its center (ibid.:59; Brett-Smith 1983:48). These sculptures generally depict simplified cows, human beings, or round solid balls (see figure 2.15).

They are commonly passed over by Western art collectors, but are the most highly prized sacred objects for the Bamana (Brett-Smith 1983:49). They may be openly displayed but not talked about publicly. "The *boli* gives material form to the spiritual forces at the disposal of the initiation society" (Ezra 1986:14). The *Boliw* of each local secret association have complete judicial authority to hear a case, divine a culprit and decree a sentence. They are believed to be able to poison and kill at long distances through the assembled, compacted human and animal excrement, so greatly feared by the Bamana (Brett-Smith 1983:50). Visual metaphor and verbal pun both suggest that the *Boliw* are "poisonous stomachs." The form is also linked to the fact that Bamana secret associations are talked of as living beings with "heads," "tails," "stomachs," etc. The *Boliw* are the gut of the association and are kept hidden in the "belly" of the sacred grove, while the "heads," or masks, perform publicly outside (ibid.:52). The initiates are talked of as being swallowed as part of the initiation process. The bovine and humanoid forms must be understood in the traditional economic context where cows and humans are the two most important forms of wealth.

Sarah Brett-Smith takes the analysis of form and composition even further, by showing how the cow also connotes wealth with "incipient treachery" but which can be seen by the *Boliw*, and how the inner core of white rolled cotton relates to the highly symbolic act of wrapping something with cloth in Bamana society (ibid.:58). So just as women make children by wrapping the skin of their belly around blood, the *Boliw* are viewed as symbolic "children." But in fact the *Boliw* "embody the most radical reversal of the natural process of life. The sorcerers who construct *Boliw* are not merely playing a symbolic game: they are appropriating the most fundamental defining characteristic of women—the right to produce

and control life" (ibid.:61). The secrecy and tyranny of the *Boliw* conceals this sexual confusion and freedom, in the interests of social order. (This is, of course, very reminiscent of the creative role of blacksmiths.)

The use of artworks to ward off evil can extend to even the humblest items. In his work on the arts of Burkina Faso, Christopher Roy describes a number of household and jewelry articles which are believed to confer protection or blessings (1987). The carved wooden spoons and ladles used by the Nuna and Winiama are decorated with the heads of protective animals and spirits (ibid.:62f.). They are believed to ward off poisoning as they ladle out the sauce for millet gruel and change color on detection of poison. Granary doors in the Kurumba area have small locks that represent protective agricultural spirits that watch over the contents of the granary. These locks frequently have a female figure as the central vertical member. In the past it was common for people in Burkina Faso to wear anklets, bracelets, rings and pendants of brass or other metals, or of ivory or stone to keep at bay the disease and misfortune caused by malevolent spirits. Nowadays they are little worn, having been taken for the most part to the tourist markets in the larger cities. Cast brass rings, bearing tiny models of masks may be worn by the Mossi, Nunuma, Winiama, and Nuna to ensure the blessings of mask spirits. Sometimes a Tsuya diviner may prescribe a small brass pendant be worn by the client to secure the blessings of whatever spirits have caused problems.

Ethiopian religious art provides some wonderful examples of protective and healing devices in the form of icons, seals, manuscripts, and talismans. These were magnificently detailed in the exhibition on art and medicine in Ethiopia held at the Musée des Arts d'Afrique et d'Océanie in Paris in 1992/3 (Mercier 1992; cf. also Mercier 1979). Some of these amulets, parchment fragments worn rolled up in silver or leather necklaces or belts, or larger parchment scrolls unwrapped and suspended in the home, were probably in use since at least the fourteenth century. They should not necessarily be ascribed to Muslim influence (ibid.:123). The texts often treated the secret names of God, which were valued throughout the region. While talismanic traditions can be traced back to the Hellenistic period, it is believed by Ethiopians that talismanic knowledge dates back to the earliest Old Testament period. King Solomon is held to have received this knowledge and the power to subjugate demons and obtain secrets from the Archangel Michael when he banished Satan from the heavens. For this reason, his image appears frequently in Ethiopian art.

But rather than the figurative designs, it is perhaps the talismans dominated by eyes and faces which are the most striking. Usually at the center is the divine face or face of God, often surrounded by angels, birds, or other supporters and intercessors set in geometric motifs. Double lines and oversized heads are frequently used in this type of magical art. Some talismans are known as "scissors," because of the Xs placed in the four directions, serving as scissors to cut off aggressive spirits. Designs centered on eyes are typical of the magic scrolls, as seen here in figure 5.16. Rather than just attributing these metonymic images solely to an economy of space, Mercier suggests that they involve manipulation—a two-way gaze. This intimacy creates the conditions for exorcism of the possessing spirit. It is believed to shout and leave its human host when it sees the talismanic image. Mercier also links this visual manipulation to the visionary or hallucinogenic experience of many clerics, who have been possessed by *zar* spirits or demons in the course of their therapeutic vocations. The cross, decorated with trees,

Figure 5.16 Ethiopian talisman, parchment scroll, 19th century. Musée des Arts Africains et Orientaux, Paris. After Mercier 1992:fig.100.

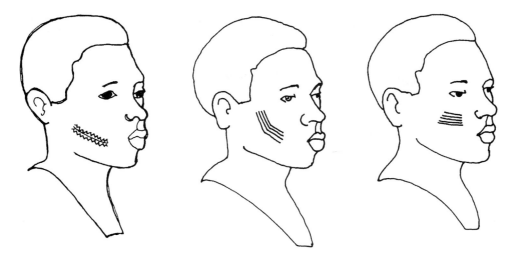

Figure 5.17 Yoruba facial markings. After Drewal 1989:246, fig.10.1.

snakes and other symbols, has long had apotropaic value for Ethiopians, whether as an image on parchment or as an object employed by the priest to drive out (as Christ transcended death on the cross) the spiritual agents of sickness.

Body markings may also have protective as well as aesthetic and identifying qualities. Yoruba body artists (olọọla) worship Ogun, the god of iron (Drewal 1989). All those who live and work with iron—believed to be a sacred substance, charged with aṣe or life-force—have a special relationship with Ogun. The body artist's implements are treated as sacred: the blades are wrapped and tied in a red or white cloth, Ogun's symbolic colors. The motifs have little direct association with Ogun, but the work of the body artist is viewed as an extension and manifestation of Ogun (figure 5.17).

This chapter endorses the view that African religions are far more pragmatically oriented than Western religions, being concerned with explaining, predicting and controlling mis-fortune, sickness, and accidents (cf. Barnes 1989:22). Through processes of transference and ritual enactments of order and disorder, diviners and ritual specialists enable supplicants to make sense of and act upon adverse forces in their public and private lives. The aesthetic serves as both antidote and transformer in this regard.

Notes

1 Beidelman, in his review of the exhibition (1990), rightly points to the ambivalence of attitudes toward the forces of the "bush". He considers that "the exhibition's view of dichotomized cosmologies may underplay the deeply positive, integrative forces that are repeatedly drawn from the bush."

2 It also offers an excellent range of bibliographical references on the subject.

3 There is a fine photograph of a Basinjom mask and gown in *Praise Poems: the Katherine White Collection* (Seattle WA: Seattle Art Museum, 1984), 112.

4 Wyatt MacGaffey (1991) offers us a most valuable, inside perspective on the *minkisi* used by Kongo peoples.

Shrines as Ritual and Aesthetic Space

Natural as well as consecrated locations serve as meeting points of human and divine forces, and as abodes of the spirits. Differentiated, yet not always fixed, they are often contrasted with the profanity, ordinariness, and wilderness of all other places (Parkin 1991a:5). As points of reference, sacred places provide bearings, meaning and unity amidst the flux of daily existence (H.W. Turner 1979:9f.). They provide a break in the homogeneity of space, a fixed point, a center, whose ritual orientation and construction have cosmogonic value in that they are considered to reproduce the work of the gods (Eliade 1976:22). In Africa, as well as in other parts of the world, these sacred places are designed and decorated to (re)present the gods to the community. Their designation and/or construction may derive from a particular community's historical experiences. Artistic forms in these locations are believed to serve as enhancers and transformers of divine-

Figure 6.1 Chalk image of a fish for Olokun, the deity who resides in the waters, Benin City, Nigeria. After Rosen 1993:37.

human relations. It is why they are sometimes called the "eye" or "face" of the spirit (Poynor 1994). Shrines are perhaps the most common embodiment of sacred space and they may be elaborate or simple in structure, serving leaders, entire communities, families, or individuals.

The Divine on Earth

Some shrines are believed to be earthly recreations of divine kingdoms. Olokun, the important deity of the waters in the Edo Kingdom of Benin, has strong associations with creativity as we saw already in chapter one (Ben-Amos 1986:62f.). Many of his devotees are spiritually directed into artistic activities, such as the decoration of his shrines. These shrines are found in villages and the urban homes of chiefs and cult leaders. Some people are chosen through divination to serve as decorators, and hang large pieces of cloth behind the altar. White cloth symbolizes the "absolute ritual purity" of Olokun's kingdom, while red cloth has apotropaic qualities. Other devotees are known as *owuorhue* who create elaborate abstract designs using ground kaolin to beautify the altar space (figures 6.1 and 6.2). These ephemeral, temporal markings are said to "open the day for Olokun in the water," and must be performed on a regular basis. The pureness and whiteness of the kaolin is

important to Olokun worship, and the various patterns are believed to be assigned to the designer by Olokun. Likewise, the figures molded by the artists, who are both men and women, are commissioned by priests and priestesses who have had a dream or vision of Olokun's demand for a molded shrine. These shrines constitute life-sized tableaux, representing the underwater palace of Olokun, his wives, chiefs, and attendants. Ben-Amos emphasizes that these shrines entail a very special creativity, in that they are not just reflections of power, but recreations on earth of an "ontological reality." The clay from the riverbank which is used in the shrines is not associated with domestic activities but "with the moment of creation, for it is the very material that Osanobua, the father of Olokun, used to form the first human beings." So in this ritual and symbolic space where gender differentiation breaks down, the artist thus becomes, in Ben-Amos' words, "not only a molder *of* the gods, but a molder *like* the gods" (ibid.; cf. also Rosen 1989).

Igbo shrines to the water spirit, Mami Wata, seek to recreate her world through the use of blue-green walls devoid of any features such as landscapes and buildings. This aquamarine space is often filled with mirrors, canoe paddles, fishnets and bas-relief snakes floating across the walls (Drewal 1988a). Sometimes the priestess herself or paintings on the walls recreate the image of the snake-charmer which derives from the nineteenth century European chromolith and which has become one of the key images of Mami Wata. The shrines reflect, in Henry Drewal's opinion, a creative configuration, interpretation and manipulation of images and ideas about indigenous and exogenous people, powers and spirits. The eclectic experiences of many of the healers are manifest in the Hindu, African, European, Christian, American, occult and astrological

Figure 6.2 Chalk image, *igha-ede*, for Olokun, Benin City, Nigeria. After Rosen 1993:38. This simple cross design with circles has many meanings: the transmission of messages to and from the other world; sharing of food among the deities; the allocation of ritual time; detection of physical ailments; and the division of the human and spiritual worlds.

beliefs and practices. One Igbo healer showed Drewal decorations in his shrine that had been copied by the carver from a book from the mystical and occult publishing company, De Lawrence of Chicago. This same healer also declared that multiple and varied images in his shrine were for others to visualize the invisible spirits that dwelled within people such as himself who had powers and visions. He went on to make the interesting reflection that "there are places called temples, and temples are shrines. They are the same thing. But you should also know that the temple is within me" (ibid.:42).

The centerpiece of many Mami Wata shrines is a sculpture of Mami Wata. This is illustrated here by the photograph of an Ewe Mami Wata shrine in Togo, an area also researched by Henry Drewal (figure 6.3). She is often depicted as a non-African female, with long flowing tresses, covered in medallions and manipulating snakes above her head (figure 6.4). As

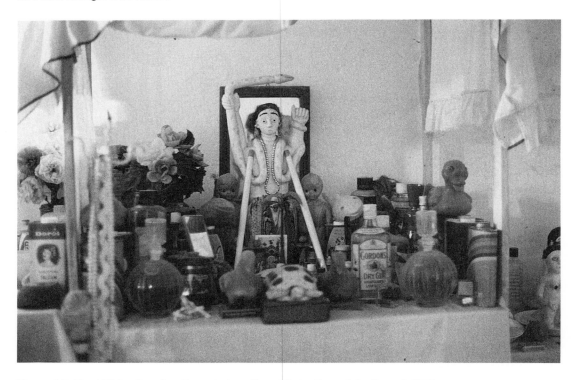

Figure 6.3 Mami Wata altar of an Ewe priestess, Togo. Photo: Henry John Drewal, 1975.

in the chromolith, the lower half of her body is concealed since she is believed to be half woman and half fish. Sunglasses and the frequent use of mirrors not only suggest her love of beauty and fashion, but also symbolize the surface of the water, the boundary between the cosmic realms of water and land. This threshold is crossed by the spirit when she possesses her mediums, and by the devotees when they travel to her watery underworld in their dreams. The shrine is usually filled with Western-style furniture, one or more cloth-covered tables bearing beautiful and sweet-smelling items, and paraphernalia such as combs and jewelry. There are also many ritual items such as candles, incense, powders, cologne, fruits, candies and drinks, which form part of the rites of personal toilet and devotion. Drewal maintains that these familiar and

Figure 6.4 Mami Wata figure, Yoruba, Nigeria. Stanley Collection of African Art, University of Iowa.

foreign objects are invested with new meaning in the quest for additional knowledge and meaningful rites to promote wealth and well-being.

Natural locations may function as ritual and artistic space. San rock paintings often appear to enter and leave the rock face through cracks and steps. For example, partially painted animals appear to suggest that the rest of the animal is behind the rock and out of sight of ordinary people (figure 6.5). Lewis-Williams and Dowson argue that the rock face is significant given the shamanistic nature of San art discussed earlier in chapter four (1990). In other words, the potency of the rock itself, as well as its texture and shape, is integral to the artistic tradition (Dowson 1992). In keeping with shamanistic experiences documented elsewhere of reaching the spirit world through holes in the ground, underground and underwater imagery feature prominently in San thought. Based on neurophysiological research and ethnographic reports which show that trance states include three-dimensionality, magnification of detail, projection of mental imagery, and after-imagery, Lewis-Williams and Dowson claim that "the walls of shelters and especially holes and inequalities in the rock surface may, under such conditions, have appeared to be entrances to tunnels leading to the spirit world" (1990:12). So the boundaries between paintings and hallucinations dissolved, with the former contributing to and even inducing shamanic visions. The walls of rock shelters, therefore, became "animated screens of powerful imagery." The paint itself had its own power, and often comprised eland blood as a source of empowerment. An old San woman reported that when shamans danced they turned to face the paintings when they wanted to increase the level of their potency.

Ancestral groves where shrines were erected to the spirits and gods who dwelt in them

Figure 6.5 San rock painting, Lesotho. After Lewis-Williams and Dowson 1990:10, fig.4. A fantastic serpent emerges from a slight step in the rock. Nearby are two therianthropes, or animal/human figures, suggesting the metaphysical transformation of the shaman.

may provide inspiration for contemporary artists such as the renowned Nigerian painter and printmaker, Bruce Onobrakpeya (Quel 1985:52). Many of his art works express the particular trees or aspects of the trees (such as knots, rings, etc.) that are worshipped in these groves and seek to expose the forces and mysteries hidden in the trees. The composition of his works is adapted after the frontal static postures of Nigerian shrine arrangements (ibid.:26).

Some Ethiopian churches were literally hewn out of the rocks in the area formerly known as Roha, and now known as Lalibala (Heldman 1992). Place names and architectural

forms suggest that it was intended to be a replica of Jerusalem. But its symbolism is multilayered, for it also replicates the cathedral at Aksum and constitutes an attempt to reproduce a royal and sacred Ethiopian city. There is also evidence of mimesis of Old Testament forms, such as rock-hewn altar chests, recalling the Ark of the Covenant. But, as Heldman is keen to point out, the Ethiopian patrons and architects appropriated these forms with a view to transforming and transcending them, and making them specifically Ethiopian. Hence, we witness the development of the Ethiopian circular church plan and its innovative subdivision of the space using ambulatories—possibly dating from the fifteenth and sixteenth centuries (see Mercier 1979:pl. 3). It is unrelated historically to the centralized church plan of early Christian and Byzantine architecture, and is now virtually universal in central Ethiopia.

Mbari: Shrines as Ritual and Artistic Process

In contrast to the greater permanency of natural locations, some shrines are more temporary in nature. Among the Owerri Igbo, *mbari* houses were made as sacrifices to major community gods. Ala, as earth deity, source of morality, fertility, wealth and yams, and generally the strongest deity in many areas, tended to dominate these sculptural monuments (Cole 1988). *Mbari* were also made for Ala's son, Amadioha, god of thunder, as well as river gods and tutelary deities. The heyday of *mbari* construction was in the 1930s, but they date back to at least the beginning of the century. With the decline in traditional worship and growth of Christianity and Western education, numbers and size of *mbari* have been considerably reduced, and styles and materials have changed. Since the civil war of 1967–70, government- and community-

sponsored, and non-spiritually motivated versions may be found, generally serving to remind the community of their spiritual roots and cultural heritage. An example of this is the Mbari Centre of the Christian sculptor Chukueggu who has done a number of commissions. Herbert Cole, who has extensively researched *mbari*, argues that its adaptive character and sense of regeneration and renewal, as well as its integrated sculptures, paintings, and architecture, have served as a stimulus to groups of artists in other parts of the country.

The decision to erect an *mbari* constitutes a response to major crises in the community, such as famine, plague, excessive death, drought, warfare, and/or poor harvests. These punishments are believed to be inflicted by Ala when she has been offended by a community. The erection of the *mbari* will appease and placate her, and remove the calamity from the community. Nwachukwu-Agbada insists that *mbari* is essentially a religious affair, in that it is a sacrifice, serving to (re)bind the community to its deity (1991). He denies, like Cole, that *mbari* is a shrine for worship, since there is no veneration of *mbari* objects, and the *mbari* house is usually constructed some distance away from shrines for the actual deities. In fact, in earlier times the *mbari* house was left to deteriorate; after a few months it had virtually disintegrated and rejoined the earth. With the advent of the iron roof, however, the buildings could remain standing for several years.

In this connection, Cole contends that *mbari* should be considered more as a process rather than a form. In fact, informants described *mbari* as a "dance" because of the interrelated and overlapping subsidiary art forms and rituals—whether singing, praying, dancing, body-painting, marching, chanting—involved in the creative process. There are three types of individuals or groups involved in the

construction of *mbari*—priests, diviners and artists/workers (Cole 1982:78f.). They are generally selected through divination, and an iron rod is ritually "tied" to seal the agreement. In the past, people feared to refuse, while acknowledging that participation would entail long-term blessings. Various sacrifices and initiation ceremonies, such as "walking the iron" connoting the hardships as well as symbolic death and rebirth of the workers, are performed before the work may begin. The workers are subject to a period of ritual seclusion until the *mbari* opens. It is supposed to be a time of peace, and most of the work, food, and living conditions are shared between the sexes on a relatively undifferentiated and equal basis (ibid.:93). Once the ground has been prepared and the initial mud structure completed, an important ceremony is performed which involves inserting European dinner plates and saucers (also known as *mbari*) into the walls. Sometimes as many as five hundred plates may be brought by the workers and people in the town, and the process may take several months to complete. This important ceremonial activity marks public acknowledgement of *mbari*.

The next stage in the process is for the workers to "go to farm to collect the yam of *mbari*" (the clay pounded like yam), a symbolic activity involving the collection of the clay from specially selected anthills to model the *mbari* figures and animals. This activity necessitates a number of ritual preparations and workers operate at night to avoid being seen by members of the community (ibid.:88f.). The first figure sculpted is never actually finished nor placed in the *mbari*. This crude figure functions as a scapegoat, draining off any evil which might disrupt the building process. The first days of modeling are transformed into a minor festival, with singing, dancing, drinking and body painting. Soon the house is filling up

with the mud-colored forms of animals, humans, monsters and deities. They are made (clay over bamboo frames) and painted in a counter-clockwise order around the house. The owner of the house, Ala, the earth deity, is a much larger figure and is constructed last. Artists claim that they find the constructing of their most feared god psychologically taxing (ibid.:94). The priest reserves an iron bar for her footrest. Ritual splashes of paint inaugurate the painting process. Before the introduction of Western poster paints, pigments were obtained from sacred sites; small paintbrushes were made from fowl feathers saved after sacrifices. Special care is taken in painting Ala; her body designs must be elegant and precise, and her head and headdress must be detailed, strong, and dignified (ibid.:96). The priest then sets a day for the *mbari* to pass the test of its patrons.

The elders must approve the sculpture and decoration, pointing out any unacceptable work. Inferior *mbari* would discredit the artist, lessen the prestige of the priest, and incur the gods' wrath. Any figures in the house considered to resemble a real human being in the community are destroyed and rebuilt since this is considered inauspicious, and *mbari* figures are supposed to be more beautiful than human beings (ibid.:97). The sacrifice has taken years to complete but it is brought to a swift and dramatic close. The private and spiritual part of the unveiling ceremony takes place at night, while the day is reserved for more secular and public celebrations. In the evening, the various tools are tossed into a pit together with the scapegoat figures and a sacrificial goat or fowl. The deity can now be formally invited into her new house. This is ritually enacted by the transfer of a symbolic stone, signifying her soul, or *chi*, to the inner chamber of the *mbari*. Then follows the purification of the workers, who ask Ala to let evil leave their bodies. The

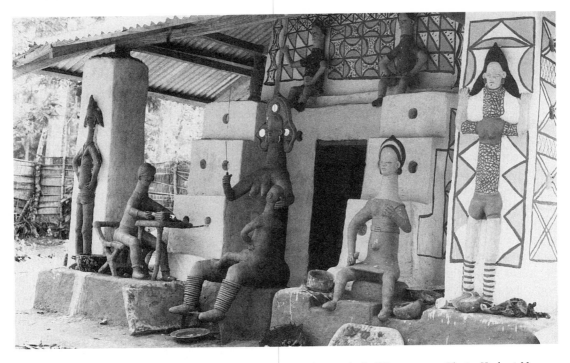

Figure 6.6 *Mbari* to Ala at Umuedi Nnorie, Igboland, Nigeria, during the building process. Photo: Herbert M. Cole, 1967.

workers then rush out of the compound, where they fling off their old clothes and put on new. Before long the fence has been torn down and the gathering crowd begins to celebrate the god's acceptance of the *mbari* (ibid.:99). The workers do not acknowledge their involvement in *mbari* once released from service, as fatal repercussions from the deity are feared. For the community as a whole and the priest in particular it is a time of great pride and rejoicing.

The *mbari* vary in size and layout, but they are intended for people to observe from the outside (figure 6.6). They are generally larger than traditional buildings and are made to seem larger than they actually are. As Cole notes, "[t]he visible spatial organization is an orderly, predictable succession of masses and voids," yet there is a "hidden interior which puzzles the visitor" (ibid.:132–3). The deity for whom the house was constructed occupies a central niche on the most accessible side of the house, while his/her children or lesser deities flank the central figure or are found on the other sides of the structure. *Mbari* artists draw on and transform existing imagery from stories, myths, proverbs, and life forms, as well as occasionally creating new images (ibid.:164). Some artists speak of dreams as sources of inspiration. Many of the characters are topical, such as the white man, and there are many items of modernity and prestige, such as Western clothes, machines, Christian paraphernalia, umbrellas, imported cloth, etc. The two-story building with zinc roof reflects a concern, according to Cole, to house the deity in the same type of prestigious house as that used by colonial officers, as well as a hope that Ala will bestow similar gifts of status and prestige on her people. Nwachukwu-Agbada argues that the incorporation of the figure of the white

man is rather an act of resistance and defiance on the part of the Igbo people: "it was in the people's bid to expose the white man to the wrath of the gods that his cast was built and placed alongside the god-figures" (1991:212).

While *mbari* arguably contains much that is not ostensibly spiritual, it still represents the most profound offering or sacrifice known in Owerri society. The *mbari* process is an act of cosmic renewal, a harmonization of opposing forces, a fusion through materials and workers of the real world, the sky world and the under-world, and, above all, a celebration of life.

Domestic Shrines

We should not forget that domestic space may also serve as a religious sanctuary. Griaule's research in particular, among the Dogon, high-lighted the interrelated symbolism of household, village, world, and cosmos. The Batammaliba (Tamberma, Somba) live in Togo and the Republic of Benin. Their name trans-lates as "those who are the real architects of the earth" (1938:2), indicating the importance of architecture in their lives. Batammaliba houses shelter both families and shrines of numerous deities (Blier 1987:80f.). The design, usage and decoration of each dwelling convey ideas about the sacred, particularly in the form of abstract architectural signs. These signs are identified with the sacred powers and represent the paths they are believed to take in returning to the house for ceremonies. The concept of the pathway is critical for understanding both the village landscape and the decoration of house facades.

Kuiye, the central, creative force in the Batammaliba cosmos, is believed to dwell in a very tall house in a village in the sky to the west. Because every Batammaliba dwelling is identified as a sanctuary for Kuiye, it expresses the same verticality and is oriented along an east-west path which is the distinctive sign form of Kuiye. This assures that the sun's rays will enter each house portal at dusk and fall upon the west-facing shrines of the family's deceased elders and game animals. People believe that Kuiye is speaking with the former about the affairs of living family members. Priests also face the west when addressing the deity. A pair of earthen horns, connoting abundance and fertility, projects from the facade of most houses, just above the entrance. The horns are particularly associated with the birth of twins, alluding to Kuiye's creation of the first humans as multiples or twins. They channel the life-giving sunlight into the woman's bedroom. Butan is the goddess of the earth and the underworld and the wife and complementary power of Kuiye. She is associated with human pregnancy and birth, and rules over agri-culture, hunting, and fishing. As in the case of Kuiye, she has both a spiritual and a corporal aspect. The latter, not visible to us, is said to resemble a mudfish. Her house is believed to be small (close to the earth) and to lie deep in the underworld. Her main shrine is a village spring. Butan's pathway sign is the circle, which characterizes the shape of every village and several worshipping groves. Incised markings on house facades, resembling the cicatrization signs on women believed to ease childbirth, reinforce Butan's role in facilitating delivery and protecting newborn children. Blier shows how the meeting of the semi-circular form of the shrine in the house and the east-west axis of the sun's rays of light creates a "deity path crossroads, one that simultaneously addresses the two key rulers of the cosmos" (ibid.:96).

The cosmological significance of lesser deities is also expressed and transposed in architectural symbols and forms—the forked shape is the principal sign form of Oyinkakwata who controls thunder, lightning and rain; the

Figure 6.7a Mural decorations by Sotho-Tswana women, Southern Africa. After van Wyk 1993:90, fig.12. The complex pattern on this house is dominated by spiritually significant zigzag motifs.

shrine of Fafawa, an initiation deity, suggests the form of a python and her sign path is enacted in the serpentine path made at the beginning of the men's initiation ceremony; the geomancy deity, Kupon, is believed to travel and mediate between the various cosmic realms, hence the steps or ladder-form signs, as well as that of the transforming chameleon, which are reproduced on the houses where geomancers reside.

Sotho-Tswana women decorate the walls of their homes in southern Africa with linear designs and natural earth ochre or bright commercial paints (van Wyk 1993). These decorations "connect the female body and its labors, the house and the field, the natural and the supernatural..." (ibid.:84). The patterning recalls the fields both visually and linguistically, colored with earth's pigments. The triangles symbolically bridge earthly and heavenly realms, and zigzags imply cyclical processes. Flowers and tendrils place women at the center of the cosmos (figures 6.7a and 6.7b). Red and white, colors associated with initiation, decorate the transitional zones of the house. In fact the woman's body in initiation with ochre covering and leg decorations

mirrors the house. Black symbolizes the dark clouds of rain brought by the ancestors. The house and courtyard are traditionally controlled by women, and identified mythically and metaphorically with the womb. With the advent of Christianity, the display of crockery on elaborate mantelpieces has replaced the mud platforms on which clay ancestral figures were once arranged. While female ancestors are no longer buried in the courtyard, altarlike mountings for the flags of independent Christian churches serve as visible reminders of the cosmological and socio-economic significance of this female gendered space.

Personal Altars

Shrines may exist for individuals alone, rather than for families or communities. In the lower Niger region, an individual's success is symbolized by the hand, and sculptures and altars reflect both achievement and potential. The Igbo *ikenga*, as shrine, symbol and idea, is the most well known of these forms (see figure 3.6). It is most commonly represented as a human with horns, sometimes abstractly rendered as just the head and horns on a base or it may be

Figure 6.7b Floral motifs painted by women on Sotho-Tswana house, Transvaal, South Africa. After van Wyk, 1990:88, fig.8.

a fully realized male seated on a stool, holding several symbols and wearing a complex headdress, dominated by horns connoting male power (Cole and Aniakor 1984:24f.). The knife frequently held in the all-important right hand adds to the symbolism of action, aggression and achievement. Generally acquired by a man by the time he is married and with a family, the *ikenga* may receive offerings from its owner and is in fact treated as a spirit (*mmuo*), remaining with him until his death. The latter's *chi* (personal god) and his ancestors are generally considered to be present in the *ikenga* shrine, as well as his right arm or hand (*aka ikenga*), his power (*ike*) and spiritual activation through prayer and sacrifice. *Ikenga* also exist for tutelary cults and villages.

The Benin *ikegobo* consists of a cylindrical stool-like form from which ivory tusks, or single antelope horns or wooden pegs, might have projected. Brass or bronze *ikegobo* were the prerogative of the Ọba and the Queen Mother, and the Ezomo, a war chief. All others were made of wood. The *ikegobo* iconography often represents the owner in full ceremonial regalia and reinforces his status. Elephant tusks, clenched fists, leopards, and severed human heads connote power, and traditional sacrificial offerings, such as mudfish, kola nuts, crocodiles, rams, cows, and coconut leaves, are frequently depicted (Dean 1983). The most common sacrifices to the hand are fish, which are associated with Olokun, the god of the waters and the wealth he is believed to bestow. For Bradbury, the cult of the hand is the "ritual expression of self-esteem" (1973:270), the shrine being prepared when someone feels that they have accomplished much in this world or when they have been advised by diviners to serve their hands (Ben-Amos 1989:60; Bradbury 1973:268). As an instrument of statecraft, it serves to distinguish the Ọba "from his line of divine ancestors by virtue of his individual accomplishments" (Dean 1983:37). Because many *ikegobo* are specific to their owners, they are buried with them; some pass on to their sons. Edo ancestral altars, also in the kingdom of Benin, will be discussed in chapter seven.

For Tukolor weavers of Senegal their loom is viewed as a personal and ritual space (Dilley 1987). Not only does the loom produce cloth by day, but it is also believed to house spirits by night. Weavers rarely work after sunset. In oral

literature, it is recounted how the loom was taken from spirits weaving in the bush and brought to humans by their mythical ancestor, Juntel Jabali. The weaver enters the loom each morning in a way which recreates Juntel's actions in causing the spirits to flee. He also utters incantations to protect himself from the spirits who inhabited the loom by night, and removes his shoes to ensure ritual purity. Seeds are planted beneath the loom to propitiate the spirits associated with the craft, and the loom reflects each weaver's individual bodily proportions. Furthermore, the loom is oriented conceptually toward the east, and weavers' songs always start by greeting the east when they greet the four points of the compass. Weavers themselves liken weaving to praying. These traditions persist despite the strong presence of Islam.

Temporary shrines or monuments for deceased members of a male warrior society used to be erected by the Anang of south-eastern Nigeria. These shrines contained fine wall-paintings and frescoes, depicting people, animals and objects from everyday life (Jones 1984:105). Cloth "walls" known as *ngwomo* cloths served as a background (Nicklin 1987; Nicholls 1991). Personal and household items were placed there for the deceased in the after-life. Since the 1970s these funerary houses have been replaced by cement tombstones, al-though I was able to view a similar type of shrine erected for an Efik chief in Calabar in 1980.

An even more temporary shrine are the Haitian Tap-Taps, brightly decorated vans that cruise the streets of Haiti's capital. Cosentino calls the Tap-Tap a "rolling *hounfor*" or "proto-shrine on wheels dedicated to the patron *loa* (deity) painted on its back" (1988). These *loa* have African antecedents but they are most often represented in the form of Catholic saints. For example, Erzuli Freda, "the vamp of the

pantheon" who likes wedding dresses, perfume, jewelry, and crystalline tears, finds life through the image of the Virgin Mary. Ogun, the god of war and iron, as well as of the road and motor vehicles, is realized through the image of St James Major, crushing Muslim infidels under the hooves of his white stallion. The dashes of red cloth and paint to be found on the vehicle are testimony to Ogun's favorite color. Dashboards may be transformed into Vodoun altars (*pe*) through the arrangements of saints' accoutrements and luxuries, such as perfume bottles, decals, plastic fruits and tinsel cord. The sides of the Tap-Tap may display painted versions of these altar fruits, together with versions of the trickster rabbit whose folkloric connections extend from the Afro-Caribbean diaspora, to the southern United States and to Kongo/Angola and the Western Sudan. Once a year Tap-Taps decorated with Erzuli and "amorous subscripts" as the vision of Notre Dame du Mont Carmel undertake a long dusty journey to the pilgrimage site of Bonheur where pilgrims see what visions they can under the waterfalls at Sodo. Haitian culture is so open to innovation and adaptation that most Tap-Taps are redone annually with paintings of the year's most popular gods and heroes.

An Ifa Diviner's Shrine

The shrine as ritual and aesthetic focus is well illustrated by Drewal and Drewal (1983:64) in their description of an Ifa diviner's shrine in Ijẹbuland. The diviner, Oṣitọla, explains that when a shrine is neglected (by not offering prayers or gifts) the spirits will leave: "All you are seeing are the images . . . The person has relegated the deities to *idols*, ordinary images . . . Deities do *not* come because of the images; images come because of the deities." All this hinges on the fact that at the center of Yoruba religious practice is the concept of *aṣẹ* or life

force which is performative power, diminishing with inaction and strengthening with activity:

> Art is therefore important in worshipping the *orisa*. The creation of artifacts for shrines and their placement is an act of devotion that equals the ritual significance of prayer or sacrifice. The Yoruba say that a shrine is the "face" (*oju*) of the divinity or the "face of worship" (*ojubo*). The shrine is the place of meeting, of facing the gods and locating oneself relative to the gods (Drewal *et al.* 1989:26).

The use of the term "face" signifies that the deity must be alert or attentive to be effective, which is a state associated with the spiritual inner head (Drewal and Drewal 1987:228). Gin is sprayed from the mouth onto the *ojubo*, or shrine, to wake up the deities. This is also done to awaken the spiritual head of someone being prayed for. The spray of gin is perceived as similar to the fresh morning dew that coats all living things at sunrise, the time when the inner head is considered to be most fresh and alert. Drewal and Drewal highlight this interesting parallel in that the inner head is to a person's face what the invisible spirit is to its shrine.

For the Yoruba, the objects on a shrine, notably the carved figures, are not images of deities but of the worshippers of the gods. They represent devotion and the empowerment by the god of those who kneel and present sacrifices and offerings. In that regard, "ritual art both shapes and is shaped by the imagination of the artist who seeks to reveal the interrelatedness of the divine and human through sculpted image, song and dance" (Drewal *et al.* 1989:26). It is the place where a Yoruba deity "sits," that is where its spirit resides and must be nourished through sacrifice. "Medicines" are buried under the ground where the shrine is placed to attract the spirit to the site.

The objects in a particular shrine, such as those of Ositola the diviner, have historical and personal significance. They are directly related to his ancestors, serving both as mementos and as ritual and symbolic objects of power. Some of these objects, whether containers or carved figures, have a personal history and their significance has changed over time. Some are gradually replaced, such as by the mother of the diviner and then his wife, reflecting "the maturation of the Ifa devotee himself and his changing relationships with women" as well as the supportive and protective roles of the latter (ibid.:65). Through divination the deities may indicate where they wish to be placed in the shrine. Some prefer to be placed outside while others prefer the darkness and invisibility of an enclosed shrine. The shrine for Eşu, the trickster deity, is "at the gate," and consists of laterite mounds, a short iron staff and figures representing different types of Eşu which have been owned by family members over the generations. These figures are paired, connoting the male/female identity and mediatory function of the deity. This family shrine for Ifa and the gods "highlights various spiritual and social relationships—both personal and general—between individuals and deities, between family members—living and dead—and between males and females" (ibid.).

Women Shrine Painters in Yorubaland

In Ile-Ifę, at the heart of Yorubaland, the shrines of several deities are decorated not so much by objects as by murals painted predominantly by women. This is an ancient tradition which dates back to the days when women decorated their homes. Only certain deities, namely Ọbaluaye, Orişaikire, Oluorogbo and Ọbatala, are celebrated with what Okediji calls these "mythomural designs" (Okediji 1986; see Harris 1994 on Okediji as artist). Mythomural compositions may be found

157

also in Oṣun shrines in Oṣogbo and Iragbiji. But it is in Ifẹ that a traditional painting school exists, composed of women who belong primarily to the Oriṣaikire shrine but who are often commissioned to decorate other shrines such as the Ọbaluaye shrine. The monopoly of women, at the latter shrine in particular, is manifest in the elderly female sentries who are posted at the doors during the execution of the designs to turn away men or women under thirty years of age. It is believed that men, who, in contrast, control the domain of sculpture, will disrupt the creative process. While the designers of the Oluorogbo shrine are more willing to allow the participation of both male and female, as well as youngsters, it is still women who are in charge of the proceedings.

The priestess of the Ọbaluaye shrine in Ile-Ifẹ commissions the women painters to decorate the shrine as part of the annual festival to honor and placate the deity (otherwise known as the formidable god of smallpox, Ṣonponna). The festival lasts for several weeks and the women are the guests of the priestess who must remunerate them and supply them with food such as cassava balls, corn balls, a goat, snails, alligator pepper, antelope meat and locally brewed drinks. The shrine painting constitutes the first ceremony in the festival. The shrine is first cleared of all paraphernalia, such as pots, beads and sculptures. All the materials derive from the local environment (particularly vegetal materials), as dictated by the deities. The colors are grouped into three chromatic categories, namely *pupa* (red), *dudu* (black) and *funfun* (white). Although, as Okediji argues (1986:8), it is hard to translate the polychromatic sensibility of the Yoruba into English terms which derive from a mono-chromatic sensibility. The new ritual year is ushered in by erasing the previous mural with black paint. While waiting for the paint to dry, the painters brush and wash shrine paraphernalia. The execution of the designs begins in the afternoon and is done collectively by several women.

For the women themselves this is an important ritual and spiritual occasion. As the Ọbaluaye priestess told Okediji (1989:122): ". . . though it appears that human hands are at work, this is a mere illusion. The human beings are merely being used. The pictures are really being painted by the Irunmole deities. This is not like the painting you learn in school or the type *you* paint." This belief is further reinforced by the songs sung by the women which create an atmosphere for divine inspiration. Frequently the women cry out "Isọye, Isọye, Isọye" invoking the deities to wake up their human minds and transform them so that their work transcends ordinary human performance (Okediji 1986:6). Okediji observes that it is the uninhibited, passionate and rejuvenated behavior of the women as they dance, sing and paint that best illustrates the notion of possession. However, he does show how this ritual and creative process is also educative, in that the women learn how to paint while on the job through observation, participation and reflection (1989:124f.).

From a dramatic point of view, there are both mimetic and non-mimetic aspects of traditional shrine painting (Okediji 1988a). The women's creative performance is a recreation of the founding myth. According to Ifa tradition, the deity Oluorogbo, known as "the scholar," invented a writing system which he used to write on the walls of his compound. These scripts became popular although they were not understood by the people. Following his death, his wife sought to imitate his writing system and, with the help of relatives and offspring, an annual festival was instituted. Today the women believe that through their designs they continue to imitate Oluorogbo's forgotten writing symbols. This is accompanied

by incantations, chants and prayers which serve as bridges between illusion and reality, between the gods and humans, and between drama and life. At these moments the shrine is turned into a theater; in fact the mythographic painting and prayer segments are referred to as *ọrọ*, a type of Yoruba sacred drama.

The design motifs are predominantly animals which represent human beings—metaphorical devices also found in Yoruba oral literature (Okediji 1986:14). The animals are portrayed in a prostrate position, signifying the correct attitude before both kings and deities. A single human figure is represented which is that of *amubọ*, a slave figure, destined to serve his god. Also found as part of the Ọbaluaye design is the *ṣẹkẹṣẹkẹ* or shackle, traditionally used to bind the hands and feet of captives. This not only recalls the experience of slavery for the Yoruba more generally but more specifically for the Orìṣaikire women who are the descendants of slaves of the Akire family. (In fact, one theory states that Akire, who was a warrior of Ile-Ifẹ, initiated the decoration of his house as a slave chore [Okediji 1991].) For them their artistic rituals are reminiscent of the ordeals of their enslaved forbears in the days of bondage. In this way the women "retain the ancestral memory of oppression, intimidation and deprivation," wearing shackles as they paint and linking themselves with a symbolic rope (Okediji 1986:15–16). The annual festival provides a forum for the descendants of slaves and the freeborn to confront each other and negotiate their different identities and histories. Through the depiction of their ancestral totemic animals, whether snakes, birds, cows or leopards, the Orìṣaikire women establish their own identity.

There is a remarkable similarity in the Ifẹ shrines, although the Ọbaluaye design is located in the interior of the shrine while that of the Orìṣaikire is painted on the outside of the shrine. The women, especially the priestess, are concerned to preserve tradition. Bọlaji Campbell (1989) points to the changes which are occurring in similar shrines in other Yoruba towns.[1] Young men are introducing imported paints and a wider range of colors. These more modern artists draw more randomly and experimentally on Yoruba mythology. Christian and Muslim symbols (crosses and writing boards) now feature (in fact since the 1960s) in the imagery.

"New Sacred Art" in Oṣogbo

Just beyond Ifẹ lies the important market town of Oṣogbo. The town has become the location for one of Nigeria's most popular traditional festivals, that of the river goddess, Oṣun, and the shrines are visited annually by tourists from all over the world. The town has been a world-renowned cultural center for more than thirty years, hosting several theater companies and artists' studios, constituting what became known as the Oṣogbo School (Beier 1991). The revitalization of the festival and its sacred locale are due in large part to the work and inspiration of one woman, the Austrian artist, Susanne Wenger.

Born in Vienna in 1914, Wenger was trained as a potter and developed a painting career in Europe (Wenger and Chesi 1983). When she came to Nigeria in the 1950s she intuitively related to the Yoruba priests and priestesses whose shrines and cults had already suffered markedly at the hands of missionaries and colonial administrators. For over forty years she has lived in Oṣogbo, surrounded by her extended family, paintings, batiks, sculptures and sacred groves. She has worked tirelessly to restore the shrines, many of which had fallen into disrepair. The traditional Yoruba world provides the framework for her creativity— "[t]he religious impetus of these people

conformed to my own artistic temperament" (ibid.:24). She has gained acceptance among the Yoruba people, becoming initiated as a priestess and being known by her ritual name, Adunni Olorişa. It was Ajagemo, Ọbatala's high priest in Ede town, who introduced her to that cult's mysteries in preparation for the rebuilding of the shrines of all the *orişa*. Before his death he commanded her to build an "upstairs house for the *orisha*"—a new dwelling that could accommodate the deity in rapidly changing times (Beier 1975:53).

Susanne Wenger has campaigned over the years to protect the sacred groves of Oşogbo and their trees from progressive leaders, agricultural and forestry projects, and land developers. Her revivalist stance has elicited sensationalist press reports on the "white priestess," European critics who regarded her as "a degenerate artist looking for exotic stimulation," and destructive acts by Muslims on the shrine-complex (Beier 1975:9). Yet she has weathered the storm and has sought to promote the work of her Nigerian artistic colleagues, such as Buraimoh Gbadamọsi. She does not try to work like a traditional Yoruba artist, nor does she believe that her co-workers can resist the new forces of our time. As she stated when Oşun asked for a gate to the grove: "I'm not a contractor. If I am asked to perform this religious function for Oshun, I can only do it my way. My religion is art, and I must be allowed to express my feeling for Oshun in my own artistic form" (Beier 1975:63–4). She views her role as discovering new artistic ways in which to reveal the principles of the *orişa*. But it is more than a revelation, as she herself states: "[w]e are not simply producing an allegory of *ibọ* [worship] forces. The dynamic forces of the gods could be contained in the *ibọ* but they can also be activated through artistic creation. Art is the only possible equivalent of ritual" (Beier 1975:91). Through her slogan:

"Art is Ritual," Wenger is at pains to deny that her "New Sacred Art," as she calls it, constitutes an art exhibition. "Our work attempts to help the gods, so that they may regain interest in us," she states (Wenger and Chesi 1983:206).

Wenger herself is known as an *olorişa*, or "one who has *orişa*." She recounts that artistic work in the Oşogbo shrine-complex began from "direct inspiration in the groves" from gods and spirits while they were engaged upon repairs on the original shrines (ibid.:207). Wenger claims that the craftsmen, carpenters, smiths, masons, and priests of the cults had seen no books nor received any instruction in Western "modern" art. Some of these were Muslims.

One of Susanne Wenger's earliest concerns was how to integrate their artistic creations with nature's own creations, notably the serene river and magnificent trees. She found a way, with Oşun's inspiration, to construct walls which not only served to protect the privacy of the shrines but whose decorations and flowing forms conveyed natural beauty and awe for the gods (Beier 1975:64f.). Yoruba mythology informs the shrine buildings and sculptures whether through the attributes of particular deities, such as Ọbatala as elephant and all-encompassing deity, or encounters of deities (Şango and Ọbatala) or their genesis (Alajere) (Beier 1975:67f.). The gate into the Oşun grove represents a tortoise, representing the weight of the world, yet lightened by the inspiration from Oşun. It is as if the worshipper, by entering the deeper part of the Oşun forest, is able to transcend the weight of his or her own body and attain the ecstasy offered by Oşun (Beier 1975:83–4).

The Ọbatala shrine is Susanne Wenger's largest and boldest creation, which is only fitting as she is a priestess of his cult. The paths to and interiors of the various shrines connote

mystery and other-worldliness. Some shrines have a series of chambers leading from one into another, revealing different and deeper aspects of the deity (ibid.:70). Among the trees one encounters cement figures by Saka which represent the spirits of the forest and deceased hunters. Susanne Wenger had asked Saka (a former bricklayer) to build these figures in such a way that they could serve as seats, where people could come and rest and make contact with the spirit world. His depiction of the goddess Oṣun on the riverbank at Ojubọ Oṣogbo conveys both Oṣun's awesome power and her ability to inspire confidence in her worshippers (ibid.:83).

Wenger has financed much of the work of the shrine restoration and creation through the sale of her own batiks, as well as from donations from friends. She has also received support from the Federal Department of Antiquities and the Institute of African Studies of the University of Ibadan. Conditions have become very difficult in terms of obtaining materials, whether local or imported. The shrine renovation program continues (Susanne Wenger has reportedly been working on a monumental and complex sculpture to Ifa for the last several years), but many of the artists are obliged to farm and produce more marketable artistic commodities such as batiks, drawings and paintings (Highet 1989).

Bwiti

Bwiti is a new religion (sometimes termed "syncretic"), born in Gabon from the fusion of Christianity and Fang culture, notably Bwiti—the ancestral cult of the Apindji, Mitsogho and Ngounié (Swiderski 1989:9). It is renowned for its art, which is an expression of the ongoing Fang quest for new cultural, religious and aesthetic forms. Our knowledge of Bwiti is considerably enriched by the work of two

scholars, Stanislaw Swiderski and James Fernandez. Swiderski has been conducting research in Gabon since 1963 and has recently produced a series of volumes on Bwiti religion, including one on their sacred art. Fernandez's monograph on Bwiti (1982) is a rich and detailed study of Bwiti thought, liturgy and architectural space.

As Swiderski emphasizes, the "new" Bwiti was born out of a situation of historical and religious repression (1989:9f.). In the course of a century, Catholic missionaries accused the cult of barbaric and deviant practices and colonial administrators persecuted several of its members. Bwiti ritual buildings provided the location in the 1940s for the emergence of ideas of political and cultural emancipation. In the face of a devaluation of their culture and a resultant "doubling of personalities" created by the pressures of colonial and missionary moral discourse, Bwiti, as a revitalization movement, was seeking "to accustom its members to a much more polyvalent existence by offering them extension into a variety of realms of being" (Fernandez 1982:301). There has been an increasing Christianization of Bwiti, but today it is accepted by both government and people alike as an authentic expression of Fang spirituality and culture. Its poetry, architecture, iconography, choreography and graphic signs and inscriptions, in particular, are intended to make accessible and facilitate the understanding for Bwiti members of the mysteries of life and death. Its artistic influence has even extended to other religious associations, such as the initiatory healing society of Ombouiri.

The Bwiti art of today has its roots in Fang art, notably the ancestral cult or *bieri* (see figure 7.14), which developed over two or three centuries of migrations. Yet Bwiti religion and art in its contemporary phase really only began around thirty years ago.[2] But it reflects not just the changed and changing historical

experiences of the people, but also their use of new artistic techniques and colors, their incorporation of new structures, new myths and new theological and philosophical concepts, derived from their contact with European culture. But feelings of cultural inferiority have been reversed, and it is now Bwiti which is regarded as the "official" art of Gabon, aided by a Bwiti initiate, Léon Mba, becoming the prime minister of Gabon (Swiderski 1989:19f.). Paintings have gradually replaced the older sculptural forms, and the early imitation of figures of Catholic saints and angels now reflects a greater synthesis of Fang and Christian imagery. To a large extent it is the Bwiti spritual guides, inspired by individual visions, who have nurtured this creativity, as well as a more emotional attitude to the art. They have also fostered a greater recognition of individual artists, such as Michel Nzé Mba whose paintings are found in many Bwiti temples (ibid.:23). Bwiti art reflects a particularly interesting transformation in its theology and that is the primacy of the woman (ibid.:21f.). Drawing on the social importance of the African mother as well as the Virgin Mary in Catholic thought, Bwiti spiritual guides displaced the earlier male-oriented theology. The female figures are more than intercessors, they play active roles in the path to salvation.

Bwiti architecture seeks to interpret Bwiti religious ideals using aesthetic means (ibid.:30). The exterior and the interior both reflect the ontological notion of birth-death-rebirth. For example, on the outside of the building there is a symbolic tomb where nocturnal ceremonies begin, symbolizing genesis, a sacred tree, image of the foetus, and a temple, where the spiritual birth of initiation begins. In cosmic and biological terms, the tomb represents the man and the sky and the temple, the woman and the earth, and their offshoot is the foetus. Among the Apindji, the exterior of the temple resembles the form of a boat, turned upside down. This is to remind the novices that the temple is like a canoe or a boat, providing passage toward the next life and the ancestors. It also is reminiscent of the image given by Christians to the church—the fishing boat of St Peter or the boat which conveys the faithful to the port of salvation (ibid.:32). It was the sentry post, which served as storehouse for the ancestral relics, as well as general meeting place, which became the temples for Bwiti. As for the Fang, these early temples were always situated within the village, unlike Catholic churches, emphasizing their role in uniting the profane and the sacred. The choice of a light wood for the roof, symbolizing the ascent of the soul, and a red wood for the central pillar, symbolizing the blood of life and sacrifice, was also significant. Fernandez shows how the architectonics of the chapel reveal how space may be organized "which locates those who live in that space in an optimum position in respect to their own bodies and in respect to their mythological, legendary, historical knowledge and feeling for space—their cosmos" (1982: 412). By its balanced or integrated oppositions it counteracts the decentering and dehumanizing aspects of life by providing what Bwiti members call "oneheartedness."

But it was gradually the form of the Catholic churches which became the predominant architectural influence. As the roofs of the temples got higher and more light entered, people started to decorate the temples. The size of the temples increased to meet greater numbers of members especially in the urban areas. But it was the addition of the central pillar, an architectonic element of great metaphysical significance—more important than the Christian cross—which came to distinguish Bwiti sacred space and provide its ritual focus (Swiderski 1989:40; Fernandez 1982:394f.).

The maleness of the pillar is counteracted (often dominated) by female forms and symbols (including the Virgin Mary) (Swiderski 1989:55f.). Where the pillar has replaced the crucifix it bears the marks of Christ's suffering, i.e. hammer, nails, ladder. In Swiderski's opinion, no other element of Bwiti art represents more effectively the ambiguities and richness of the Bwiti religion than the pillar (ibid.:94) (figure 6.8).

The interior space of the temples is triadic in the same way as the exterior: the sacred pillar, center of all Bwiti spiritual power and point of contact between the living and the dead, the center of the temple, the heart and breast of God, symbolic of life which lasts like fire, and a type of altar, known as the "head" or "mouth" of God where the music of the sacred harp is played (ibid.:45). These divisions not only reflect the triadic character of Bwiti thought but also the spiritual regeneration at the heart of the Bwiti liturgy. The fact that many ceremonies were conducted at night pointed to the belief that darkness was the symbol of female fecundity. Today, as a mark of the progressive and ecumenical thrust within Bwiti, there is a tendency to hold more daytime ceremonies.

When Bwiti introduced painting into its temples, only traditional colors were utilized because of their metaphysical and symbolic value (ibid.:105). They were white for spirituality, death, and purity, red for vital energy, and black or indigo for fertility, the sadness of the soul or the obscurity of thought. The contemporary paintings which appear on temple walls represent quite a departure from earlier types which were limited to the ritual decoration of masks and bodies. There were no specialized painters as there were sculptors. The availability of oil paints at a later stage encouraged some Fang to copy the paintings they saw hung in Catholic churches. For

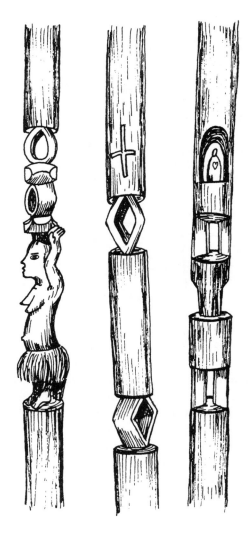

Figure 6.8 Bwiti central pillars, Fang, Gabon. After Fernandez 1982:396–7, fig.15.10.

contemporary artists, composition or technique are superseded in importance by the subject matter, and its didactic and transformative capacity.

The themes of the paintings may be classified as follows: scenes from the biblical creation, christocentric images, images of the Virgin Mary, identified with the mythical woman, Egnepé or Gningone Mebeghé, while others

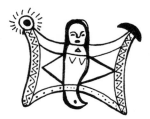

Figure 6.9a Gningone Mebeghé or the Holy Virgin in the Bwiti cult (Gabon) identified with the Holy Spirit, creating day and night.

Figure 6.9b Bwiti representation of the Holy Spirit. After Swiderski 1989:162, pl.9.

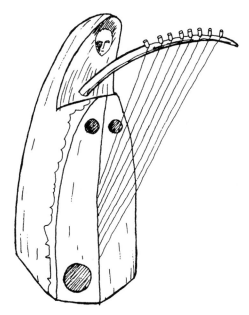

Figure 6.10 Bwiti Ngombi harp, Gabon. After Fernandez 1982:538, fig.20.1.

seek to represent notions of the Holy Spirit and angels, etc. (ibid.:108) (figures 6.9a and 6.9b). The creation scenes are the most remarkable, according to Swiderski. They not only bring alive important theological notions but also transpose them into a Fang cultural context. For example, the creative word of Nzamé is symbolized by the presence of the harp, situated on the side of the moon (and of women) and the vital, fertilizing power of the sky descends to the earth as a ladder, reminiscent of Jacob's Ladder in the Old Testament (ibid.:109). The Christ figure is less prominent than that of the Virgin Mary, reinforcing the Bwiti notion that women are the source of life. Christ in Bwiti theology and art remains a model of human suffering and moral perfection. It is interesting to note that images of the devil are absent in accordance with Bwiti claims that the devil and the angels are no more than an invention of the Catholic clergy (ibid.:132). Animal imagery in Bwiti

temples is minimal. Now that some artists have access to a variety of books and magazines and Western folklore, they have introduced some new figures such as sirens and eagles and reflect a greater interest by the artists in geometric design.

Vestments, masks and other liturgical items merit discussion, most notably the sacred harp which is the centerpiece of Bwiti religion (ibid.: 167f.) (figure 6.10). As a mulitvalent sign it evokes through its form, sound and colors the dynamism of Bwiti thought and experience. There are a great variety of harps in the different branches of Bwiti, but there is a shared belief that the harp is the symbol of the woman, in terms of its form and its sound. It represents Badzioku, the mythical and savior woman sacrificed by her brother-in-law, Melonga, to pay for the secret of revelation. In some cases a woman's head or full figure is found atop the instrument, personifying it for the initiates who listen to its sweet music

throughout the nocturnal rituals. It is said that the harp "speaks" rather than "plays," transporting the initiates and re-enacting the tragic myth. In fact, it is believed that God speaks through the harp, through its music. The harp is often covered by red and white cloth symbolizing biological birth and spiritual renaissance, and male and female. With its perceived beneficial properties, it is paraded by the priest like a sacrament, eliciting inspirational songs from the kneeling congregation as it passes. The "miraculous" quality of the harp is further endorsed by the fact that in some congregations it is borne into the chapel through the death exit and leaves by the birth exit (Fernandez 1982:539). Swiderski links the emergence of the harp as a central artistic and cultic object to the development of the cult of the Virgin Mary and the redemptive role of the woman, Gningone Mebeghé, within Bwiti during the 1960s (1989:180).

"Faces of the Gods"

The art of the altars of Africa and the New World has been the focus of two recent works, *Divine Inspiration: From Benin to Bahia* by Phyllis Galembo (1993) and *Face of the Gods: Art and Altars of Africa and the African Americas* by Robert Farris Thompson (1993). The latter was in fact accompanied by a major exhibition, "Face of the Gods" at the Museum for African Art in New York City. Galembo's work is a photographic essay of altars in Nigeria, mainly Benin City, and in Bahia, Brazil. She is interested in the shrine symbols used by oriṣa/orixa priests and priestesses to guide people through complex and predestined life-patterns. Robert Farris Thompson's work documents the artistic creativity of these structures for sacrifice, prayer and devotion among the Mande, Akan, Fon, Yoruba, Ejagham of West Africa, and the BaKongo and their neighbors in Central Africa. These altars are also focal points of the worship of New World traditionalists, notably in Cuba, Haiti and Brazil, and also in North America. These altars served to encode the collective memory, sometimes in a covert way, through a combination of objects, music, dance, and symbols. Or, as Thompson more eloquently phrases it, "Sacrificial food and liquid joined art and gesture at the altar as hieroglyphs of the spirit" (ibid.:21). In our excursus through the fascinating and eclectic world of the Afro-Atlantic altars, Thompson points out the various creative processes at work, namely continuity, fusion and change. For example, the elaborate stone seats of power of Ile-Ifẹ undoubtedly provide historical sanction for the magnificent *tronos* or altars of enthronement and initiation, which feature in Yoruba worship in the New York City area today (ibid.:149). Kongo cosmograms or mystic cruciform figures drawn on the ground which portray the soul's cosmic orbit, fuse with the practice of the Fon people of Dahomey (now Republic of Benin) who draw lines and geometric patterns of cornmeal on the ground to summon the spirits from the other world to produce the Haitian *vévé* or ground blazons of Vodun (ibid.:293). He also shows how devotees of the Yoruba gods and goddesses in Cuba and Brazil have turned to pottery and cloth to create dressed shapes and spaces on their altars.

What is interesting to note with regard to the actual exhibition at the Museum for African Art in New York is the range of responses that these altars evoked in visitors.[3] Many placed offerings, money and popcorn, or performed rituals of greeting. Some people were bothered by the forces they felt were present at the bottle tree or symbol of ancestral life. Others were concerned by whether the shrines were "real" and how they had got there. In fact, in some cases priests had sought permission from the

deities and spirits to relocate the altars. A purification ceremony was performed in front of the museum before the exhibition opened. One Afro-Cuban priest reportedly came in weekly to "feed" his altar to Sarabanda with rum and water from the Hudson River (ibid.:286–8). A blurring of the fields of religion and art occurred in the museum setting, provoked by the responses of the public and the artist practitioners. It fuelled many debates among the museum organizers (see Roberts 1994:52–4).

Concluding Remarks

As seen from the above examples, there not only exists a variety of ritual locations where people seek to make contact with the gods, spirits and ancestors, but also diverse ways of rendering these locations aesthetically pleasing and powerful. The imaginative use of statues, murals, pots, carved pillars, cloth, and the creative application of colors, designs, and architectonics not only serves to constitute and demarcate the ritual space, but to induce appropriate experiences on the part of participants and initiates. Of particular interest is the way that art may serve as a conduit or transformer, making present the divine, through particular forms, materials, dances and songs. Figure carvings may enhance the efficacy of a shrine, extending mystical protection and blessings to individual, family and clan.[4] Through this sacred microcosm which is the shrine, artistic forms and objects may also recreate mythos and history, convey metaphysical and moral teachings, and represent the cosmological universe to its human dependents. Once again it is important to emphasize the interactive and multidimensional aspects of these shrines, in that the physical structures themselves can only be understood in terms of the light, movement, sounds, prayers, music, location, and actors which inhabit, construct and activate them.

Notes

1 Olabiyi Yai reports that there are similar wall paintings to be found in the shrines of his home town of Sabe or Savé in the Republic of Benin (personal communication February 1994).

2 Fernandez suggests an earlier date, around 1914, based on missionary reports that Bwiti was flourishing among Fang youth (1982:348). The earliest form of Bwiti is Disumba or Mikongi. The name refers to the Pygmy woman who discovered *eboga*, the hallucinogenic plant used to elicit visions, and who was then sacrificed (ibid.:476).

3 I am grateful to Modei Akyea, who was an intern at the Museum at the time of the exhibition, for this information. Personal communication, 4 April 1994.

4 This is well illustrated in the case of the Moba of northeastern Ghana and northwestern Togo (see Kreamer 1987).

CHAPTER 7 Allusion and Illusion:
The Rituals and Symbols of Death and Beyond

Rituals and associated art objects abound in Africa to mark the end of this life and transition to the next. Indeed, some of the finest art produced by African societies is funerary art. Elaborate taboos and ceremonies help explain the mystery surrounding death and alleviate the disruption caused to a family and community by the loss of one of its members. While ideas about death and reincarnation, and attendant practices, vary from region to region, there is an underlying conviction that physical death is not the end but rather a gateway to another existence. The nature of this after-life is to a large part determined by conduct in this life, social status, type of death, appropriate rituals, longevity and gender. The longstanding and respected community leader who dies a "good" (or timely and natural) death goes on to become an ancestor in many societies, while the person who dies a "bad" death before his or her time or is inappropriately buried runs the risk of becoming a wandering ghost.

This chapter therefore addresses the panoply of concepts, attitudes, myths, symbols, and values surrounding death which are so vividly expressed through the performing and visual arts of many African societies. As in previous chapters, a selection has to be made. Examples have been drawn from a variety of cultures such as the Senufo, Akan, Yoruba, Fon, Kuba, Fang, and Kalabari, to allow illustration and discussion of the range of media and forms

employed, as well as the different stages involved in dealing with death, namely burial (interment), separation, cleansing, funerary rites, mourning, and reintegration.

The mysteries and ambiguities of death lend themselves particularly well to symbolic expression and masking traditions. Furthermore, we see clearly in this chapter how art serves as an agent of transformation at critical stages of individual and social life, and how the artist plays a vital role in the much-needed sense of continuity. In this connection, there are many similarities, indeed actual overlap, with rites of initiation and the activities of secret societies, described above in chapter four. The varying uses of representational or non-representational forms will also recall the discussions regarding embodiment in chapter two. The use of the aesthetic to neutralize the harmful and polluting forces of death echoes the protective capacities of art described in chapter five.

Textiles and Terracottas

In many parts of Africa people attach great importance to the cloth in which they will be buried. The Kuba of Zaire are no exception. Their raffia textiles are one of the great decorative art traditions of sub-Saharan Africa (Darish 1989) (figure 7.1). These cloths have been used as clothing and currency since the sixteenth century among various societies in

Figure 7.1 Kuba raffia textile, Zaire, used at funerals. After Picton and Mack 1989.

Central Africa. Today, the most common occasion for their display is at funerals. The deceased will be buried with the textiles, costume accessories and other gifts. The dressing of the corpse reflects both individual and collective beliefs about proper burial. There is a strong belief among the Kuba that they will not be recognized by their deceased relatives in the land of the dead unless they are wearing raffia textiles. In fact, it is tantamount to being buried nude. The display of traditional attire at funerals, despite the adoption of more modern dress at other times, stems from a strong desire to preserve Kuba cultural heritage. Furthermore, relatives fear that the spirit of the deceased may become angered and troublesome if proper respect is not shown. The clan section must recognize prestige and status of the deceased by utilizing the appropriate number and quality of textiles. Darish reports that people readily criticized the embroidery or quality of the textiles displayed on corpses at funerals. Beyond their aesthetic appeal, the textiles reaffirm the interdependent efforts of the men and women who produced them, and the use of raffia, an inexhaustible resource for centuries, symbolizes wealth, continuity and security for the community. Moreover, just as the raffia cloth marks the liminal status of death, it also serves to mark the changes of status in initiation rituals (Darish 1990). However, being something from the forest, growing in the abode of nature spirits, it represents something dangerous to the uninitiated.

Akan funerals in Ghana constitute an important social and ritual event. At these funerals they wear mourning cloths known as

Figure 7.2 *Adinkra* man's cloth (detail), Asante, Ghana. After Cole and Ross 1977:47, fig.76.

adinkra which state and confirm relationships among the living while also honoring the dead (Mato 1994). These cloths, which may be different shades of indigo blue, red, brown, yellow and white, are stamped with *adinkra* symbols (figure 7.2). These geometrically stamped patterns, created by a carved piece of calabash and a locally produced black dye which dries to a glossy surface, express verbal arts and proverbs (Quarcoo 1972) and invite interpretation on a number of levels (Mato 1994). The cloth is popular in most parts of Ghana, but there are various ideas about its origins. It is often traced to an 1818 Asante war with Gyaman, when a Gyaman chief, Kofi

Adinkra, tried to copy the Asante Golden Stool (Cole and Ross 1977:45). Adinkra lost his head and his people lost the war, and the design and technology of *adinkra* cloth were supposedly imported into Asante and named after the defeated king. However, there are claims that the cloth existed before this date. Some scholars (e.g. Rattray 1927:265; Mato 1994) attribute the motifs to Islamic sources (trade with the Islamized north had been conducted since the fourteenth century). The Islamic graphic image was appreciated as much for its protective qualities as its textual meaning (cf. Battestini 1994). Further examples of this are discussed in the concluding chapter to this

Figure 7.3a *Adinkra* symbol Gye Nyame, translated as "Except God" or "Only God". It signifies God's omnipotence, omnipresence and omniscience. After Quarcoo 1972:10.

Figure 7.3b *Adinkra* symbol Owu Atwedee or Owu Atwedee Obaako Mforo, which is translated as "the ladder of death" or "the ladder of death will be climbed by all." This reminds people of the inevitability of death and the necessity to qualify as worthy ancestors. After Quarcoo 1972:48.

book. Muslim influences cannot be denied but many of the symbols are too firmly rooted in Akan culture to be ascribed to external sources. In his book, Danquah looks to the meaning of the term, *adinkra*, to understand its origins and function:

> The word is clearly made up of *di*, to make use of, to employ and *nkra*, message . . . *Di nkra* means to part, be separated, to leave one another, to say goodbye. The word "*nkra*" or "*nkara*". . . means message, intelligence, and where human destiny or life span is concerned, it refers particularly to the intelligence or message which each soul takes with him from God upon his obtaining leave to depart from earth . . . Clearly the use of Adinkra cloth and symbols is intended to mark the link forged between the living and the dead, the present and the future, the affairs of the now and the affairs of the hereafter . . . (1944: xxxviif.).

Three examples of *adinkra* symbols are illustrated here (figure 7.3a,b and c) which are commonly seen on the cloths (see Quarcoo 1977:10f. and Antubam 1963:157f.). Surprisingly few *adinkra* symbols with their associated proverbs allude directly to death (Mato 1994). More commonly they address the insecurities of life, correct behavior, and the strength of the king. Nowadays some cloths use actual written texts in place of images—such as "Owuo begya hwan" or "Whom will death spare"—perhaps reflecting a loss of cultural literacy (ibid.). Factory-made cloths may also be worn as a fashion item, for parties or churchgoing, for example (figure 7.4).

Many other types of funerary art are created by the Akan, such as terracotta pots and figures. The notion that pots can be containers for spirit beings was previously discussed in chapter two. From the seventeenth century onwards there is evidence of terracotta heads being used in a funerary context by the Akan peoples. Figure 7.5 shows one of these

sculptures, made by Akosua Foriwa of Mpraeso in 1962 to commemorate the late priest of the tutelary deity, Buruku. The sculpture is placed on the *asimpim* chair of the deceased, after having been brought out of the shrine house where it was stored.

However, Michelle Gilbert underlines the ambiguity and uncertainty regarding the meaning and function of these sculptures (1989). She rather focuses on the Akuapem kingdom of southeastern Ghana, where she found terracotta heads in use in an Akuropon shrine in the 1970s and 1980s. In the past, among neighboring Akan peoples, pots surmounted by a representation of the deceased were used as funerary vessels, into which human hair was put from the shaved heads of mourning fellow clan members. The heads were sometimes hollow, with reclining flat faces and ringed necks. Platvoet, in his survey of Akan funerary terracottas, argues that they served as means whereby the Akan communicated with, rather than commemorated, their dead before they became ancestors (1982). In contrast, Kwasi Myles (n.d.), recalling the traditions associated with the making of the terracotta figurines, reveals how skilled female potters would pray over a bowl of water to obtain a revelation of the image of the deceased, emphasizing the commemorative aspect. Gilbert notes that the Akuapem people still use pots as containers for ancestral food at funerals of kings and chiefs, but that elders could not recall the use of funerary terracotta heads or figurines. However, today, naturalistic, life-sized terracotta heads are used in second burial celebrations as part of an effigy figure to represent a deceased king or chief. People of status normally receive two funerary rites, the first is a rite of separation where the person is buried, while the second, much larger and more expensive, marks the end of a reign and may be held several years after the burial.

Figure 7.3c *Adinkra* symbol Nyamedua, literally "God's tree", is a symbol of the three-forked post planted in front of homes and in compounds. It is considered to be an altar for God and signifies God's presence and protection. A vessel is often placed in the fork of the post, containing an axe stone, water, herbs and sometimes eggs. People might sprinkle themselves with water from the vessel to protect themselves and identify themselves with the spirit. After Quarcoo 1972:11.

Figure 7.4 *Adinkra* symbols, Asante, Ghana.

171

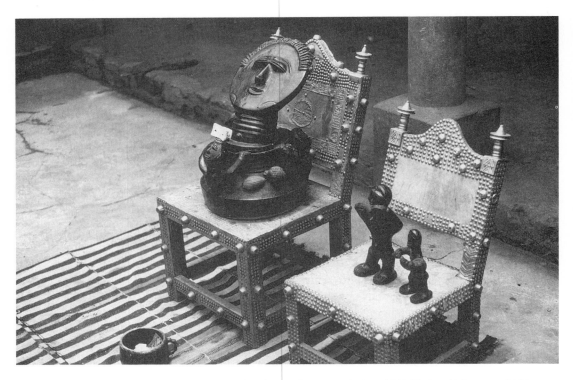

Figure 7.5 Akan funerary terracotta, Kwahu-Tafo, Ghana. Photo: Roy Sieber, 1964. National Museum of African Art, Eliot Elisofon Archives, Smithsonian Institute, Washington, D.C. On the adjoining chair are two retainer figures, one blowing a trumpet and one playing a drum. In front is the priest's private drinking cup which was also used for pouring libations.

The terracotta head or *mma* shown here is from the Anyi people of Côte d'Ivoire (figure 7.6). It has a characteristic horizontal slit in each eye, with a complex wedge-shaped hairstyle and colorful painted lines on the cheeks and forehead. These figures were considered as portraits of the dead in that identifying features such as jewelry, scars, hats, beards, etc. were reproduced. The figures were probably richly dressed in real cloth for implantation in the "village of *mma*"—a forbidden area near the town (Soppelsa 1988). Christian and Islamic items depicted on the figures were appropriations against witchcraft rather than an indication of the owner's religious affiliation. As in the case of the other heads described above, the *mma* were central to the symbiosis

between the living and the dead, with protection and fertility for the former, and maintenance and memory of the latter.

Potting serves as a more general model throughout Africa that links human birth, death, growth and the yearly cycle. Death may involve the breaking of pots, while marriage may involve the making of them. Among the Dowayo of Cameroon (Barley 1994:88f.), when a woman dies her water-jar is dressed like a human being and fermenting beer is poured into it. The bubbling of the beer is believed to indicate the presence of her spirit. The jar is decorated with beads and other finery, signifying the removal of restrictions on the wearing of similar finery by close female relations in mourning. The Dowayo preserve

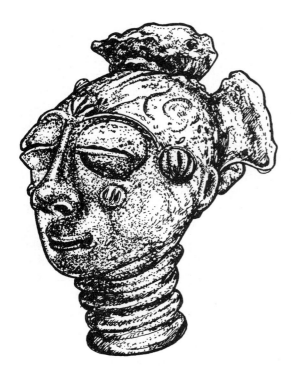

Figure 7.6 *Mma* terracotta head, Anyi, Côte d'Ivoire. Stanley Collection of African Art, University of Iowa.

the skulls of the deceased in pots for further ritual use, whereas in the case of rainchiefs a water-jar is substituted for a skull (figure 7.7).

An Orchestrated "Work of Art"

For the Senufo of Côte d'Ivoire, their elaborate funerals are the "single most important occasion for the expression of aesthetic values, social relationships, and religious concepts" (Glaze 1981). They have, as their express purpose, to perform the final rite of passage—to effect the transformation of the dead "into a state of being that is beneficial to the living community, thereby ensuring a sense of community between the living and the dead" (ibid.:149). It is the masquerades of Poro, a men's secret society among the Senufo, who

perform the crucial rites during the funeral ceremonies—they lead the deceased from his/her village to the "Village of the Dead" (Förster 1993:34f.). The Poro not only sees to the separation of body and spirit, it also regulates the distribution of wealth among the groups in the village and stresses the values of mutuality, thus guarding against social fragmentation in such a rural context. Important cultural knowledge and values are transmitted through the society by means of a secret metaphoric language.

All initiated elders have the right to Poro society rituals, but social importance and status augur well for the influence of the ancestors-to-be from the next world, so they are treated to the most elaborate funerals (Glaze 1981:149f.). The funerals may last several days and are, in Glaze's words, "multimedia events." They involve a complex configuration of dance, sculpture, colorful costumes, music and song texts—all destined to reveal dramatically the nature and quality of a person's life and to provide the necessary closure, and ensure their transition to ancestorhood. Glaze comments that it is noteworthy that the Senufo employ aesthetic means as a primary way of dealing with the negative and destabilizing forces that

Figure 7.7 Deceased father's soul pot (*baba*), Mafa, Cameroon. After David *et al.* 1988:369, fig.3.3.

potentially come from the spirits of the dead. She recounts a popular Senufo tale which points, somewhat ironically, to the close relationship between art and death.

> Death entered the world at the hands of a genie or bush spirit because of a Senufo woman. Her error was to steal meat that belonged to the bush spirit and eventually deliver her own daughter to the cannibalistic bush spirit. In the end, the woman was killed by the *madeö* and returned to her people in the village. When the *madeö* saw their grief-stricken weeping, he realized that he had done a bad thing. But then he saw the woman's people begin to bring out their balafons and drums. And soon they were "laughing, eating, and singing and dancing." The *madeö* decided that he had done them a good turn after all. The tale concludes: "And from that time on the *madeö* has remained in the village, killing people. If he weren't staying here, there would be no death in the village. It is because of this bush spirit that death came to the village" (ibid.:195).

As Glaze suggests, because of their social and aesthetic exploitation of the situation, that is to say the woman's death, the Senufo became involved in elaborate funeral art and ritual, which entailed further death in the village. This tale of this "fatal cycle" serves to reveal the interlacing relationships of the negative factor, death, and the positive factors, art and aesthetic enjoyment. In her book, Glaze provides a detailed narrative account of the various stages of a particular funeral, with a concern to show how the art forms are integrated in the overall human context (ibid.:158–93). Such details cannot be reproduced here. Instead, attention will be focused on the principal masks involved in the funerary rituals. These are well described and analyzed by Till Förster in his work on Poro art, notably among the Kafibele Senufo farmers of central Senufoland (1993).

Soon after the death of a Poro elder has been announced by rifle shots, masqueraders known as *yarajo* appear in the village (ibid.:36) (plate 4). The mask is made of raffia fibers, feathers and other similar materials. The face part, behind which the performer's face is hidden, is made of cloth onto which colored pieces of fabric have been sewn. A hairdo of long colored raffia fibers hangs down each side of the face. The masquerader wears a one-piece, padded cotton suit. The humorous behavior of the performer, interspersed with seemingly absurd questions to passers-by, has a distinct purpose. It serves to determine, through the questions which are passwords, who is an initiate and may attend the secret rituals. After the gifts and cloth have been presented and distributed, music and dancing begin, and the deceased's body is sewn into the cloths on which it is lying by four or five members of the deceased's age grade. The sons of the deceased wear women's clothes made from their best fabrics—a form of ritual reversal that occurs in many African societies at critical junctures.

When the Poro drums are heard in the distance from the grove of the secret society, only initiates (*colobele*) and close relatives are allowed to remain. Before long the village is almost deserted, in anticipation of the arrival of the society's most important mask—the large zoomorphic helmet mask. The figure is known as *kporo* and is regarded as the embodiment of the society. What is striking about the mask is its incorporation of imagery from different animals, notably the most powerful and aggressive. Its performance is referred to by the elders as the "work of Poro." In museums, these masks are commonly referred to as "fire spitters" as in the example shown here in figure 7.8. In central Senufoland they have long horns, said to be those of an antelope or buffalo. Antelopes, admired for their speed and grace, represent ideal human behavior. The gaping jaws resemble those of a crocodile or hyena, and the long, pointed ears could be

Figure 7.8 Poro *Kponyungo* or "fire spitter" mask, Senufo, Côte d'Ivoire. Stanley Collection of African Art, University of Iowa.

those of a hyena also. Long tusks like those of a warthog (violent and unpredictable) curve backwards from the upper jaw. The chameleon, gripped in the jaws of a hornbill, is associated with communication between the visible and invisible worlds. It is that the various Poro associations know their *kporo* and can distinguish it from those of other initiation centers, but they do this rather in terms of the costume than the mask. The details of the mask, which are important to the carvers, are less significant than the ritual acts it performs according to the rules.

If the *kporo* comes from the initiation center of the deceased then the head is hidden under fresh foliage. The masquerader is responsible for going to the corpse and performing the necessary rituals to separate his life force from the corpse. This is done to the accompaniment

of the Poro drums. The corpse is then buried before nightfall with a few personal belongings. Förster makes the point that the Poro masquerade, when it escorts the dead to the other world, is not acting on behalf of any particular lineage or specific power in the village. In fact, the *kporo* itself is, in Förster's words, "at this moment . . . a creature that cannot be classified, a mask that simultaneously depicts and integrates the most diverse wild creatures. It is an impersonal and ambiguous chimera" (ibid.:41). He takes this notion of representation even further by noting the close analogy between the actions of the mask, the grove from where it emerges, and the construction of the mask itself. All have multiple meanings. So just as the grove is an area where the categories of village and wilderness overlap, and the mask is a

combination of seemingly disparate elements, so it is able to remove the deceased from the human realm and to estrange him from his relatives as a lifeless piece of wood. So the mask is able to tie up the loose ends of life and death and village and wilderness.[1] Yet despite its ambiguity, its path always leads back to unambiguity and the preservation of social knowledge. As Förster points out, masks prove to be more appropriate at these critical phases of life because they are more dynamic than figures and may show the path, take action, point out localities and mark the boundaries and bonds between the various life-phases (Förster 1988:10).

Art as Victory Over Death

The Yoruba of southwestern Nigeria believe that they have succeeded in neutralizing the powers of Death, using art as a weapon (Lawal 1977). They may now achieve immortality, as the following story illustrates:

Long, long ago, Death (*iku*) and his followers regularly invaded Ifẹ. Every fourth day they came from heaven to Ojaifẹ market where they killed as many people as they could with the staffs that Death had given them. Eventually, most of the people of Ifẹ were destroyed, and those who remained cried to Lafogido who was then Ọni and to Odua, Orisanla, Orisa Ijugbe, Orisa Alaṣẹ, and all the *orisa* to save them. But the *orisa* could do nothing to drive these spirits away. Finally, Amaiyegun promised to save them. He bought brightly coloured cloths which he sewed into a costume which completely covered his body. The arms of the costume were like gloves to fit his fingers, and the legs of the costume like gloves to fit his toes. He sacrificed a ram, a cock and three whips (*isan*) in making the costume.

Then he called the people to him. First he put his left foot into the leg of the costume, which came up to the knee. Then he showed it to the people and they began to sing: "Come and see the foot, a fine secret" (ẹ wa w'ẹsẹ awo rẹbẹtẹrẹbẹtẹ). He put his right leg into the costume and extended it so that the people could see. They sang the song again. He put his left arm and then his right arm into the costume. Each time ... (the people sang): "Come and see the hand, a fine secret" (ẹ wa w'owo awo rẹbẹtẹrẹbẹtẹ).

Finally he put on the gown which covered his face and entire body.

He took off the costume and stored it away in the room. When he found that Death would come again the next day, he went to the Ọni and promised he would save the people on the morrow. In the morning . . . (Amaiyegun) and his followers, who did not wear costumes, went to Ojaifẹ market and hid in the buttresses of the large trees. Soon the townspeople began to come to the market, and not long afterwards Death and his followers descend on them, killing them with their staffs. Amaiyegun came out from his hiding place, crying in the low gutteral voice of Egungun "khaaa, khoo". Death and his followers dropped their staffs and fled in terror. Amaiyegun and his followers picked up the staffs and pursued them. As they overtook them, they struck them on the head. "Gba!" one fell; "Gba!", another fell. Since that time Death and his followers have never returned to Ifẹ (Bascom 1944:56; cited in Lawal 1977).

Lawal argues that to understand how Death could be defeated with the aid of a mask, it is necessary to take account of Yoruba onto-logical conceptions. Human beings are regard-ed as a type of sculpture animated by the breath of the Supreme Being, Olodumare, who delegated Ọbatala to mould their physical body. When the vital breath or soul withdraws, death results and the body eventually decomposes into clay—its original substance. However, the dematerialized soul finds new life in the next life and in reincarnation. Reincarnation may take the form of the rebirth of a dead ancestor in the same family or when the soul of a type of

spirit child or *abiku* "borrows" the body of a woman. Since it does not stay long on earth, a woman who has lost several children is considered to be troubled by the spirit of *abiku*. What is fascinating in this regard, however, is the Yoruba equation of the human body with sculpture. The reincarnated ancestor and the *abiku* are held to be no more than temporal masks, the handiwork of Ọbatala, that will perish at death. Conversely, it is also believed that humanly created sculpture can localize and embody the human soul. So clay or wooden effigies which bear some physical resemblance to an enemy may be used to invite the soul of the latter into the figure which is then destroyed. This is why naturalistic representations of a person were feared, and to some extent, photographs. Effigies may also be used in a funerary context, such as at the second-burials of hunters, where a naturalistic effigy of the deceased is paraded around town and then taken to the bush, along with a basket of the late hunter's hunting charms. Clothes of the deceased may be used to dress the effigy to symbolically achieve resemblance. The figure is then destroyed by gunshots or left to disintegrate, ritually marking the end of the physical existence of the deceased.

Naturalistic, life-sized effigies are also used in second-burial ceremonies by the people of Owo, an ancient Yoruba city situated approximately midway between Ife and Benin City (Abiọdun 1976; cf. also Drewal *et al.* 1989:91f.). This ceremony is performed several months, sometimes years, after the death of an important man or woman. A life-sized image of the deceased, known as *ako*, is dressed in his or her clothes and given a funeral before being placed in a shrine in the house. In some cases a child of the deceased was dressed in his father's clothes and led around the town, being addressed according to his father's rank and status (Lawal 1977:52). The carvers seek to achieve a realistic portrait, especially of the face, that equals those found in the Ife bronzes and terracottas. Abiọdun argues that this naturalism is integral to this ancient ceremony. *Ako*, through its symbolic reconstruction of the physical, social and psychological identity of the individual, makes it possible for the "distinguished dead" to enter heaven—a realm of superior existence—with "assured success," and from which they may assist those still on earth. It goes without saying, therefore, that a poor funeral may seriously jeopardize this relationship.

So while the destruction or burial of this effigy means that his former mask or physical form can never be reused, the departing soul may want to return to the living in a new mask, whether in the form of reincarnation through descendants or through an *egungun* mask made by his or her children (to be discussed below) (ibid.:54f.). A shrine may also be built as a way of harnessing the power of the departing soul for the living. The altar sculpture is often stylized since the form of the soul is unknown and only resembles a human being to hint at the human essence of the soul. The head is often emphasized because of its importance in Yoruba thought as the essence of human personality, the seat of the soul and the controller of an individual's destiny. Lawal describes the sculpture as a type of mask through which the dead interact with the living. It serves to demarcate the physical and metaphysical worlds, endorsing the myth of Amaiyegun's victory over Death. In fact it is this firm belief in the indestructibility of the soul, as well as its reinforced power in the afterlife, that has led the Yoruba to elevate the souls of particular ancestors and culture-heroes to the status of deities, with an attendant expansion of their constituency from direct descendants to a whole community. The worship of these gods has, as has already been

Figure 7.9 Twin figure, *ibeji*, Egba, Yoruba, Nigeria. Stanley Collection of African Art, University of Iowa.

rates in many parts of Africa it is really only the Yoruba who have a tradition of sculpture for twins (Thompson 1971b; cf. also Mobolade 1971). For the Yoruba whose territory was once under the influence of the Ọyọ Empire, twins are regarded as *ẹmi alagbara* ("powerful spirits") who have the powers of an *orisa*, or deity (Drewal *et al.* 1989:170–5). But they are viewed ambivalently as they are considered capable of bringing riches to their parents and misfortune to those who do not honor them. They are viewed as both one and two, and as both deity and animal (they are called *edun* like the black and white Colobus monkey which has multiple births and carries its young at the back and at the front) (Houlberg 1973). There is evidence that twin births were once viewed as unacceptable among the Yoruba, as is still the case among certain southeastern Yoruba communities. It is possible that the cult of twins was legitimized within Ọyọ Yoruba culture by the identification of the deity, Ṣango, as the protector of twins. Twins are linked to *abiku* ("born to die") spirits, who are believed to lure children from their parents because they have a propensity toward dying (Brain 1980:200). Twins receive special attention and food from their mothers.

If one of the twins should die (and though physically double they are regarded as sharing only one soul [Lawal 1977:56]), the parents will consult an Ifa divination priest to find out which carver should carve an *ere ibeji*, or wooden image, of the deceased twin (figure 7.9). Various negotiations regarding food, fees and sacrificial materials occur between the parents and the carver. The latter invokes the *ẹmi* (spirit) of the deceased child before handing over the *ere ibeji* to the parents, by submerging the figure for several days in a concoction of leaves crushed in water and then rubbing the carving when it is dry with a mixture of palm oil and shea butter known as

discussed, survived over the course of several centuries to the present day. Lawal remarks that "the fact that many of the gods are no more than deified ancestors seems to be responsible for the prominence of anthropomorphic sculptures on their altars, even when the gods themselves may not be represented in person but by non-figurative symbols, like the thunderbolt in the case of Ṣango" (ibid.:56).

The immortality of the Yoruba *ọba*, or king, as expressed through the crown, was discussed in chapter three. The twin statuettes known as *ere ibeji* offer perhaps the best example of Yoruba sculpture representing the living dead. Despite the high twinning and infant mortality

Figure 7.10 Twin figures, *ibeji*, Egba, Yoruba, Nigeria. Stanley Collection of African Art, University of Iowa. The figures are dressed in cowrie capes.

ero. On the day that the parents take possession of the figure, they will feast the carver and his family. The figure is placed at the shrine of Ogun, the god of iron, and a sacrifice will be made. The woman will then tuck the *ere ibeji* in her wrapper and dance and sing appropriate songs for twins. She will be instructed by the carver not to talk to anyone nor look back on the way home. While it is the artist who retains the stylistic prerogative, it is the mother who transforms the carved image into something more than a memorial figure through her ritual care of the figure, in terms of washing, feeding (especially with palm-oil and cooling beans), dressing and decorating it (see figure 7.10). The deceased child is believed to be "present to the living in, with, and through the *ibeji* figure" (Drewal *et al.* 1989:175). The sacrifices are also believed to prevent the

deceased twin from harming the living. In her extensive study of *ere ibeji*, Houlberg has some fascinating examples of how Muslim and Christian converts still believe in the power of the twins and have modified the form and rituals (1973). For example, some may wear Islamic amulets or anklets—leather packets which contain Qur'anic quotations believed to have apotropaic value. The human form may be simplified and the services of the traditional diviner, or *babalawo*, dispensed with.

The Yoruba have one of the highest twin birth rates in the world (approximately forty-five out of every thousand births). This single, widespread art form, the *ere ibeji*, with their powerful, life-affirming human features, has afforded scholars of African art a remarkable opportunity to make comparative studies of regional styles.

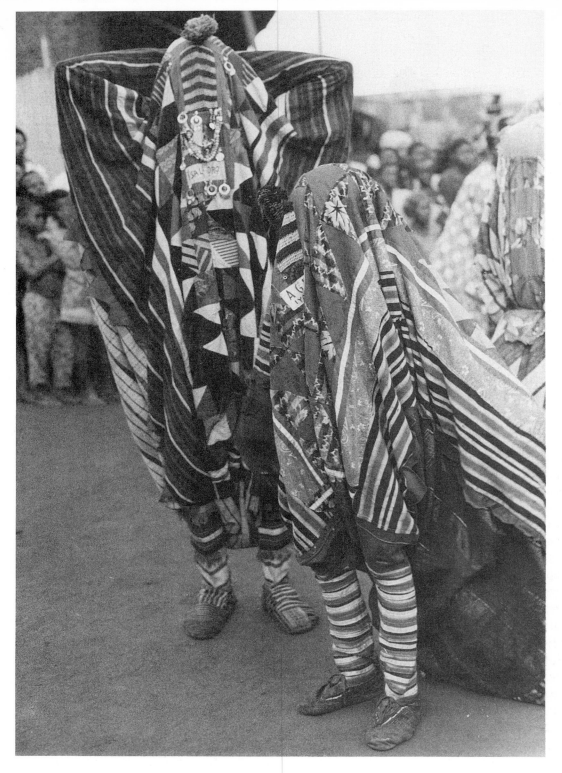

Figure 7.11 Egungun maskers, Egbado-Yoruba, Nigeria. Photo: Margaret Thompson Drewal, 1978.

The most dramatic representation of Yoruba beliefs concerning the afterlife is found in the form of the *egungun* masqueraders. *Egungun* masks are considered to be representations of ancestral spirits. They perform at funerals for society members, as well as during *egungun* festivals held annually or biennially in communities throughout Yorubaland (M. Drewal 1992:89f.). The masks do not portray dead spirits nor do they bear the names of human beings, only praise epithets such as "Riches-Bring-Beauty." The masks vary in style, but are generally voluminous and tent-like, composed of layers upon layers of multicolored cloths, which cascade to the ground sometimes from a wooden headpiece (see figure 7.11). The cloth is normally cut in long strips so that when the performer whirls, it splays out, though still concealing the human body. Each year new cloth may be added to the *egungun* by the owner. Older *egungun* therefore have hand-woven and locally dyed strips of dark blue and red cloth overlaid by brighter pieces of machine-made cloth. Some carry carved head-dresses, whose grotesque and amusing images of juxtaposed human and animal features serve to depict the "peculiar nature and extra-ordinary presence of the living dead." Others have a top-piece which may be a tray bearing charms, animal bones and skulls. The masquer-ader speaks in a guttural voice to connote his other-worldly identity. In Pemberton's words, "[t]heir appearance stands in sharpest contrast to that of the living" (Pemberton 1978:43). While like any mask they are intended to conceal the identity of the wearer, their main intention is "to reveal a reality not otherwise observable" (Pemberton in Drewal *et al.* 1989: 182).

In addition to the myth cited above which attributes the origin of the *egungun* costume to Amaiyegun, there are other mythical accounts of the origin of this phenomenon (Lawal 1977:57). One story tells of how the costume was first used to bring an abandoned corpse from the bush into the town under the pretext that it was the spirit of the dead that had returned. Another version recounts that the first *egungun* were heavenly beings sent by the supreme being, Olodumare, to help stabilize the earth at a time of disaster. Legends with a more historical basis claim that the Yoruba borrowed the masks from the Nupe, their neighbors to the north, who had once used *egungun* to terrorize them. Some myths of origin refer to the pataguenon monkey, a creature that moves between and lives in both the forest and the cultivated fields of the farmer (Pemberton in Drewal *et al.* 1989:183). As Lawal points out, nearly all the accounts emphasize the use of the *egungun* to impersonate heavenly beings (1977:58).

The *egungun* performance has a wonderful double dynamic as the masks both refer backwards in time to presumed pasts as well as simultaneously renegotiating the present (M. Drewal 1992:94). It is both informed by tradition and experimental. Margaret Thompson Drewal describes *egungun* masks as "shrines in motion" as they are made up of elements found in stationary shrines in members' compounds. She focuses on Apidan performance in particular since it defies strict categorization in terms of whether it is ritual or theater (ibid.:94, 97). The principal mask is known as a "miracle worker" who revels in acts of transformation as he turns its large, circular outer garment inside out or peels it off to reveal a monkey form. By inverting his womb and giving birth to miracles, he both usurps and transcends the role of women. Certain Apidan may satirically depict human stereotypes. This type of mask can evoke or rather invoke and actualize several myths, rituals and other contexts at the same time. In Drewal's view its ambiguity lies in its exploration of reality and

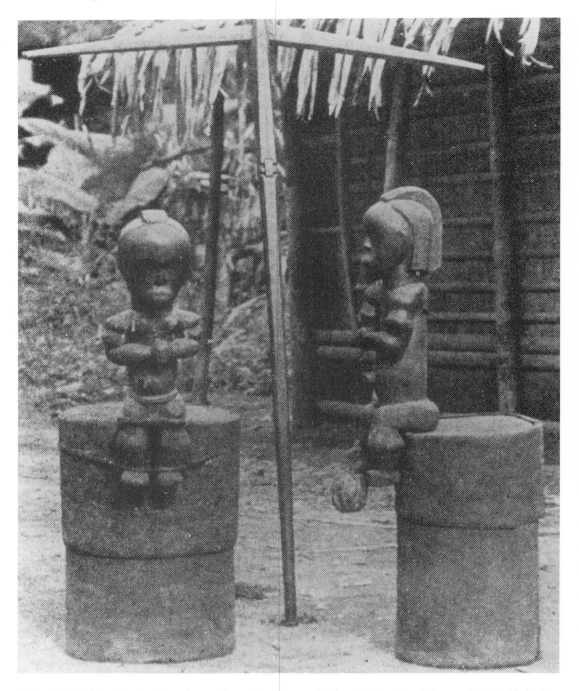

Figure 7.12 Reliquaries, Fang peoples, southern Cameroon and Gabon. Photo: Hans Gehne, *c.* 1913. Published in Zimmerman, Karl, 1914, *Die Grenzgebiete Kameruns im Suden und im Osten.* 2 vols. Mitteilungen aus den Deutschen Schutzgebieten, 9a and 9b, Berlin. The figures and bark containers (together with a mysterious crossbow) were placed outside for the purposes of this photograph.

the fact that it is a ritual play *about* play and transformation. This "deliberately confounds the *as if* and the *is*" (ibid.:103). The ritual specialists through their performance "bring the idea of the spirit into a tangible existence" with spectators looking through and moving back and forth between different levels of reality (ibid.). They know the spirit images are human beings but they all protect the "secret." The whole spectacle is a mediation of the phenomenal world and the spirit world. But it is also a reflection of social relationships.

Egungun express the continuing and dialectical relationship of the living and the dead, as well as the relationship between living members of a family. There may be several masks associated with one household, although one may be considered to be the principal representative of the lineage group (Pemberton in Drewal *et al.* 1989:183f.). An individual may learn through divination that he is required by a deceased parent to create an *egungun*. What follows is a collaborative process involving patron, divination priest, carver, tailor, herbalist who prepares the packet of medicines, leader of the *egungun* cult, performer, drummer, and women of the house who sing praises of the mask and lineage. The *egungun* festival is a time of rejoicing, as the ancestors are once again present among the living, seeing to the sick and the barren, legal disputes, and the general spiritual well-being of the society. The Yoruba, once again, celebrate the triumph of the human spirit over Death. Yet the rituals and songs of the festival also suggest a time of anxiety about the death feared in barrenness and in the loss of lineage continuity —the death brought about by witchcraft. Women's powers in this regard, as well as their marginal and ambiguous situation because of divided loyalties between the house of the father and that of the husband and children, explain their exclusion from *egungun*

(Pemberton 1978:43f.). Lawuyi and Olupọna, in an essay on metaphoric associations and the Yoruba conception of death (1988), argue that death is a metaphor for power relations between the sexes. In Yoruba society women dominate the market while men are in control of the palace and the home. Death, as a male figure, enters the market intending to restore order and subvert women's dominance. As recounted in the myth, Amaiyegun re-established the status quo by changing into a costume, a costume which still carries immense significance in many parts of Yorubaland today.

Fang Reliquary Art: A Question of Balance

The Fang peoples of Cameroon and Gabon believe that an individual's vital force is situated in the skull, hence they venerated the skulls of their most important ancestors (Sieber and Walker 1987:139). These included the founders of lineages and successive lineages, clan or family heads and powerful women who were famed for their supernatural abilities or exceptional procreativity. The ancestral relics were kept in containers made from bark sewn together (figure 7.12). These reliquaries were surmounted by either a head or a statue (figure 7.13). The ancestral cult, or *byeri*, is an essential feature of Fang spirituality in that the dead are believed to be able to transfer their blessings to the living.

The magnificent carved figures have been commonly viewed as guardians, destined to scare away non-initiates. But they need to be seen also as an integral part of the wider symbolic and ritual discourse (Laburthe-Tolra and Falgayrettes-Leveau 1991). The ritual creates a time and a space where the contradiction between life and death is eliminated. In this respect it is closely tied in with the whole area of initiation. The aim of the ritual is not just to reanimate and regenerate the ancestors,

but also to incite the initiates to transcend their material bodies. So there is a dynamic complementarity between the bodies of the initiates and the wooden reliquary figures. The figures aim to impress upon observers that there is more to the contents of the box than is suggested. They also contribute considerably to breaking down the opposition between the universes of the living and the dead, in that they are firmly linked to the relics and are also the focal point of the initiation ceremony.

Fernandez and Fernandez (1976) are also concerned to correct certain wrongful notions about the Fang ancestral cult and its figures.

Figure 7.14 Reliquary guardian, *eyima bieri*, Fang peoples, southern Cameroon and northern Gabon. Stanley Collection of African Art, University of Iowa.

Figure 7.13 Reliquary head, Fang peoples, southern Cameroon, Rio Muni (Equatorial Guinea), northern Gabon. Stanley Collection of African Art, University of Iowa. The heads gradually replaced the full anthropomorphic figures, whose torso cavities held the bones. The latter were placed instead in bark boxes or woven bags. (Roy 1992:97).

They point out that early colonial literature incorrectly assumed the cult to be based on human sacrifice. In fact, initiation into the cult occurred as a consequence of a certain status in the society or having accidentally seen the skulls. The authors maintain that, based on their research, the main quality inherent in the statues is that of "protective benevolence," together with an air of maturity and secret knowledge appropriate to the ancestors (ibid.: 744). They convey that all is in order in the unseen world. But, beyond the serenity, there is another aspect to these figures, which is apparent prior to the ceremony. Here the Fang treat the figures as children, as they are being cleaned with palm oil before receiving requests from the living. Furthermore, their big heads, wide staring disc eyes, and flexed small legs

give the statues an infantile appearance (figure 7.14). In fact, the Fang frequently call them "medicine children." This ambiguous combination of infantile and mature qualities is not unique to the Fang. In other parts of Africa and beyond, "little people," such as pygmies, dwarfs and trolls, are believed to mediate between the material and spiritual worlds. The fact that these awesome figures were at times used as puppets further illustrates, according to Fernandez and Fernandez, these contrasting qualities in tension. This relates to the qualities most valued in mature Fang men, namely "composedness," "even-handed tranquillity" and the ability to hold opposites in balance.

Production of these ancestral figures for ceremonial purposes had virtually ceased by the 1970s. It had been fairly easy to acquire the statues from the Fang as they were far less valued than the skulls.

The close links between mortuary and initiatory rites can be seen in other contexts. For example, the importance of symbolic action linked to regeneration in the various initiation sequences of Tamberma funerals is noted by Blier (1981:125). Houses are decorated to recall the image of the novices as they emerge from their initiation rites. Rich funeral cloths are draped over the upper stories of the funeral house as they are draped over the shoulders of the novices. Cowries are hung around the portal as they are placed around their necks and earthen horns on the center of the entrance roof resemble the horned headdresses the initiates wear. The designs on a particular art work, such as the graphic patterns of the small Bwa plank mask in figure 7.15, may communicate rules for the conduct of life to a particular group. This particular mask was carved to commemorate an ancestor who was a dwarf in life. The patterns are associated with the scars applied to families who own the masks.

Figure 7.15 Bwa mask, Burkina Faso. Stanley Collection of African Art, University of Iowa. This small plank mask was carved to commemorate an ancestor.

Altars for the Ancestors: Creating Closure and Community

Altars and altar ensembles may also offer important statements about the relationship of and channels of communication for the living and the dead. The Mambila of Cameroon display their ancestor figures in front of simple, painted screens which decorate the facades of small, elevated shrine houses (Nooter in Preston 1985:61, figs 54–6). The anthropomorphic figures, made of raffia-palm pith and wood, are suspended in a net in front of the

painted wooden screen. A male-female pair surrounded by the cosmic forces of the universe (sun, moon and rainbow) is the main feature of the painting, surmounted by a triangle, representing the village. This communicates to people that their community is the microcosm of the universe, and that each individual acts as a link between the spiritual and material realms. The figures were once painted in the ritual colors of red, white and black and so the overall composition would have presented a vibrant effect. The intention was not to depict individual ancestors but rather ancestors in general, and their protective and intercessory role in the affairs of the living.

Edo ancestral altars, in the kingdom of Benin, reflect class and distinctions between commoners, chiefs and royalty through an increasing elaborateness in numbers, types, and materials of objects on display (Ben-Amos 1988). Paternal altars consist of a raised mud platform, surmounted by a series of carved wooden rattle staffs. Each staff symbolizes the authority of the senior son when he assumes his role as family priest. It is also his source of communication with the spirit world. The staff itself is segmented and is considered by the Edo to be a representation of a particular wild bush with small branches that break off when they reach a certain length. This is seen to be symbolic of a life span. The segments on the staff therefore represent the life span of the family members, and the multiplication of the staffs on the altar suggests lineage continuity. The finials on the staffs of commoners have a generalized ancestral head, while those of aristocrats are topped by carved elephants and mudfish, symbols of ancestral power.

Commemorative heads are also found on these altars—wooden ones for chiefs and brass ones for kings. Brass has a complex symbolic meaning in Benin. Since it never rusts or corrodes, it expresses the permanence and continuity of kingship. It is described as "red" by the Edo, and held to be threatening and capable of dispelling evil forces. A carved ivory tusk rests on each head. The elephant is considered to be the most powerful of all animals. The use of the tusk as well as leopard figures on the shrine represents the harnessing of the powers of the wild forest by the rulers of the settled land. The heads also form part of the altar of the Head, which is associated with personal luck or fortune. The latter is kept right inside the house while the former is placed in the front parlor, becoming the "outward, public manifestation of the inner personal essence of the chief's survival, well-being, and achievements." While these heads are "generalized references to lives that were respectable and full of accomplishment" (ibid.:27), the brass altarpieces (unique to kings) depict specific events in the reigns of particular monarchs.

Paula Girshick (Ben-Amos) describes the ancestral altars as a kind of "frozen funeral, making . . . narratives of self concrete and permanent" (ibid.:25; Girshick 1994:4). Negotiation and accounting also occur in the course of the funerary rites. The final rite of the funeral, known as the senior son's "planting," is the establishment, decoration and dedication of the ancestral altar at which the deceased, now fully incorporated in the spirit world, is to be served and honored (ibid.:8). It also fixes the interpretation permanently as the carved and cast objects create closure.

The Edo see sculptures and photographs as alike in that they capture and preserve images. While the various altar objects are said by the Edo to have no particular spiritual powers, their importance is understood only by paying attention to the wider Edo cosmology and conceptions of human destiny.

Figure 7.16 Metal altar, *asen*, Fon, Republic of Benin. After Bay 1985:cat. no. 8. The figure is holding high the rainbow snake, Dan, as a gesture of lineage solidarity and family continuity. The deity is charged with the transmittal of souls from the sky to their earthly abode.

Metal altars made of iron and brass and surmounted by cast and/or beaten brass figures are used by the Fon of the Republic of Benin to commemorate their deceased relatives (figure 7.16).[2] Known as *asen*, they were origin-ally limited in use to members of the royal family, but smiths started to make them for commoners following the downfall of the kingdom. These *asen* are kept in a special one-roomed building in the household courtyard.

They may either serve individual ancestors or the collective spirits of the family. The altars may be planted in the ground or lean against the wall. They provide the focal point for contact between the living and the dead and are treated with due respect. Shoes are removed, men bare their torsoes, and women uncover their shoulders. Water is offered at the bases of the *asen* to summon the spirits to hear the supplications of the living. There are also offerings of alcohol and food, followed by the blood of animal sacrifices. The prayers are conducted by the oldest living women of the lineage. When these prayers and questions to the ancestors are concluded, the remaining food and drink is shared among the living.

The various figures atop the altar generally represent the deceased relative and survivors. There are also images and objects which refer to Fon deities, and allude to proverbs and praise songs. The lidded calabash is a recurrent motif, since it is a ceremonial vessel whereby one offers food and water to the dead. It also symbolizes the two parts of the universe and the creator couple, Mawu and Lisa. It is said that only the donor and the maker of *asen* can fully comprehend its multivalency. The *asen* produced in Ouidah tend to be larger (around 1 metre in height) than those from Abomey. They are more elaborate, having been influenced by Afro-Brazilian culture. All *asen* made of iron are associated with Gun (or Ogun), the patron deity of all those who work with iron. Christians do commission *asen*, as evidenced by the ornate crosses which feature as motifs. In a fascinating essay on recycling in Benin, Allen Roberts describes how the blacksmiths use old car bumpers and imported brass pipes to produce their art (Roberts 1994). They prefer the shinier finishes since these are believed to have greater apotropaic value. Roberts emphasizes how Ogun's polythetic nature and status as "God of the Cutting Edge"

(Thompson 1983:53 cited in Roberts) makes him a suitable candidate for the role of god of recycling. Iron has long been recognized as having the potential to realize *aṣẹ* (power to make things happen) and the "astonishing genius of *ara*."

Another interesting altar form for the ancestors may be mentioned briefly here. Kalabari ancestor memorial screens are made to commemorate the lives of the most prominent traders in the New Calabar area of the Niger Delta (Barley 1988; Brain 1980:102f.). They are kept in a public place in the assembly hall of the "house" or social units which functioned as trading corporations. The screens exemplify the role of the househead as leader and chief—the presence of a ship reflects his power in commerce and heads show that he traded and owned slaves. The carved figures of the ancestors and their attendants are usually attached to a large, patterned wicker screen. It is possible that the Delta carpenters were influenced by their contact with seamen and traders for hundreds of years and the introduction of carpentry. They may also have been inspired by the Benin bronze plaques in their assemblages of these impressive scenes composed of separately carved heads, figures and motifs.

Barley argues that "the ancestral screens need to be considered in the context of a tradition where carvings are held to provide points of contact for otherwise free-moving spiritual entities" (Barley 1988:21). The sculptures are seen as substitutes for the decayed body of the deceased, especially his forehead—the location of the dead man's *teme* or spirit. They also serve as channels of communication between the living and the dead. The screens are different from the figures in that they are composite constructions and meaningfully organized, compared to the haphazard arrangement of figures in shrines. While the physical likeness of the house head is not reproduced, his association with the Ekine masking society is depicted and serves to identify him. A number of regulations and taboos may be observed in the various houses. For example, women are not generally allowed to enter the room where the screen is kept, but they may see and make offerings to the ancestors. Visitors have to remove their shoes so as not to anger the spirits and those approaching the screens must first cleanse themselves with the leaf of a special tree. Barley notes that Christian house heads delegate the duty of making offerings before the screens. Gin is generally poured on the ground, screens and mud pillars erected in front of the screens. These phallic pillars have greater significance than the screens themselves. In addition, numerous items belonging to the successful Atlantic trader would have been formerly displayed in the shrine. During the ancestral period of the ritual cycle, the screens receive offerings and are scrubbed, painted and repaired. It is difficult to find carvers prepared to replace a screen, because of the dangers stemming from several years of offerings on the screens. In one case, the remains of the original figures on the screen were buried in a coffin.

Fashions, Families and Futures

Given the attention paid to funerals in many African societies, and the messages being conveyed about individual and family status, and qualification for ancestorhood, it is not surprising that there are trends and fashions in funerary art. For many people, to be forgotten is worse than death itself, and so art plays an important role in this quest for immortality and a place in historical and cultural memory. More durable cement funerary sculpture and more elaborate graveyard monuments began to appear in a number of places along the West

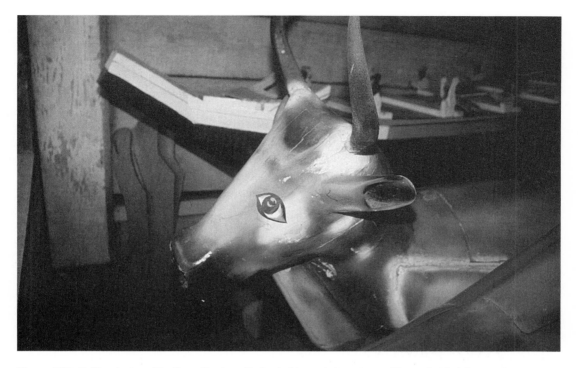

Figure 7.17 Coffins designed by Kane Kwei on display in his workshop, Accra, Ghana. Behind the cow is a canoe, and a cocoa pod is just visible in the foreground. Photo: Rosalind I. J. Hackett, 1991.

African coast from World War II onwards, spurred on by the commodities and oil booms. Some of these monuments offer a showcase of figures, whether lions, angels, military and police officers, musicians, animals, stools, swords, trees—some providing a narrative of the deceased's life, others constituting an entourage befitting a chiefly or royal subject. Several of the artists draw on Christian symbols which they then situate within the context of local ideas about death (cf. Domowitz and Mandirola 1984). The Ibibio sculptor, Sunday Jack Akpan (b.c. 1940), with his life-size cement figures, has extended the genre's range of subjects and their realism (Nicklin and Salmons 1977; Vogel 1991:101). He claims God as the only master for his work. Artists of this type commonly display their wares by roadsides, often in the larger cities, and produce sculp-

tures for commercial and tourist enterprises to supplement their income. Another contemporary artist whose work centers on death is the late Kane Kwei (1927–92), a Gan carpenter and coffin-maker who lived in the outskirts of Accra in Ghana (Vogel 1991:97f.; Burns 1974; Secretan 1994). He has gained international renown for his original coffin designs, which range from cocoa pods, elephants, chickens, buildings, Bibles, boats and Mercedes Benzes! (figure 7.17) His work has been exhibited in the US and France and he has been the subject of several documentaries. Following a request by his dying uncle to make a special coffin, he produced one in the shape of a boat. Its local success led to the creation of a whole representational tradition, with the intention of honoring and portraying the lifetime occupations of his deceased clients, whether cocoa farmers,

contractors, matriarchs (symbolized by the mother hen), transport owners, fishermen, etc. One coffin might cost more than the annual salary of many Ghanaians.

Traditional funerary practices, especially where they involve great expense, have been criticized by the Christian churches. For instance, the Kalabari practice of dressing the funerary bed with richly decorated textiles (of Kalabari, Igbo and Ghanaian origin) has been modified by the presence of Christianity (Eicher and Erekosima 1987:41). A white gown

Figure 7.18 Ancestor figure, Bangwa, Cameroon. After Brain 1980:134, fig.6.3.

is used to identify the deceased as Christian and the bed, walls and ceilings of the funeral room are dressed completely in white—usually combinations of commercially produced white fabric known as "lace." White and silver jewelry may be used to decorate the corpse. Like the cloth it may come from the storehouse of the extended family since the funeral is an exercise in prestige and display as well as communal solidarity.

The various ways discussed in this chapter in which the deceased is preserved or represented by a substitute, such as a carved figure (figure 7.18) or an empty coffin, whether through impersonation by a relative, masquerade, or an effigy (see figure 2.19), or via spirit possession, all point to the need for the living to communicate with the dead, especially when there is a lapse of time between the death and the funerary ceremonies (Poynor 1987). Artistic representations, whether naturalistic or stylized, by providing a point of contact, facilitate this communication and the performance of the necessary rites of separation and transition. Art works provide visual symbols which suggest interpretations and resolutions of death with all its ambiguity and destruction (cf. Bentor 1994).

It is not always masks and carved figures which represent the ancestors or other powers, even though these may be singled out by Western museums and collectors. The magnificent Kota reliquary guardian figures, whose stylized forms glisten with thin strips of precious brass and copper, are a good example of this (figure 7.19). We have seen that cloth is commonly used. Ritual knives and axes have taken on renewed importance for the Shona as symbols of the ancestors at domestic rituals and public ceremonies. This has occurred since the 1960s and the increase of nationalistic sentiment in Zimbabwe, spurred on by the war of liberation (Dewey 1994). The Shona still

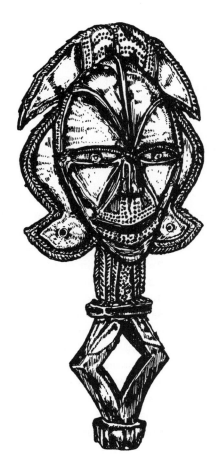

Figure 7.19 Reliquary guardian figure, *mbulu*, Kota-Obamba, northern Gabon. Stanley Collection of African Art, University of Iowa. The projecting shapes represent hairstyles.

pound" (Geary 1993). A striking feature of these performances is the imitation of a male statue—a prestige object owned by a wealthy relative—by one of the women who sat motionless in the pose of the statue throughout the funeral. Similarly, women may imitate the dance steps and carry items of prestigious masquerades which once belonged to the patrilineage but had long since been sold to collectors.

This brief overview of the relationship between art and beliefs and practices surrounding death in Africa highlights the inadequacy in numerous cases of referring to ancestral figures as commemorative. Furthermore, the focus on religion reveals the need for a broader context of analysis to understand funerary art and ritual in Africa (Smith 1987)—one that includes not just the various media but also other factors such as sound, movement, gesture, posture, and spatial organization. Arguably the art associated with death is conceptually the most interesting and perhaps the most challenging for the artist to execute as he/she seeks to juggle illusions of death with allusions to life and the hereafter. The material discussed in this chapter, maybe more than any other, underscores the importance of local perceptions of the agency, as well as the presentational and transformational capacities, of artistic creation in Africa.

believe that ancestral communication is best received by chiefs and diviners while dreaming on a headrest.[3] Sometimes the choice of art form may be gender-specific—Oron women in southeastern Nigeria were commemorated by non-representational terracotta pots, while important men were traditionally represented by carved wooden portrait figures. As part of Weh women's funerals in the northern Grasslands area of Cameroon short theatrical performances are staged by the "women of the com-

Notes

1 Masquerades, also of indeterminate form known as *nosolo* or "ox-elephant," with a tent-like structure, play a similarly important role in shaping transitions among some Senufo groups (Förster 1988).

2 This account is taken from Poynor 1994, Freyer 1993 and Bay 1985.

3 See the recent exhibition entitled "Sleeping Beauties: African Headrests and Other Highlights from the Jerome L. Joss Collection" at the University of California at Los Angeles, jointly curated by Doran Ross and William Dewey.

Conclusion:

Winds of Change

In this closing section, we shall look at some of the connections between artistic expression and religious change, notably those influenced by the spread of Christianity and Islam.

"Traditional" art and religion are commonly viewed as victims of the spread of Christianity and Islam, and the political, economic, and cultural developments of the twentieth century.[1] There is plenty of evidence of this as the older cults decline due to migration, opposition, lack of interest, or economic or political constraints. With fewer commissions from the once powerful secret societies or ancestral cults, young artists find the urban and international markets more lucrative. Initiation associations, such as the Sande and Poro societies in Liberia and Sierra Leone, which traditionally trained young people for adulthood and marriage, and which were long renowned as sponsors of masking and sculptural traditions, have curtailed their activities, particularly in the urban areas, to fit in with the formal schooling system. Once the focal points of festivals, shrines now suffer from declining resources and interest, when in the past many of them were described as veritable sculptural monuments, such as the *mbari* shrines to the earth deity, Ala, which flourished in Igboland in the 1960s (see Cole 1982). Ancient fertility figures, formerly associated with the well-being of a village, have been sold (usually by young Christian converts) to passing traders (cf. Merriam 1974:48). While the growing international art market for African objects in the 1960s onwards is in part to blame for the exodus of many pieces, it is primarily the gradual erosion of belief in the efficacy of carved objects and masks. This is mainly attributable to the effects of Christianity since the nineteenth century—not so much the deliberate destruction of artifacts and shrine paraphernalia by missionaries in the early days, but more the loss of cosmological and practical relevance of such objects and their attendant cults to life in the cities, and the changes wrought by formal Western-style education, nationalist, particularly socialist, governments, changing health care patterns, and the growth of the market economy.[2]

As we saw in earlier chapters, traditional rulers and their kingdoms have in the past been major patrons of arts of display and status. But with their authority undermined by national governments, the royal arts are less elaborate than before. Fortunately, this is not the case with all the kingdoms—the Yoruba, Akan, Benin and Kuba courts still flourish. There are also deities whose cults and constituencies respond well to the demands of modern, urban lifestyles. Ogun and Oṣun are two fine examples. As the Yoruba god of iron, Ogun is now associated with drivers and mechanics (Barnes 1989), oil workers and military governments (Sanford 1994), and artists into recycling (Roberts 1994). Oṣun's cooling and

192

perpetually renewing waters provide healing for women and children, but also for all those suffering from present-day economic stringencies (Sanford 1994). But it is more often the case that traditional festivals and their masquerades and art works only survive if they have entertainment value, or may serve as politicized and commodified objects.[3] The masquerade figures of the Ekpe secret society are a good case in point. With their colorful black and red raffia manes and black knitted body costumes together with accoutrements such as hats and feathers, they have become modern-day symbols of political and social power. The masquerades may bring their dramatic and ritual displays to airport tarmacs, bank forecourts or sports stadia. In their scaled down model form, they may also pass into the hands of visiting dignitaries or tourists as gifts or purchases.[4] Yoruba ritual pots, no longer in demand, are transformed into flower pots (Fatunsin 1992:81), sacred cloth becomes a fashion item,[5] and ancestral and shrine figures and royal stools become tourist paraphernalia devoid of their spiritual meaning.[6]

Yet, as emphasized at the outset, it would be wrong to view African cultures as passive or art as a mere reflection of wider socio-religious changes. Artists in particular provide creative channels for the interpretation, contestation, and adaptation of the changes people face in their religious and cultural environment.[7] There are plenty of examples of the ways in which artists have incorporated these changes into their creations (see Ottenberg 1988b). There exists a range of representations of the "colonialist Other," for example (see Lawal 1993; Kramer 1993). These images have several levels of meaning, some positive and others negative, depending on the context, as Lawal has ably shown with regard to Yoruba art. Before the real penetration of the "oyibo" (as the white man was called) into Yorubaland

in the 1840s, stories were already circulating of his invincibility and powerful witchcraft. Before long his powers and perceived superior might due to his military and technical skills were being compared to those of the *orisa* or Yoruba divinities: *Oyibo, ekeji orisa* ("White man, next in rank to the gods"), and new Yoruba names were being coined to stress his "supernatural endowments," such as *Fatoyibo,* or "the divination deity is as powerful as the white man" (Lawal 1993:2). It was not surprising, therefore, that missionaries were subsequently welcomed into Yorubaland from the mid-eighteenth century onwards. Indeed one of the earliest representations of a white man suggests a missionary figure being welcomed into Yoruba society. Lawal shows how many of the early artistic representations of the white man did not just reflect this fear and admiration, but also satirical elements. The bizarre behavior and dress of this white-skinned and long-nosed figure were well developed, for instance, in the work of a Lagos artist in the 1940s, Thomas Ọna Odulate. Another fine example of the way in which African artists may provide an interpretation of European visitors is seen in the motifs elaborately carved onto the elephant tusks which served as furnishings for altars of various types in Benin City, Nigeria, from the eighteenth century onwards (Blackmun 1988).

The Dogon people of Mali have long been subject to the scrutiny of anthropologists and tourists because of their elaborate mask dances and festivals. Van Beek's work on the Dogon illustrates well how they have continually introduced changes (new masks, myths, divination techniques, as well as innovations in performance) into their mask festivals, which are quickly absorbed and soon regarded as "traditional" (van Beek 1991a:73). The masks provide new ways of interpreting the world, and the new power-holders, whether neighboring Fulani, Mossi or Sawo, or visiting foreigners—

now increasingly of the tourist variety (without forgetting anthropologists!). While tourism has created some "cognitive dissociation" between the *dama* or funerary dances performed for ritual purposes and those performed as entertainment for tourists, it has served to stimulate mask production (van Beek 1991a:70ff.). The newer masks tend to have less of a religious function than the older ones, but the roots of the *dama* festival still lie in traditional Dogon religion and therefore reflect changes in the Dogon religious environment. Islam and Christianity are both well established in Dogon society, and this has resulted in a growing number of the population ceasing to perform the sacrifices (the Dogon definition of the practice of their traditional religion). But as van Beek observes, "[w]hen the more performative aspects of the festival are highlighted, integration with the new religion becomes less problematic" (ibid.:72). By adding on new elements, such as social ridicule, and the fertility rites, the Dogon are able to enlarge the range of *dama* without deleting the ritual as such.

Spiritual themes persist too in Zairean urban art, notably in the case of the popular Mami Wata paintings such as by the now well-known Chéri Samba (Jewsiewicki 1991, 1995), which are believed to have their own protective potency (figure 8.1). As noted in earlier chapters, the cults of this seductive water spirit are found along the coastal areas from Senegal

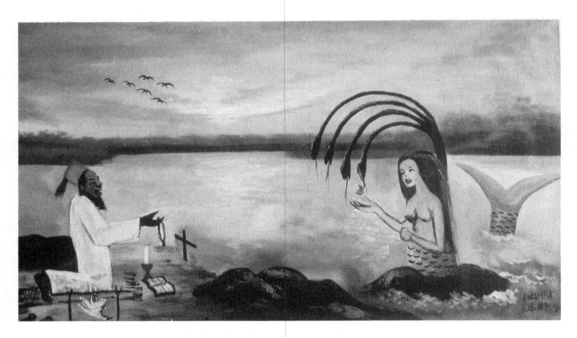

Figure 8.1 Mami Wata painted by Londe, from Bunia, Zaire. Photo: Bogumil Jewsiewicki, 1991. The Christian symbolism of women, snake, cross and Bible is central to the picture. It is believed that only God can provide protection against the costly relationship of power with satanic, white Eve — the sterility, the required sacrifice of close family members and resultant social destruction. The mermaid is frequently charged with symbols of modernity — light skin, watch, sunglasses, etc. The painting also connotes the manipulative power of other religions — in this case, Islam. The Muslim here is seeking the power of Mami Wata in addition to his own magic. It is common for painters in eastern Zaire to associate magic with Islam — a perceived (evil) source of success in business (Jewsiewicki, personal communication, 3 November 1995).

194

to Angola. The shrines with their images of Mami Wata as mermaid and Indian snake-charming goddess, reflect, in Henry Drewal's opinion, a creative configuration, interpretation and manipulation of images and ideas about indigenous and exogenous people, powers and spirits. The eclecticism of many of the Mami Wata priests and healers—notably the urban ones—is manifest in the Hindu, African, European, Christian, American, occult and astrological imagery.

The festival of another female figure, that of the river goddess, Oṣun, in Oṣogbo, western Nigeria has turned into one of the most popular in Nigeria. People come from all over to receive the blessings, notably of fertility, from Oṣun, and to enjoy the cultural riches of one of Nigeria's foremost artistic centers (Sanford 1994). In this case, artistic initiative has served as a precursor of religious revival and the work of Susanne Wenger, the Austrian artist who settled in Oṣogbo in the 1950s and became a devotee of Yoruba religion, has been discussed in chapter five.

The world-renowned contemporary stone sculptures of Zimbabwe provide us with a wonderful example of how traditional concepts and values may form the basis of an artistic renaissance. It is not appropriately labelled "religious art" or "ritual art" as such, in that it has no ceremonial usage, and the form and content of many of the works by younger sculptors deals with the human dimension of life. Yet the aesthetic origins of this monumental and "expressively charged" sculpture "largely lie in the artists' realisations of the spiritual dimensions of their traditional cultures" (Winter-Irving 1991:1).[8] Despite the varied background of many of the sculptors (Shona from Zimbabwe, Chewa and Yao from Malawi, Mbunda from Angola, as well as others from Mozambique), the subject matter of many of the pieces derives from the myths and beliefs

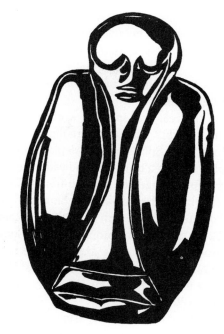

Figure 8.2a "Spirit Rising from Within." Peter Mandala, Zimbabwe. After Ponter 1992:18.

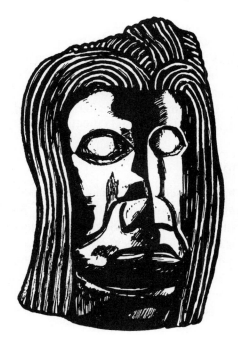

Figure 8.2b "Man Transforming into Lion Spirit." Felix Tirivanhu, Zimbabwe. After Ponter 1992:22.

195

of oral traditions, whether ancestral spirits, or spiritually powerful animals (as in the work of Wazi Maicolo [ibid.:83]). As a recently produced book on this increasingly popular art suggests in its title—*Spirits in Stone*[9]—the sculptures reflect the lack of distinction between the real and spiritual worlds (figures 8.2a and 8.2b). Nicholas Mukomberanwa's sculpture, "My Spirit and I," depicts subject and spirit sharing a third eye, and with face and features fused together (Winter-Irving 1991: 109) (see also the work and biography of Richard Mteki and Joseph Ndandarika [ibid.: 103, 120]). Several sculptors, such as Henry Munyaradzi, claim that the ancestors are their inspirational source, with the sculptures often appearing to them in dreams (*Magiciens de la Terre* 1989:209).

Even when the work of artists does not exhibit explicitly religious themes or titles, it may still have a religious significance as far as the artist is concerned. This is well illustrated by Johanna Agthe in her survey of contemporary East African art. Furthermore, biblical scenes may be presented in a traditional idiom, according to local oral literature, as in the case of Kennedy Wesonga's "Baboon", where Lot's wife turns into an ape, after disobeying the order not to look behind (1994).

Christianity

When we look at Christianity, we discover a range of responses on the part of Africa's contemporary artists.[10] Some have preferred to remain faithful to their own traditions, while others have sought to incorporate Christian symbols and biblical themes into their work. Many of the artists who were trained at the various workshops established by churches and missionaries in Southern Africa, Nigeria, Cameroon and Zaire, for example, focus on liturgical or devotional art. Spearheaded by

Roman Catholic priests in the 1940s and 1950s, this ongoing revival provides important evidence of the processes of inculturation of Christianity in Africa.[11] The workshops and schools of Father Kevin Carroll in Nigeria which trained and supported a number of leading carvers, including Lamidi Fakẹyẹ, and that of the Jesuit, Father E. Mveng, in Cameroon, both produced art for non-Christian contexts and encouraged the use of traditional subjects in the quest for an African Christianity. The Serima Mission in Zimbabwe, founded by Father John Groeber in 1948, was an early attempt to use Shona art forms for Christian expression. This type of art was not always well received, particularly by some of the Protestant denominations, fearing "syncretism" and "adoration" rather than "decoration." Father Carroll sidestepped the problem by emphasizing the humanistic rather than the spiritual side of Yoruba art—its illustrations of Yoruba life. But he had to contend with African visitors to the compound observing that by employing traditional carvers they were "encouraging pagans, and taking people back to what they had left" (Carroll 1967:57).

Even some of the more conservative Christian groups are coming to appreciate the value of art as a means of communicating the Gospel, although they are somewhat selective in their use of the visual.[12] A large indigenous pentecostal organization, the Deeper Life Bible Church, headquartered in Lagos, Nigeria, employs artists to produce its very graphic posters (with themes such as the "Blood of Jesus") and illustrate its newsletter.[13] One of their former pastors, Chineidu Agbodike, who is now a full-time artist, did a series of altar paintings for them and served as their art editor.[14] In Zaire, pentecostal evangelists had established workshops in the 1970s, producing popular paintings for evangelistic purposes, creatively combining subject matter,

inscriptions, titles and personal commentary either in church or studio (Badi-Banga 1982:162f.). The Ibibio artist, Nsisak Essien, has been marked by his recent conversion to Pentecostalism (Ottenberg 1995). He no longer draws on traditional Igbo *uli* designs in his work, nor does he paint the political and social art of his youth. In 1994 he destroyed his old works and sketch books and gave his art books to his old art school. His work is now much more spontaneous and centered on "Happy" paintings, as he claims to be guided directly by Jesus Christ.

Ethiopian artists, despite the pressures of the tourist market, continue to produce paintings for the Church, as they have done probably since the introduction of Christianity to Ethiopia in the fourth century. In a recent exhibition, "Ethiopia: Traditions of Creativity," two of the featured artists—Qangeta Jembere Hailu and Qes Adamu Tesfaw—reflect this heritage.[15] Both learned painting as part of their church education, and later turned to full-time careers as artists. They are frequently commissioned to produce wall paintings for churches, or smaller devotional images for individual use. While they replicate the styles of Ethiopian traditional painting,[16] there is still room for their own creativity. One of Adamu's daughters has produced a few paintings. Painting was traditionally a male preserve, but now there are a few trained women becoming artists. However, they are not painting within the church tradition.

Political commentary combines with the religious convictions of some artists. In southern Africa, John Ndevasia Muafangejo's (1943–87) visionary linocuts depict historical events, Namibian scenes and Biblical literature. His religious faith permeates his work. He was trained and taught at mission schools, notably the Lutheran Rorke's Drift Art and Craft Centre in Natal (1967–70). His print,

"Windhoek People Pray for Peace and Love" in 1977, shows a gathering of Black and White faces listening to two clergymen, one Black, one White. The racial intermingling also has an aesthetic effect with the dark and light values contrasting with and complementing one another (Kjeseth 1990:30-33; see also Levinson 1992). Muafangejo's work records the occupation of his country by a neocolonial power, his people's resistance, and the "particular relationship between church and state that forms a unique and integral part of his country's history" (Danilowitz 1993:46-7). So the frequent references to religious events in Muafangejo's work (such as "Oniipa New Printing Press and Book Depot on 11 May 1975" [1975] and "Oniipa Rebuilding of Printing Press Was Bombing upon the 19.11.80" [1981]) (ibid.:56, figs 10 and 11) reflect the church's increasingly leading role in popular resistance.[17] His powerful use of black and white allows for the "inventive construction of positive and negative forms and can be read as a direct reference to the racial polarization of pre-independence Namibian society and culture, where an individual's destiny was quite literally predicated on skin colour" (ibid.:50).

The African independent or "spiritual" churches, founded out of a different type of protest—the search for a more relevant and practical Christianity—have provided a forum for local artistic creativity. One of the finest examples of this is Bwiti—described in chapter five in some detail—a new religion (sometimes termed "syncretic"), born in Gabon from the fusion of Christianity and Fang culture. Renowned for its art, Bwiti is an expression of the ongoing Fang quest for new cultural, religious and aesthetic forms. There are many other examples that could be cited from the vast field of Africa's newer Christian movements—such as the "sculpture gardens" of the

Figure 8.3 Zulu beaded wristbands, anklets, and broad bands of beadwork used to decorate headdresses, South Africa. After Morris and Preston-Whyte 1994:66. The white background indicates that they were made by members of the Church of the Nazirites. Drawings based on photographs by Jean Morris from *Speaking with Beads* by Eleanor Preston-Whyte, published by Thames and Hudson, London, 1994.

Twelve Apostles Church or Nackabah People in west and central Ghana, where cement statuary of angels, Christ, the saints, and the Virgin Mary abounds (Breidenbach and Ross 1978). But large statues of the Archangel Michael are not favored by all churches of this type. The Kimbanguist Church of Zaire, for example, only allows artistic design on ecclesiastical vestments and stoles. The Celestial Church of Christ, based in Nigeria, with branches all over West Africa, as well as in Europe and the US, continues to utilize a Caucasian Christ image in its literature, wall paintings, and shrine or personal devotionalia, although it has commissioned local carvers to produce church doors in many parts of western Nigeria which depict biblical scenes and characters in Yoruba style. Any consideration of the art of this type

of independent or spiritual church must take into account its provenance or the influence of the respective "parent" bodies. In the case of Celestial Church of Christ, this is well reflected in the founder's (Samuel Biléou Oschoffa) background—Methodist, Roman Catholic, and Cherubim and Seraphim, and his attempt to reconcile the simplicity of Methodist liturgy with the ritual and devotional complexities of Roman Catholicism, together with the "aesthetics of heaven" of the Cherubim and Seraphim with their candles, white costumes, and colored sashes.

One of Africa's largest independent churches, the Nazareth Baptist Church (or Church of the Nazirites) in Natal, South Africa, founded by the prophet Isaiah Shembe in c.1910, is famous for its pilgrimages and festivals. A unique display of dress and dancing characterizes these events. Beadwork proliferates in the costumes of women and girls (Morris and Preston-Whyte 1994:66f.). It identifies the faithful and incorporates them as worshippers into the church community. Both the wearing and weaving of the beads represents a religious obligation for women of the church. The Shembe beadwork is distinguished from traditional beadwork by the predominance of white beads for the background to the designs, which are personally chosen by the wearer (figure 8.3). The uniforms mark a distinction between married women and adolescent girls. Prophet Shembe's concern to integrate traditional Zulu values and organizational structures into his church, notably in the form of traditional dance and dress, distinguishes the Nazaretha Church from all other religious movements in the region.

Islam

Ali Mazrui contends that a divergence does persist between Islamic aesthetics and African

aesthetics in areas like sculpture, painting, dance, and drumming (1994). He sees the uncompromising emphasis on monotheism and ancient distrust of idolatry as persisting in the work of contemporary African artists. Only a few, such as the Makonde woodcarver, Rashid Rukombe of Tanzania, have tried to blend cultures and engage in "organic" art. Mazrui posits that it is in the areas of poetry, music, architecture and calligraphy that Islam encounters African cultures. Yet he acknowledges that the desire to turn to sculpture to express artistically the stories of Islam, such as the Prophet Muhammad's ascent to heaven from the rock in Jerusalem on the night of the Miraj, is particularly strong in West Africa.

Despite the restrictions on Muslim artists there are some fascinating examples of the incorporation, sometimes subtle, of Arabic inscriptions and Islamic symbols into textile patterns and other forms of adornment (see Ottenberg 1988; Bravmann 1983). These can expand our understanding of local perceptions of Islam, when it was first introduced into parts of West Africa, for instance. In his study of horned masking (see figure 4.6) among the Jola and other groups of the Casamance region of West Africa, notably the *Ejumba* or cylindrical helmet mask used in the context of men's initiation ceremonies (discussed in chapter four), Peter Mark discusses the Muslim elements, such as leather amulets, which have been added to the mask over the years (1992). He dismisses this as evidence of the Mande and thus Muslim roots of the masks, and rather argues that the Muslim motifs have been added for the sake of efficacy resulting from a long contact and exchange with Muslims in the area. That this contact was strong is evidenced by the fact that even Muslim groups such as the Mandinka have come to use horned masks in their own men's initiation ceremonies. Furthermore, he shows how Muslim influence may also explain why the horned cap, or *Usikoi*, has come to replace or usurp the role of the more powerful *Ejumba* mask, regardless of the culture.

In nineteenth-century Kumase, the capital of Asante in Ghana, a study by Bravmann and Silverman of royal cloth and sandals covered with Arabic script proves very rewarding in depicting the ongoing relationship between Muslims and non-Muslims (1987). They argue that such objects have been ignored or dismissed by scholars as simply items covered with pseudo-Arabic script created by Muslims at the capital for a "gullible Asante clientele." These beautifully decorated items provide historical evidence to suggest that Islam was being absorbed at the very deepest levels of Asante culture. Muslims were only a minority at the time, but they were highly visible and influential because of their knowledge of the Qur'an and their perceived mystical and esoteric powers. The painted incantations provide a creative transformation of the names of Allah and verses from the Qur'an. One particular cotton tunic worn by Osei Bonsu in 1820 displays an aesthetic of repetition, illustrating well the Asante belief in the efficacy of repeated Muslim prayer and the empowering effect of surrounding oneself with Allah's presence. The royal sandals worn by Kofi Kakari, lavishly decorated with colored leather straps, bejeweled motifs and gold buckle, extend the visual claim on the divine by adding painted magic squares and invocations on the soles. While the meaning of these cannot always be discerned, the intent is clear—they served as a protective shield (notably against the growing British military and political presence), as well as a means of divining the future for the Asantehene and his people. What must be noted is that this intimate relationship between the Asante ruler and the Islamic religion did not entail a rejection of his

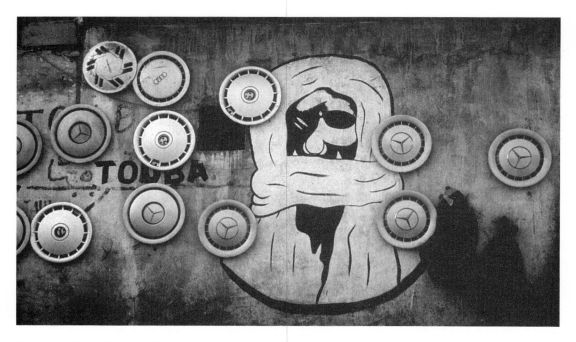

Figure 8.4 Painted image of Amadou Bamba on wall of hubcap shop in Dakar, Senegal. Photo: Mary Nooter Roberts and Allen F. Roberts, 1994.

ancestral faith. When the British Vice Consul visited the palace in 1820 he records how for the *Akwukudae* festival, the Asantehene not only ritually fed the blackened stools of his ancestors and royal predecessors, but he marked his body with blood and white clay, a visible sign of his heightened state of spiritual grace and closeness to the ancestors.

Further examples from other parts of Africa provide evidence of the growing presence of Islam and its appropriation at a more popular level. Glass painting in Senegal spread from Islamic North Africa at the turn of the century and thrived until the 1950s (Vogel 1991:117–18; Bouttiaux-Ndiaye 1994). It was inspired by photography. Nowadays the main market is for tourists. Yet one of the most widely circulated icons is that of Sheikh Amadou Bamba, the Islamic holy man, political leader and founder of the Mouride Muslim brotherhood. He has become something of a national hero and the various forms of his (political and talismanic) image (figure 8.4), whether photocopies or wall paintings, all derive from a single photograph taken in 1913 (Diouf 1992).[18] Decorated gourds in northern Nigeria now include Muslim emblems invoking the presence of Allah (Berns 1985). Such designs also reflect the changing religious affiliations of the artists (male and female) and clientele. In her study of the women's Sande society among the Mende of Sierra Leone, Ruth Phillips (1993) notes the formation of Muslim Sande chapters in response to the sporadic challenge of reformist and iconoclastic Islamic groups in this century. They have significantly dispensed with the masking traditions and some other features, but co-exist with more traditional Sande chapters. Gẹlẹdẹ masks in southwestern Nigeria, represent the fascination of the Yoruba with Islam by capturing some of the eccentric practices and styles of dress, as

well as their ability to divine and to prepare protective medicines (as evidenced in the frequent portrayal of leather-encased amulets) (Drewal and Drewal 1983:191). Ewe witch-finding sculptures, placed in shrines, were frequently depicted as people from the north, with cotton smocks, Mossi hats, and Islamic amulets, reflecting the popular belief in the mystical power of Muslims.

In an earlier article, deriving from his fieldwork among the Islamized Mande of northeastern Côte d'Ivoire and west central Ghana, Bravmann further argues that the arts have been neglected in seeking to understand the Islamization of African societies (1975; see also Bravmann 1974). They demonstrate that the effects of Islam were perceived as far from negative, and that numerous compromises were made between the universalizing precepts of Islam and local traditions. He shows how masking and figurative traditions, especially those concerned with anti-witchcraft activities, persisted as they were deemed more efficacious than Islamic prayers and chants. The co-existence, even fusion, of Islamic and masking rituals, is recorded by the North African chronicler, Ibn Battuta, in the mid-fourteenth century at the royal court of Mali. Moving to this century, there is evidence of Muslim clerics sanctioning important Bozo fishing and hunting rituals involving masks and figurative sculpture. Do masks perform during the most important Islamic festivals (figure 8.5); they dramatize, for example, the breaking of Ramadan, entertain people during *id al-kabir*, after the prayers and sacrifices of goats, and appear at the funeral rites of all members of the *ulama*. This Muslim masking tradition among the Mande is one of long standing, according to the evidence cited by Bravmann. The anti-witchcraft Gbain masks among the Islamized Dyula and Hwela do not enjoy the same support from Muslim clerics or the same

approval as the Do masking cult. Many of the masks are said to derive their power over witchcraft from Muslim charms which are attached to the forehead or muzzle of the masks. Sometimes these charms contain fragments of Islamic script. So, while Islam was not always tolerant of local beliefs and practices, and was at times even destructive of them, the examples discussed by Bravmann point not only to the vitality of the visual arts, but to the role they may play in expressing the interactive relationship between Mande and Islamic traditions.

Similar continuities are described by Abdellah Hammoudi in his work on sacrifice and masquerade in the Maghreb (1993). In a small Berber town in the Atlas Mountains in Morocco, he studied the festival of sacrifice celebrated by local Muslims to mark the culmination of the annual pilgrimage to Mecca, and the ensuing masquerades and youth-led festivities which often follow it. These show a marked contrast to the solemnity of the blood sacrifice because of their gaiety and licentiousness, yet Hammoudi argues that they form part of a single celebration. They do not repres-

Figure 8.5 Do mask, Côte d'Ivoire and west central Ghana. After Bravmann 1974:pl.74.

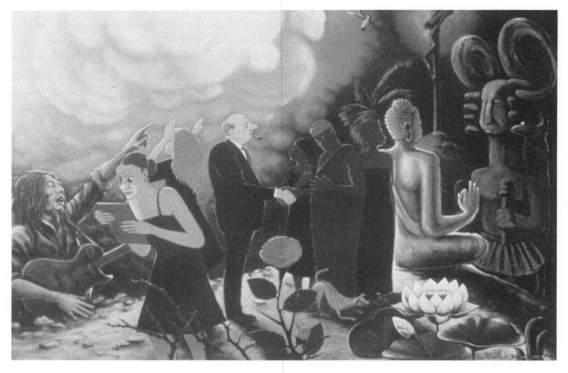

Figure 8.6 "On the way to Babel." Boniface Okafor, Nigerian painter. Photo: Simon Ottenberg, 1993.

ent a stratum of pagan rites challenging a superficial Islamicization, but rather a recreation of the foundations of the existing order, which they appear to destroy.

New Directions

A number of more recent examples point to a continuing fruitful interrelationship between artistic creation and traditional religious concerns. For High Priest Osemwegie Ebohon of the Olokun Traditional Religious Foundation of Benin City, Nigeria, art in the form of shrine sculpture and public dance performances has become an important medium for him to publicize his activities as a priest. Several artists in the Oṣogbo school in Nigeria see the artistic revival there as a means of

reviving interest in their ancestral beliefs and practices. In Morocco, the artist Abdellatif Zine has created a form of "trance-art" whereby members of the Gnawa brotherhood and who are possessed by spirits known as *mluk*, go into trance and externalize a particular color.[19] In the course of a staged ceremony, accompanied by musicians who help activate the trance-states, the possessed men and women cover themselves with the appropriate paint and then make physical contact with a white canvas which the artist has erected. The resultant fresco is seen as an externalized dream, a purifying experience, an invocation of protective spirits, and a testimony to the historical roots of trance-inspired art.

In the context of greater political and religious freedom, Vodun arts in the Republic

of Benin are enjoying a period of creative renewal, putting an acceptable face on a much maligned tradition. The first "International Festival of Vodun Art and Culture" was held in Ouidah in 1993.[20] The streets of this ancient slave-trading port were lined with contemporary Vodun sculptures and the temples were decorated with wall paintings, all depicting Benin's rich history and its impact on African religions in the New World, namely Vodou in Haiti, Santeria in Cuba, Puerto Rico and the United States, and Umbanda and Candomblé in Brazil. In the Yoruba village of Oyotunji, South Carolina, large and dramatic shrine sculptures, (re)presenting the various Yoruba deities, dominate the Yoruba community which grew up there in the 1970s, led by an African American from New York, Olobatala Oseijeman Adefunmi, and other oriṣa followers (see Omari 1991). In his account of Yoruba-American art, John Mason points to the influence the community had on a host of other artists around the country (1994:244). Today there is a sizeable group of artists in New York City who draw on Yoruba culture, fused with other ethnic and new world styles, to produce art works for "yuppie" collectors, as well as more reasonably priced items for their own worshipping communities. The work of Renée Stout, an African-American artist, has been more influenced by the art of Central Africa. She has sought to internalize some of the fundamental principles behind Kongo minkisi in her powerful sculptures which were featured as part of a recent Smithsonian exhibition, "Astonishment and Power" (Harris 1993). There is much more that could be said about the creative efforts of contemporary African American, Afro-Cuban, and Afro-Brazilian artists whose work still pays homage to, yet adapts and transforms, their African spiritual heritage (see, for example, Thompson 1994; Omari 1991). But space

precludes that in the present work.

There are artists, however, who would not consider themselves as Christians, Muslims or as practitioners of any ancestral heritage. They are more eclectic in their ways, rather seeking a synthesis of different religious paths. They have often been influenced by religious and inspirational literature of Eastern origin. They may belong to spiritual science movements such as AMORC, the Rosicrucian Fellowship, the Aetherius Society or Soka Gakkai. For the most part, this type of spirituality, because of its esoteric, occult and individualistic nature, is overlooked by scholars of religion.[21] An attendant artistic expression is starting to engage the attention of some art historians. Simon Ottenberg's work on contemporary Eastern Nigerian artists examines the way in which they use the visual arts to reconcile external and internal religious influences in their lives (1994). His research has revealed one very interesting artist by the name of Boniface Okafor whose work is a direct expression of these new religious trends. Ottenberg describes Okafor, an Igbo artist in his forties, as searching beyond his Igbo and Catholic roots for a more universalist approach to art and religion. His art pieces are symbolically very rich, with meanings generated by himself as well as other sources. For several years he has produced illustrations for the Rosicrucian Fellowship's calendar in Nigeria and his ties with that movement are seen in his predilection for Egyptian pyramids and the Nile river in his paintings. Ottenberg reports that he could take over three hours to explain four of his paintings. The artist has also privately published a couple of booklets to adumbrate on the philosophical and religious aspects of his work.[22] As the details of his paintings and writings reveal, he is concerned with issues of peace, morality, racism, and spiritual self-development. His work is an important statement not just of new forms of

spirituality, but also of the growing religious pluralism of Nigeria today. In the painting shown here, "On the Way to Babel" (figure 8.6), a Buddha on the right hand side faces a depiction of the Christ on the cross and an Igbo *ikenga* carving—the popular wooden shrine figure which expresses personal strength and prosperity, but which here stands for all traditional religions. The fireball in the upper left of the painting is the Babel, here the Babel of racial, religious and political blindness. The positive symbols of peace and love, are tempered by negative considerations of unsure identity and colonial exploitation (Ottenberg 1995).

In sum, an investigation of art in Africa can enrich our understanding of religious change and encounter in the various contexts. As stated previously, we should not stop at viewing art as a mere expression of religious culture, nor as a mere tool of religious institutions, but also as an agent of reflection, critique, and transformation in its own right. Art constitutes an important symbolic interface for the changes in people's social and religious worlds, notably those which have occurred in the twentieth century, namely colonialism, missionization, political independence, as well as the demands of post-coloniality and global market trends. In the midst of these different modernities and in the face of the desacralization of art in the West, it is surely significant that many of Africa's contemporary artists and those who purchase the art continue to emphasize the significance of the spiritual dimension in the artistic process.[23]

Notes

1 See Matory (1994) for a far more creative perspective on these processes with regard to the Ọyọ-Yoruba of southeastern Nigeria.

2 Merriam (1974:49) notes that the Zairean village of Lupupa Ngye, where he and his wife had photographed hundreds of masks and figurines in 1959–60, was virtually bereft of such objects when they returned there in 1973.

3 Strother's work on the Pende of Zaire underscores the dangers of generalizing on this point, however (1995:33). She describes how among the Eastern Pende the masquerades have lost mainstream appeal and become an ossified religious practice for predominantly older citizens. Yet for the Central Pende the masquerades have almost entirely lost their religious function and developed into sources of popular entertainment—with key dancers appearing on Zairean television, at festivals and even overseas.

4 While Ekpe society initiates turn a blind, if sometimes disdainful, eye to the public face of these figures once forbidden to the sight of non-initiates, it is interesting to note that children are aware of the mysterious and fearful nature of Ekpe. When I purchased an Ekpe masquerader (about 60 cm tall) from a tourist shop in Calabar, southeastern Nigeria, in July 1994, I was struck by the reactions of the children who gathered outside and followed me to the car. They were both afraid, yet fascinated, by this intriguing leopard-like figure, about whom myths and tales still circulate. This seems to provide a good illustration of Rudolph Otto's *mysterium tremendum et fascinans*.

5 Within the last six months I have come across photographs in both an American and a British fashion magazine of models wearing *ukara*-type print dresses. *Ukara* cloth is an indigo sew dye cloth produced in Igboland. It is reserved for use as a wrapper by senior initiates of the Ekpe secret society of the Cross River region of southeastern Nigeria and western Cameroon. It is also used as a curtain in the Ekpe temple, marking the divide between the outside world and the "holy of holies."

6 In his work on the commodification of African art (1994), Christopher Steiner notes that the Muslim traders who sell a lot of African art for the tourist and export markets are not bothered by the desacralization of African art in the West. However, he does record an incident that he witnessed in a market, where some Muslim traders were disturbed by a French art dealer purchasing a Muslim protective belt (pp. 161–2).

7 Zeitlyn (1994:47) offers an important observation from his fieldwork on the Mambila of Cameroon in this regard, when he notes that "[a]lthough the figurines and carved headpieces may have vanished from Mambila society, the symbolic system which produced them retains its vitality."

8 Jonathan Zilberg, in an article entitled, "Inscriptions and Fantasies in the Invention of Shona Sculpture," in *Passages* (Northwestern University African Studies Program) issue 7, 1994:13,16, argues that the idea of "Shona" sculpture as an ancient tradition revealing spirits and culture in stone is in fact a recent construct of the art world.

9 The text contains magnificent photographs of the art, artists and Zimbabwean landscape (Anthony and Laura Ponter, 1992).

10 This range of responses is well illustrated by Agthe in her interviews and descriptions of the work of a number of Kenyan artists, whose work depicts biblical scenes, which reflect their training, commissions, market, as well as personal faith (1994).

11 On 27 March 1989, *Time* magazine featured an enthusiastic article on "Africa's Artistic Resurrection."

12 It is interesting to note that they seem to be more enamored of the dramatic arts. Youth groups regularly perform dramatic sketches as part of the liturgy and hold drama festivals to illustrate the necessity of a "born-again" Christian commitment and perilous risks of absence of same—risks which are expressed in a very traditional idiom (such as mysterious illness, "locked wombs," impotence and infertility, troubling dreams, bewitchment, misfortune, and early death.)

13 When visiting their editorial office in July 1994, I observed one of the graphic artists taking his inspiration from a Jehovah's Witnesses' Bible—long popular in Nigeria at least because of its colorful and romantic(ized) illustrations.

14 He is now a member of the Church of Jesus Christ of Latter-Day Saints and has painted some very Mormon-type images of Christ. That notwithstanding, he has established a series of paintings which represent his quest for ancient African art forms, notably the traditional designs and patterns applied to cloth, skin and buildings. He calls this "Ogaru Art," after the name given to such art in his own area, namely Igboland (see Ogbadike 1993). His work compares to that of another Igbo artist, Nwachukwu, who seeks to incorporate traditional *uli* designs into his work (see Ottenberg 1994).

15 The exhibition was organized by Raymond Silverman at Michigan State University. Profiles of the art and artists were published in a folder (1994) from where this information is taken.

16 These styles are magnificently documented in Heldman with Munro-Hay (1993).

17 Muafangejo's early supporters and collectors were Anglicans. With the church's increasing activist role, several of his prints were acquired by international support groups for sale to raise funds in the struggle against apartheid (Levinson 1992:16).

18 Allen Roberts and Polly Nooter Roberts have been engaged on a research project to study the wall paintings and other expressive culture associated with Amadou Bamba and the Mouride Brotherhood. Polly Nooter Roberts presented a paper entitled: "The 'Work' of African Art: Urban Islamic Wall Painting and Devotional Display" at the Tenth Triennial Symposium on African Art, New York City, 19–23 April 1995. Al Roberts kindly made available his unpublished paper (work in progress) on "The Aura of Amadu Bamba: Photography and Fabulation in Urban Senegal."

19 Pierre Restany, *Transe'Art: Empreintes Magiques*, Paris 1990 (brochure available at National Museum of African Art library, Washington, D.C.).

20 Dana Rush, "History, Politics and Religion as Reflected in the Contemporary Vodun Arts of Ouidah, Bénin." Paper presented at the 4th Annual PASALA Graduate Symposium, April 1994.

21 See Rosalind I. J. Hackett, "New Age and Esoteric Religion," Entry for *Encyclopaedia of African Religions and Philosophy*, ed. V. Mudimbe (New York City: Garland Press) and "New Age Trends in Nigeria: Ancestral or Alien Religion." In *Perspectives on the New Age*, eds. J. Lewis and G. Melton (Albany, NY: SUNY Press, 1992). Interestingly, the spirituality of African art and culture, notably in its contemporary form, is the subject of a special issue, entitled "Aspects of African Spirit" of *Chrysalis* (vol. 3,1: spring 1988), the journal of the Swedenborg Foundation.

22 Boniface Okafor, 1982, *On the Way to Babel*. Enugu: the Author; and 1985, *The Grain of Corn: Thoughts and Images*. Enugu: the Author. I am most grateful to Simon Ottenberg for making documentation available to me on this artist.

23 This point comes across clearly in the exhibition and catalogue, *Western Artists/African Art* (New York: Museum for African Art, 1994). The New York-based Ivoirian artist, Ouattara, for example, describes how he uses a Ṣango dance staff and a twin figure (both Yoruba that he brought from his family in Africa) to go into a trance. From thence he is able to communicate with the spirits and establish the all-important spiritual basis of the work (p. 36).

Principal Ethnic Groups Mentioned in the Text

Afikpo (Nigeria)

Akan (Ghana)

Akpa (Nigeria)

Akuapem (Ghana)

Anang (Nigeria)

Anyi (Côte d'Ivoire)

Asante/Ashanti (Ghana)

Azande (Sudan)

Bamana (Mali)

Bangwa (Cameroon)

Banyang (Cameroon)

Batammaliba (Togo, Benin)

Baule (Côte d'Ivoire)

Bemba (Zambia)

Beti (Cameroon)

Bobo (Burkina Faso)

Bozo (Mali)

Bulahay (Cameroon)

Bwa (Burkina Faso)

Chamba (Nigeria, Cameroon)

Chewa (Zambia, Malawi, Mozambique)

Chokwe (Angola, Zaire, Zambia)

Dan (Liberia, Côte d'Ivoire)

Dangme (Ghana)

Diola (Senegal)

Dogon (Mali)

Dowayo (Cameroon)

Ebira (Nigeria)

Edo (Nigeria)

Efik (Nigeria)

Ejagham (Nigeria, Cameroon)

Ewe (Togo, Ghana)

Fang (Gabon, Cameroon)

Fante (Ghana)

Fon (Benin)

Fulani (West Africa)

Giriama/Mijikenda (Kenya)

Gola (Liberia, Sierra Leone)

Ibibio (Nigeria)

Idoma (Nigeria)

Igbo (Nigeria)

Ijo (Nigeria)

Jola (Senegal)

Kalabari (Nigeria)

Kongo (Congo, Zaire, Angola)

Kono (Sierra Leone)

Kota (Zaire)

Kuba (Zaire)

Kwele (Gabon, Congo)

Lagoon peoples (Côte d'Ivoire)

Lega (Zaire)

Lobi (Burkina Faso, Côte d'Ivoire, Ghana)

Luba (Zaire, Zambia)

Luchazi (Angola)

Lunda (Angola, Zambia)

Luvale (Angola, Zambia)

Mafa (Cameroon)

Mambila (Cameroon)

Mande (Mali)

Mandinka (The Gambia)

Mangbetu (Zaire)

Mbete (Gabon, Congo)

Mbunda (Angola)

Mende (Sierra Leone)

Mijikenda/Giriama (Kenya)

Mossi (Burkina Faso)

Ndembu (Zambia, Zaire)

Nuna (Burkina Faso)

Nunuma (Burkina Faso)

Nupe (Nigeria)

Oron (Nigeria)

Pende (Zaire)

Sakalava (Madagascar)

San (Southern Africa)

Sapo (Liberia)

Senufo (Côte d'Ivoire, Mali)

Shila (Zambia, Zaire)

Shona (Zimbabwe)

Shoowa (Zaire)

Songye (Zaire)

Sotho-Tswana (Southern Africa)

Suku (Zaire)

Tabwa (Zaire, Zambia)

Temne (Sierra Leone)

Tiv (Nigeria)

Tukolor (Senegal)

Vai (Liberia, Sierra Leone)

Venda (Northern Transvaal)

Weh (Cameroon)

Winiama (Burkina Faso)

Yaka (Zaire)

Yao (Malawi)

Yoruba (Nigeria, Republic of Benin)

Yungur (Nigeria)

Zande (Zaire, Sudan)

Zulu (South Africa)

Bibliography

Abimbola, Wande, ed. 1975. *Yoruba Oral Tradition, Poetry in Music, Dance and Drama*. The African Languages and Literatures Series, no. 1, Ife: Department of African Languages and Literatures.

Abiọdun, Rowland. 1975. "Ifa Art Objects: An Interpretation based on Oral Traditions," in *Yoruba Oral Tradition: Poetry in Music, Dance and Drama*, ed., Abimbola. 421-58.

— 1976. "A Reconsideration of the Function of *Ako*, Second Burial Effigy in Owo," *Africa* 46,1:4-20.

— 1983. "Identity and the Artistic Process in the Yoruba Aesthetic Concept of Iwa," *Journal of Cultures and Ideas* 1,1:13-30.

— 1987. "Verbal and Visual Metaphors: Mythic Allusions in Yoruba Ritualistic Art of Ori," *Word and Image* 3,3:252-70.

— 1989a. "The Kingdom of Owo," in *Yoruba: Nine Centuries of African Art and Thought*, eds, Drewal *et al.*, 91-115.

— 1989b. "Women in Yoruba Religious Images," *African Languages and Cultures* 2,1:1-18.

— 1990. "The Future of African Art Studies: An African Perspective," in *African Art Studies: the State of the Discipline*, 63-89. Washington, D.C.: National Museum of African Art.

— 1994a. "Introduction: An African(?) Art History: Promising Theoretical Approaches in Yoruba Art Studies," in *The Yoruba Artist*, eds. Abiodun *et al.*, 37-48.

— 1994b. "Aṣẹ: Verbalizing and Visualizing Creative Power through Art," *Journal of Religion in Africa* 24,4 (November):294-322.

Abiọdun, Rowland, Henry J. Drewal and John Pemberton III, eds. 1994. *The Yoruba Artist*. Washington, D.C.: Smithsonian Institution Press.

Adams, Marie Jeanne (Monni). 1980. "Afterword: Spheres of Men's and Women's Creativity," *Ethnologische Zeitschrift Zuerich*.

— 1983. "Current Directions in the Study of Masking in Africa," *Africana Journal* 14,2/3:89-114.

— 1989. "African Visual Arts from an Art Historical Perspective," *African Studies Review* 32,2 (September): 53-103.

Adepegba, Cornelius O. 1991. "The Yoruba Concept of Art and Its Significance in the Holistic View of Art as Applied to African Art," *African Notes* 15, 1/2:1-6.

Agbodike, Chinedu. 1993. *Ogaru: Rebirth of Afrikan Art*. An Exhibition of Original Ancient African Art, Paintings and Drawings. National Museum, Lagos, 30 October-6 November 1993.

Agthe, Johanna. 1994. "Religion in Contemporary East African Art," *Journal of Religion in Africa* 24,4 (November): 375-88.

Alali—Festival Time. 1987. Middlesborough, UK: Dorman Museums.

Amadiume, Ifi. 1987. *Male Daughters, Female Husbands*. London: Zed Press.

Anderson, Martha G. and Christine Muller Kreamer. 1989. (ed. Enid Schildkrout) *Wild Spirits, Strong Medicine: African Art and the Wilderness*. New York, NY: Center for African Art.

Aniakor, Chike. 1979. "Ancestral Legitimation in Igbo Art," *West African Religion* 18,2/3:13-30.

Antubam, Kofi. 1963. *Ghana's Heritage of Culture*. Leipzig: Koehler and Ameland.

Anyodike, Chima. 1992. "Tradition and the "traditional" in the African Novel". *Principles of "Traditional" African Culture* 40-53.

Apter, Andrew. 1992. *Black Gods and Kings: the Hermeneutics of Power in Yoruba Society*. Chicago, IL: University of Chicago Press.

Arens, W. and Ivan Karp, eds. 1989. *Creativity of Power: Cosmology and Action in African Societies*. Washington, D.C.: Smithsonian Institution Press.

Armstrong, Robert Plant. 1981. *The Powers of Presence: Consciousness, Myth and Affecting

Presence. Philadelphia, PN: University of Pennsylvania Press.

Aronson, Lisa. 1980. "Patronage and Akwete Weaving," in *African Arts* 13,3.

— 1989. "To Weave or Not To Weave: Apprenticeship Rules among the Akwete Igbo of Nigeria and the Baule of the Ivory Coast," in *Apprenticeship: From Theory to Method and Back Again*, ed. Michael W. Coy, 149-62. Albany, NY: State University of New York Press.

— 1991. "African Women in the Visual Arts," *Signs: Journal of Women in Culture and Society* 16,3:550-74.

ART/Artifact: African Art in Anthropology Collections. 1988. New York: The Center for African Art.

Art et Mythologie: Figures Tshokwe. 1988. Paris: Fondation Dapper.

Augé, Marc. 1988. *Le Dieu objet*. Paris: Flammarion.

Awolalu, J. Omasade. 1979. *Yoruba Beliefs and Sacrificial Rites*. London: Longman.

d'Azevedo, Warren L. 1973a. *The Traditional Artist in African Societies*. Bloomington, IN: Indiana University Press.

— 1973b. "Mask Makers and Myth in Western Liberia," in *Primitive Art and Society*, ed., Anthony Forge. London: Oxford University Press.

Babatunde, Emmanuel D. 1988. "The Gẹlẹdẹ Masked Dance and Ketu Society: The Role of the Transvestite Masquerade in Placating Powerful Women While Maintaining the Patrilineal Ideology," in *West African Masks and Cultural Systems*, ed., Kasfir, 45-64.

Badi-Banga, Ne-Mwine. 1982. "Expression de la foi chretienne dans l'art plastique zairois," *Cahiers des réligions africaines* 16, 31-2 (janvier-juillet):135-63.

Baldwin, James *et al.* 1987. *Perspectives: Angles on African Art*. New York, NY: Center for African Art.

Barber, Karin. 1987. "Popular Arts in Africa," *African Studies Review* 30,3 (September):1-78.

Barley, Nigel. 1988. *Foreheads of the Dead*. Washington, D.C.: Smithsonian Institution Press.

— 1994. *Smashing Pots: Feats of Clay from Africa*. London: British Museum Press.

Barnes, Sandra T. ed. 1989. *Africa's Ogun: Old World and New*. Bloomington, IN: Indiana University Press.

Bascom, William. 1944. "The Sociological Role of the Yoruba Cult Group," *American Anthropologist* 46, Memoir 63.

— 1973. *African Art in Cultural Perspective*. New York, NY: Norton.

Bassey, E. O. n.d. "Ekpe Society," *Heritage* 1:36-7.

Bates, Robert H., V. Y. Mudimbe, and Jean O'Barr, eds. 1993. *Africa and the Disciplines*. Chicago, IL: University of Chicago Press.

Battestini, Simon P. X. 1991. "Reading Signs of Identity and Alterity," *African Studies Review* 34,1 (April):99-116.

— 1994. "Objets d'art et "texte," *Passages* 7:16-19.

Bay, Edna. 1985. *Asen: Iron Altars of the Fon People of Benin*. Atlanta, GA: Emory University Museum of Art and Archaeology.

Beaudoin, Gérard. 1984. *Les Dogons du Mali*. Paris: Armand Colin.

van Beek, Walter E. A. 1988. "Functions of Sculpture in Dogon Religion," *African Arts* 21,4:58-69, 92.

— 1991a. "Enter the Bush: a Dogon Mask Festival," in *Africa Explores*, ed., Vogel, 56-73.

— 1991b. "Dogon Restudied: A Field Evaluation of the Work of Marcel Griaule," *Current Anthropology* 32,2 (April):139-67.

Beidelman, T.O. 1990. Review of "Wild Spirits, Strong Medicine" exhibition at the Center for African Art (1989), New York, *African Arts* 23,2:81-2.

Beier, Ulli. 1975. *The Return of the Gods: the Sacred Art of Susanne Wenger*. Cambridge: Cambridge University Press.

— 1982. *Yoruba Beaded Crowns*. London: Ethnographica.

— 1991. *Thirty Years of Oshogbo Art*. Bayreuth: Iwalewa House.

Ben-Amos, Paula. 1980. "Patron-Artist Interactions in Africa," *African Arts* 13,3 (May):56-7, 92.

— 1983. "In Honor of Queen Mothers," in *The Art of Power: the Power of Art*, eds. Ben-Amos and Rubin, 79-83.

— 1986. "Artistic Creativity in Benin Kingdom," in *African Arts* 19,3 (May):60-7, 83-4.

— 1988. "Edo Ancestral Altars: Testimonials to a Life Well Lived," *Proceedings of the May 1988 Conference and Workshop on African Material Culture*, organized by Mary Jo Arnoldi, Christaud M. Geary, and Kris L. Hardin, held at the Rockefeller Foundation's Bellagio Center, Bellagio, Italy.

— 1989. "African Visual Arts from a Social Perspective," *African Studies Review* 32,2:1-53.

Ben-Amos, Paula and Arnold Rubin, eds. 1983. *The Art of Power: the Power of Art. Studies in Benin Iconography*, no. 19. Los Angeles, CA: Museum of Cultural History, University of California at Los Angeles.

Bentor, Eli. 1994. "'Remember Six Feet Deep:' Masks and the Exculpation of/from Death in Aro

Masquerade," *Journal of Religion in Africa* 24,4 (November):323–38.

Berns, Marla C. 1985. "Decorated Gourds of Northeastern Nigeria," *African Arts* 19,1 (November): 28–45, 86–7.

— 1988. "Ga'anda Scarification: A Model for Art and Identity," in *Marks of Civilization: Artistic Transformations of the Human Body*, ed. Arnold Rubin, 57–76. Los Angeles, CA: Museum of Cultural History, University of California at Los Angeles.

— 1990. "Pots as People: Yungur Ancestral Portraits," in *African Arts* 23,3 (July):52–60, 102.

Biebuyck, Daniel. 1968. "Art as a Didactic Device in African Initiation Systems," *African Forum* 3,4 & 4,1 (Spring and Summer):35–43.

— 1973. *Lega Culture: Art, Initiation, and Moral Philosophy among a Central African People*. Berkeley and Los Angeles, CA: University of California Press.

— 1986. *The Arts of Zaire*. Vol. I, *Southwestern Zaire*; Vol. II, *Eastern Zaire*. Berkeley and Los Angeles, CA: University of California Press.

Binkley, David A. 1987. "A View from the Forest: the Power of Southern Kuba Initiation Masks." PhD dissertation, Indiana University.

— 1990. "Masks, Space and Gender in Southern Kuba Initiation Ritual," *Iowa Studies in African Art*, vol. III., ed. Roy, 151–71.

p'Bitek, Okot. 1971. *African Religions in Western Scholarship*. Nairobi: Kenya Literature Bureau.

Birch Faulkner, Laurel, 1988. "Basketry Masks of the Chewa," *African Arts* 21,3 (May): 28–31, 86.

Blackmun, Barbara Winston. 1983. "Reading a Royal Altar Tusk," in *The Art of Power: the Power of Art*, eds, Ben-Amos and Rubin, 59–68.

— 1988. "From Trader to Priest in Two Hundred Years: the Transformation of a Foreign Figure on Benin Ivories," *Art Journal* 47,2 (summer):128–37.

— 1990. "Ọba's Portraits in Benin," *African Arts* 23,3 (July):61–9, 102.

Blakely, Thomas D., Walter E.A. van Beek and Dennis L. Thomson, eds. 1994. *Religion in Africa: Experience and Expression*. London: James Currey; Portsmouth, NH: Heinemann (Monograph series of the David M. Kennedy Center for International Studies, Brigham Young University, vol. 4).

Bledsoe, Caroline. 1984. "The Political Use of Sande Ideology and Symbolism," *American Ethnologist* 11,3 (August):455–72.

Blier, Suzanne Preston. 1981. "The Dance of Death: Notes on the Architecture and Staging of Tamberma Funeral Performances," *RES* (New York) 2 (autumn):107–43.

— 1987. *The Anatomy of Architecture: Ontology and Metaphor in Batammaliba Architectural Expression*. Cambridge: Cambridge University Press.

— 1988a. Review of *African Art in the Cycle of Life*, in *African Arts* 22,3 (May):21–6, 79.

— 1988b. "Words about Words about Icons: Iconology and the Study of African Art," *Art Journal* 47,2 (summer):75–87.

— 1988-9. "Art Systems and Semiotics: the Question of Art, Craft, and Colonial Taxonomies in Africa," *The American Journal of Semiotics* 6,1:7–18.

— 1990a. "African Art Studies at the Crossroads: An American Perspective," *African Art Studies: the State of the Discipline*, 91–107. Washington, D.C.: National Museum of African Art.

— 1990b. "King Glele of Danhomè: Divination Portraits of a Lion King and Man of Iron," *African Arts* 23,4 (January):42–53, 93.

— 1993. "Truth and Seeing: Magic, Custom and Fetish in Art History," in *Africa and the Disciplines*, eds, Bates, *et al.*, 139–66.

— 1995. *African Vodun: Art, Psychology and Power*. Chicago, IL: University of Chicago Press.

Boone, Sylvia Ardyn. 1986. *Radiance from the Waters: Ideals of Feminine Beauty in Mende Art*. New Haven, CT: Yale University Press.

Bourgeois, Arthur P. 1985. *The Yaka and the Suku. Iconography of Religions*, VII/D, 1. Leiden: E. J. Brill.

Bouttiaux-Ndiaye, Anne-Marie. 1994. *Senegal Behind Glass: Images of Religious and Daily Life*. Munich: Prestel.

Bradbury, R.E. 1959. "Divine Kingship in Benin," *Nigeria Magazine*, 62:186–207.

— 1973. *Benin Studies*. London: Oxford University Press for the International African Institute.

Brain, Robert. 1980. *Art and Society in Africa*. London: Longman.

Bravmann, René. 1974. *Islam and Tribal Art in West Africa*. Cambridge: Cambridge University Press.

— 1975. "Masking Tradition and Figurative Art among the Islamized Mande," in *African Images: Essays in African Iconology*, eds, Daniel F. McCall and Edna G. Bay. New York: Africana Publishing.

— 1983. *African Islam*. Washington, D.C.: Smithsonian Institution Press.

Bravmann, René and Raymond A. Silverman. 1987. "Painted Incantations: the Closeness of Allah and Kings in 19th-Century Asante," *The Golden Stool: Studies of the Asante Center and Periphery*, ed., Enid Schildkrout with Carol Gelber. Anthropological Papers

of the American Museum of Natural History, New York Vol. 65, part 1, 93–108.

Breidenbach, Paul S. and Doran H. Ross. 1978. "The Holy Place: Twelve Apostles Healing Gardens," *African Arts* 11,4 (July):28–35, 95.

Brenner, Louis. 1989. "'Religious' Discourses In and About Africa," in *Discourse and its Disguises*, eds, Karin Barber and P.F. de Moraes Farias. Birmingham University African Studies Series, 1, Birmingham: Centre of West African Studies, 87–105.

Brett-Smith, Sarah. 1982. "Symbolic Blood: Cloths for Excised Women," in *RES* 3 (Spring):15–31.

— 1983. "The Poisonous Child," *RES* 6 (Fall):47–64.

Burns, Vivian. 1974. "Travel to Heaven: Fantasy Coffins," *African Arts* 7,2:25.

Butler, Vincent F. 1963. "Cement Funeral Sculptures in Eastern Nigeria," *Nigeria Magazine* 77 (June):117–24.

Butt-Thompson, F. W. 1969 [1929]. *West African Secret Societies: Their Organisations, Officials and Teaching*. New York, NY: Argosy-Antiquarian.

Campbell, Bolaji. 1989. "Continuity and Change in Yoruba Shrine Painting Tradition," *Kurio Africana: Journal of Art and Criticism* (Ife) 1,1:109–16.

— 1992. "The Trial of 'Traditional' Art: the Bird Symbolism in Contemporary Yoruba Painting," in *Principles of "Traditional" African Culture*, ed., Okediji, 54–69.

Carroll, Kevin. 1967. *Yoruba Religious Carving*. London: Geoffrey Chapman.

Childs, S. Terry and David Killick. 1993. "Indigenous African Metallurgy: Nature and Culture," *Annual Review of Anthropology* 22:317–37.

Clifford, James. 1988. *The Predicament of Culture: Twentieth-Century Ethnography, Literature and Art*. Cambridge, MA: Harvard University Press.

Cole, Herbert M. 1972. "Ibọ Art and Authority," in *African Art and Leadership*, eds, Fraser and Cole, 79–87.

— 1982. *Mbari: Art and Life among the Owerri Igbo*. Bloomington, IN: Indiana University Press.

— ed., 1985. *"I Am Not Myself": The Art of African Masquerade*. Los Angeles, CA: Museum of Cultural History, University of California at Los Angeles.

— 1988. "The Survival and Impact of Igbo Mbari," *African Arts* 21,2:54–65, 96.

Cole, Herbert M. and Chike C. Aniakor. 1984. *Igbo Arts: Community and Cosmos*. Los Angeles, CA: Museum of Cultural History, University of California at Los Angeles.

Cole Hebert M. and Doran H. Ross, eds. 1977. *The Arts of Ghana*. Los Angeles, CA: the Museum of Cultural History, University of California at Los Angeles.

Coote, Jeremy and Anthony Shelton, eds. 1992. *Anthropology, Art and Aesthetics*. Oxford: Clarendon Press.

Cornet, Joseph. 1982. *Art Royal Kuba*. Milan: Edizioni Sipiel.

Cosentino, Donald. 1988. "Divine Horsepower," *African Arts* 21,3(May):39–42.

Culwick, A. T. 1931. "Ritual Use of Rock Paintings at Bahi, Tanganyika Territory," *Man* 31,41–59 (March):33–6.

Danilowitz, Brenda. 1993. "John Muafangejo: Picturing History," *African Arts* 26,2 (April):46–57, 92.

Danquah, J. B. [1944] 1968. *The Akan Doctrine of God*. London: Frank Cass.

Danto, Arthur C. 1988. "Artifact and Art," *ART/artifact*, 18–32.

Darish, Patricia. 1989. "Dressing for the Next Life: Raffia Textile Production and Use among the Kuba of Zaire," in *Cloth and Human Experience*, ed., Annette B. Weiner and Jane Schreider, 117–40. Washington, D.C.: Smithsonian Institution Press.

— 1990. "Dressing for Success: Ritual Occasions for Ceremonial Raffia Dress among the Kuba of South-Central Zaire," *Iowa Studies in African Art*, vol. II, ed., Roy, 179–89.

Dark, Philip. 1962. *The Art of Benin*. Chicago, IL: Chicago Natural History Museum.

— 1973. *An Introduction to Benin Art and Technology*. Oxford: Clarendon Press.

David, Nicholas, Judy Sterner and Kodzo Gavua. 1988. "Why Pots are Decorated," with comments, *Current Anthropology* 29,3 (June):365–90.

Dean, Carolyn. 1983. "The Individual and the Ancestral: *Ikegobo* and *Ukhurhe*," in *The Art of Power: the Power of Art*, eds, Ben-Amos and Rubin, 33–7.

DeMott, Barbara. 1982. *Dogon Masks: A Structural Study of Form and Meaning*. Ann Arbor, MI: UMI Research Press.

Devisch, Renaat. 1990. "From Physical Defect Towards Perfection: Mbwoolu Sculptures for Healing Among the Yaka," *Iowa Studies in African Art*, vol. II, ed., Roy, 63–85.

— 1991. "Mediumistic Divination among the Northern Yaka of Zaire," in *African Divination Systems*, ed., Peek, 112–32.

Dewey, William J. 1986. "Shona Male and Female Artistry," *African Arts* 19,3 (May):64–7, 84.

— 1994. "AK-47s for the Ancestors," *Journal of Religion in Africa* 24,4 (November):358–74.

Dieterlen, Germaine. 1951. *Essai sur la religion bambara* Paris Presses, Universitaires de France.

— 1989. "Masks and Mythology among the Dogon," *African Arts* 22,3:34-43, 87, 88.

Dilley, Roy M. 1987. "Tukolor Weaving Origin Myths: Islam and Reinterpretation," in *The Diversity of the Muslim Community: Anthropological Essays in Memory of Peter Lienhardt*. London: Ithaca Press for the British Society of Middle Eastern Studies, 70-9.

— 1992. "Dreams, Inspiration and Craftwork among Tukolor Weavers," in *Dreaming, Religion and Society*, eds, M. C. Jedrej and R. Shaw, 71-85. Leiden: E.J. Brill.

Diouf, Mamadou. 1992. "Islam: Peinture sous verre et idéologie populaire," in *Art pictoral zaïrois*, ed., B. Jewsiewicki, Sillery (Québec: Eds, du Septentrion) 29-40.

Domowitz, Susan and Renzo Mandirola. 1984. "Grave Monuments in Ivory Coast," *African Arts* 27,4 (August):46-52, 96.

Dowson, Thomas A. and David Lewis-Williams, eds. 1995. *Contested Images: Diversity in Southern African Rock Art Research*. Johannesburg: Witwatersrand University Press.

Dowson, Thomas A. 1989. "Dots and Dashes: Cracking the Entoptic Code in Bushman Rock Paintings," *South African Archeological Society Goodwin Series* 6:84-94.

— 1992. *Rock Engravings of Southern Africa*. Johannesburg: Witwatersrand University Press.

Drewal, Henry John. 1980. *African Artistry: Technique and Aesthetics in Yoruba Sculpture*. Atlanta, GA: High Museum of African Art.

— 1983. "Art and Divination among the Yoruba: Design and Myth," *Africana Journal* 14,2-3:139-56.

— 1988a. "Mermaids, Mirrors and Snake Charmers: Igbo Mami Wata Shrines," *African Arts* 21,2:38-45,96.

— 1988b. "Object and Intellect: Interpretations of Meaning in African Art," *Art Journal* 47,2 (summer):71-4.

— 1988c. "Performing the Other: Mami Wata Worship in West Africa," *The Drama Review* 32,2:160-85.

— 1989. "Art or Accident: Yoruba Body Artists and their Deity Ogun," in *Africa's Ogun*, ed., Barnes, 234-60.

— 1990. "African Art Studies Today," *African Art Studies: the State of the Discipline*, 29-62 Washington, D.C.: National Museum of African Art.

— 1994. "Introduction: Yoruba Art and Life as Journeys," in *The Yoruba Artist*, eds, Rowland Abiọdun *et al.*, 193-200.

Drewal, Margaret Thompson. 1986. "Art and Trance among Yoruba Shango Devotees," *African Arts* 20,1:60-7, 98-9.

— 1990. "Portraiture and Construction of Reality in Yorubaland and Beyond," *African Arts* 23,3:40-9,101.

— 1992. *Yoruba Ritual: Performers, Play, Agency*. Bloomington, IN: Indiana University Press.

Drewal, Henry John and Margaret Thompson Drewal. 1983. *Gẹlẹdẹ: Art and Female Power among the Yoruba*. Bloomington, IN: Indiana University Press.

— 1987. "Composing Time and Space in Yoruba Art," *Word and Image* 3,3 (July-September):225-51.

Drewal, Henry John and John Pemberton III with Rowland Abiọdun. 1989. *Yoruba: Nine Centuries of African Art and Thought*. New York, NY: The Center for African Art.

Dutton, Denis. 1995. "Mythologies of Tribal Art," *African Arts* 28,3 (summer):33-43, 90.

Eicher, Joanne B. and Tonye V. Erekosima. 1987. "Kalabari Funerals: Celebration and Display," *African Arts* 21,1 (November):38-45, 87.

Ekpo, Ikwo A. 1978. "Ekpe Costume of the Cross River," *African Arts* 12,1:72-5.

Eliade, Mircea. 1958. *Myth of the Eternal Return (Cosmos and History)*. New York: Harper Torchbooks (1959).

— 1976. "The World, the City, the House," in *Occultism, Witchcraft and Cultural Fashions*. Chicago, IL: University of Chicago Press.

Enekwe, Onuora Ossie. 1987. *Igbo Masks: The Oneness of Ritual and Theatre*. Lagos: Nigeria Magazine.

Evans-Pritchard, E. E. 1937. *Witchcraft, Oracles and Magic among the Azande*. London: Oxford University Press.

Eyo, Ekpo. 1982. *Primitivism and Other Misconceptions of African Art*. Munger Africana Library Notes, no. 63. Pasadena, CA: California Institute of Technology.

— 1988. "Response by Ekpo Eyo," *African Art Studies: the State of the Discipline*, 111-18. Washington, D.C.: National Museum of African Art.

Ezra, Kate. 1986. *A Human Ideal in African Art: Bamana Figurative Sculpture*. Washington, D.C.: Smithsonian Institution Press for the National Museum of African Art.

— 1988a. *Art of the Dogon*. New York, NY: Harry N. Abrams for the Metropolitan Museum of Art.

— 1988b. "The Art of the Dogon," in *African Arts* 21,4:30-32.

Fagg, William. 1970. *Divine Kingship in Africa*. London: British Museum.

Bibliography

— 1973. "In Search of Meaning in African Art," *Primitive Art and Society*, ed., Anthony Forge. London: Oxford University Press.

Faik-Nzuji, Clémentine M. 1993. *La Puissance du sacré: L'homme, la nature, et l'art en Afrique noire*. Paris: Maisonneuve & Larose.

Fardon, Richard. 1990. *Between God, the Dead and the Wild: Chamba Interpretations of Religion and Ritual*. Washington, D.C.: Smithsonian Institution Press.

Fatunsin, Anthonia. 1992. *Yoruba Pottery*. Lagos: National Commission for Museums and Monuments.

Feeley-Harnik, Gillian. 1985. "Issues in Divine Kingship," *Annual Review of Anthropology* 14:273-313.

— 1989. "Cloth and the Creation of Ancestors in Madagascar," in *Cloth and Human Experience*, eds, Annette B. Weiner and Jane Schreider, Washington, D.C.: Smithsonian Institution Press, 73-116.

Fernandez, James W. 1982. *Bwiti: An Ethnography of the Religious Imagination in Africa*. Princeton, NJ: Princeton University Press.

Fernandez, James W. and Renate L. Fernandez. 1976. "Fang Reliquary Art: Its Quantities and Qualities," *Cahiers d'études africaines* 60, 15-4:723-46.

Fischer, Eberhard. 1978. "Dan Forest Spirits: Masks in Dan Villages," *African Arts* 11,2 (January):16-23, 94.

Fischer, Eberhard and Hans Himmelheber. 1984. *The Arts of the Dan in West Africa*. Zurich: Museum Rietberg.

Flam, Jack. 1970. "Some Aspects of Style Symbolism in Sudanese Sculpture," *Journal de la société des africanistes* 40:137-50.

Forman, W. and B. and Philip Dark. 1960. *Benin Art*. London: Paul Hamlyn.

Förster, Till. 1988. *Art of the Senufo: Museum Rietberg Zuerich from Swiss Collections*. Zuerich: Museum Rietberg. Catalogue texts (available in English translation).

— 1993. "Senufo Masking and the Art of Poro," *African Arts* 26,1 (January):30-41, 101.

Frank, Barbara E. 1994. "More Than Wives and Mothers: the Artistry of Mande Potters," *African Arts* 27,4 (Autumn):26-37, 93.

Fraser, Douglas and Herbert M. Cole, eds. 1972. *African Art and Leadership*. Madison, WI: University of Wisconsin Press.

Freedburg, David. 1989. *The Power of Images: Studies in the History and Theory of Response*. Chicago, IL: University of Chicago Press.

Freyer, Bryna. 1993. *"Asen": Iron Altars from Ouidah, Republic of Benin*. National Museum of African Art. Catalogue to exhibition, 1993-4.

Galembo, Phyllis. 1993. *Divine Inspiration: From Benin to Bahia*. Albuquerque, NM: University of New Mexico Press.

Gallagher, Jacki. 1983a. "Between Realms: the Iconography of Kingship in Benin," in *The Art of Power: the Power of Art*, Ben-Amos and Rubin, eds, 21-6.

— 1983b. "'Fetish Belong King:' Fish in the Art of Benin," in *The Art of Power: the Power of Art*, Ben-Amos and Rubin, eds, 89-93.

Garlake, Peter. 1995. *The Hunter's Vision: The Prehistoric Art of Zimbabwe*. London: British Museum Press.

Geary, Christraud M. 1993. "Burying 'Mothers of Crops': Funerals of Prominent Women in Weh (Cameroon Grassfields)," Paper presented at the African Studies Association annual meeting, Boston.

Gilbert, Michelle. 1987. "The Person of the King: Ritual and Power in a Ghanaian State," in *Rituals of Royalty: Power and Ceremonial in Traditional Societies*, Cambridge: Cambridge University Press, 298-330.

— 1989. "Akan Terracotta Heads: Gods or Ancestors?," in *African Arts* 22,4 (August):34-51, 86.

Girshick, Paula. 1994. "He Has Done Big Things in His Lifetime': Ancestral Altars and the Construction of Social Memory in the Benin Kingdom, Nigeria". Paper presented at the Annual Satterthwaite Conference.

Glaze, Anita. 1975. "Woman Power and Art in a Senufo Village," *African Arts* 8,3:20, 29, 64-8, 90.

— 1981. *Art and Death in a Senufo Village*. Bloomington, IN: Indiana University Press.

— 1986. "Dialectics of Gender: Senufo Masquerades," *African Arts* 19,3:30-9, 82.

Goody, Jack. 1993. "Icons and Iconoclasm in Africa". Paper presented at the Institute for the Advanced Study and Research in the African Humanities, Northwestern University, 25 October.

Griaule, Marcel. 1938. *Masques Dogons*. Université de Paris, Travaux et Mémoires de l'Institut d'Ethnologie, no. 33. Paris: Institut d'Ethnologie.

Griaule, Marcel et Germaine Dieterlen. 1965. *Le Renard Pâle*. Paris: Institut d'Ethnologie.

Gwete, Lema. 1982. "Essai sur la dimension religieuse de l'art négro-africain. Référence à la sculpture traditionnelle au Zaire," *Cahiers des religions africaines* 16,31-2:71-111.

Hackett, Rosalind I. J. 1989. *Religion in Calabar: the Religious Life and History of a Nigerian Town*. Berlin: Mouton de Gruyter.

— 1990. "Images of African Religions," *Religion* 20,4.

— 1993a. "Teaching African Religions," in special issue of *Spotlight on Teaching* (American Academy of Religion publication) 1,2 (May).

— 1993b. "Women in African Religions," in *Religion and Women*, ed., Arvind Sharma. Albany, NY: SUNY Press, 61–92.

— 1994. "Art and Religion in Africa: Some Observations and Reflections," *Journal of Religion in Africa* 24,4 (November):294–308.

Hallen, Barry. 1995. "Some Observations about Philosophy, Postmodernism and Art in Contemporary African Studies," *African Studies Review* 38,1 (April):69–80.

Hammoudi, Abdellah. 1993. *The Victim and Its Masks*. Trans. by Paula Wissing. Chicago, IL: University of Chicago Press.

Harley, George W. 1941. *Notes on the Poro in Liberia*. Papers of the Peabody Museum of American Archaeology and Ethnology, Harvard University, vol. 19,2.

— 1950. *Masks as Agents of Social Control in Northeast Liberia*. Papers of the Peabody Museum of American Archaeology and Ethnology, Harvard University, vol. 22,2.

Harris, Michael D. 1993. "Resonance, Transformation, and Rhyme: The Art of Renée Stout," in *Astonishment and Power*, MacGaffey and Harris, 107–56.

— 1994. "Beyond Aesthetics: Visual Activism in Ile-Ife," in *The Yoruba Artist*, eds, Abiọdun *et al.* 201–16.

Heldman, Marilyn E.. 1992. "Architectural Symbolism, Sacred Geography and the Ethiopian Church," *Journal of Religion in Africa* 22,3 (August):222–41.

Heldman, Marilyn with Stuart C. Munro-Hay. 1993. *African Art: the Sacred Art of Ethiopia*. New Haven, CT: Yale University Press.

Henderson, Richard N. and Ifekandu Umunna. 1988. "Leadership Symbolism in Onitsha Igbo Crowns and Ijele," *African Arts* 21,2 (February):28–37, 94.

Herbert, Eugenia W. 1984. *Red Gold of Africa*. Madison, WI: University of Wisconsin Press.

— 1993. *Iron, Gender and Power*. Bloomington, IN: Indiana University Press.

Hersak, Dunja. 1985. *Songye: Masks and Figure Sculpture*. London: Ethnographica.

de Heusch, Luc. 1988. "La Vipère et la cigogne: Notes sur le symbolisme tshokwe," in *Art et mythologie: Figures tshokwe*. Paris: Fondation Dapper.

Highet, Juliet. 1989. "Return to the Shrine," *New African* (February):42–3.

Holas, Bogumil. 1952. *Les Masques kono: leur rôle dans la vie religieuse et politique*. Paris: Librairie Orientaliste Paul Geuthner S.A.

— 1969. *Sculpture sénoufo*. Abidjan: Centre des Sciences Humaines.

— 1978. *L'Art sacré sénoufo: ses différentes expressions dans la vie sociale*. Abidjan: Nouvelles Editions Africaines.

Horton, Robin. 1963. "The Kalabari *Ekine* Society: a Borderland of Religion and Art," *Africa* 33,2:94–114.

— 1986. "Judaeo-Christian Spectacles: Boon or Bane to the Study of African Religions?" *Cahiers d'etudes Africaines* 24,4:391–436.

Houlberg, Marilyn Hammersley. 1973. "Ibeji Images of the Yoruba," *African Arts* 7,1:20–7, 91–2.

Idowu, E. Bọlaji. 1963. *Olodumare: God in Yoruba Belief*. London: Longman.

— 1973. *African Traditional Religion: A Definition*. London: Longman.

Ikenga Metuh, E. 1973. "The Supreme God in Igbo Life and Worship," *Journal of Religion in Africa* 5,1.

— 1985. *African Religions in Western Conceptual Schemes*. Bodija, Ibadan, Nigeria: Pastoral Institute.

Imperato, Pascal. 1978. *Dogon Cliff Dwellers: The Art of Mali's Mountain People*. New York, NY: L. Kahan Gallery.

Jedrej, M. C. 1980. "A Comparison of Some Masks from North America, Africa, and Melanesia," *Journal of Anthropological Research* 36,2 (Summer):220–30.

— 1986. "Dan and Mende Masks: a Structural Comparison," *Africa* 56,1:71–80.

Jewsiewicki, Bogumil. 1991. "Painting in Zaire: From the Invention of the West to the Representation of Social Self," *Africa Explores*, ed., Vogel, 130–75.

— 1995. *Chéri Samba: The Hybridity of Art*. Westmount, Quebec: Galérie Amrad. Contemporary African Artists, no.1.

Jones, G. I. 1984. *The Art of Eastern Nigeria*. Cambridge: Cambridge University Press.

Jordán, Manuel. 1993. "Masks as Ironic Process: Some *Makishi* of Northwestern Zambia," *Anthropologie et société*, 17,3.

Jules-Rosette, Bennetta. 1984. *The Messages of Tourist Art: An African Semiotic System in Comparative Perspective*. New York, NY: Plenum Press.

Kasfir, Sidney Littlefield. 1987. "Apprentices and Entrepreneurs: The Workship and Style Uniformity in Subsaharan Africa," *Iowa Studies in African Art*, vol. II. "The Artist and the Workshop in Traditional Africa," in Iowa City, IA: University of Iowa.

Bibliography

— 1988. *West African Masks and Cultural Systems.* Tervuren: Musée Royale de l'Afrique Centrale.

— 1989. "Remembering Ojiji: Portrait of the Artist as an Old Man," *African Arts* 22,4 (August):44-51.

— 1991. "The King as Mask: the Iconology of Sacred Kingship in Idoma". Unpublished paper presented at Harvard University.

— 1992. "African Art and Authenticity: A text with a Shadow," *African Arts* 25,3 (April): 41-53, 96.

Kennedy, Jean. 1992. *New Currents, Ancient Rivers: Contemporary Artists in a Generation of Change.* Washington, D.C.: Smithsonian Institution Press.

Kerchache, Jacques, Jean-Louis Paudrat and Lucien Stéphan. 1993. *Art of Africa.* New York, NY: Harry N. Abrams, trans. from the French by Marjolin de Jager (1988).

Kjeseth, Martha. 1990. "John Ndevasia Muafangejo: Namibian Artist," in *Pattern and Narrative*, ed., Freida High W. Tesfagiorgis. Madison, WI: University of Madison-Wisconsin Afro-American Studies.

Kofoworola, Ziky O. 1987. *Hausa Performing Arts and Music.* Lagos: Department of Culture, Federal Ministry of Information and Culture.

Koloss, Hans Joachim. 1984. "Njom among the Ejagham," *African Arts* 18, 1:71-3, 90-3 (November).

Kramer, Fritz W. 1993. *The Red Fez: Art and Spirit Possession in Africa.* Trans. by Malcolm Green. London: Verso.

Kreamer, Christine Mullen. 1987. "Moba Shrine Figures," *African Arts* 20,2:52-5, 92.

Krieg, Karl Heinz and Wulf Lohse, 1981. *Kunst und Religion bei den Gbato-Serinfo.* Hamburg: Hamburgisches Museum für Völkerkunde.

Kuper, Hilda. 1973. "Costume and Identity," *Comparative Studies in Society and History* 15:348-67.

Kyerematen, A. 1969. "The Royal Stools of Ashanti," Africa 39,1 (January):1-9.

Laburthe-Tolra, Philippe. 1985. *Initiations et sociétés secrètes au Cameroun: Les mystères de la nuit.* Paris: Karthala.

Laburthe-Tolra, Philippe and Christiane Falgayrettes-Leveau. 1991. *Fang.* Paris: Musée Dapper.

Laget, Elisabeth. 1984. *Bestiaires et génies: dessins sur tissus sénoufo.* Paris: Quintette.

Lamp, Frederick. 1985. "Cosmos, Cosmetics, and the Spirit of Bondo," *African Arts* 18,3 (May):28-43.

Lande, Jean. 1973. *African Art of the Dogon.* New York: The Brooklyn Museum.

Lawal, Babatunde. 1974. "Some Aspects of Yoruba Aesthetics," *British Journal of Aesthetics* 14,3 (summer):239-49.

— 1977. "The Living Dead: Art and Immortality among the Yoruba of Nigeria," *Africa* 47,1:50-61.

— 1993. "Oyibo: Representations of the Colonialist Other in Yoruba Art, 1826-1960". Discussion paper (24) in the African Humanities Program, African Studies Center, Boston University, MA.

Lawuyi, Olatunde B. and J.K. Olupọna. 1988. "Metaphoric Associations and the Conception of Death: Analysis of a Yoruba World View," *Journal of Religion in Africa* 18,1 (February):2-14.

Leib, Elliott and Renee Romano. 1984. "Reign of the Leopard: Ngbe Ritual," *African Arts* 18,1 (November):48-57, 94.

Le Moal, Guy. 1980. *Les Bobo: nature et fonction des masques.* Paris: ORSTOM.

Levinson, Orde, comp. 1992. *I Was Lonelyness.* Cape Town: Struik Winchester.

Lewis, I. M. 1986. *Religion in Context: Cults and Charisma.* Cambridge: Cambridge University Press.

Lewis-Williams, J. D. and Thomas A. Dowson. 1988. "The Signs of All Times: Entoptic Phenomena in Upper Palaeolithic Art," with comments, *Current Anthropology* 29,2 (April 1988):201-46.

— 1989. *Images of Power: Understanding Bushman Rock Art.* Johannesburg: Southern Book Publishers.

—1990. "Through the Veil: San Rock Paintings and the Rock Face," *South African Archaeological Bulletin* 45:5-16.

Lifschitz, Edward. 1988. "Hearing is Believing: Acoustic Aspects of Masking in Africa," in *West African Masks and Cultural Systems*, ed., Kasfir, 221-7.

MacGaffey, Wyatt. 1977. "Fetishism Revisited: Kongo *Nkisi* in Sociological Perspective," *Africa* 47:140-52.

— 1988. "Complexity, Astonishment and Power: The Visual Vocabulary of Kongo Minkisi," *Journal of Southern African Studies* 14,2 (January):188-203.

— 1990. "The Personhood of Ritual Objects: Kongo *Minkisi*," *Etnofoor* 3,1:45-61.

MacGaffey, Wyatt, ed. and trans. 1991. *Art and Healing of the Bakongo, commented by themselves: minkisi from the Laman Collection.* Stockholm: Folkens Museum-Etnografiska; Bloomington, IN, distributed by Indiana University Press. (Monograph series, Folkens Museum Etnografiska, 16.)

MacGaffey, Wyatt. 1993. "The types of understanding: Kongo *Nkisi*." In *Astonishment and Power* by MacGaffey, Wyatt and Michael D. Harris

MacGaffey, Wyatt and Michael D. Harris. 1993. *Astonishment and Power* Washington, D.C.: Smithsonian Institution Press.

Mack, John. 1990. *Emil Torday and the Art of the Congo: 1900–1909*. London: British Museum Press.

Macquet, Jacques. 1986. *The Aesthetic Experience: An Anthropologist Looks at the Visual Arts*. New Haven, CT: Yale University Press.

Magiciens de la Terre. 1989. Paris: Editions Centre Georges Pompidou.

Mark, Peter. 1988. "*Ejumba*: the Iconography of the Diola Initiation Mask," *Art Journal* 47,2 (Summer):139–46.

— 1992. *The Wild Bull and the Sacred Forest: Form, Meaning, and Change in Senegambian Initiation Masks*. Cambridge: Cambridge University Press.

Mason, John. 1994. "Yoruba-American Art: New Rivers to Explore," in *The Yoruba Artist*, eds, Abiọdun *et al.* 241–50.

Mato, Daniel. 1994. "Clothed in Symbols: Wearing Proverbs," *Passages* 7:4–5, 9, 11–13.

Matory, J. Lorand. 1994. *Sex and the Empire that is No More: Gender and the Politics of Metaphor in Ọyọ Yoruba Religion*. Minneapolis MN: University of Minnesota Press.

Mazrui, Ali. 1994. "Islam and African Art: Stimulus or Stumbling Block?," *African Arts* 27,1:50–7.

Mbiti, John. 1969. *African Religions and Philosophy*. London: Heinemann.

— 1970. *Concepts of God in Africa*. London: Heinemann.

McCaskie, T. 1995. *Asante: State and Society in African History*. Cambridge: Cambridge University Press.

McClelland, E. M. 1982. *The Cult of Ifa among the Yoruba*. Vol. 1: *Folk Practice and the Art*. London: Ethnographica.

McNaughton, Patrick R. 1988. *The Mande Blacksmiths: Knowledge, Power and Art in West Africa*. Bloomington, IN: Indiana University Press.

Melii, Edith and Betty Wass. 1983. "Ozo Title-Taking Insignia in Onitsha," *African Arts* 27,1 (November).

Mercier, Jacques. 1979. *Ethiopian Magic Scrolls*. New York, NY: George Braziller.

— 1992. *Le Roi Salomon et les maîtres du regard: Art et médecine en Ethiopie*. Paris: Editions de la Réunion des musées nationaux.

Merriam, Alan P. 1974. "Change in Religion and the Arts in a Zairian Village," *African Arts* 7,4 (summer):46–52.

Messenger, John C. 1973. "The Carver in Anang Society," in *The Traditional Artist in African Societies*, ed., d'Azevedo. 101–27.

Meyer, Piet. 1981. *Kunst und Religion der Lobi*. Zurich: Museum Rietberg.

Mobolade, Timothy. 1971. "Ibeji Custom in Yorubaland," *African Arts* 4,3:14–15.

Morphy, Howard. 1991. *Ancestral Connections: Art and an Aboriginal System of Knowledge*. Chicago, IL: University of Chicago Press.

Morris, Brian. 1987. *Anthropological Studies of Religion*. Cambridge: Cambridge University Press.

Morris, Jean and Eleanor Preston-Whyte. 1994. *Speaking with Beads: Zulu Arts from Southern Africa*. London: Thames and Hudson.

Mudaba, Yoka Lye. 1982. "Bobongo: la danse sacrée et la libération," *Cahiers des religions africaines* 16,31–2:277–91.

Mudiji, Malamba Gilombe. 1988. "Culture et art africain au défi de l'acculturation," *Revue africaine de théologie* 12,23/24 (avril–octobre):251–60.

— 1990. "Elévation spirituelle par l'esthetique en Afrique noire," *Cahiers des religions africaines* 24,47 (janvier–juillet):251–60.

Mudimbe, Valentin Y. 1986. "African Art as a Question Mark," in *African Studies Review* 29,1:3–4.

— 1988. *The Invention of Africa*. Bloomington, Indiana: Indiana U.P.

— 1991. "'Reprendre': Functions and Strategies in Contemporary African Arts," in *Africa Explores*, ed., Vogel, 276–87.

Mulago, Vincent. 1980. *La religion traditionelle des Bantu et leur vision du monde*. 2nd edn, Kinshasa: Faculté de Théologie Cattolique.

Mveng, E. 1963. "L'Art africain d'hier et l'Afrique d'aujourd'hui," *Présence africaine* 45,1:35–51.

— 1964. *L'Art d'Afrique noire*. Paris: Mame.

— 1967. *Art nègre, art chrétien?* Rome: Les Amis Italiens de Présence Africaine.

Myles, Kwasi. n.d. *Funerary Clay Figurines in West Africa*. Accra: The Organisation for Museums, Monuments and Sites of Africa.

Napier, A. David. 1986. *Masks, Transformation, and Paradox*. Berkeley and Los Angeles, CA: University of California Press.

— 1988. "Masks and Metaphysics: An Empirical Dilemma," in *West African Masks and Cultural Systems*, ed., Kasfir, 231–40.

Nettleton, Anitra. 1988. "History and the Myth of Zulu Sculpture." *African Arts* 21, 3, (May) 48–51, 86–7.

— 1989. "The Crocodile does not leave the Pool: Venda Court Arts," in *African Art in Southern Africa: From Tradition to Township*, eds, Nettleton and Hammond-Tooke, Johannesburg: A.D. Donker, 67–83.

Nettleton, Anitra and D. Hammond-Tooke. 1989. "San Rock Art". In *African Art in Southern Africa: From*

Bibliography

Tradition to Township, eds, Nettleton and Tooke, Johannesburg: A.D. Donker, 30–48.

Nevadomsky, Joseph. 1984a. "Kingship Succession Rituals in Benin—2:The Big Things," *African Arts* 17, 2:41-7, 90-1.

— 1984b. "Kingship Succession Rituals in Benin—3:The Coronation of the Oba," *African Arts* 17, 3:48-57, 91-2.

Nevadomsky, Joseph and Daniel E. Inneh. 1983. "Kingship Succession Rituals in Benin—1:Becoming a Crown Prince," *African Arts* 17,1:47-54, 87.

Nicholls, Andrea. 1991. "A Cloth of Honor," Notes for the National Museum of African Art, Smithsonian Institution, Washington D.C.

Nicklin, Keith. 1987. "Nigeria: Annang Funeral Shrine, applique panel," *Religion in Art* (London) (catalogue no. E 732) (January).

— 1989. "A Calabar Chief," in *Journal of Museum Ethnography* 1 (March):79-84.

Nicklin, Keith and Jill Salmons. 1977. "S.J. Akpan of Nigeria," *African Arts* 11,1:30-4.

Nooter, Mary (Polly) H. 1990. "Secret Signs in Luba Sculptural Narrative," *Iowa Studies in African Art*, vol. II, 35-49.

— ed., 1993. *Secrecy: African Art that Conceals and Reveals*. New York, NY: The Museum for African Art.

Northern, Tamara. 1984. *The Art of Cameroon*. Washington, D.C.: Smithsonian Institution Press.

Ntonga, Nappa. 1979? "The Drama of *Gule Wankulu*." MA Dissertation, University of Ghana.

Nwachukwu-Agbada, J.O.J. 1991. "*Mbari* Museum Art: Covenant with a God Fulfilled." *Anthropos* 86:207-13.

Nwoga, Donatus. 1984a. *Nka na Nzere*. Ahiajoku Lecture. Owerri, Nigeria: Ministry of Information, Culture, Youth and Sports.

— 1984b. *The Supreme God as Stranger in Igbo Religious Thought*. Ekwereazu, Nigeria: Hawk Press.

Og̣badike, Chinedu. 1993. *Oganu: Rebirth of Afrikan Art*. pp126-50. Catalogue of an exhibition of Painting and Drawing held at the National Museum. Onikan Lagos, October 30-November 6 1993.

Ojo, J. R. O. 1979. "Semiotic Elements in Yoruba Art and Ritual," *Semiotica* 28,3/4:333-48.

— 1985. "Descriptive Terms and the Study of Traditional African Art," *Proceedings of the 4th Annual congress of the Nigerian Folklore Society*, Ife, 1984, 530-40.

— 1988. "Traditional African Art and Anthropologist," in *Yoruba Images*, ed., Okediji, 7-33.

Okediji Mọyọ. 1986. "Orisa Mythomural Designs in Ile-Ifẹ," Paper presented at the Third World Congress of the Orisa Tradition, University of Ifẹ, 1-6 July.

— 1988a. "Oluorogbo Mythographic Painting: Theatre Design as Drama," *Nigerian Theatre Journal* 2,1 (August):181-91.

— ed. 1988b. *Yoruba Images: Essays in Honour of Lamidi Fakeye*. Ifẹ Humanities Monograph, 3. Ifẹ: Ifẹ Humanities Society.

— 1989. "Orisaikire Painting School in Ile-Ifẹ," *Kurio Africana: Journal of Art and Criticism* (Ifẹ) 1,1:116-29.

— 1991. "Sacred Painting of Ile-Ifẹ," Talk presented to the Nigerian Museum Society (Ifẹ branch), 17 April.

— ed., 1992a. *Principles of 'Traditional' African Culture*. Ibadan: Bard Book.

— 1992b. "Algebra of Picton's Complex," in *Principles of 'Traditional' African Culture*, ed., Okediji, 108-26.

Okpewho, Isidore. 1977. "Principles of Traditional African Art," *The Journal of Aesthetics and Art Criticism* 35,3:301-14.

Olupona, Jacob K. 1991. *Kingship, Religion, and Rituals in a Nigerian Community*. Acta Universitatis Stockhomiensis, Stockholm Studies in Comparative Religion, 28. Sweden: Almqvist & Wiksell International.

Omari, Smith Mikelle. 1991. "Candomblé: A Socio-Political Examination of African Religion and Art in Brazil," in Blakely *et al.* eds, *Religion in Africa*, 135-59.

Ottenberg, Simon. 1975. *Masked Rituals of Afikpo*. Seattle, WA: University of Washington Press.

— 1988a. "Psychological Aspects of Igbo Art," *African Arts* 21,2:72-82.

— 1988b. "Religion and Ethnicity in the Arts of a Limba Chiefdom," *Africa* 58,4:437-65.

— 1990. "Response by Simon Ottenberg," *African Art Studies: the State of the Discipline*, Washington, DC: National Museum of African Art, 125-34.

— 1994. "Ambiguity and Synthesis in Religious Expression in Contemporary Eastern Nigerian Art," Paper presented at the Tenth Satterthwaite Colloquium on African Religion and Ritual, 16-18 April.

— 1995. "Christian and Indigenous Religious Issues in the Work of Four Contemporary Eastern Nigerian Artists," Paper presented at the Tenth Triennial Symposium on African Art, New York, 19-23 April.

Ottenberg, Simon and Linda Knudsen. 1985. "Leopard Society Masquerades: Symbolism and Diffusion," *African Arts* 18,2 (February):37-44, 93-5, 103, 104.

Otto, Rudolf. 1959 [1917]. *The Idea of the Holy*. Trans. J. W. Harvey. Penguin: Harmondsworth.

Paden, William. 1991. "Before 'The Sacred' became Theological: Reading the Durkheimian Legacy,"

Method and Theory in the Study of Religion 3.2. (1991):10–23.

Parkin, David. 1981. *Speaking of Art: a Giriama Impression.* The Alan P. Merriam Memorial Lecture in Anthropology. Bloomington, IN: African Studies Program.

— 1991a. *Sacred Void: Spatial Images of Work and Ritual among the Giriama of Kenya.* Cambridge: Cambridge University Press.

— 1991b. "Simultaneity and Sequencing in the Oracular Speech of Kenyan Diviners," in *African Divination Systems*, ed., Peek, 173–89.

Peek, Philip ed. 1991. *African Divination Systems: Ways of Knowing.* Bloomington, IN: Indiana University Press.

Pemberton, John III. 1978. "Egungun Masquerades of the Igbomina Yoruba," *African Arts* 11,3:40–5.

— 1989. "The Dreadful God and the Divine King," in *Africa's Ogun*, ed., Barnes, 106–46.

— 1990. "Response by John Pemberton III," *African Art Studies: the State of the Discipline.* Washington, D.C.: National Museum of African Art, 137–43.

Pemberton, John III. 1994. "Introduction: In Praise of Artistry." In *The Yoruba Artist.* eds, Abiọdun, Rowland, Henry J. Drewal and John Pemberton III.

Pernet, Henry. 1987. "Ritual Masks in Nonliterate Cultures," *Encyclopedia of Religion*, ed., Eliade, 263–9. New York, NY: Macmillan.

— 1992. *Ritual Masks: Deceptions and Revelations.* Columbia, SC: University of South Carolina Press. Trans. from the French by Laura Grillo.

Phillips, Ruth B. 1993. "Masking in Mende Sande Society Initiation Rituals," in *Arts of Africa, Oceania and the Americas,* eds, Janet Catherine Berlo and Lee Anne Wilson, 231–43. Englewood Cliffs, NJ: Prentice Hall.

— 1995. *Representing Woman: Sande Masquerades of the Mende of Sierra Leone.* Los Angeles, CA: Fowler Museum of Cultural History, University of California at Los Angeles.

Picton, John. 1988. "Some Ebira Reflexions on the Energies of Women," *African Languages and Cultures* 1,1:61–76.

— 1989. "On Placing Masquerades in Ebira," *African Languages and Cultures* 2,1:73–92.

— 1990. "What's in a Mask?," *African Languages and Cultures* 3,2:181–202.

— 1992a. "On the Invention of 'Traditional' Art," in *Principles of "Traditional" African Culture*, ed., Okediji, 1–10.

— 1992b. "Tradition, Technology, and Lurex," in *History, Design, and Craft in West African Strip-Woven Cloth*, 13–52. Washington D.C.: National Museum of African Art.

— 1993. "In Vogue, or The Flavour of the Month: the New Way to Wear Black," *Third Text* 23 (summer):89–98.

Picton, John and John Mack. 1989. *African Textiles.* London: British Museum Press.

Pietz, William. 1985. "The Problem of the Fetish, I," *RES* 9:5–17.

— 1987. "The Problem of the Fetish, II," *RES* 12:23–45.

— 1988. "The Problem of the Fetish, IIIa," *RES* 16:105–23.

Platvoet, Johannes G. 1982. "Commemoration by Communication: Akan Funerary Terracottas," *Visible Religion: Annual for Religious Iconography* (Leiden), 112–32.

Ponter, Anthony and Laura. 1992. *Spirits in Stone: the New Face of African Art.* Sebastopol, CA: Ukama Press.

Poppi, Cesare. 1992. "Looking at the Invisible, Seeing the Unseeable: Communication Strategies and Representation in the *Sigma* Cult of Northwestern Ghana." Paper presented at the IX Triennial Symposium on African Art, Iowa City, IA.

— 1993. "Sigma! The Pilgrim's Progress and the Logic of Secrecy," in *Secrecy*, ed., Nooter, 197–204.

Poynor, Robin. 1987. "Naturalism and Abstraction in Owo Masks," *African Arts* 20,4:56–61, 91.

—1994. *African Art at the Harn Museum: Spirit Eyes, Human Hands.* Gainesville, FL: University Press of Florida.

Preston, George Nelson. 1985. *Sets, Series and Ensembles in African Art.* New York, NY: The Center for African Art. Catalogue: Polly Nooter.

Price, Sally. 1989. *Primitive Art in Civilized Places.* Chicago, IL: University of Chicago Press.

Quarcoo, A. K. 1972. *The Language of Adinkra Patterns.* Legon: Institute of African Studies.

— 1990. "The Sacred *Asesdwa* and Mission," *International Review of Missions* 79,316:493–8.

Quarcoopome, Nii Otokunor. 1993. "*Agbaa*: Dangme Art and the Politics of Secrecy," in *Secrecy*, ed., Nooter, 113–20.

— 1994. "Thresholds and Thrones: Morphology and Symbolism of Dangme Public Altars," *Journal of Religion in Africa* 24,4 (November):339–57.

Quel, Safy. 1985. *Bruce Onobrakpeya: Symbols of Ancestral Groves.* Mushin, Nigeria: Ovuomaroro Gallery.

Ranger, Terence. 1983. "The Invention of Tradition in Colonial Africa," *The Invention of Tradition*, Eric

Bibliography

Hobsbawm and Terence Ranger eds. Cambridge: Cambridge University Press, 211–62.

Rattray, R. S. 1969 [1927]. *Religion and Art in Ashanti*. Oxford: Clarendon Press.

Ravenhill, Philip. 1980. "Baule Statuary Art: Meaning and Modernization." Working Paper 5, Institute for the Study of Human Issues, Philadelphia, PA.

— 1993. "Dreaming the Other World: Figurative Art of the Baule, Côte d'Ivoire." National Museum of African Art catalogue, 9 pp.

— 1994. *The Self and the Other: Personhood and Images among the Baule, Côte d'Ivoire*. Monograph series, 28. Los Angeles, CA: Fowler Museum of Cultural History, University of California at Los Angeles.

Ray, Benjamin C. 1976. *African Religions: Symbol, Ritual, and Community*. Englewood Cliffs, NJ: Prentice-Hall.

Ray, Keith and Rosalind Shaw. 1987. "The Structure of Spirit Embodiment in Nsukka Igbo Masquerading Traditions," *Anthropos* 82:655–60.

Richards, Audrey. 1956. *Chisungu: a Girls' Initiation Ceremony among the Bemba of Northern Rhodesia*. London: Faber and Faber.

Roberts, Allen F. 1988. "Of Dogon Crooks and Thieves," *African Arts* 21,4:70–5, 91.

— 1990a. "Initiation, Art and Ideology in Southeastern Zaire," *Iowa Studies in African Art*, vol III., ed., Roy, 7–32.

— 1990b. "Tabwa Masks: An Old Trick of the Human Race," *African Arts* 23,2 (April):37–47,101–3.

— 1994. "An African God of Recycling." Unpublished paper.

Roberts, Mary Nooter. 1994. "Does An Object Have a Life?," in *Exhibition-ism: Museums and African Art*, Mary Nooter Roberts and Susan Vogel, with Chris Müllen, New York, NY: Museum for African Art, 37–55.

Rosen, Norma. 1989. "Chalk Iconography in Olokun Worship," *African Arts* 22,3:44–53, 88.

— 1993. "The Art of Edo Ritual," in *Divine Inspiration*, Galembo, 33–45.

Roy, Christopher. D. 1983. *The Dogon of Mali and Upper Volta*. München: Feld und Jeus Jahn.

— 1987. *Art of the Upper Volta Rivers*. Meudon: Chaffin.

— ed., 1990. "Art and Intitiation in Zaire," *Iowa Studies in African Art*, vol. II. Iowa City, IA: University of Iowa.

— 1992. *Art and Life in Africa: Selections from the Stanley Collection, Exhibitions of 1985 and 1992*. Iowa City, IA: University of Iowa Museum of Art.

Sackey, Brigid. 1985. "The Significance of Beads in the Rites of Passage among some Southern Ghanaian Peoples," *Research Review* (Legon) (NS) 2,2 (July):1–13.

Saler, Benson. 1977. "Supernatural as a Western Category," *Ethos* 5:31–53.

Salmons, Jill. 1977. "Mammy Wata," *African Arts* 10 (April):8–15.

Sanford, Mei-Mei. 1994. "Oṣun: A New God for a New Age?: A Yoruba Religion in Contemporary Nigeria". Unpublished paper presented at the American Academy of Religion, Chicago, IL, 20 November.

Sarpong, Peter. 1971. *The Sacred Stools of the Akan*. Tema, Ghana: Ghana Publishing Corporation.

Schaedler, Karl-Ferdinand. 1992. *Gods, Spirits, Ancestors: African Sculpture from Private German Collections*. Munich: Panterra.

Schildkrout, Enid and Curtis A. Keim. 1990. *African Reflections: Art from Northeastern Zaire*. Seattle, WA: University of Washington Press.

Secretan, Thierry. 1994. *Il Fait sombre va-t'en: cercueils au Ghana*. Paris: Hazan.

Serima: Toward an African Expression of Christian Belief/Ein Versuch in afrikanisch-christlicher Kunst. Gwelo: Mambo Press.

Shaw, Rosalind. 1990. "The Invention of African Traditional Religion?" *Religion* 20, 4 (October):339–54.

Shaw, Rosalind. 1991. "Splitting Truths from Darkness: Epistemological Aspects of Temne Divination," in *African Divination Systems*, ed., Peek, 137–52.

Sieber, Roy. 1977. "Some Aspects of Religion and Art in Africa," in *African Religions: a Symposium*, ed., Newell Booth, New York, NY: Nok, 141–57.

Sieber, Roy and Roslyn Adele Walker. 1987. *African Art in the Cycle of Life*. Washington, D.C.: Smithsonian Institution Press.

Silverman, Raymond A. 1983. "Akan Kuduo: Form and Function," in *Akan Transformations: Problems in Ghanaian Art History*, eds, Doran H. Ross and Timothy F. Garrard. Los Angeles, CA: Museum of Cultural History, University of California at Los Angeles.

Simon, Kavuna. 1995. "Northern Kongo Ancestor Figures," in *African Arts* 28,2 (spring):49–53, 91. Trans. by Wyatt MacGaffey.

Siroto, Leon. 1976. *African Spirit Images and Identities*. Essay accompanying exhibition catalogue, Pace Gallery, New York, 6–22.

— 1979. "Witchcraft Belief in the Explanation of Traditional African Iconography," in *The Visual Arts: Plastic and Graphic*, ed., Justine M. Cordwell, 241–91. The Hague: Mouton.

Smith, Fred T. 1987. "Death, Ritual, and Art in Africa," *African Arts* 21,1 (November):28–9, 84.

Solomon, Anne. 1995. "'Mythic Women': A Study in Variability in San Rock Art and Narrative," *Contested Images: Diversity in Southern African Rock Art Research*, eds, Dowson and Lewis-Williams, 331–71.

Soppelsa, Robert. 1988. "Western Art Historical Methodology and African Art: Panofsky"s Paradigm and Ivoirian *Mma*," *Art Journal* 47,2 (summer):147–53.

Steiner, Christopher B. 1994. *African Art in Transit.* New York, NY: Cambridge University Press.

Sterner, Judy. 1989. "Who is Signalling Whom? Ceramic Style, Ethnicity and Taphonomy among the Sirak Bulay," *Antiquity* 63:451–9.

Strother, Zoe. 1995. "Invention and Reinvention in the Traditional Arts," *African Arts* 28,2 (spring):24–33, 90.

Sullivan, Lawrence E. 1988. *Icanchu's Drum: An Orientation to Meaning in South American Religions.* New York, NY: Macmillan.

de Surgy, Albert, ed. 1985. "Fétiches: Objets enchantés, mots réalisés," *Systèmes de pensée en Afrique*, 8.

Swiderski, Stanislaw. 1989. *La Religion bouiti.* Vol. IV. L'Art sacré. New York, NY: Legas.

Sylla, Adbou. 1988. Création et imitation dans l'art africain, *Initiations et études africaines*, no. 34. Dakar: Université Cheikh Anta Diop de Dakar, IFAN— Ch. A. Diop.

Talbot, P. Amaury. 1912. *In the Shadow of the Bush.* London: Heinemann.

Thompson, Robert Farris. 1971a. *Black Gods and Kings.* Los Angeles, CA: University of California.

— 1971b. "Twin Images among the Ọyọ and other Yoruba Groups," in *African Arts* 4,3:8–13, 77–80.

— 1972. "The Sign of the Divine King: Yoruba Bead-Embroidered Crowns with Veil and Bird Decorations," in *African Art and Leadership*, eds, Fraser and Cole, 227–60.

— 1974. *African Art in Motion.* Berkeley and Los Angeles, CA: University of California Press.

— 1989 [1973]. "Yoruba Artistic Criticism," in *The Traditional Artist in African Societies*, ed., d'Azevedo, 19–61.

— 1993. *Face of the Gods: Art and Altars of Africa and the African Americas.* New York, NY: Museum for African Art.

— 1994. "The Three Warriors: Atlantic Altars of Esu, Ogun and Osoosi," in *The Yoruba Artist*, eds, Abiọdun *et al.*, 225–40.

Thompson, Robert Farris and Joseph Cornet. 1981. *The Four Moments of the Sun: Kongo Art in Two Worlds.* Washington, D.C.: National Gallery of Art.

Tilley, Christopher. 1989. "Interpreting Material Culture," in *The Meaning of Things: Material Culture and Symbolic Expression*, ed., Ian Hodder, 185–94. London: Unwin Hyman.

Tonkin, Elizabeth. 1988. "Cunning Mysteries," in *West African Masks and Cultural Systems*, ed., Kasfir, 241–52.

— 1979. "Masks and Powers," *Man* 14,2:237–48.

Torgovnick, Marianna. 1990. *Gone Primitive: Savage Intellects, Modern Lives.* Chicago, IL: University of Chicago Press.

Turner, Harold W. 1979. *From Temple to Meeting House: the Phenomenology and Theology of Places of Worship.* The Hague: Mouton.

Turner, Victor. 1967. *The Forest of Symbols: Aspects of N'dembu Ritual.* Ithaca, NY: Cornell University Press.

— 1986. *The Anthropology of Performance.* New York, NY: PAJ Publications.

Tyler, Stephen A. 1986. "Post-Modern Ethnography: From Document of the Occult to Occult Document," in *Writing Culture: the Poetics and Politics of Ethnography*, eds, James Clifford and George E. Marcus, 122–40. Berkeley and Los Angeles, CA: University of California Press.

Vansina, Jan. 1972. "*Ndop*: Royal Statues among the Kuba," in *African Art and Leadership*, eds, Fraser and Cole, 41–53.

— 1978. *The Children of Woot.* Madison, WI:

— 1984. *Art History in Africa.* London: Longman. University of Wisconsin Press.

Visona, Monica Blackmun. 1987. "Divinely Inspired Artists from the Lagoon Cultures of the Ivory Coast," in *Iowa Studies in African Art*. Vol. II. *The Artist and the Workshop in Traditional Africa*, ed., Roy. Iowa City, IA: University of Iowa.

Vogel, Susan. 1980. "Beauty in the Eyes of the Baule: Aesthetics and Cultural Values." Working Papers in the Traditional Arts, 6. Institute for the Study of Human Issues, Philadelphia, PN.

— ed. 1981. *For Spirits and Kings: African Art from the Paul and Ruth Tishman Collection.* New York, NY: Metropolitan Museum of Art.

— 1987. "Introduction" and Notes, in *Perspectives: Angles on African Art.* New York, NY: The Center for African Art.

— ed. 1988. "Introduction," in *ART/artifact.* New York, NY: The Center for African Art.

— 1991. "Elastic Continuum," in *Africa Explores: 20th Century African Art*, ed., Vogel, 32–55. New York, NY: The Center for African Art.

Bibliography

Walker, Roslyn Adele. 1994. "Anonymous Has a Name: Olowe of Iṣẹ," in *The Yoruba Artist*, eds, Abiọdun *et al.* 91–106.

Wenger, Susanne and Gert Chesi. 1983. *A Life with the Gods in their Yoruba Homeland*. Worgl, Austria: Perlinger Verlag.

Westerlund, David. 1985. *African Religion in African Scholarship*. Stockholm: Almqvist & Wiksell.

Willis, Elizabeth A. 1967. "A Lexicon of Igbo *Uli* Motifs," *Nsukka Journal of the Humanities* 1 (June):91–121.

— 1989. *"Uli* Painting and the Igbo World View," in *African Arts* 23,1:62–7, 104.

Winter-Irving, Celia. 1991. *Stone Sculpture in Zimbabwe: Context, Content and Form*. Harare, Zimbabwe: Roblaw Publishers.

Witte, Hans. 1994. "Ifa Trays from the Oṣogbo and Ijẹbu Regions," in *The Yoruba Artist*, eds, Abiọdun *et al.* 59–78.

Van Wyk, Gary. 1993. "Through the Cosmic Flower: Secret Resistance in the Mural Art of Sotho-Tswana Women," in *Secrecy: Art that Conceals and Reveals*, ed., Nooter, 81–97.

— 1994. "Convulsions of the Canon: 'Convention, Context, Change' at the University of Witwatersrand Art Galleries," *African Arts* 27,4 (Autumn):54–67, 95.

Yai, Olabiyi Babalola. 1994. "In Praise of Metonymy: the Concepts of 'Tradition' and 'Creativity' in the Transmission of Yoruba Artistry over Time and Space," in *The Yoruba Artist*, eds, Abiọdun *et al.*, 107–18.

Yoshida, Kenji. 1991. "Masks and Transformation among the Chewa of Eastern Zambia," *Senri Ethnological Studies*, No. 31.

Zahan, Dominique. 1960. *Sociétés d'initiation bambara*. Paris: Mouton.

— 1979. *The Religion, Spirituality, and Thought of Traditional Africa*. Chicago, IL: University of Chicago Press.

— 1988. "The Boat of the World as a Pendant," *African Arts* 21,4 (August):56–7.

Zeidler, Jeanne and Mary Lou Hultgren, 1988. "Things African Prove to be the Favourite Theme": The African Collection at Hampton University." In *ART/Artifact* , 97–152.

Zeitlyn, David. 1994. "Mambila Figurines and Masquerades: Problems of Interpretation," *African Arts* 27,4 (Autumn):38–47, 94.

Index

221

Index

Index

Index